D1258215

GRAPHIC PASSION

GRAPHIC PASSION

MATISSE AND THE BOOK ARTS

John Bidwell

With contributions by Michael M. Baylson,
Frances Batzer Baylson, Sheelagh Bevan, and
Jay McKean Fisher

PUBLISHED BY

THE PENNSYLVANIA STATE UNIVERSITY PRESS · UNIVERSITY PARK, PENNSYLVANIA

AND THE MORGAN LIBRARY & MUSEUM · NEW YORK, NEW YORK

Exhibition at the Morgan Library & Museum, New York
30 October 2015–18 January 2016

Graphic Passion: Matisse and the Book Arts is made possible by the generous support of the Pierre and Tana Matisse Foundation, The Grand Marnier Foundation, the Gladys Krieble Delmas Foundation, the Charles E. Pierce, Jr. Fund for Exhibitions, and by the gift in 2010 of the collection of Frances and Michael Baylson, a major resource for the study of Henri Matisse. The catalogue is underwritten by the Franklin Jasper Walls Lecture Fund.

LIBRARY OF CONGRESS CATALOGUING-IN-PUBLICATION DATA
Bidwell, John, 1949– , author.
Graphic passion : Matisse and the book arts / John Bidwell ; with a foreword by Colin B. Bailey and essays by Michael Baylson and Frances Batzer Baylson and Jay Fisher.
pages cm — (The Penn State series in the history of the book)
Summary: "Recounts the publication history of nearly fifty books illustrated by Henri Matisse, including Lettres portugaises, Mallarmé's Poésies, and Matisse's own Jazz. Explores his illustration methods, typographic precepts, literary sensibilities, and opinions about the role of the artist in the publication process"—Provided by publisher.
Includes bibliographical references and index.
ISBN 978-0-271-07111-4 (cloth : alk. paper)
1. Matisse, Henri, 1869–1954—Criticism and interpretation.
2. Illustration of books—France—20th century.
3. Illustrated books—France—History—20th century.
I. Title. II. Series: Penn State series in the history of the book.

NC980.5.M35B53 2015
096'.109440904—dc23
2015014717

"Matisse Book Illustrations" © 2015 Michael M. Baylson and Frances Batzer Baylson
"Mallarmé's *Poésies:* 'I will be vindicated by my maquette'" © 2015 Jay McKean Fisher

Copyright © 2015 The Morgan Library & Museum. All rights reserved. This book may not be reproduced in whole or in part, in any form (beyond that copying permitted by Sections 107 and 108 of the U.S. Copyright Law and except by reviewers for the public press), without written permission from the publisher.

Printed in Canada by Friesens

Matisse on Art edited by Jack Flam. Copyright © 1995 by Jack Flam. English translation copyright © 1995 by Jack Flam. Underlying text and illustrations by Matisse. Copyright © 1995, 1973 by Succession Henri Matisse (University of California Press). Reprinted by permission of Georges Borchardt, Inc., for Jack Flam.

All works of Henri Matisse © 2015 Succession Henri Matisse / Artists Rights Society (ARS), New York.
All quotes and writings of Henri Matisse © 2015 Succession Henri Matisse.

Frontispiece: Henri Matisse, self-portrait in *Les fleurs du mal* (No. 31).

Full-page illustrations: p. vi (Fig. 2, p. 23); p. x linocut in *Pasiphaé* (No. 21); p. 18 (Fig. 14, p. 36); p. 42 (Fig. 2, p. 97); p. 50 Mallarmé mock-up (see Fig. 1, p. 21); p. 224 (Fig. 4, p. 146).

The pen-and-ink ornaments on pages i and 253 are from *Les fleurs du mal* (No. 31).

Illustrations on page v (counterclockwise from top left): portrait of Annelies Nelck, *Vingt-trois lithographies* (Fig. 2, p. 153); portrait of Montherlant, *Pasiphaé* (Fig. 6, p. 125); frontispiece, *Apollinaire* (Fig. 1, p. 216); frontispiece, *Dessins: Thèmes et variations* (Fig. 1, p. 116); rejected cover design, *Jazz* (Fig. 4, p. 182); lithograph, *Lettres portugaises* (Fig. 7, p. 149), rejected design, *Poésie de mots inconnus* (Fig. 3, p. 200).

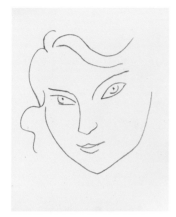

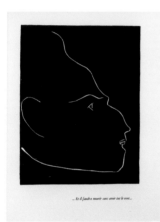

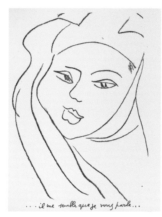

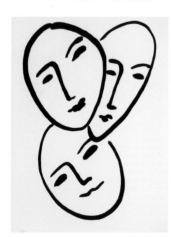

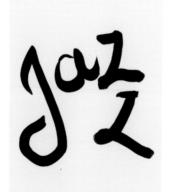

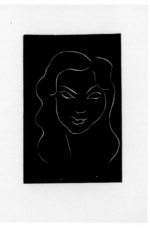

CONTENTS

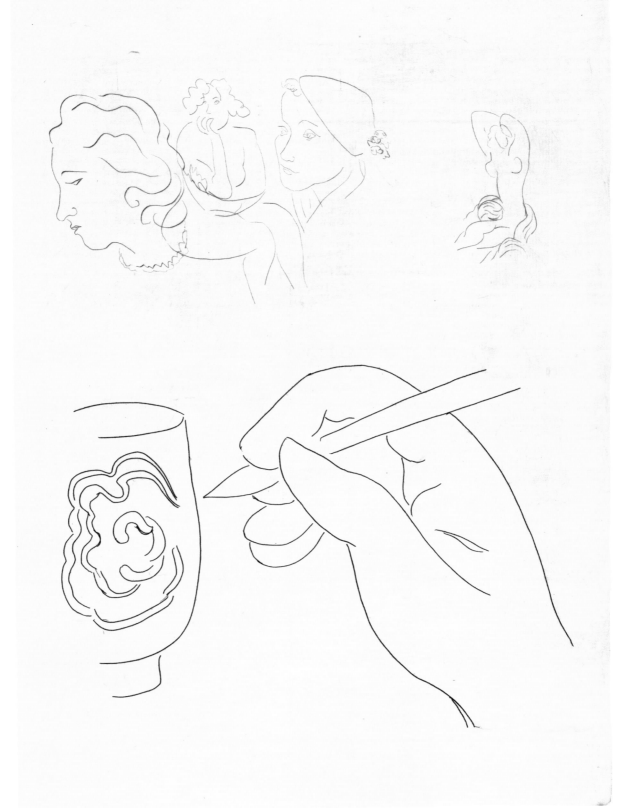

DIRECTOR'S FOREWORD

Henri Matisse developed a passion for typography and illustration late in life. Having had some experience in book production, he saw what other artists accomplished, learned from them, and then surpassed his predecessors in achieving a perfect fusion of image and text. More than any others of his rank and stature he understood the principles of visual communication and the potential of letterpress printing. A master printmaker, he directly participated in type selection, page layout, lettering, ornament, and cover design to ensure a seamless harmony between his illustrations and the printed page. On occasion a book inspired him to take command of the manufacturing operations, which he supervised with characteristic vigilance and zeal. His keen and spirited interpretations of literary texts are evidence of the sheer joy he took in the act of bookmaking during a final and triumphant phase of his artistic career. This is the subject to which our exhibition and the catalogue that accompanies it are devoted.

Graphic Passion is the first comprehensive in-depth analysis of Matisse's ventures in book design and the first systematic survey of the topic in English. Like previous catalogues, it describes his most important illustrated books, but it also investigates the commercial and cultural contexts for them in unprecedented detail. It shows how Matisse conceived these books and saw them through the press in the company of authors, printers, and publishers who understood his artistic goals and shared his taste for opulent fine printing. Drawing on unpublished correspondence, it provides new information about type, paper, and reproduction processes—matters of great interest to him but often overlooked by scholars. Other publications of the Morgan Library & Museum have taken a similar approach, most notably Gordon N. Ray's monumental two-volume *The Art of the French Illustrated Book, 1700–1914*. Bequeathed to the Morgan in 1987, the Gordon N. Ray Collection includes luxury editions that influenced Matisse's ideas about styles of typography and the function of illustration.

The Morgan obtained a major resource for the study of Matisse with the generous donation of the Frances and Michael Baylson Collection in 2010. Michael M. Baylson, a senior federal judge on the United States District Court for the Eastern District of Pennsylvania, and Frances Batzer Baylson, M.D.,

a distinguished specialist in reproductive endocrinology, have contributed to this catalogue a personal account of their deep appreciation for Matisse's books over the course of forty years of collecting. They have built a complete run of the canonical illustrated books along with proofs, ephemera, periodical covers, more than five hundred catalogues, and a reference library of scholarly publications. Their collection includes legendary rarities such as *Échos* and *Vingt-trois lithographies pour illustrer* Les fleurs du mal, one issued in fifteen copies, the other in five, as well as special copies on fine paper with extra suites of illustrations. Their copy of *Jazz*—a promised gift to the Morgan—is one of the high points of the exhibition. We are greatly indebted to them for their generosity, counsel, and enthusiastic encouragement.

I would also like to acknowledge the continuing support and assistance of the Pierre and Tana Matisse Foundation. A son of the artist and a prominent art dealer in New York, Pierre Matisse played an important role in introducing his father's work to an American audience. He participated in several publications and inherited a rich trove of proofs and preliminary drawings, some of which have been loaned to this exhibition. In 1997 the foundation gave to the Morgan the Pierre Matisse Gallery Archives, containing, among other treasures, correspondence between father and son concerning book illustration projects such as *Jazz* and *Ulysses*. Matisse described his business arrangements, reported on work in progress, and critiqued the finished product in trenchant terms he used only when confiding in his family. These letters complement the correspondence in the Archives Henri Matisse (Issy-les-Moulineaux), which has also informed the findings of this catalogue. John Bidwell, Peggy Fogelman, and I are particularly grateful to Alessandra Carnielli, Executive Director of the Matisse Foundation, and Wanda de Guébriant, Director of the Archives Matisse, who have both supplied expert advice and information during

every phase of this project. Georges Matisse also helped in guiding us through the rights and permission process for the catalogue illustrations.

Thanks are due as well to Jay Fisher, Deputy Director for Curatorial Affairs and Senior Curator of Prints, Drawings, and Photographs at the Baltimore Museum of Art. In addition to arranging important loans from the Cone Collection, Mr. Fisher has written for this catalogue an essay about the Baltimore Museum's incomparable Matisse holdings, with special reference to the presentation maquette of Mallarmé's *Poésies,* a definitive statement of the artist's methods and intentions.

The exhibition was organized by John Bidwell, Astor Curator of Printed Books and Bindings at the Morgan, who also wrote the catalogue with the exception of Nos. 39 and 46, which are the work of Sheelagh Bevan, Andrew W. Mellon Assistant Curator of Printed Books. Karen Banks, Publications Manager, oversaw catalogue production; Patricia Emerson, Senior Editor, edited the text; and Marilyn Palmeri and Eva Soos in the Department of Imaging and Rights secured the illustrations. Graham Haber photographed Morgan holdings as well as the loans from the Baylson collection and the Matisse Foundation. Conservators Maria Fredericks, Frank Trujillo, and Reba Snyder prepared material for photography and installation in the exhibition. I am very grateful for all their efforts in making this catalogue a meaningful resource for specialists and nonspecialists alike.

Finally, it should be noted that our attempts to reassess Matisse as a book artist would not have been possible without the generosity of several important donors. A grant from the Pierre and Tana Matisse Foundation covered a significant portion of the exhibition expenses. Major contributions were received from The Grand Marnier Foundation and the Gladys Krieble Delmas Foundation along with additional assistance from the Charles E. Pierce, Jr. Fund for Exhibitions. The Franklin Jasper Walls Lecture Fund provided support for lectures on this topic and the

means to rework those lectures for publication in this catalogue.

These contributions are part of a great tradition. American admirers of Matisse organized groundbreaking exhibitions of his work and collected it with courage, discernment, and determination. They bought his books and participated in the publication of the Mallarmé, *Cinquante dessins, Jazz,* and *Ulysses.* They welcomed him when he crossed the country, starting off in New York, where he was entranced by the quality of the light, the beauty of the skyscrapers, and the vitality of the people. Here in midtown Manhattan, we seek to continue that tradition, enlisting museum and library resources to promote understanding of the book arts and of Matisse's extraordinary achievements in particular. Such accomplishment and creativity we hope are manifest in both this exhibition and catalogue.

Colin B. Bailey
Director

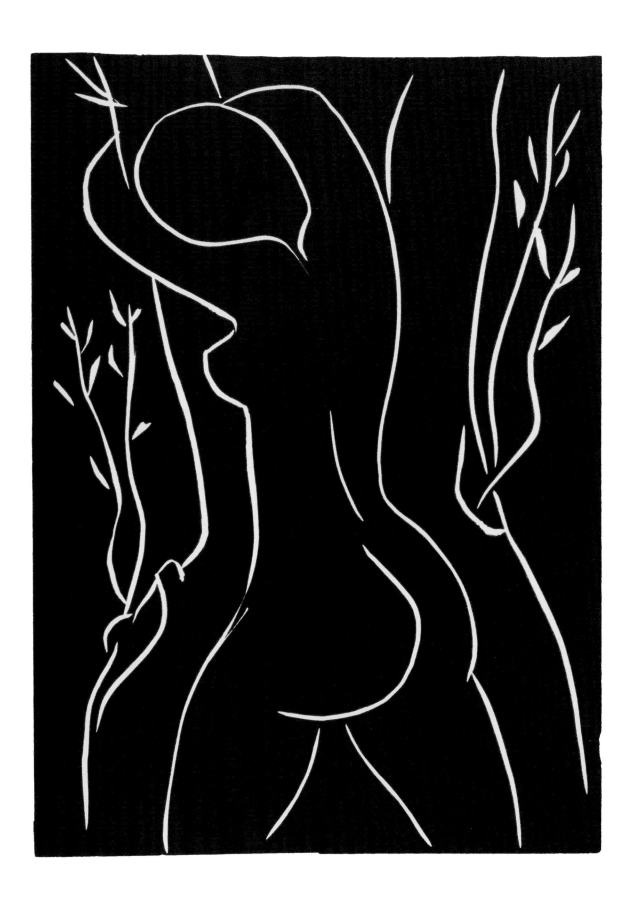

MATISSE BOOK ILLUSTRATIONS

MICHAEL M. BAYLSON

FRANCES BATZER BAYLSON

"I do not distinguish between the construction of a book and that of a painting."

The great painter Henri Matisse was also a great artist of the book. A pioneering member of the Fauves (the "wild beast" artists of early-twentieth-century Paris); a supreme colorist who painted lush, decorative interiors and seductive, lounging nudes; a remarkable draftsman whose drawings, etchings, and lithographs possess an elegance unmatched by the work of any other modern artist; a creative genius whose art became ever younger as he aged and who in his final years devised a new art form, the cutout—this is the Matisse known and admired by everyone with even a passing interest in modern art. But few know Matisse as an artist who designed and illustrated his own books.

Matisse did not seriously undertake illustrating books until the early 1930s, when he was in his sixties. Book illustrations were his principal artistic activity during the war years of the 1940s, and his interest in illustrations continued until the time of his death in 1954. These works reflect his ongoing experimentation and imagination, distinctive features of a continually evolving artist. His innovative, colorful cutouts, which he created during the last years of his life, became the basis of his most famous illustrated book, *Jazz,* published in 1947.

One reason Matisse is not better known as a creator of magnificent illustrated books is that his paintings have and always will overshadow his books. A large painting hanging on a wall, particularly one by a great colorist such as Matisse, is overwhelming to the senses when viewed straight on, as one stands before it. Books are different: they have an intimate, tactile value. Illustrated books are the artistic example of the maxim that small is beautiful. In addition, a book simply is not as accessible as a painting. The turning of pages, the search for the illustrations placed throughout the text, the comparison of one illustration with others, and of the text with the illustrations—all this presents the artist and the viewer with opportunities that are not available in any other medium.

Exhibiting a book presents challenges. A museum could show a different page every day, but

I

to examine an entire book, a visitor would have to return day after day. Some illustrated books are not bound, so all pages can be viewed at once, arranged in a large frame or plexiglass box, but books exhibited this way lose much of their intimacy and charm. Some museums are now displaying entire artists' books through a digital reader, enabling the viewer to turn the pages by pressing a button.

We came to recognize the difference between illustrated books and a well-established subset, books illustrated by artists. The former is a generic category, which includes books with cartoons, photographs, and various types of art reproductions. The latter is more distinctive: a special situation in which artist/illustrators create graphic images with the intention of reproducing them within the confines of a bound volume, a unique work of art. Illustrated books of high artistic quality have a long history, from the Egyptian Book of the Dead to the Irish Book of Kells, from Botticelli's illustrations for Dante's *Divine Comedy* to the 1896 Kelmscott Press edition of Chaucer's works. Through our exposure to museums and libraries, we learned that artists often contributed to written histories of Middle Eastern and Asian civilizations, sometimes in a book, often in a scroll.

We realized that French artists of the late nineteenth century began a singular and impressive tradition of illustrating books, at first contributing their own works, often reproductions of drawings, to accompany a text. As we read more about the French tradition of illustrated books, we came across the publication of Manet's illustrations of Poe's *The Raven*. This was one of the first examples of a prominent French artist demonstrating a pronounced interest in illustrating books. Bonnard was among the first Postimpressionist artists to do so. His lithographs illustrating Paul Verlaine's *Parallèlement*, published in 1900 by the art dealer Ambroise Vollard, set a high standard for illustrating poetry in a fine printed book. This volume reflected a new collaboration between artist and publisher. We thought Vollard would have been the

ideal publisher for Matisse, and, although Vollard went on to produce books illustrated by many other famous artists working in Paris during the early years of the twentieth century, he never collaborated with Matisse. Vollard did sponsor Matisse's first solo exhibition of paintings in 1904, but the two never established a warm or lasting relationship.

With more research, we realized that book illustrations became an important vehicle for many School of Paris artists to become better known. The very nature of a book allows for wider distribution at a much lower cost than paintings or drawings. It was also obvious to us that principles of artistic competition played a role in bringing many artists, including Matisse, to book illustration. Picasso, who had first illustrated several books of poems or plays by his friend Max Jacob by 1920, led the way; Matisse was always watching what his friend and sometime competitor was doing. As artists gained in reputation, their illustrated books became more popular. Chagall, Rouault, Miró, in addition to Matisse and Picasso—these are a few of the famous Paris-based artists who turned their talents to book illustration and enriched a tradition known as *livres d'artistes,* or "artists' books," that has flourished around the world into the twenty-first century.

MICHAEL

How did I become interested in Matisse in the first place? I can't say it hit me like a bolt of lightning that I had to build a collection of his illustrated works, nor did I have the assets to go out and purchase an existing collection. Indeed, the fruits of my Matisse habit have been enjoyable because the collection was slow-growth, as a fine wine ages in the barrel and then the bottle. But the first inspiration is well-inked in my mind—a visit to the Barnes Foundation, in Merion, just outside Philadelphia, when I was an undergraduate at the Wharton School in 1960.

Matisse gained fame in the United States when he won the Carnegie Institute Prize in 1927.

He was featured on the cover of *Time* magazine in 1930. That same year, he accepted a commission from Albert Barnes for a huge painting, often erroneously referred to as a wall mural, in Barnes's mansion in Merion. Installed in 1933, this work is the largest celebration of one of Matisse's recurrent themes, the dance. When Matisse agreed to the terms of the notoriously difficult Barnes, however, he may not have known that the doors to the Barnes mansion would be closed to the public for decades to come. Barnes had assembled one of the very great collections of French modern art in the world. After his death in 1951, his will directed that his home was to become a private school for art appreciation, and admission to the collection was generally limited to the school's small number of students. Otherwise, getting admitted to the Barnes in the 1960s was an effort, often an unsuccessful one.

To be selected for a two-hour guided tour by the curator Violette de Mazia required a creative approach. Well known for rejecting requests from anyone even slightly associated with the art world, the Barnes nonetheless would admit a few people every week, but there were constant reports implying that the decisions of whom to admit or reject were inconsistent and arbitrary; indeed, many recommended that the best strategy was to write a letter of request in block letters on plain white paper, concealing any possible indication of education, intelligence, or interest in art. I went partly owing to a course in art history that had been a welcome break from the required business courses and had kindled my latent interest in twentieth-century French painters. Also, I intended to write an article for the *Daily Pennsylvanian,* where I was a features reporter.

My visit to the Barnes was an eye-opener, a life-changing experience. Immediately upon entering the mansion, encountering major works by some of the greatest painters in the world, among them Picasso, Cézanne, Seurat, and Renoir, I was overwhelmed by the literally overarching beauty of the huge *Dance* by Matisse in the most prominent spot, framing the upper-story windows. My resulting features article was not a remarkable or even memorable piece of reportage—but I did strongly criticize the Barnes trustees for slavishly following the prejudices of the late Dr. Barnes in refusing public admission but nonetheless claiming a huge tax exemption. Some days later, several former Barnes students wrote letters to the editor, ridiculing my comments and claiming that Barnes's wish to keep his collection private was more important than granting public access. Nonetheless, the opportunity to see masterpieces in that setting was the beginning of my interest in Matisse.

FRANCES

My fascination with Matisse started in high school and intensified in college. My high school art teacher, Mary Lou Skull, was one of the special few who could communicate the importance of looking, seeing, and understanding at the same time. She instilled within me the value of an artist's vision, encouraging me and my classmates to explore our own creative abilities. David Sylvester, a prominent art critic and trustee of the Tate Gallery, London, was a visiting professor during my senior year at Swarthmore. Under his tutelage, I learned to look at modern art with a sense of wonder and new respect for its cultural resonances. The subject of my senior thesis was an account of Matisse's sculpture, which had not yet been studied systematically because the artist had died less than ten years before. There was only one major work on Matisse at the time, the monograph by Alfred Barr. Much of Matisse's exploration of mediums other than the traditional oil and canvas was undocumented. Albert Elsen's survey of Matisse's sculpture did not include many of his later cast pieces. It was not until 1988 that Claude Duthuit published his catalogue raisonné of Matisse's illustrated works, including not just *Jazz*

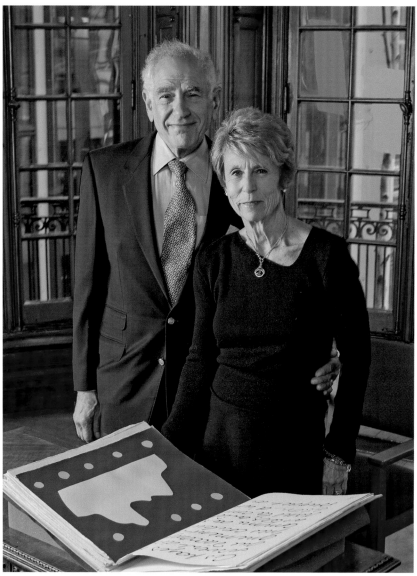

Fig. 1. Michael and Frances Baylson with *Jazz*

but many other books unknown to collectors at that time. Barr had devoted fewer than ten pages to this part of Matisse's career.

Modern art and Matisse took on a new meaning when my fiancé Michael took me to see *Jazz* at the Philadelphia Museum of Art. It was my first encounter with a major illustrated book. The process of page turning felt relevant to Matisse's working method of repetition and simplification.

I could turn the pages forward or backward as well as in a sequence of my own fashion. I was given my very own copy of *Jazz* (Fig. 1) when I passed my specialty medical boards! I was among the 270 luckiest people in the world. A page from *Jazz*, changed on a regular basis, has prominently adorned our walls ever since.

Book printing is usually in black and white, but Matisse's books taught me about the impor-

tance of his use of color. *Jazz* may be the best-known example, but there are many others, including *Pasiphaé* (Fig. 2), in which he balanced brilliant red initials with his linocuts as well as the open page of text. After I completed medical school, we embarked on a fabulous bike trip from Nice to Marseilles. This excursion had to include Matisse's hotel, Le Régina in Cimiez, Nice, and his villa, Le Rêve, in Vence, where he spent his later years. The chapel he designed for the Dominican nuns in Vence at the end of his life was to be the high point of the trip. Here I was sure he had accomplished his final goal—putting color into sculpture, making color three-dimensional, a technique mastered by the Greeks and Egyptians but then generally neglected (although Picasso's *Absinthe Glass* of 1914 is a notable exception).

We arrived at the chapel on a gray autumn morning. Although it was magnificent even then, the sun was not shining through its famous *Tree of Life* stained-glass windows. I was a bit disappointed, because I felt Matisse had been seeking to communicate his visionary ideas about color through this three-dimensional medium. With *Jazz,* he had sculpted color with scissors, but the final presentation to the viewer was limited to two dimensions. Here, in his final masterpiece, he could express his lifetime commitment to color with the tangible play of light through the stained-glass windows. After a while we left, a little crestfallen at not being able to see the chapel at its best. As we were biking over the next hour or so, the sun came out brilliantly. I insisted on returning ten or more kilometers along quite a hilly road. We arrived in time to see the fall light shine through the windows, conveying color through the airy interior to the brilliant white ceramic tiles on the walls with the line drawing of St. Dominic. I knew it was one of those magical color moments that Matisse had been pursuing for a lifetime.

Fig. 2. Linocut and facing text, *Pasiphaé,* Frances and Michael Baylson Collection

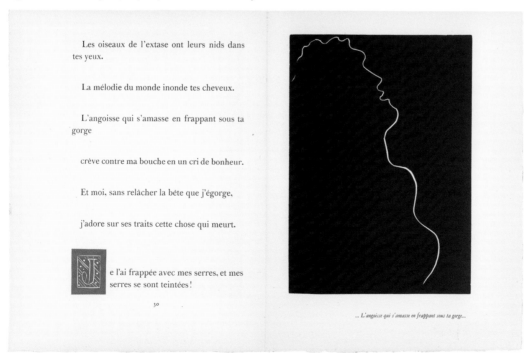

Illustrated books have long fascinated me. An illustrated Old Testament filled out, in graphic images, the relatively dull Sunday-school sessions I attended as a child. Growing older, the first thing I would always look for in editions of classic works read in school, such as the Mark Twain novels, was the illustrations; after finding them, I would look for the text each illustrated to see how well they fit. At the University of Pennsylvania, I often studied at night in the dingy but quiet stacks of bookshelves that seemed to stretch endlessly into the far nooks of knowledge. For a break, I would prowl around until I found a collection of books with informative illustrations.

I greatly admired illustrated Haggadahs, prayer books used during the Seder, the key event of the Passover holiday, celebrating the Jews' exodus from Egypt. Haggadahs have been illustrated for centuries. While facsimiles were available, very few original editions could be found. They were not affordable, so I moved on to Matisse. I thought Matisse the greatest artist of the twentieth century, and I wanted to focus on building a Matisse collection that would be unique and limited to a relatively unknown area of his work. As I quickly discovered, his paintings and drawings were way beyond our means, and his graphics, although attractive, were also widely known and frequently available to the highest bidder at auctions of modern prints. Matisse's illustrated books were the undiscovered nuggets—elegant but not yet costly.

These books appealed to me as an amalgam of literature and art, of word and picture—a multimedia format—and they were relatively affordable. I realized this was a niche collection, but as Matisse's renown as an artist was proliferating, I also thought my investment of time, energy, and money was worthwhile as a learning experience, and a pleasant distraction from the practice of law.

My focus on Matisse as an artist and my passionate pursuit of his illustrated books were also inspired by a young woman's college thesis—the young woman who became my wife. I met Frances in 1967, when she was studying art history at Swarthmore. After graduating from medical school, and after several years of residency and fellowship, she specialized in reproductive endocrinology, helping thousands of women overcome infertility. While she was at Swarthmore, she was working on a senior paper about Matisse's cutouts and how their inspiration flowed from his early work as a sculptor. Frances was, of course, devoting an important part of her paper to *Jazz,* although she had never actually seen an original copy. Within a short time after meeting Frances, I accompanied her to a museum where we were able to page through this very special illustrated book. We learned more about it in Alfred Barr's landmark monograph about Matisse, which has several reproductions from *Jazz.* Together, we admired the coloring of the many shapes, some recognizable, some abstract. I had seen nothing like this in the Matisse works at the Barnes. I was entranced by it but also fascinated to learn that Matisse had chosen a book to communicate such an incredibly original artistic statement. Some years later, I was able to surprise her with a copy of *Jazz* to celebrate her passing her specialty boards.

After Frances and I were married in 1969, I began the pursuit of books by and about Matisse with the limited (but growing) funds of a young Philadelphia lawyer. Over the course of forty years, after scouring dusty shelves in many old bookstores as well as catalogues from auction houses and many book dealers in many countries, I built a unique and complete collection of all the books designed and illustrated by Matisse, plus almost all of his original illustrations for other books, in addition to hundreds of monographs, dozens of catalogues, and a quantity of ephemera. In this way I have assembled the material to trace the artistic development of this consummate artist of the book. As proud as I have been of our collection, I have revealed to very few my interest in these books. It has been a reclusive pursuit. I discovered that the pursuit of old

books was not very common, and that the overall supply was plentiful enough that catalogues and monographs, the two principal types of books a collector could find about artists, were not unduly expensive. Those items acquired by mail were delivered to my office and transported to our home without Frances's knowledge. My acquisitions—quiet, selective and somewhat secretive—were accumulated and stored in a locked metal cabinet in a seldom visited third-floor closet in our home. Periodically they were gradually given, as surprise birthday or anniversary presents, to Frances, to become part of our collection.

FRANCES

So the collection began. Michael drew up a list—desiderata, as he called it. These were the Matisse illustrated books still to be found, the ones not yet on our shelves, the prints not yet on our walls. Often I had to wait until a birthday or an anniversary to share the excitement of a new acquisition. But then the story would come out. Sometimes I did not even know that I had been along on the chase because Michael would go off and visit antiquarian bookstores as soon as we arrived in a new city where there might have been collectors or patrons of Matisse.

Once Michael was involved in a case in Helsinki, and we made a side trip to Saint Petersburg. The travel connections were simple. One of Matisse's biggest patrons, Sergei Shchukin, had built a major collection of Matisse paintings, which became part of that city's Hermitage Museum after the Russian Revolution. It was a dark and cold February, and it was snowing when we arrived, a list of bookstores in hand. People were playing chess in the park, eating ice cream from street vendors, and I was freezing. The bookstore list was not very fruitful, but the Hermitage was fabulous—three rooms of closely hung works by Matisse ending abruptly in 1915, with the beginning of the Russian Revolution. This exhibit underscored for us the importance of the collector as the person responsible for assembling art in one repository. Shchukin's monumental collection, now visited by art lovers from all over the world, inspired us to complete our collection.

MICHAEL

Published in 1951, the masterful critical biography of Matisse by Alfred H. Barr, Jr., formerly director of the Museum of Modern Art, is still the most complete single volume about the artist and his work. It included the first thorough, albeit compact, discussion of Matisse's illustrated books. More important for building a Matisse library, it also contained in a series of appendices a nearly comprehensive catalogue of the books he illustrated up to that date as well as lists of his writings, his contributions of drawings and covers to periodicals, exhibition catalogues, and monographs about his work. Relying on Barr, I adopted several strategies to collect Matisse books on a systematic basis.

As any book lover knows, the demise of retail storefront bookstores is almost complete. In particular, most dealers in used and rare books have retreated to the Internet. The days of prowling the aisles and shelves of used bookstores in search of either a masterpiece or any easy-to-read novel are just about gone. In the days before the Internet and e-mail, locating used books on any subject required a combination of diligence, detective work, and determination. Visiting bookstores specializing in used books was the primary activity, although collectors had to be willing to travel to likely sources. Another strategy was to canvass members of the Antiquarian Booksellers' Association of America and send them lists of wanted books, referred to as desiderata. Some years, I went to their annual show in the Armory on Park Avenue in New York. There I put my name on the mailing lists of dealers who sent out catalogues. Another tactic was to find the "yellow page" telephone directories for various cities, which usually

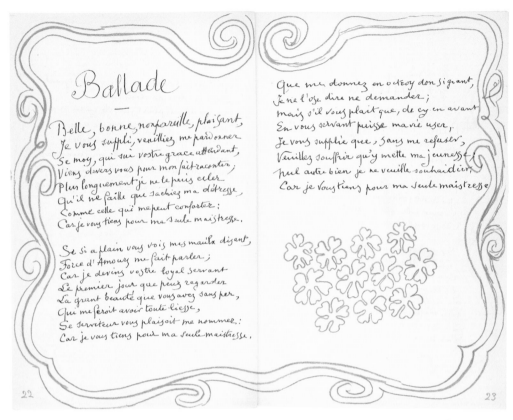

Fig. 3. *Ballade,* handwritten text in decorative frame, *Poèmes de Charles d'Orléans,* Frances and Michael Baylson Collection

had a separate section for "Books—Used and Rare." I would copy and adopt these as a source for my forays into other cities or countries.

But I should say that I started in Philadelphia and then ventured to other cities in Europe and America. Although Philadelphia had a number of used bookstores, none of them had the cachet and atmosphere of Charles Sessler Inc. on Walnut Street. It was a classic English breakfront-style bookstore with large, inviting windows. There were long wooden tables and bookshelves, but no cash register or discounted book in sight. It contained a stock of uncommon depth and breadth: bestsellers, usually more nonfiction than fiction, along with first editions, literary criticism, multivolume biographies, and collections of correspondence. The rare book room in the rear of the store, accessible only

through an elegant wrought-iron gate, was ruled over by Mabel Zahn, the doyenne of Philadelphia book dealers. In her prime, Miss Zahn, as everyone called her, was a commanding presence at all the major book and manuscript auctions, and a guiding force in the acquisition of major American book collections. In her own way, she had become the successor to another famous Philadelphia book dealer, the legendary A. S. W. Rosenbach.

Every collector remembers the first time. It was at Sessler's, through Miss Zahn, that I acquired my first original Matisse book, the colorful *Poèmes de Charles d'Orléans* (Fig. 3), in 1970 (No. 41). At $300, it was by far the most expensive book I had ever bought, and even though I knew it was not Matisse's most important illustrated book, nor particularly rare (at 1,200 copies, an extremely

large number for a limited-edition artist's book), it got me started on a long quest, and incidentally gave me many hours of pleasure in turning its pages filled with rabbits, trefoils, and flowers. I found nothing else for my collection in this establishment, although I visited it for many years.

Years ago, Philadelphia, like many other major cities, had a number of antiquarian book dealers. Leary's was probably the best-known, its fame spreading after a casual inspection of an old book on a shelf yielded a first-edition broadside Declaration of Independence. When work allowed an elongated lunch hour, I would visit these places and quickly peruse the modern art section. Although most used book dealers tried to arrange art books alphabetically by artist, a determined collector would not at all rely on a clerk's adherence to the alphabet. Books are commonly misshelved; the collector must search widely to compensate for that kind of error. I visited all kinds of used bookstores, which often had a small section on art books—and I would never, never take the owner's word that he had nothing on Matisse. Very often I would sit myself on the floor, and a thorough look through the art section would yield treasures, such as an old catalogue or monograph, and on a few occasions, a book with an original Matisse graphic.

The other Philadelphia bookstores warranted visits and yielded occasional finds of old Matisse monographs, catalogues, and sometimes special treasures. One such visit, to a dreary second-floor used bookshop at 19th and Chestnut streets, yielded, surprisingly, one of the rejected plates from Mallarmé's *Poésies*. The owner produced this proudly and promptly from the second drawer of an old cabinet after I asked, as I usually did, for any Matisse items. In the 1980s, John Warren, an expert on art books and the owner of a highly successful mail-order catalogue business, opened a retail store in center city Philadelphia, specializing in art books. Although knowledgeable about Matisse as a book artist, he did not carry any out-of-print books. He did, however, kindly come to

our house some years ago and remarked that we had started, and could probably complete, a unique and valuable book collection. This gave me confidence that the effort was worthwhile.

Not every quest for a Matisse-illustrated book was successful. My most frustrating failure relates to four covers Matisse created in 1951–52 for a Japanese periodical, *Bungeishunjū*. These had been on my wanted lists for many years with nary a bite. On one overseas trip to Tokyo to interview several clients who were possible witnesses in an antitrust case, I spent a full day in the section of the city where most of its used book dealers were located. As I walked from store to store, with the names *Bungeishunjū* and *Matisse,* written in both Japanese and English, and a photocopy of the cover of one of the issues, I was optimistic some clues would develop, if not a copy of at least one of the four issues. It did not happen. I am still looking. Perhaps this exhibition and publication will spread the word, and some lucky person in possession of one of these issues, who may not realize its rarity, will volunteer to give it to the Morgan for this collection.

New York City was a more rewarding location for the expenditure of time, energy, and effort in hunting for new material for my Matisse addiction. Madison Avenue elegantly housed two distinguished dealers who specialized in modern illustrated books—Lucien Goldschmidt and Philip Duschnes—but they carried only very high-end material. Irving Zucker's store, with its entirely different atmosphere, aggressively bought and sold at high prices all the major illustrated works by the twentieth-century artists.

Alongside these experts in rarities, several bookstores were almost entirely devoted to used (and new) art books, and these yielded treasures on almost every visit. Established in 1923, the Weyhe Book Store and Gallery on Lexington Avenue had published Matisse monographs in the 1930s, but its retail operations were truly disorganized. On one visit, I found a monograph lying innocently on the shelf and discovered, tucked

inside the cover, a letter that Matisse had drafted, in his own hand, and signed, commenting on an exhibit he had seen while visiting New York City. This original letter, which has since become a treasured part of our collection, had somehow found its way to the owner of the book.

Wittenborn, which first opened in 1937 on the Upper East Side, was already declining from its earlier heyday as a resource for art books but was still worth a visit. Ex Libris, on East 70th Street, had a very strong collection of books on early-twentieth-century Russian art and Surrealism, but French magazines that featured Matisse could sometimes be found on its shelves. Seymour Hacker, a kindly, old-world gentleman with the brightest blue eyes, had a small bookshop on West 57th Street, where, in 1974, I made another special purchase of *Repli,* for a price that then seemed expensive. Mr. Hacker also advised me that he had a copy of *Jazz* for sale for the princely sum of $7,500. Although my wife and I, just recently married and not having any idea what the future would hold, could not afford this, it would have been a great bargain—considering that today copies of *Jazz* sell for six-figure sums.

I cannot recall when I first encountered Ursus Books, formerly based in the elegant Carlyle Hotel and now situated in another landmark building on Madison Avenue. Its comprehensive shelves are full of art books—used and new—of every genre, with the rare treasures in a special showroom. Peter Kraus, whose cousin was also a well-known rare book dealer, has become the most respected, and longest surviving, dealer in rare art books in New York with few rivals worldwide. While Ursus frequently had rare Matisse illustrated books for sale, its prices were usually higher than I wanted to pay and, with patience, I could do better with overseas sources, or at auctions. Because of Peter's expertise, Frances and I consulted him when we were contemplating what to do with our collection. He visited our home in Philadelphia to prepare the appraisal that must accompany the donation of a book collection.

Every time I traveled, whether for business or pleasure, I made a point of finding and visiting bookstores that were likely to carry old art books. In arranging for return trips to Philadelphia, I would try to reserve a late plane or train, so when I had finished with depositions, hearings, or conferences, I would have time to check out the old bookstores, particularly those specializing in art books. After I learned about book dealers such as Arcana in Santa Monica, Santa Fe Booksellers, and Transition Books in San Francisco, each became recipients of my lists of desiderata. In a more hit-or-miss type of attack, many hours were spent perusing the art sections of these bookstores, often in vain, but sometimes with success. Many books were also acquired from dealers who conducted a mail-order response to requests; principal among these was Arthur Minters, who had an uncanny ability to locate rarities from across the ocean.

In quick order, I began to pay attention to book auctions. Freeman's in Philadelphia and Swann in New York City had book auctions several times a year, but with few Matisse items. Sotheby's and Christie's in New York, London, and Paris were the more logical choices. Through frequent inquiries and by befriending their specialists, I got on their mailing lists for catalogues. These catalogues filled many linear feet of shelf space in our home.

For books with illustrations by French artists, Paris is the Mecca, the source—but like hunting for treasures in an attic crowded with other searchers, finding out-of-print books with Matisse illustrations in Paris can be a challenge. Most of the world's bibliophiles have already been there. But it is a very pleasurable challenge, to be sure, with visits to the grand boulevards, twisting streets of the Latin Quarter, and out-of-the-way neighborhoods.

My first foray into the world of Parisian book dealers was on the high end. On a walk along the rue du Faubourg Saint-Honoré, famous for designer clothes and antiques, I came upon the large, elegant Librairie Auguste Blaizot, an anti-

quarian of the first order who also dealt in limited editions of illustrated books by French artists. On one occasion an important Matisse book, *Letters from a Portuguese Nun,* was available within the range the book brought at auction—a good sign of a reasonable price.

Several other bookstores along the rue du Faubourg Saint-Honoré carried a large stock of old art books. But in recent years, probably because the sale of old books with any value has moved to the Internet, these stores now sell mostly new books. On the Left Bank, I will always be grateful for some rarities to M. Yves de Fontbrune, of Cahiers d'Art, a memorable institution which formerly published one of the great art periodicals, including several issues devoted to Matisse. Similar thanks to M. LeBouc, owner of the Bouquinerie de l'Institut, a compendium of books, as well as drawings and prints from the School of Paris, for finding me a copy of *Échos,* a small book of lithographs, of which Matisse only made fifteen copies. He also owns another great source for both new and used art books, on the Right Bank, Librairie les Arcades.

My best finds were consistently on the Left Bank, where many old bookstores are concentrated, a few of which specialize in art books. These little shops were a great source for finding issues of French periodicals published from the 1920s until World War II, which featured Matisse long before he became a household name. In these shops I also found limited editions to which Matisse contributed a lithograph or etching, often as a frontispiece, such as lithographs of the face of the French author Colette, the memoirist Paul Léautaud, and the physician René Leriche, who had taken care of Matisse when he was ill.

I can name many other dealers in Paris, without assurance that any of them are still in the business or selling limited-edition art books. Among them are Julien Cornic, Paul Prouté, Librairie Lardanchet, Henri Picard, Jean-Claude Vrain, Léonce Laget, Florence Loewy, Lucien Desalmand on the quai

Malaquais, and Bernard Loliée, proprietor of a very distinguished shop among many on the rue de Seine.

A few European trips, some for lawyering, some for pleasure, also resulted in getting to know art book dealers in different cities—many of these are also gone because of the Internet. London is of course a prime source of rare books of all types—the leading art book emporium for many years was Zwemmer, but it had more or less ceased carrying limited-edition books when I got serious about Matisse. For many years, Max Reed of Sims, Reed & Fogg was a leading dealer in illustrated books by modern artists. In Geneva, Galerie Patrick Cramer had long specialized in illustrated books by various artists, and the rare book dealers of Nice published a brochure listing their specialties, with a map showing their location—I followed it diligently on several visits. Although I never visited Galerie Gerda Bassenge in Berlin, it frequently held auctions of modern art, sometimes including books.

I read everything in English I could find about Matisse's adventures in the world of illustrating books. Based on my research, I learned that before 1930, Matisse had contributed a number of reproductions of drawings for publications of poetry or as frontispieces of books but had not designed and illustrated an entire book. I was familiar with John Russell's enchanting biography of Matisse and his son, *Matisse: Father and Son* (1999), which contains important details about the artist's first major illustration project, Stéphane Mallarmé's *Poésies,* published by Albert Skira in 1932. The Russell book contains correspondence showing how proud Matisse was of the Mallarmé and the less rewarding experience he was having with his subsequent work, the Limited Editions Club *Ulysses.* Matisse's letters explain that the eventual sold-out success of the Mallarmé motivated him to undertake the design and illustration of the poems of other French writers, such as Baudelaire and Ronsard.

My initial knowledge of the Mallarmé *Poésies* was based on reproductions of selected pages in various books about Matisse because it took some

time to acquire our own copy. What I had also found so intriguing about this first truly Matisse-designed-and-illustrated book were the extra pages of illustrations in a few special copies. Five copies included an original drawing, and some of these have been on the auction market in recent years. An additional limited number of copies has an extra set of the illustrations with tiny remarques—drawings of satyrs, nymphs, and other mythical characters along the edge of a page. I was able to locate several impressions of the illustrations with remarques as well as one page with a notation, signed in the plate by Skira, dated 3 December 1933, certifying that the plate had been destroyed after publication of the book. Further, Matisse had not used all of the illustrations he had prepared, and very limited sheets were pulled of these so-called rejected plates, most of which reside at the Baltimore Museum of Art as part of the Cone Collection, which we have visited several times.

Later on I acquired another important scholarly resource, the *Catalogue raisonné des ouvrages illustrés* (1988) by Matisse's grandson Claude Duthuit. This landmark publication documents virtually all of Matisse's book illustrations. It gives valuable details about each book, such as the number of copies, special copies with extra plates, publication information, and other relevant particulars based on research in the archives of the Matisse family. We have studied it carefully while building our collection. It contains a complete listing of all the periodical illustrations save one, a linocut included in *Arts et métiers graphiques,* no. 68 (Paris, 1939). I am not sure why the editors decided to include it in their catalogue raisonné of prints and not in this comprehensive publication.

Matisse had written essays about his art and why he was attracted to book illustration. His interest in illustrating books is not surprising given that he had long been interested in the written word. Indeed, he conveyed his artistic philosophy in many writings, most of which are now collected and annotated in both French and English.

The first and most important of his essays on his artistic objectives, "Notes of a Painter," was published in 1908 in *La grande revue,* a literary journal published in Paris. I was lucky to find this rare volume in the catalogue of a used book dealer and snapped it up. Because of its delicate condition, we had it rebound. This essay remains Matisse's principal explanation (and in many ways his defense) of his early years as a controversial painter. Although he does not specifically refer to book illustrations, Matisse's defining statement, "What I am after, above all, is expression," fully applies to the book illustrations he began to create twenty-five years after he wrote this essay.

An essay more pertinent to Matisse's book illustration is titled "How I Made My Books." Published in 1946, it appeared in an anthology of French illustrated books compiled by Albert Skira, a Swiss publisher who was also responsible for producing some of Matisse's finest work in this field. In this essay, Matisse details his approach to illustrating several of his books more as case studies than an attempt to state an overall theory of book illustration. He does reveal something of his convictions and commitment when he writes, "I do not distinguish between the construction of a book and that of a painting."

FRANCES

As the collection grew, I was privileged to look through Matisse's book illustrations at leisure (without wearing white gloves or having someone standing over me). The covers were a good starting point in this visual experience, just as it was intended by Matisse, who designed many covers in the course of his graphic arts career. The repetitive process of viewing one page after another provided opportunities to think about his illustration strategies and to sense some of the emotion in his drawings while noting that they are always perfectly balanced with the text on the facing pages. The more I learned about the books, the more I came to appreciate their

special features. I began to understand Matisse's concern with process, not so easy to show in a finished oil painting viewed on its own but readily evident in the act of turning pages. The maquette for Mallarmé's *Poésies,* Matisse's first complete illustrated book, resides in the Cone Collection along with thirty etchings rejected by the artist while choosing which of his works would appear in the published version. These and the preliminary studies he made in the maquette reveal the long decision-making process behind the production of a major illustrated book. Similarly, the decision to publish Joyce's *Ulysses* with a selection of preliminary drawings for each of the etchings allows for a richer understanding of his deliberative process leading up to the final selections suitable for publication and underscores his comments made in the catalogue of the 1948 Philadelphia Museum of Art exhibit, *"L'exactitude n'est pas la verité."*

MICHAEL AND FRANCES

Our first reaction to Matisse's books was similar to that of many who admire Matisse's great oil canvases—it is difficult to compare his large and colorful paintings with the small black-line etchings and lithographs illustrating a book of poetry, yet both are a form of his artistic expression. We realized that Matisse considered spatial relationships in every aspect of his work. This principle, so obvious in the Barnes *Dance,* is also exemplified in his books. Most artists' work is designed to exist within four corners, on a wall, facing the viewer. Matisse famously included open windows in many of his drawings and oils, as if to expand the feeling of space from the four corners of the work of art into a larger space, almost into infinity. His book illustrations also reflect the concept of spatial expansion because the page-by-page illustrations reflect movement and impart to the reader turning the pages the excitement of seeing new images, in both words and art. We saw that Matisse furthered his expression of spatial relationships in his color-

ful cutouts during his final years. His most elaborate use of cutouts, *The Swimming Pool,* extends around the walls of an entire room (which we saw exhibited in London in 1970).

If we had to pick our favorite illustrated book (after *Jazz,* of course), it would surely be the Ronsard *Florilège des amours* (Figs. 4 and 5). The illustrations are printed in a deep reddish brown ink, and the images are among his most seductive and sensuous—indeed, sexy. Several copies of the Ronsard also have an extra suite of illustrations, some of which are signed or initialed.

Just as Matisse's innovative oils contributed to the development of the art of painting, we believe that several of his illustrated books constitute an important development in the tradition of the *livre d'artiste.* The juxtapositions of poems with the sublime elegance of Matisse's line drawings immediately capture the reader. The illustrated book represents an aesthetic whole, a harmony between word and image, achieving what the artist called a "rapport with the literary character of the work" (see the appendix).

The pairing of words with art in his illustrated books gave Matisse new opportunities for expression as well as for decoration, which is a pronounced aspect of his book illustrations. Decoration was a major theme of Matisse's paintings, but he was far more than a decorative artist. In the space he chose, he had the ability to decorate a room, or any other subject—not just through clever designs, the work of a journeyman decorator, but through the imaginative integration of color, design, and subject in a defined space. Similarly, Matisse looked at the pages of a book as a space for decoration, just as when he prepared to paint a canvas, draw on a white sheet of paper, or etch a copperplate. He brought to the page his expressive imagination and skill, his unique combination of elegant line, spatial juxtapositions, and distortions of figures. The result is a blending of expression and decoration that becomes an imaginal concept of beauty.

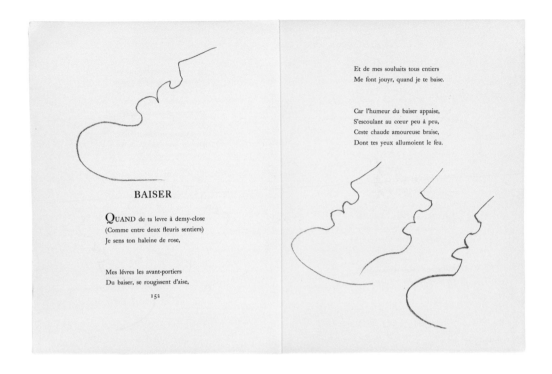

BAISER

Quand de ta levre à demy-close
(Comme entre deux fleuris sentiers)
Je sens ton haleine de rose,

Mes lévres les avant-portiers
Du baiser, se rougissent d'aise,

152

Et de mes souhaits tous entiers
Me font jouyr, quand je te baise.

Car l'humeur du baiser appaise,
S'escoulant au cœur peu à peu,
Ceste chaude amoureuse braise,
Dont tes yeux allumoient le feu.

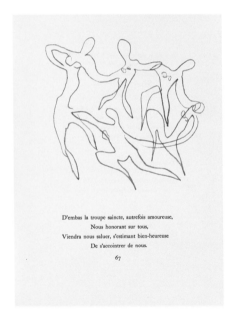

D'embas la troupe saincte, autrefois amoureuse,
Nous honorant sur tous,
Viendra nous saluer, s'estimant bien-heureuse
De s'accointrer de nous.

67

Fig. 4. Lithograph illustrations, *Florilège des amours de Ronsard,* Frances and Michael Baylson Collection

Fig. 5. Lithograph, *Florilège des amours de Ronsard,* Frances and Michael Baylson Collection

Although he had contributed some drawings for books as early as 1912, it was not until the 1930s that Matisse first began to execute and achieve the creative potential of book illustrations. By this time, his place in art history was secure. His discoveries with color in the early years of the twentieth century, when he had been one of the leaders of the Fauves, had already earned him widespread attention in France, the United States, and Russia.

Matisse's illustrated books were all the more astonishing when we realized that many were conceived and published when he was in his seventies. He referred to those later years as his second life, a time of new and significantly different artistic output after he had suffered serious illnesses and gone through difficult operations just before World War II. Because of illness, he was largely confined to his bed or an easy chair. After his illness, he told friends that he was disappointed by his inability to create oil paintings, which had for so long been the vehicle for his rising reputation. Several of his friends proposed that he resume creating illustrations of French poems, as he had done so successfully with the Mallarmé. Obviously well aware of the French tradition of finely illustrated books, he was motivated to design and illustrate books in part because he had seen many fine examples by artists such as Bonnard and Vuillard, whom he considered his predecessors in the School of Paris, and by his contemporaries, notably Picasso.

Proud as well as talented, Matisse no doubt knew he could make his own distinctive contribution to the genre. He carefully selected the books he would illustrate and worked assiduously on their overall design as well as on the illustrations. His desire to adopt new mediums and explore different styles resulted in his color-laden cutouts, his large black brushstroke drawings, and an innovative series of illustrated books. We believe that *Jazz* represents the coming together of all three of these new means of artistic expression (Fig. 6). Using the traditional French pochoir technique, a type of stenciling that enabled him to rep-

licate his highly saturated gouache cutouts, Matisse selected circus-related themes, which he rendered in vibrant colors on pages facing his own words written out in his own black script. We consider our copy of *Jazz* to be one of the high points of our collection, and we are glad that it can be exhibited along with the Morgan's copy of the unfolded pages.

As a result of perseverance, research, patience, and luck, we were able to accumulate over five hundred books, catalogues, and ephemera relating to Matisse. We believe our book collection to be the most complete in private or public hands with the possible exception of that of the artist's family. Matisse personally designed and illustrated ten books, one of which was published posthumously. His illustrations are the major component of another twenty-seven books. He also contributed covers and original illustrations for approximately thirty other books. Many books in our collection contain original Matisse graphics or reproductions of his early work dating from the early twentieth century.

Our collection includes unique proofs (*bons à tirer*) with Matisse's handwritten comments of the 1920 monograph reproducing fifty of his drawings, *Cinquante dessins* (No. 6). Another book, a special edition of Matisse's illustrations for Baudelaire's *Les fleurs du mal*, is the last copy (out of an edition of five) to have been in a private collection (No. 28). A third book, *Échos* (No. 46), was limited to fifteen copies. Several of the books in our collection were inscribed by Matisse.

When our collection was complete, our feeling of pride was combined with a desire to share, so we needed to think of the future and decide on how to make the best use of our efforts. We briefly considered a sale at one of the international auction houses, but we were reluctant to see our collection broken up. We became interested in donating it to an institution that would keep it intact and sponsor an exhibit with an appropriate catalogue, so that scholars and the general public would be aware of the collection as a whole and

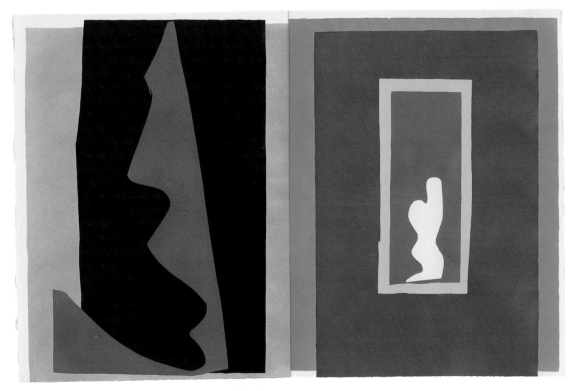

Fig. 6. *Destiny*, plate XVI of *Jazz,* courtesy of Frances and Michael Baylson

share our appreciation of Matisse's creations of illustrated books.

As lifelong Philadelphians, we had also inquired of several art institutions in our home city. The Rosenbach Museum & Library, an amazing collection of rare books based on the bequest from the famous book dealer A. S. W. Rosenbach, occupies an elegant town house in center city. Its most notable property is the manuscript of James Joyce's *Ulysses.* The Rosenbach had put on a small exhibit of some of our illustrated books in the 1980s, but it does not have substantial holdings in *livres d'artistes.*

The Morgan Library & Museum has long been one of our favorite stops on visits in New York City, most often accompanied by performances at the Metropolitan Opera. The Morgan is the world's premier museum of the illustrated book, so we initiated discussions with that institution, which was most welcoming. As an added factor, the Morgan had already been expanding its huge collections of illustrated books, going back many centuries, with an interest in twentieth-century artists. More specific to Matisse, the Pierre and Tana Matisse Foundation, which had been established to administer the estate of the artist's son—who operated a famous art gallery in New York City for many years—had already donated the gallery's archives to the Morgan. In 2001 the Morgan put on a great exhibition from this collection and published a catalogue entitled *Pierre Matisse and His Artists.* We had seen the exhibition. More recently, we were privileged to view many of the highlights in that archive, including letters and valuable biographical mate-

rial about Pierre's father. The Morgan has significant strengths in artists' books of an earlier era that strongly influenced Matisse's ideas about book design and illustration techniques. Few museums can provide comparable book conservation facilities, cataloging services, and research access. Few libraries can offer similar opportunities to display artists' books as independent works of art. We decided that the Morgan would help us to realize the potential of our collection and to share the pleasure we have had in building it. We are thrilled that it is the basis of this catalogue and hope that it will promote a better appreciation of Matisse's accomplishments in the art of the book.

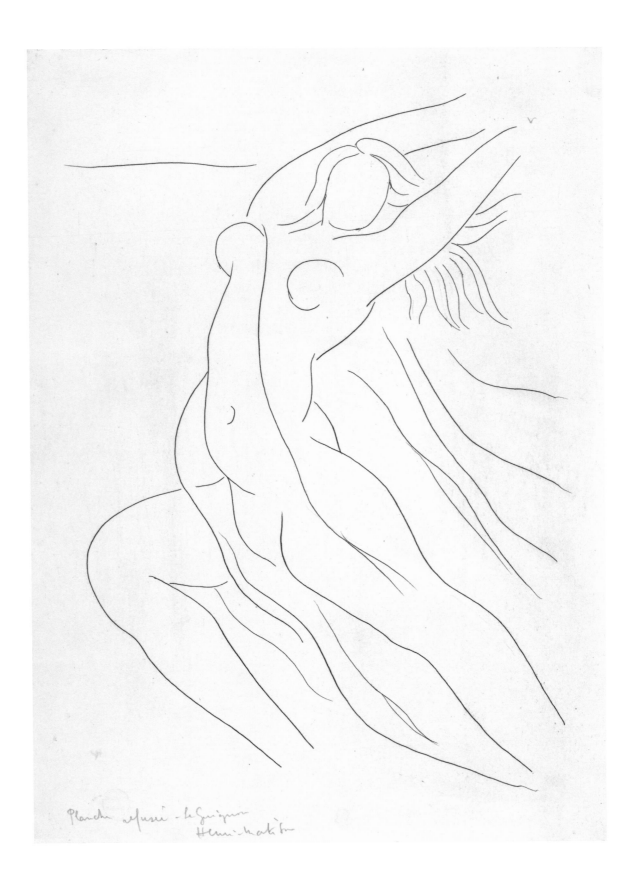

Planche refusée – le Guignon
Henri-Matisse

MALLARMÉ'S *POÉSIES*

"I will be vindicated by my maquette"

JAY MCKEAN FISHER

DEFINING A *MAQUETTE*

Matisse undertook his book projects with thorough attention to almost every aspect of their production. He was a knowledgeable collaborator who worked with publishers, typographers, designers, and printers, always maintaining control over artistic decisions. Evidence of his comprehensive involvement with elements of a book's design can be found within the various archives, museums, and libraries whose collections contain a considerable amount of preparatory material. Matisse's first major illustrated book, *Poésies de Stéphane Mallarmé*, put into practice a method for working through the decision making crucial to such a complicated creative project. For the comparably ambitious projects that would follow, his approach would remain largely the same—with one significant exception. The Mallarmé book is the only project accompanied by a presentation maquette—an exhibition-ready demonstration of his creative process. Matisse selected drawings for this maquette in order to introduce a sequence of progressive revisions, followed by proofs of the etched illustrations, all arranged to lead the viewer

to the final stages of an illustration's transformation. The preliminary works included in the Mallarmé maquette address the artistic aspects of the book, concentrating on the illustrations as they developed, and have less to do with the specific details of the book's design.

The word *maquette* is frequently used to describe an artist's preparatory work, especially as it relates to those aspects to be carried out by others, such as publishers, designers, and printers. Of course, for an active sculptor such as Matisse, this term also relates to a preliminary stage of a sculpture. For a book, a maquette might entail a mock-up for presentation to a publisher or editor that provides a plan for the general format of the book, particularly the intended relationship of text to illustration. Sketches of preliminary choices for an illustration might be included here. This early level of decision making yields important information to provide to a publisher, helping to determine the size and potential cost of a book's production. There is such a mock-up for the Mallarmé book in the collection of the Pierre and Tana Matisse

Foundation.[1] Some of the sketches included are more advanced, already revealing the evolution in a conception for an illustration. The density of a drawing may develop to match a block of text that faces it, and a design may change to fill the page balancing the adjacent text. Such an exploration was one of the most essential artistic ideas defining Matisse's approach to the Mallarmé book. Ultimately, his presentation maquette made this crystal clear. Matisse, the artist-acrobat, would write about the Mallarmé book:

I compare my two pages to two objects taken up by a juggler. Suppose that his white ball and black ball are like my two pages, the light one and the dark one, so different, yet face to face. In spite of the differences between the two objects, the art of the juggler makes a harmonious whole in the eyes of the spectator.[2]

The Mallarmé mock-up is held together by a snap binder, allowing pages to be moved so that those to which blocks of text have been glued can be interleaved with blanks or those containing sketched illustrations. Similar mock-ups exist for other Matisse books, including *Pasiphaé* (No. 21) and the closest book in character to the Mallarmé, Pierre de Ronsard's *Florilège des amours* (No. 38). For the Mallarmé, there is also important evidence of work on illustrations that precede those included in that mock-up, contained in several small spiral sketchbooks.[3] There are several drawings of a swan, for instance, made by the artist while boating on a pond in the Bois de Boulogne.[4] The early sketchbook page to the sketch in the mock-up offers a progression that foretells a similar sequence in the Mallarmé presentation maquette. The mock-up has a more advanced drawing of the swan, which recoils and fluffs its feathers, raising its wings to fill the page, its neck a perfect Matisse arabesque (Fig. 1).

Thanks to the artist and his descendants, there is a significant archive documenting Matisse's extensive work on his books. The most substantive body of preparatory material for a book project,

catalogued by the Bibliothèque nationale as a maquette and donated to the library by the artist's descendants, is that assembled for the Ronsard *Florilège des amours,* published in 1948. Unfortunately, the mock-up that we know Matisse produced for *Ulysses* (No. 14), the book that followed the Mallarmé in 1935, has not been located. In the midst of contentious communication about the book, Matisse had sent the publisher a clear statement of his conception for the book, a plan rejected out of hand. The *Ulysses* contract stipulated that an unspecified number of drawings were to be reproduced in the book to accompany the etched illustrations. There was never a resolution between the artist and the publisher, George Macy, about how these twenty drawings would be presented. Macy seems to have seen them as a premium for the buyers who might be dissatisfied with the six etched illustrations. Macy could have seen the Mallarmé maquette during its 1932 exhibition at the Marie Harriman Gallery in New York. If he did, however, there is no evidence that seeing it had any influence on his decisions about *Ulysses.* The approach finally taken in *Ulysses* was to group these preparatory drawings before each of the etched illustrations, where they were presented as poorly realized facsimiles of different sizes, printed on colored papers. This was certainly not the artist's intention, but at least this approach introduced the idea of his working progressively to the final illustration. It is no surprise that Matisse disavowed this failed collaboration, for any correlation between the artistic goals of the Mallarmé book—emphasized in its presentation maquette, representing a seamless integration of content and execution—and those of the poorly realized *Ulysses* was totally compromised.

Because of the division of the Matisse estate among his three children and subsequent generations, today's scholar must turn to many different archives to seek out his preparatory material. There are scattered bits of preparatory work for most of the books, including various trials for text initials,

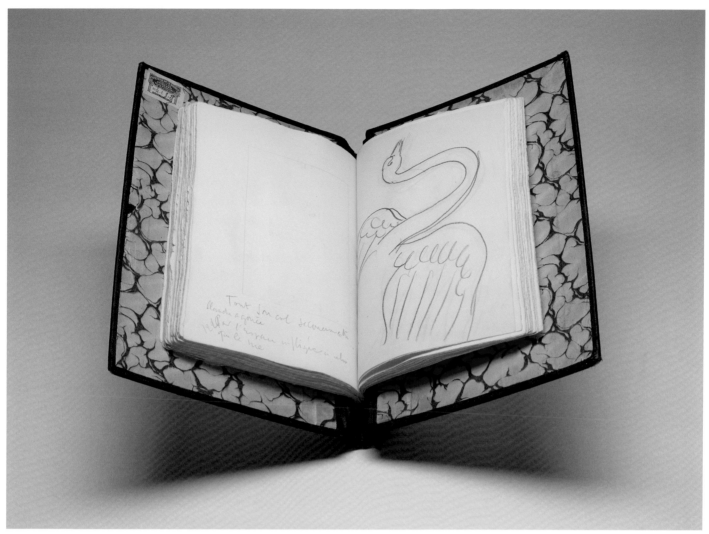

Fig. 1. Spread from the Mallarmé mock-up, The Pierre and Tana Matisse Foundation

typography, and of course illustrations. The present volume provides significant documentation to facilitate future research on this material. Matisse's diligent retention of preparatory work for all of his projects foregrounds his practice in the studio. These maquettes demonstrate how essential it was that this process be visible to his audience, making it possible to follow the manifestation of his art as the result of work in the studio, tracing the stages of visual transformation. This began with a pre-liminary idea, most often working with a model, leading to a final synthesis of his visual experi-ence—a step-by-step consideration of alterna-tives, references to past works, and an occupation with variations on a theme.

After Matisse's death in 1954, the archives established by his daughter, Marguerite Duthuit, in Paris, and carried on by her son Claude Duthuit and Wanda de Guébriant, upheld the high priority the artist gave to preserving evidence of his formative

process, which someday will be fully catalogued and accessible. In this regard, Matisse's significant dedication to the practice of printmaking (he made over 800) testifies to his commitment to documenting his explorative practice of drawing as having been similarly based on multiples as well as to making such progressive series of drawings accessible to a larger public, including scholars and critics. The artist also advanced his agenda of making his drawings well known to the public by producing several books that are documented in this volume, including the 1920 *Cinquante dessins* (No. 6), the 1925 *Dessins* (No. 8), and the 1943 *Dessins: Thèmes et variations* (No. 20). These, too, were carefully designed publications, sometimes including an original print. For his first publication of drawings, *Cinquante dessins,* the artist chose as the frontispiece an etched portrait of Duthuit, reflecting her important role assisting him in his studio. The drawings are carefully sequenced to underscore their primacy to his artistic vision, particularly to a public whose knowledge of the artist came from seeing only his exhibited paintings. Although he recognized the value of artist-produced books with original graphics, Matisse was not in the least deterred from using photolithographic and other commercial printing processes to make his drawings accessible to the public. His standards for reproduction were high, and he worked with the finest practitioners.

Over the past decade, museums and galleries have exhibited more and more of Matisse's drawings, and prints as well, in the context of his paintings and sculpture, just as he would have wished. Presented among these have been preparatory drawings that are outside the canon of the best-known and most frequently exhibited drawings—works we might consider more finished and complete as final drawings in a progression. The inclusion of intermediate drawings representing alternative solutions makes clear to viewers how the artist worked, a studio practice in which different approaches were considered and advanced, utilizing simultaneously (or alternatively) all the mediums with which he worked: painting, sculpture, drawing, printmaking, and illustrated books.

A PRESENTATION MAQUETTE

What Matisse would describe as his *maquette de travail*[5] is a presentation of carefully selected, sequenced, and arranged drawings and prints that reveal a clear process of steps, culminating in this select copy of the published book. What the Mallarmé maquette is *not* is a compilation of a wide range of preparatory work, starting at the beginning with the most preliminary sketches and including detailed excursions into the finer elements of design. The maquette for Ronsard's *Florilège des amours* is the best example of that sort of objective, and there is no indication that the artist was responsible for its current organization. The Mallarmé maquette is not intended to communicate work in progress so much as to present a retrospective commentary on the completed work—an explication of the final phases of the artist's work. Every choice articulates in detail the artist's intentions, bringing us to our own sense of resolution and synthesis as presented in the published book. As such, the Mallarmé book, supported by its maquette, is among the singular works that best represent the transformation of Matisse's art in the early 1930s, most prominently realized in *The Dance,* the mural he created in 1932–33 for the Barnes Foundation, now in Philadelphia. Matisse was aware of a perception that, without the experience of his work in the studio, final works like the Mallarmé illustrations might appear too simple, facile, or technical. The Mallarmé maquette is structured as a viewing experience in support of the final result of the published book, itself part of the maquette as copy no. 1 from the edition of 145. What Matisse selected for the maquette represents the final step before the completed, published book, represented not only by copy no. 1 but also by the copperplates from which the etched illustrations were printed as well as a

significant postcompletion offering: suites of prints in which remarques, or small sketches, were added by Matisse to the margins of the completed plates (Fig. 2). These are not made with the etching technique used for the illustrations but are instead drawn directly on the plates with a sharp drypoint tool. To accomplish this, the steel facing that had protected the plates from wear during the printing of the edition needed to be removed so that the artist could draw directly on the plate. This explains the remarques' appearance as light, rapid notations drawn with an overall thin line, different in character from the darker etched lines.[6] These sketches provided Matisse with the opportunity to revisit the illustrations with more spontaneous reflection on their content. The remarques may refer back to early preparatory sketches for the Mallarmé illustrations; there are also examples that relate to concurrent work on the *Dance* mural. After these remarques were added, the plates were canceled by the publisher, Skira, to eliminate the possibility of further printing, and they were given a new protective coat for future handling. In recognition of the deluxe status of this edition, and to appeal to the most dedicated and informed book collectors, two editions of these illustrations with remarques, printed on different types of paper (Japon and Chine), were included with the earlier editions of the book—available at a higher price, of course.

In the Mallarmé maquette, Matisse sought to provide a map of the creative evolution of the book, but he did not return to the preliminary drawings made in the summer of 1931, when his work on the project began. Instead of taking an encyclopedic approach, he chose from a larger body of drawings made in the late stages of his work on the book. He chose drawings that led directly to the printed illustrations. Some finished etchings were rejected, *planches refusées*, but all are represented in the maquette to speak for alternative choices, finally bypassed.[7] One of the most notable, a refused plate for *Afternoon of a Faun*

Fig. 2. Etching from canceled plate with remarques for *Untitled (Hand and Cup)*, Mallarmé maquette, The Baltimore Museum of Art, BMA 1950.12.910.7

(The Concert), was given by Matisse to Albert Barnes. It recalls his recent viewing of the painting *Le bonheur de vivre* in the Barnes Collection (Fig. 3).[8] The actual copperplates used for the illustrations, including a number of those used for the *planches refusées*, are present to attest to the practice of making the prints, one step at a time. They lend a sense of immediacy to the actual printing of the book and its illustrations. The artist first drew through the ground with a sharp, sapphire-tipped etching needle. By pressing down on the tool, the line was made to swell, such as when it might turn to follow a figure's contours, a contour that not only denotes shape but also models volume. His line was then captured as the acid bit into the plate. The ground was removed, and in viewing the copperplates, one can see the exquisitely drawn lines caught in a gleam of light. Finally, through the *bon à tirer* volume, we are introduced to the inking and printing of the plates as well as the

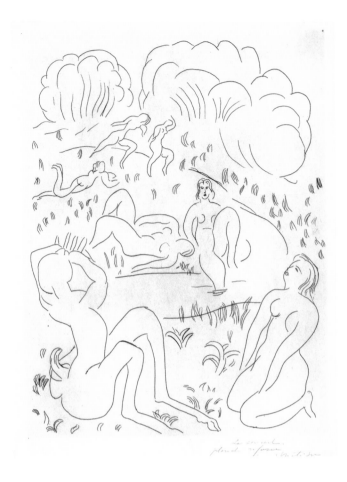

Fig. 3. Refused etching for
Nymphes et faune, Mallarmé
maquette, The Baltimore
Museum of Art, BMA
1950.12.694.17

wrote to Lacourière, expressing his disappointment with the editioned printing of the etchings. Marguerite had warned her father that he might not be satisfied, and the letter is likely an overreaction. He wrote:

I found all the etchings flattened and bloodless. Compared with the proofs of my working maquette, any one of the proofs, they give me the impression of being cadavers.[9]

Lacourière sent back a strong defense of his work, citing both the bad condition of the plates, which he said created tremendous challenges in printing, and what he considered the artist's unrealistic expectations.[10] In spite of this exchange, Matisse would eventually come to see the Mallarmé book as one of his most important artistic achievements.

As a whole, the maquette manifests a moment of final comprehension and clarity, the synthesis of a completed creative process. Like Matisse's metaphorical juggler, in the midst of a gripping performance, the maquette presents the viewer with an awareness of the "harmonious whole."[11]

Finally, it was this maquette, a testament to his hard work achieved in the realization of precise standards, that the artist believed would vindicate any possible disappointments he and his audience might have with the completed book. Matisse wrote to Lacourière:

I will be vindicated by my maquette, which I hope will be accepted by the Bibliothèque nationale: they [the elements of the maquette] will serve as proof for those who are willing to be convinced that I have given my all to illustrate this book with energy and sensitivity—and that, if the result has been mediocre, the fault is not mine.[12]

The maquette consists of sixty-one preparatory drawings for the etched plates, a set of thirty-three refused etchings—etched compositions abandoned in favor of different compositions—and copy no. 1 of the book. The total number of objects catalogued in the maquette is 256. The structure of the

final proofing of the printed illustrations. In all of this, we appreciate the intensity of this complicated work as well as the collaboration of the artist and his skilled printer, in this case one of the best of his time: Roger Lacourière. He was trusted to bring Matisse's drawn lines to life in the careful inking and printing of the plate, though—as the artist was also deeply involved in the *Dance* mural—he insisted that Marguerite be present for press supervision. The *bon à tirer* volume introduces us to a dialogue between artist and printer in which Matisse points out, with instructions for improvement, the most subtle but crucial failures in Lacourière's translation to the printed page. On 2 December 1932, when Matisse received the book, in spite of the proofing that had taken place, he

maquette took the form of three individual volumes, ultimately put into slipcases: copy no. 1, the published book, by itself, and two other volumes together in a larger slipcase. The first of these is an early page-proof volume within which Matisse ordered drawings for the illustrations in a progressive arrangement, sometimes designated with roman numerals for didactic clarity. The drawings were either drawn on paper the same size as the printed book, or they were on smaller sheets mounted to paper of that size. With the exception of the copperplates, everything conforms to the dimensions of the printed book. The other volume in the second slipcase is a *bon à tirer* volume, ostensibly the place for the artist to make his final comments on the printing of the etchings before the final edition. Where Matisse found a few millimeters of an etched line too weak or too strong, he circled that area, alerting the printer to the importance of a subtle change: for instance, a change in tonality as a line turns and takes on volume. To this volume was added the *planches refusées,* those the artist abandoned in favor of new ideas. The maquette holds a complete set of these refused plates, though there are others, described as *études* in the Duthuit catalogue, which are not all included.

We do not know precisely when Matisse determined to undertake a maquette for what is acknowledged to be his first "artist's book." Was it at the behest of the publisher, Albert Skira? There is no existing contract between Matisse and Skira specifying the exact requirements of the Mallarmé project, and no archive of correspondence between the artist and publisher has been located that verifies the details of their collaboration. It is evident, however, that the artist shared a close and productive relationship with the publisher, which affirmed and supported his precise requirements. There is a contract in the Matisse archives in Paris, dated 28 April 1930, that documents the first idea agreed upon by Skira and Matisse. It was for a different book, *Les amours de Psyché* by La Fontaine.[13] This plan was later put aside for the Mallarmé

book, but the early contract apparently provided a template stipulating the features Skira wanted to include for eventual sale. Among these were *une maquette* for which he required thirty drawings for this purpose, together with *suites* of the illustrations in preliminary and final states. The eventual request for Mallarmé drawings would double to sixty drawings, a considerably more ambitious maquette. There was also the request for five additional drawings, one each to be included in the first five, deluxe copies of the book. This proposed formula for the Mallarmé was established as a standard for Skira's series of deluxe artist books, having been applied earlier to the publication of Picasso's book *Les metamorphoses d'Ovide,* published in 1931, just a year before the completion of the Mallarmé. For the Ovid, however, there was no equivalent maquette proposed, though Picasso made numerous drawings in preparation for the etched illustrations. It is more likely that Skira saw an opportunity for the commercial exploitation of a feature that Matisse conceived as central to his art. At first, Matisse was open to Skira's ownership of the maquette for the purpose of selling it to an individual collector or institution, but working through Marguerite, Matisse soon repurchased the drawings and returned them to his studio for his own purposes.

In the Archives Matisse, Paris, there is an invoice addressed to Marguerite, according to which she agreed to purchase the Mallarmé maquette from Skira, including sixty drawings, twenty-eight refused plates, twenty-nine copperplates from which the etchings were printed, and volume no. 1 of the editioned book, with the accompanying suites of the etchings on different papers and the single drawing that accompanied this copy, one of the five specials.[14] This is essentially the inventory for the Baltimore presentation maquette, though there were a few additional refused plates added, for a total of thirty-three.

We do not know when Matisse actually made his selection of drawings for the Mallarmé

maquette and when they were sent to Skira. He chose them from numerous other drawings presumably made in the later stages of his process of conceiving the Mallarmé book, which began in the summer of 1930. Though there is no catalogue raisonné of Matisse's drawings, we do know that drawings from the Mallarmé book have been deposited in various collections, principally through the division of the Matisse estate. These include fourteen now in the Bibliothèque nationale, from the bequest of the artist's son Jean Matisse;[15] seven at the Baltimore Museum of Art, part of the Marguerite Matisse Duthuit Collection; and several drawings plus a mock-up of the Mallarmé book in the Pierre and Tana Matisse Foundation in New York. Drawings in the Baltimore maquette are marked with a circular blind stamp reading *MALLARME / ET / MATISSE*, as are some of the Mallarmé drawings apart from the maquette. Though the number of drawings remains the same, it is possible that substitutions were made from the total oeuvre of Mallarmé drawings between the time the maquette was returned to Matisse's studio, after Duthuit's purchase from Skira in October 1932, and the shipment of the maquette to its subsequent purchaser, Etta Cone, as described in a letter to Cone from Duthuit in March 1933.[16]

In the letter to Lacourière, Matisse stated his hope that his Mallarmé maquette would be accepted into the collection of the Bibliothèque nationale. The purchase by Cone, however, had already been agreed upon, with an initial payment made, confirmed in a letter from Marguerite to Cone.[17] The materials that constitute the Ronsard maquette would eventually be deposited at the Bibliothèque nationale, and while the Mallarmé maquette was instead sold to a private individual after all, Matisse had reason to be certain it would eventually find an institutional home at the Baltimore Museum of Art, affirmed during his visit in December 1930 to Etta Cone in Baltimore. Perhaps he also thought of the relatively close geographical proximity of the *Dance* mural he was concurrently working on for Albert Barnes in Merion, Pennsylvania, a commission very closely related to the Mallarmé project. Matisse had sent Barnes several examples of the Mallarmé illustrations, including refused etchings from the Mallarmé book, so that he would be aware of the nature of this closely related project.[18] In fact, Matisse attempted to interest Cone in purchasing the mismeasured first version of the *Dance* mural, which would eventually go to the Musée d'Art Moderne, Ville de Paris.

THE COLLECTOR: ETTA CONE

After the death of her formidable elder sister, Dr. Claribel Cone, in 1929, Etta Cone seemed to flower with greater confidence as a collector. Claribel had taken the initiative in the acquisition of many of their most important single works by artists other than Matisse, such as Cézanne and Courbet, and of Matisse's *Blue Nude* of 1907 and two other important works by Matisse from 1917. But the sisters' greatest commitment was to the artist's work of the 1920s, of which they formed an exemplary collection. Though they knew Matisse well, they bought many works from this period through dealers. After Claribel's death, Etta developed a closer relationship with Matisse, establishing a collaborative approach in which he selected works to propose for her consideration. This process was facilitated by Marguerite, who handled all of Matisse's business matters. During summer trips to visit Matisse in Nice, which she undertook annually from 1930 until the outbreak of World War II in 1939, Etta benefited from this close collaboration, acquiring a remarkable number of significant works from this period, inclusive of all the mediums in which he worked: painting, sculpture, drawings, prints, and illustrated books. Whereas Barnes acquired over sixty paintings dating from the early years of Matisse's career to the time of the *Dance* mural, other collectors championed

Figs. 4 and 5. (left to right)
Etta Cone (II/VI), The Baltimore
Museum of Art, BMA
1950.12.64; *Etta Cone (III/VI)*,
The Baltimore Museum of Art,
BMA 1950.12.67

more narrow epochs of Matisse's art with intense periods of buying. In addition to the Cone sisters, in the early years these included Leo and Gertrude Stein and, before 1915, the great Russian collectors Morosov and Shchukin.

During Matisse's 1930 visit to Etta in Baltimore, when he delivered his condolences after Claribel's death, he saw many of his works the two sisters had collected during the 1920s that he had not seen for many years, including *Blue Nude.* This clearly heightened his interest in the potential of the Cone Collection as a major repository of his work. During his visit to Baltimore, he had the opportunity to see the newly constructed Baltimore Museum of Art and was well aware of the potential for the Cone Collection—which contained a veritable Matisse museum—to become a part of it. In his 1999 study of the American collecting of Matisse, John O'Brian suggested that the prospect of such a major collection of his work entering a significant museum's collection "stirred Matisse's imagination."[19]

At the time of his visit, he accepted a commission to produce a posthumous portrait of Claribel, and by 1934 he had produced ten drawings in two series of portraits, one of each sister. These two series of portraits followed the example of the series of developing drawings within the Mallarmé maquette and were numbered State 1, State 2, State 3, etc., as one would catalogue the stages of work on a print (Figs. 4 and 5). The practice of making multiple drawings for a portrait became an important approach for the artist, anticipating his *Thèmes et variations* (No. 20). The full suite of portrait drawings of both sisters was published in the 1934 catalogue of the Cone Collection, the first publication of what would later become an important aspect of Matisse's work.[20]

The depth of the relationship between Matisse, Marguerite Duthuit, and Etta Cone is documented by the considerable correspondence in the Dr. Claribel and Etta Cone Papers at the Baltimore Museum of Art. It was Marguerite who clearly handled the coordination of purchases with Cone, including arrangements for the purchase of the maquette. She brought the assembled maquette, which contained a total of 250 works, as a presentation work, housed in a binding she had made. Though Duthuit paid 150,000 francs to purchase the maquette from Skira, Cone paid less,

140,000 francs.[21] This still amounted to a very high price, especially relative to paintings Cone purchased around the same time, including the seminal work *The Yellow Dress* (1929–31; 200,000 francs), *Interior with Dog* (1934; 75,000 francs), and *Large Reclining Nude* (1935; 90,000 francs).

With such a strong collection of works from Matisse's early Nice period from the 1920s, to which she continued to add in the 1930s, Cone provided Matisse with considerable support during this period of transition, as he made a significant break from the work of the 1920s. First she acquired a transitional painting, the great *Yellow Dress* (Fig. 6), begun before the Barnes mural but completed while it was in progress, and then three additional major works: *Interior with Dog,* one of the first easel paintings made after the *Dance* mural; *Large Reclining Nude;* and *Purple Robe* (1937). In 1930–31 she acquired a major group of sculptures, including *Large Seated Nude* (1925) and two major sculptures from 1930: *Tiari* and *Venus in a Shell.* Cone had always been interested in establishing a rapport with the artists she collected. In this case a personal relationship developed with both the artist and, particularly, his daughter, Marguerite, with whom there is an extended correspondence both about business (collecting) matters and family life.

Cone was clearly influenced by what she learned from Matisse during her visits, but she also had an innate understanding of the character of his art during the 1930s, particularly his process of simplification through drawing. She purchased all of Matisse's major publications of his drawings, and her interest in his serial imagery, themes, and variations is evident in her extensive collecting of Matisse's graphic art. She was fascinated by the artist's process of work in the studio, and with the artist's encouragement, she sought to represent that in her collection. From the time of her earliest acquisitions, when she acquired drawings by Picasso and Matisse, she was a great drawings enthusiast and collected drawings by earlier artists, including Degas, Ingres, Manet, and Seurat. She had collected Matisse drawings throughout the 1920s, but after the Mallarmé acquisition, particularly in 1936–37, she made increasingly ambitious drawing purchases, forming one of the most important collections of major Matisse drawings from the 1920s and 1930s.

In addition to the Mallarmé maquette, two works may be singled out to characterize Cone's engagement with Matisse at work. The first is *The Yellow Dress,* which she acquired in 1932, about a year after its completion. Matisse began the painting in 1929 and subsequently struggled through many changes, periodically putting it aside for work on the Barnes mural and the Mallarmé project. In its evolution from a more typical Odalisque-style painting from the later 1920s to what it became—a transition to his more formal pictures of the early 1930s—it is an extraordinarily important indicator of a period of change in the artist's work. The finished painting, with visible pentimenti, provides evidence of its shift to a more monumental style. It is unclear when Cone came to know about the painting, though its challenges would have been very much on Matisse's mind during his 1930 visit to Cone and Barnes. Matisse may have been hesitant to sell the painting at first, especially since it marked the beginning of a period of change in his art, but there were benefits in sharing with Cone aspects of his studio life in Nice. In the case of the *The Yellow Dress,* a year after Cone had made the purchase, Matisse brought the creation of the painting alive for her as a tableau vivant. Matisse arranged for the model Lisette Löwengard to pose in the same room, dressed in the yellow taffeta dress with ribbons featured in the painting.[22] Löwengard was the model who worked with Matisse on the Barnes mural as well as the Mallarmé book. Cone became a witness to the painting's execution, and she was absolutely thrilled.

In 1936, Cone acquired *Large Reclining Nude.* How did she come to know about this painting? It

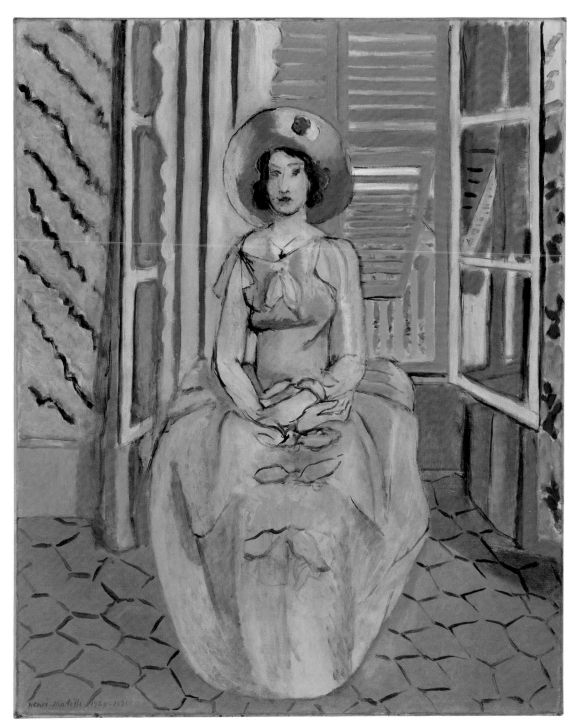

Fig. 6. *The Yellow Dress*, The Baltimore Museum of Art, BMA 1950.256

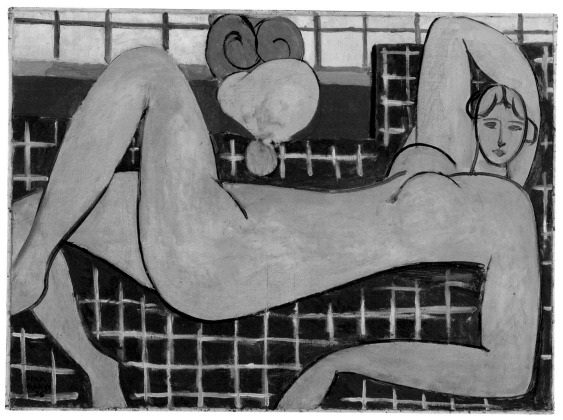

Fig. 7. *Large Reclining Nude,* The Baltimore Museum of Art, BMA 1950.258

was completed in 1935, and while Matisse worked on it, his studio assistant, Lydia Delectorskaya, made photographs documenting its evolution in a total of twenty-two states. Matisse sent the photographs along to Cone so that she could witness the progressive transformation of the painting that she would eventually come to buy in the summer or fall of 1936. She became a witness to the creation of the painting as it progressed to its final resolution (Figs. 7 and 8).

EXHIBITING THE MAQUETTE

Matisse could be certain that Cone would not disperse the Mallarmé maquette and that it would be housed within an institution where it could be available to the public.[23] Before she took physical possession of the maquette, it was exhibited in three locations. The first, in December 1932, was the Marie Harriman Gallery in New York. Harriman had financially supported the publication, retaining rights to sell books in the United States. The exhibition unveiled the Mallarmé book to the American public. In the newsletter of the Baltimore Museum of Art, Adelyn Breeskin enthusiastically described the Harriman exhibition and announced the acquisition of the maquette by Cone and its loan to the museum. Breeskin noted that:

It is possible in studying this collection, to view the rudiments of the artist's vision, to note the elimination of unnecessary lines, the cropping off here and changing there until the finished etch-

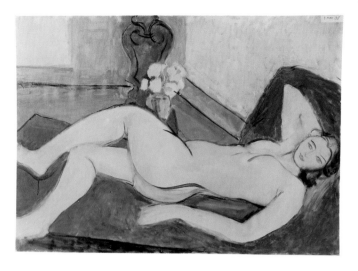
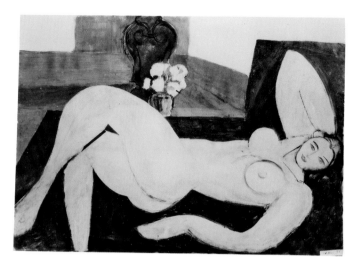
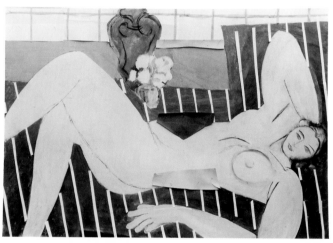
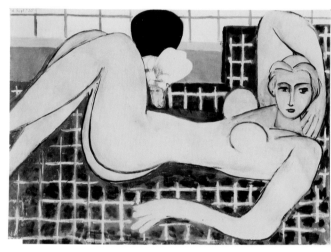
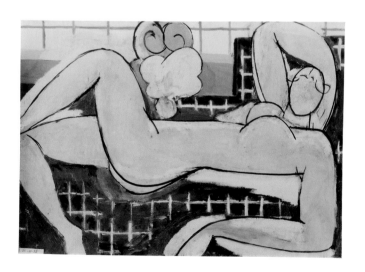
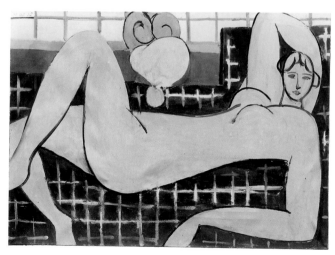

Fig. 8a–8f. Photographs of *Large Reclining Nude* in progress (left to right, top to bottom), stages I, V, IX, XIV, XXI, and XXII, The Baltimore Museum of Art Archives

ings evolve. It affords a rare opportunity to students to lift the curtain and view the process of the creation of a work of art.[24]

A review in the *Art Digest* also pointed out the benefits to student viewers of the maquette, especially because of the opportunity to see how an artist approached "the process of eliminating unnecessary lines down to the finished etching, which stands out in fine simplicity of line."[25] The exhibition then traveled in February 1933 to the Galerie Pierre Colle and then to the Zwemmer Gallery, London, from 3 to 10 February 1933. An enthusiastic review of the Paris exhibition published in *L'intransigeant* made no significant mention of the maquette.[26] In a letter of March 1933, Duthuit wrote to Cone about the arrival of the maquette aboard the steamship *Lafayette*:

I wanted to send you something as fine as possible, and since each of the specialists who worked on it delivered his contribution behind schedule, it took an interval of several weeks for the entire contents to reach me. I dare hope that you will be completely satisfied. . . . Gathered together, the ensemble of your purchase forms something very important from the artistic viewpoint as well as that of the edition alone.

The elements of the original volume are not bound. Thus showing them at the museum will be possible. For the placement [of the works] the best [thing to do], which is also the opinion of my father, would be to assemble on panels all the drawings and etchings related to the same illustration; thus it would be easier to follow the thinking process through the [execution of the work]. Then display the etchings composing the book of the edition the order followed in the book and following that arrangement the etchings with "Remarque" also that is having the drawings added after the run of the edition. The visit can thus follow perfectly the evolution of the book all the way to the last stage.[27]

Cone immediately put the maquette on loan to the Baltimore Museum of Art, though the larger part of her collection would remain in her apartment until its transfer to the museum in 1950, following her death in 1949. In January 1933, Breeskin

announced the forthcoming exhibition, in April, of the maquette in the museum's print gallery, expressing her hope that it remain on permanent display. Though it has since been exhibited in whole or in part from time to time over the years, better wisdom has determined that, like all works on paper, it is best preserved in storage and brought out only for special exhibitions.

The maquette was never again exhibited outside the Baltimore Museum of Art, except for the rare loan of one or more sequences. In 1935, Breeskin wrote what remains a perceptive article on the maquette, "Swans by Matisse." Although some have suggested that she may have corresponded with Matisse at the time of the 1933 exhibition in Baltimore, no correspondence with Matisse can be located in either the Matisse or Breeskin Papers in the Baltimore Museum of Art Archives. (There is, however, a note written on the envelope of a letter written to Cone by Duthuit, passing the letter along to Breeskin at the museum.)[28] The passage she quotes from the artist was actually excerpted from an interview by Tériade from 1931 (see No. 13). Written without the benefit of Matisse's own views of the maquette, beyond what she may have gleaned from other sources, such as Duthuit or perhaps Pierre Matisse, Breeskin wrote:

The finished etchings give the impression of great facility, as though they had been done with ease and spontaneity. It is only upon examination of all of the preliminary studies for the finished works that we begin to grasp the subtlety of the steps that went into their creating. The first idea in each case is drawn from nature. . . . Then, the next step in the evolution of these illustrations is the gradual elimination of the nonessential.[29]

VIEWING THE MAQUETTE

For the few times over the recent decades that the maquette has been shown at the Baltimore Museum of Art, the drawings have been framed and hung on the walls, with the unbound book placed in cases below. In the future, a well-conceived digital pre-

sentation may provide an alternative approach, making it possible for audiences at the museum and beyond to share the progressive and sequential visual experience that the maquette provides. This more focused experience, in which we can almost imagine ourselves looking over the shoulder of the artist as he was assembling the maquette, would complement the public exhibition that Matisse clearly envisioned. At the only exhibition of the maquette Matisse could have seen, at the Galerie Pierre Colle, Paris, in 1933, Marguerite, who arranged for the showing, encountered the significant logistical challenges presented by the public exhibition of such a complicated piece of process art.[30] One is provided the opportunity to proceed sequentially through the different parts of the maquette, moving through a progression of images, not just once, but back and forth, until the process of change is recognized in all its variations. Matisse wanted the maquette to be shown, to be available to the public for study, and he intended this experience for an American audience that he knew would have access to rich collections of his art as context. The maquette provides an intense viewing experience that makes clear the primary concern of his visual process, a key to experiencing his art. His own writings affirm that Matisse was an explainer, seeking means through which his art could be understood and appreciated.

In this essay, which can be no more than a critical overview, it is possible to discuss only a small selection of objects from the maquette, a selection much like the more private experience a visitor to a museum print room might enjoy. So let's pretend we have come to the Baltimore Museum and have arrived in the Samuel H. Kress Foundation Study Center for Prints, Drawings, and Photographs, where the maquette is kept. A curator unlocks a cabinet, and we see the maquette pretty much as it appeared upon its arrival from Paris in 1932. The three-volume maquette, in slipcases, with a *Made in France* sticker attached for the benefit of import regulations, is taken out and placed on the table. The first editioned copy of the completed volume is alone in its slipcase, covered with black leather and stamped in gold: *STÉPHANE MALLARMÉ / POÉSIES.* It is withdrawn and placed front and center, as the finished work of art must be the point from which we look back to the beginning of the visual journey Matisse devised.

This volume also includes two additional sets of etched illustrations with remarques, best seen later while revisiting the published copy or when studying the heavy copper printing plates, which are stored separately from the maquette proper. Two other volumes of the same dimensions are found together in a larger slipcase, again lettered in gold *POÉSIES DE / STÉPHANE MAL-LARMÉ* with Roman numerals I and II. The first contains an early proof of the printed text, known as the page-proof volume, in which all the drawings have been interleaved. Current museum practice requires removing many of the drawings from this format and matting them. This facilitates safer viewing in mats that are also designed for showing both sides of a sheet. For our imagined viewing experience, we will pretend they are together again, as Matisse intended. The second volume from this slipcase is a *bon à tirer* copy of the book, in which Matisse annotated final proofs of the etchings, advising his printer where changes and improvement should be made. It is astonishing to see the degree of attentiveness Matisse had for the smallest detail. For instance, he would draw a line to a millimeter or two of a given line, circling where it needed to be strengthened or printed more lightly. Such an adjustment could change the way the line appeared, capturing how a contour could model form. This volume also contained the refused etchings to be viewed in connection with both the preparatory drawings and the finished illustrations seen in the published volume. These other elements can be examined from an array of open volumes placed around the publication.

A choice of several less complicated sequences follows, but it must be acknowledged that we can-

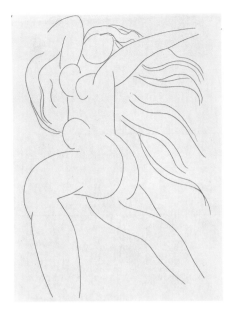

Fig. 9. *Le guignon,* Mallarmé maquette, The Baltimore Museum of Art, BMA 1950.12.691.1

of energy in the first illustration for *Le guignon* (Fig. 9), a powerful female figure that seems to be blown across the page despite her muscular force (see p. 36). On the next page, above the text of the first two stanzas of the poem, is an image of a hand grasping a shaft. Moving to the page-proof volume, we find both related drawings for these illustrations. We come first to a preliminary graphite drawing for the figure (Fig. 10). This drawing seems quite advanced in how it represents the artist's intentions for filling the page. The figure is held in place against a sweep of movement to the left of the page. Like a figure from the *Dance* mural, this one is characterized by its monumentality. Heavy graphite lines enunciate the contours that will be selected and simplified in the etched illustration. What appear to be quickly drawn scribbles add shading to these contour lines, suggesting the modeling of volume. Again, such annotations provide a reference for the drawing on the plate, where a line can be made to swell as it turns, suggesting volume while outlining shape. Across the page is a drawing of similar intention, showing the hand and shaft. When we turn this double page over (Figs. 11 and 12), we see that both these drawings have been traced, using a light table, onto the verso of the sheet. To facilitate printmaking, a tracing orients the design in reverse for eventual drawing on the plate, but more relevant for our understanding of Matisse's process of purification is the fact that tracing provided the means for simplifying the drawing, eliminating the shading and strengthening contours. We see this most clearly in the drawing of the hand, so obviously a straightforward tracing without modification, just as we saw with the tracing of the figure. Matisse even traced the title and lines of text in the two stanzas, making sure his image was perfectly placed on the page with the blocks of text.

Next we encounter a drawing titled by the artist *Le guignon II* (Fig. 13). It is clearly inserted into the maquette, as it is drawn on a smaller sheet. It is tempting to identify this drawing as an earlier ver-

not be positive of the exact sequence of the drawings because the museum's acquisition numbering has not been entirely consistent. The maquette remained on loan from Cone from 1933 until the bequest of her entire collection in 1950. Sometime after the bequest, sequenced numbers were added, but by this time the maquette had been frequently disassembled for exhibition, and the original order may have changed.

LE GUIGNON

The first comes first: *Le guignon* (The Jinx), an illustration the artist viewed as particularly successful.[31] Opening to the title page, we see printed on the facing page *Exemplaire* and in the artist's hand, in pen, *1*. The artist's signature, *Henri Matisse,* appears below. Turning the page, we come upon five blank pages—providing quiet and space to foster concentration before Mallarmé's introductory verse, *Salut.* This is followed by two more blank pages, after which we arrive at an explosion

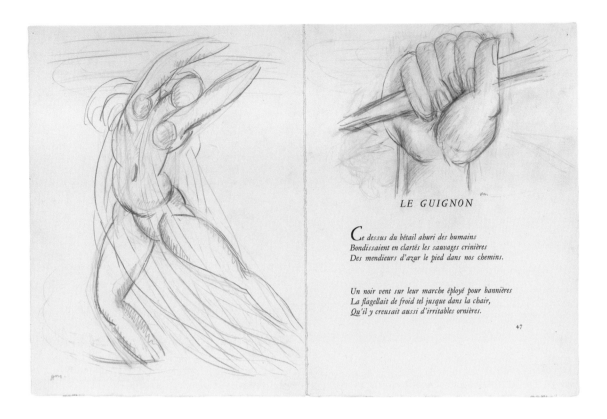

LE GUIGNON

Ce dessus du bétail ahuri des humains
Bondissaient en clartés les sauvages crinières
Des mendieurs d'azur le pied dans nos chemins.

Un noir vent sur leur marche éployé pour bannières
La flagellait de froid tel jusque dans la chair,
Qu'il y creusait aussi d'irritables ornières.

47

Fig. 10. Preliminary studies for *Le guignon,* Mallarmé maquette, The Baltimore Museum of Art, BMA 1950.12.691.2, BMA 1950.12.691.3

Figs. 11 and 12. Preliminary studies for *Le guignon,* Mallarmé maquette, The Baltimore Museum of Art, BMA 1950.12.691.4, BMA 1950.12.691.1

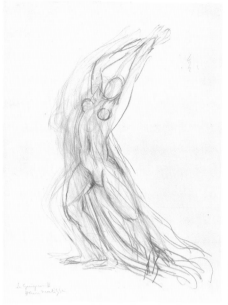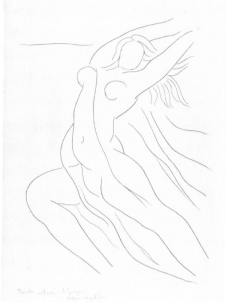

Figs. 13 and 14. (left to right) Preliminary study for *Le guignon,* Mallarmé maquette, The Baltimore Museum of Art, BMA 1950.12.695; Refused etching for *Le guignon,* Mallarmé maquette, The Baltimore Museum of Art, BMA 1950.12.694.1

sion of the illustration because it seems so different—smaller, more compact, with an almost Expressionist sense of emotion and movement. It is a striking drawing on its own but is clearly indicated by the artist with a Roman numeral II, as a second version. We can actually see an idea in the midst of change through erasure and revision. As the figure seems to move forward, it begins to rotate, weight shifting from the buttresslike extended left leg to the right leg that now juts forward. Even after executing the tracing that simplifies the contours of the figures to prepare for drawing on the etched plate, Matisse seems to have taken a step back, using a different sheet of paper from those provided by the page proof copy, to consider an alternative approach. Could he have pulled this drawing from a folio of other preparatory drawings available to add to the maquette to make a stronger point?

Now we move to the prints, where a refused plate, a version he would finally reject, takes us a step further from the second version of the drawing (Fig. 14). Notice how the figure's right leg juts even further forward as the other leg seems to trail

behind without providing support. The final etching in the book is quite different, but the seeds of change were planted in the drawing of the second version. Refer back to the published volume to see our monumentalized figure, now with a straight, trunklike torso turned to the right, resulting from the shift of weight to the right leg. Curving lines now indicate hair unfurled around the head, blown back to the right. The figure has moved to the left of the sheet instead of occupying the center. This compresses and limits the potential for forward movement. Another refused plate, for the image of the hand, indicates how closely the etching initially followed the graphite tracing, but this first etching was then rejected in favor of a reworking of the hand, now more rounded and volumetric. We can now turn to the suite of illustrations with the remarques added to the plates. The remarques were drawn with a drypoint tool, directly on the plate, rather than using the etching process, as was done for the illustrations. The lines look entirely different from those that were etched, appropriate for such rapid sketches that provided the artist an opportunity to muse over completed work in the

published volume. He looked back to drawings from sketchbooks made for Mallarmé or revisited works from decades before. The remarques for this illustration seem miscellaneous, containing figures in poses that could relate to the *Dance* mural or even *Le bonheur de vivre,* Matisse's 1905 masterpiece that he had recently seen at the Barnes. Now would be the time to pick up the heavy copper printing plate from which this print was made. Move it in the light to discern Matisse's serpentine lines, drawn freely and without hesitation, informed by a process of distillation, never second nature, but motivated through the fresh stimulation of observation.

L'APPARITION

The second illustration chosen from the Mallarmé maquette is for *L'apparition* (Fig. 15). Looking at the plate in the book, the subject reminds us of the great drawings from 1919 that feature his model Antoinette Arnoux. Known as the *Plumed Hat,* two of these drawings were acquired by Etta Cone.[32] The connection is not just in the flamboyant style of the hat but also in Matisse's approach to drawing in this period. As we turn to the preparatory drawings, we come to a work the artist titled *Apparition I* (Fig. 16). It is a strong portrait drawing of his model Lisette Löwengard, who posed for the Mallarmé illustrations, the *Dance* mural, and *The Yellow Dress.* Her powerful visage fills the upper half of the sheet, rising to the top edge of the paper. Working with graphite, Matisse drew with a careful, restrained style in the manner of the classicist Jean-Auguste-Dominique Ingres, articulating the shape and volume of the face with short, parallel lines, lightly drawn. Löwengard's face, structured by her long nose and symmetrically curved brow, takes on a stern, straightforward expression. This head, with its restrained, stonelike modeling, could have been carved in marble. The model's almond-shaped eyes contrast with the sensuality of her soft lips. Having accomplished this portrait head—only the point of departure—

Matisse could take the image in a different direction, away from the model, and any personal association with her, to something more timeless and refined. To quote Mallarmé:

My eyes on the worn stones, I wandered then,
When suddenly you happened to appear,
Laughing, with evening sunlight in your hair;
And I thought I saw the fairy with the cap
Of Light, who passed before my infant sleep,
Opening her hands to scatter through the years
Snowy bouquets of richly scented stars.[33]

We come to a second drawing of a head and torso, no longer a portrait but more like a vision (Fig. 17). This woman is crowned by an elaborately decorated, plumed hat with her hair flowing past her shoulders. She is turned to a one-quarter profile. Visible erasures provide evidence of reworking to enhance the contours of the portrait, leading us to another tracing on the back of the sheet, where only the outlined contours remain (Fig. 18). In this tracing, all the animation of the first drawing, the subtle modeling of form, has disappeared in favor of a linear approach. A first etching follows this tracing directly, but it is soon rejected as the artist decides to abandon the quarter profile in favor of a full-face view, returning to *Apparition I,* the first portrait drawing. This second attempt is almost overwhelmed by a wild configuration of zigzags that denote the model's collar and by her similarly unfurled long hair (Fig. 19). This, too, was rejected in favor of the quiet, timeless image we see in the book.

CONCLUSION

Accepting the commission to illustrate the *Poésies de Stéphane Mallarmé* in 1930, a project upon which Matisse would work intermittently while also painting the *Dance* mural, provided an intensive creative project through which the artist could develop new approaches to his art in the 1930s. Thus, the artist's successful and prolific achieve-

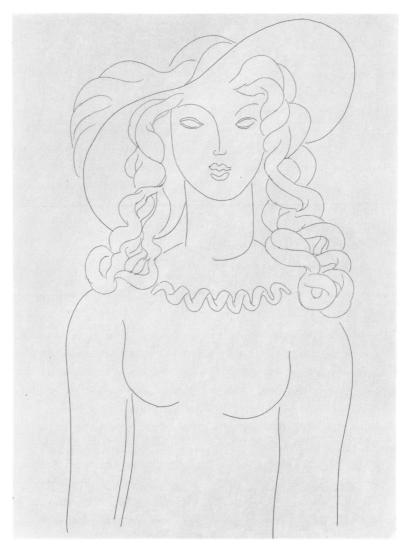

Fig. 15. *L'apparition,* Mallarmé maquette, The Baltimore Museum of Art, BMA 1950.12.691.3

ment in the 1920s slowed to comparatively few works at the beginning of the next decade. This pause allowed Matisse to travel to Tahiti and the United States, where he revisited and reconsidered much of his earlier work; it was a catalyst for something new. Matisse's formative work on his painting *The Yellow Dress,* begun in 1929 but not completed until 1931, marks a clear transition from what had become an exhausted approach of plac-

ing a figure in an interior space flattened by decorative detail. Clearly visible pentimenti document this transition: the figure grows to fill the space—not unlike the figures in the Mallarmé illustrations—with a greater monumentality reflective of figures in *The Dance.* This intense period of study and exploration in the studio, which led to the completion of the Mallarmé book in tandem with closely related work on *The Dance,* marked both a

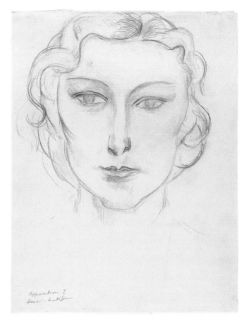

Fig. 16. Preliminary study for *L'apparition,* Mallarmé maquette, The Baltimore Museum of Art, BMA 1950.12.696

Figs. 17 and 18. Preliminary studies for *L'apparition* (recto and verso), Mallarmé maquette, The Baltimore Museum of Art, BMA 1950.12.697

Fig. 19. Refused etching for *L'apparition,* Mallarmé maquette, The Baltimore Museum of Art, BMA 1950.12.694.4

break and a renewal that would continue to stimulate innovation in the coming years.

The patronage of Etta Cone, along with the wider enthusiasm for Matisse's work that greeted the artist as he traveled to the United States, provided support during a period of uncertainty and change. Beginning in 1930, Cone acquired many major Matisse works, including the sculpture *Large Reclining Nude*, another piece with a long period of gestation, from 1925 to 1929; *The Yellow Dress;* the Mallarmé maquette; one of his first paintings after the *Dance* mural, *Interior with Dog;* and a bookend to an earlier Cone acquisition, *Blue Nude,* 1907: the painting *Large Reclining Nude,* 1935. Along with these major paintings and sculptures, Cone acquired a significant representation of the artist's prints, together with several important drawings. Just before seeing *Blue Nude* again in Cone's collection, Matisse had seen *Le bonheur du vivre* (1905–6) at the Barnes Foundation, another seminal painting that would influence his later work. The arrival of the Mallarmé maquette just before the installation of *The Dance* at the Barnes created an opportunity to survey within a close geographic range a remarkable period in the evolution of Matisse's art.

Although he had considered placing his Mallarmé maquette in the Bibliothèque nationale, Matisse instead asked Marguerite Duthuit to facilitate its sale to his dedicated patron Etta Cone. Considering the proximity of the *Dance* mural, Matisse acknowledged the advantages of placing the maquette in another public institution with a strong collection of his work in order to offer a chronological context. For Matisse, the maquette provided a focus on process that revealed the direction of his transforming vision. It was not to be catalogued in an archive more suitable for the placement of miscellaneous compilations of preparatory work. Matisse wanted his hard work acknowledged and understood with the accusations of simplicity and lack of depth dismissed. This maquette was far from a by-product of his work on the Mallarmé. It was itself a work of art, a harmonic whole, carefully ordered as progressive steps revealing an overreaching vision. It is didactic in its approach as a presentation intended for public education. In that way, it is intended to instill viewers with an appreciation of something both universal—how an artist actually works through a visual idea—and specific—Matisse's process of vision and revision. We see a preliminary statement of how an illustration might be approached, and through progressive steps, guided by a technique to facilitate simplification, Matisse achieved a consummate balance between all the visual and textual elements that make the Mallarmé a masterpiece.

NOTES

1. See No. 13, pp. 85–93.
2. Matisse 1995, p. 167.
3. Photographs of the images in these sketchbooks are in the AM collection. The current location of these sketchbooks is not known. One that came on the market recently and another, which formerly belonged to Pierre Simon, have apparently been lost.
4. PML and the Baltimore Museum of Art have photographs by Pierre Matisse of his father making these sketches in the Bois de Boulogne.
5. HM to Roger Lacourière, 2 December 1932, AM.
6. Thomas Primeau and Kimberly Schenck, "Matisse's Drawing and Prints: Materials and Techniques," in *Matisse: Drawing Life,* Queensland Art Gallery, 2011, pp. 324–27.
7. The Duthuit catalogue also includes some etchings referred to as *études,* which can be confused with the refused plates. The Baltimore maquette does not include all of these *études* (Duthuit 1988, pp. 30–34).
8. See Karen Butler's entry for refused plate XVII, *Afternoon of a Faun (The Concert),* in the forthcoming catalogue *Matisse in the Barnes Foundation.*
9. HM to Roger Lacourière, 2 December 1932, AM.
10. Roger Lacourière to HM, 7 December 1932, AM.
11. Matisse 1995, p. 167.
12. HM to Roger Lacourière, 2 December 1932, AM.
13. Contract between HM and Albert Skira, 28 April 1930, AM.
14. Invoice from Albert Skira to MD, 25 October 1932, AM. A letter from MD to Etta Cone, 22 October 1932 (Dr. Claribel and Etta Cone Papers, Archives and Manuscripts Collections, the

Baltimore Museum of Art), explains why Cone's purchase needed to be made through this roundabout route to avoid payment to Marie Harriman, who had the right to sell the Mallarmé in America.

15. Paris 1981, nos. 141–54, pls. 141, 153, and 154.

16. MD to Etta Cone, March 1933, Dr. Claribel and Etta Cone Papers, Archives and Manuscripts Collections, the Baltimore Museum of Art.

17. MD to Etta Cone, 22 October 1932, Dr. Claribel and Etta Cone Papers, Archives and Manuscripts Collections, the Baltimore Museum of Art.

18. See Karen Butler's entry for refused plate XVII, *Afternoon of a Faun (The Concert),* in the forthcoming catalogue *Matisse in the Barnes Foundation.*

19. O'Brian 1999, p. 82.

20. *The Cone Collection of Baltimore, Maryland: Catalogue of Paintings, Drawings, Sculpture of the Nineteenth and Twentieth Centuries,* Baltimore, Etta Cone, 1934.

21. Invoice from Albert Skira to MD, 25 October 1932, AM, charging 150,000 francs for maquette containing 60 original drawings, 28 *planches refusées,* 29 canceled copperplates, and copy no. 1 with one suite on Chine and another on vieux Japon with remarques. There may have been other materials included in the purchase from Skira to account for the higher price paid by Duthuit and the subsequent lesser price paid by Etta Cone.

22. O'Brian 1999, pp. 88–91.

23. John Rewald, "The Cone Collection in Baltimore," *Art in America,* October 1944, p. 203.

24. Adelyn D. Breeskin, "Miss Cone Presents Matisse Etchings," *News-Record of The Baltimore Museum of Art,* vol. 4, no. 10, January 1933.

25. "How an Artist Transmutes Poetry into Line," *The Art Digest,* 1 December 1932, p. 27.

26. Roger Vitrac, "A propos de l'exposition d'un livre: Mallarmé et Matisse," *L'intransigeant,* 7 February 1933.

27. MD to Etta Cone, March 1933, Dr. Claribel and Etta Cone Papers, Archives and Manuscripts Collections, the Baltimore Museum of Art. The envelope for this letter to Etta Cone was annotated, *For Mrs. Breeskin / Museum of Art / Baltimore* acknowledging Breeskin's important role in preparing the maquette for exhibition.

28. Ibid.

29. Breeskin 1935.

30. MD to Etta Cone, March 1933, Dr. Claribel and Etta Cone Papers, Archives and Manuscripts Collections, the Baltimore Museum of Art.

31. Baltimore 1971, pp. 116–17.

32. Baltimore 1971, pp. 88–91.

33. "Apparition," in Stéphane Mallarmé, *Collected Poems,* translated by Henry Weinfield, Berkeley, University of California Press, 1994, p. 7.

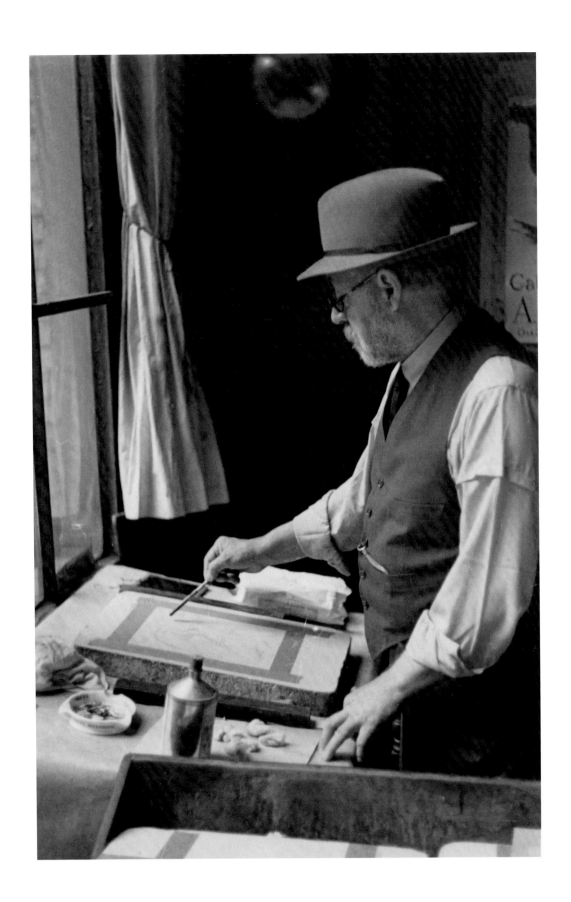

INTRODUCTION

JOHN BIDWELL

This catalogue describes forty-seven books illustrated by Matisse between 1912 and 1954. Some of these contain only a single illustration, a print commissioned by a publisher, or a portrait solicited by a friend. Others occupied his attention for weeks and months while he drew preliminary studies, constructed a typographical framework, and supervised the production process. Each of these projects, large and small, reveals something about his deep appreciation for the printed word. Of all the great artist illustrators of his generation, he put the most in and got the most out of the books he made, a personal investment amply repaid by the success of Mallarmé's *Poésies, Lettres portugaises,* and *Jazz.* He had a highly refined literary sensibility attuned to a wide range of poetry and prose that encompassed canonical works of French literature as well as experimental verse of the avant-garde. He endeavored to express his admiration for his favorite authors and sought to share his pleasure in the reading experience. Reading for him was a joyous and intense exercise of mind and spirit, an essential part of the daily routine during his sedentary old age and a salutary distraction during the worst part of the war. As he grew older and more infirm, he turned his bedroom into a studio, a place with drafting instruments at hand, where he could plot the layout of a page or jot down ideas for illustrations. If better suited to his physical limitations, illustration was not an inferior alternative to painting. It was not a second-choice career. Rather, it was a natural outgrowth of his literary interests and his desire to reach a wider public than was possible with other artistic mediums.

Through his publications, Matisse could communicate directly with students, collectors, customers, and critics. He welcomed the opportunity to display his work in printed form without having to depend on dealers. Their showrooms were the marketplace of paintings, which could also be seen in museums, but many of Matisse's most ambitious efforts had been acquired by private collectors whose holdings had become inaccessible except to a privileged few. Such was the fate of important paintings he had sold to the American collector Albert Barnes and the Russian entrepreneur Sergei Shchukin—one unwilling and the other unable to

make them available for study and exhibition. Facsimiles were not an option because paintings were difficult to reproduce with the color printing technologies available at that time. He much preferred to publish albums of black-and-white drawings, monograph surveys designed to show his latest thinking in that medium. The photogravure and collotype processes could render line and tone with a pinpoint accuracy still beyond the reach of modern high-resolution offset printing. Printed on fine paper, these albums contained original prints and other accoutrements highly valued by collectors. At Matisse's insistence, they always appeared with some kind of textual accompaniment explaining or describing his objectives.

Ordinarily he resisted the temptation to write about his work. He discouraged attempts at interpretation and distrusted art movements that intellectualized the visual experience. He believed that an artistic product should be self-sufficient, a freestanding independent entity unencumbered by outside influences. Nonetheless, he had an analytical cast of mind, a love of language, and a way with words evident on those occasions when he broke his rule of silence and expressed his views about the creative process and the state of his profession. He developed a remarkably cogent theory of illustration, which emerges almost fully formed in interviews and essays. As one might expect, he rejected conventional notions of interpretative illustration and advocated a less subservient approach, a reconception rather than a recapitulation of a literary text. An author's work should succeed on its own merits, he believed, and should not require any kind of commentary, visual or otherwise. The artist should not depict settings, incidents, and individuals but rather "accompany the author on a parallel track" and provide a sympathetic "equivalent" in a different medium that might enhance the reading experience. These and other comments are quoted in this catalogue wherever they apply to specific publications. His most substantial statement on this subject, "How

I Made My Books," is reprinted here in an appendix. He was working on several books when he wrote that essay and could recount how he thought through the design concepts for some he had already completed. Evaluating what he had produced, and visualizing what he wished to achieve, he outlined his two main artistic goals in creating an illustrated book: first, to establish a "rapport with the literary character of the work"; second, to strike a harmonious balance between image and text. He excelled in both of these endeavors, an accomplishment attributable to his versatility, temperament, and resources.

Matisse relished his friendships with writers and members of the book trade. Henry de Montherlant, Tristan Tzara, Louis Aragon, Pierre Reverdy, and René Char were among the authors of his acquaintance who participated in more than one of his publication projects. They helped to form his taste in literature and encouraged him to explore illustration possibilities. For literary guidance, he frequently turned to his comrade and confidant André Rouveyre, whose voluminous correspondence has provided invaluable information for this catalogue. He had long-standing cordial relationships with printmakers such as Fernand Mourlot and Roger Lacourière, both conversant with his working methods and capable of carrying out his commissions in his absence. They also advised him on his book production ventures, although he decided which printing process would best suit the character of the text and the price point of the publication. Equally adept in different techniques, he produced linocuts, lithographs, and etchings for luxury books signed and numbered to indicate the extent of his contributions. Occasionally he allowed his work to be interpreted as wood engravings or pochoirs but only under close supervision. For ordinary trade books and demiluxe editions, he provided charcoal drawings reproduced as halftones and pen-and-ink designs printed by zinc cuts—photomechanical methods he disliked in practice but would

accept as a favor to a friend and a rare concession to commercial considerations.

Matisse had the good fortune to live at a time when he could choose between many different printing techniques. Some of them are no longer practiced on a commercial basis. The pochoir business was already in decline when he selected that process as the one best qualified to reproduce the gouache cutouts he made for *Jazz*. The graphic arts industry abandoned collotype in the 1980s. Letterpress was in its heyday during the lifetime of Matisse but would soon lose ground to photocomposition, offset printing, and other postwar technological developments. He lived in a period of typographic innovation, yet he preferred a strict and conservative style of book design. Under no circumstances did he want his work to be associated with the Symbolist and Art Nouveau extravagances in vogue at the turn of the twentieth century (a transitional period aptly surveyed in Willa Z. Silverman's *The New Bibliopolis*). His taste ran to sober old-style typefaces set in large sizes with generous leading and a vast expanse of margin, a time-honored formula he adopted for his Mallarmé, Ronsard, Baudelaire, and *Visages*. He upheld the tenets of classical typography just as he espoused the principles of "order and clarity" in his painting. "I do not distinguish between the construction of a book and that of a painting," he claimed, "and I always work from the simple to the complex, yet I am always ready to reconceive in simplicity." That last comment speaks to his labor-intensive approach to art creation in all mediums—paintings and drawings as well as books. His conviction that many studies should lead up to the finished product and his indefatigable experimentation with themes and variations help to explain the elegant proportions of the printed page, the carefully calibrated weight of text, the inspired design of ornaments, and the uncluttered appearance of the ensemble, all while preserving a sensual pleasure in the tint of ink, the grain of paper, and the quality of the impression.

Attentive as he was to these details, Matisse did not sketch out typographical ideas entirely on his own. He expected printers to submit for his approval sample pages and specimens of type that would allow him to consider a range of possibilities. He could ask for revisions in a back-and-forth exchange of proofs and could use the proofs to make a pasteup dummy, a maquette, which enabled him to envisage the overall appearance of the book and assess the effect of two-page openings in the proper sequence. Sometimes he prepared a series of maquettes while changing his mind about the placement of the illustrations and the organization of the text. After giving due time to these deliberations, he would allow the printers to proceed, although he might inspect another round of proofs while the book was in press. As a matter of principle, he insisted that they had to abide by the decisions he made in the maquette and in the course of correcting proofs. He had the last word, but they gave him the means to express himself in typographic terms. He respected their skills, invited their advice, and learned from their opinions.

It cannot be emphasized too strongly that book production is a collaborative enterprise, a group effort organized by publishers in association with artists, authors, agents, editors, printers, binders, booksellers, and many others engaged in allied trades. Some of the larger publishers employed executive assistants and middle-management personnel such as art directors, book designers, and production managers. Altogether Matisse worked with nearly forty different publishing firms, some renowned in literary circles, others in the artistic community. By recounting his dealings with these firms, this catalogue shows how he relied on book people for guidance and assistance, how he formulated his instructions, and how he evaluated the results. It covers the entire book production process from the original conceptualization to the point of sale.

In that respect it is more of a publishing history than a catalogue, although it contains the

usual bibliographical apparatus and describes typographical features in greater detail than other accounts of his illustrated work. Instead of focusing on single illustrations, it puts them in context with the artistic agenda he discussed with his business partners as well as the commercial goals and financial factors he mentioned in his contracts and correspondence. These documents shed new light on his methods and intentions, which are easier to interpret with a grounding in the basics of the book trade. They reveal how he coped with the almost constant turmoil in the French economy occasioned by the Depression, the German Occupation, and the ever-present problem of inflation. Sometimes he took on a project more as a friendly gesture than a business proposition. *Graphic Passion* tracks his relationships with people who solicited illustrations and presents biographical information about them to explain how they gained his confidence and persuaded him to undertake these projects. Some of the authors were already famous before they became acquainted with Matisse. Some of the publishers were fairly obscure, but they are worth noting here to show how they made a living in this trade and what they hoped to accomplish by making illustrated books.

The catalogue entries are arranged in chronological order. At a glance it will be obvious that book illustration played only a small part in Matisse's artistic career until the 1930s, and even then it did not fully engage his attention until the outbreak of the war. From then on he became increasingly absorbed in this activity and sometimes had several concurrent projects under way. Some he allowed to lapse and then revived years later after having started others in the meantime. The actual publication dates are difficult to establish because an edition might have been completed a few copies at a time while the covers were being prepared and while the constituent parts of the edition were being assembled—the ordinary copies, the specials, and the extra ingredients in the spe-

cials. There is, however, a fixed point in the production process that can be used to establish a consistent chronology, the *achevé d'imprimer,* the date when the letterpress printing was concluded. Other manufacturing operations occurred after this date, but it is a reliable means of organizing the catalogue entries in a predictable sequence. If authors or publishers collaborated with Matisse on more than one illustration project, biographical information concerning them will be found in the first of the entries in which they play a part, and the later entries will refer to them only in regard to their participation in those publications. This way one can see how Matisse formed a network of trusted associates in the book trade. Some people dropped out of his inner circle after suffering setbacks in their political and business affairs (e.g., Waldemar-George and Martin Fabiani), while others became increasingly involved in his illustration ventures during the last years of his life (e.g., Tériade and Fernand Mourlot). In the background hover artists and writers such as Apollinaire, Cocteau, and Picasso, just to cite three names that frequently recur in this catalogue. Directly or indirectly they influenced the literary content and design concepts of many of these books.

Artwork by Matisse appears in a wide range of printed matter—books, periodicals, albums, brochures, catalogues, and programs. These publications are described in Claude Duthuit's *Catalogue raisonné des ouvrages illustrés* (1988) in varying levels of detail, depending on the nature and extent of Matisse's artistic contributions. Duthuit identified nearly forty books containing original prints. If a book contained a number of prints, he listed them in a comprehensive page-by-page inventory, including an itemized record of decorative initials and ornaments in text. About a hundred shorter entries account for less ambitious illustration projects. Taking Duthuit's work as a starting point, I have selected all the books in which Matisse had some direct personal participation, even though it may be more perceptible in his

business dealings than in the finished product. With one exception, I have not discussed any of his posthumous publications, but I mention some of them in passing to explain how a major undertaking such as *Pasiphaé* or *Apollinaire* might provide the wherewithal for satellite projects such as *Gravures originales* (1981) and the ill-fated *Lettres à Lou* (ca. 1955). Some but not all of the books abandoned by Matisse figure here as evidence of his illustration methods. His correspondence is full of plans for books he would never complete, a promising opportunity for further research. Likewise more work could be done on his cutout designs for the covers of books and journals. Perhaps they deserve a separate chapter in this monograph, but once again I have opted to touch on just a few representative examples.

Each entry concludes with a bibliographical note summarizing the publishing history and physical characteristics of the book. By referring to these notes, one should be able to identify the books, compare them, and visualize some of their graphic features. Anglo-American bibliographical conventions have been followed in most respects, although some procedures have been adapted to account for French printing and publishing practices. I have translated most of the technical terms but have retained some that designate qualities of paper and different types of special copies. I have cited the full names of artists, printers, printmakers, papermakers, and typefounders whenever possible. Here follow some explanatory comments about the particulars of bibliographical description.

PAGE SIZE. Measurements are in centimeters, height before width. In some cases it has been possible to establish the format of the book in terms of the traditional French paper sizes. Grand Jésus (56 × 76 cm), raisin (50 × 64 cm), and carré (45 × 56 cm) were among the common sizes used in sheet-fed presses at that time. A Jésus sheet could be folded in various ways to make books of different sizes such as a 38 × 28 cm quarto or a 19 × 14 cm

16mo. These terms of the trade were dying out, but a few publishers still used them, and they reveal some of Matisse's preferences in book design. He understood the economic advantages of a modest Jésus 16mo and would gladly make a frontispiece to fit. Conversely, he admired the stately proportions of a raisin quarto and sometimes opted for that format when planning a large luxury book like Mallarmé's *Poésies* or *Pasiphaé*.

PAGINATION. French printers customarily included a number of blank leaves at the beginning and end of a bibliophile edition. I have recorded them, even though they might look like binders' flyleaves. Some of the blanks are difficult to see because they have been tucked inside the wrappers, but they should be mentioned if only because they are sometimes conjugate with a half title or a frontispiece. Square brackets indicate the presence of unnumbered leaves that cannot be inferred from the pagination sequence, usually leaves at the beginning or end of the volume. Full-page plates are almost always included in the pagination, even though they were separately produced and had to be inserted alongside the letterpress leaves. Matisse was meticulous about the placement of his plates and often depended on the pagination to instruct binders and collectors about his intentions. His frustration with the missing page numbers in *Repli* is a case in point.

ILLUSTRATIONS. This section enumerates illustrations by Matisse as well as those of other artists who contributed to collaborative projects in which he was involved. Printmaking terms were sometimes used indiscriminately during this period. For example, the title page of *Repli* refers to lithographs as gravures, a misnomer Rouveyre unsuccessfully urged him to correct. I have used standard nomenclature for photogravures and collotypes as well as various types of relief cuts such as wood engravings, linocuts, halftone blocks, and zinc-cut reproductions of line drawings. It is unclear whether

Matisse's printers used the original linocuts or zinc-cut reproductions in some of his books (see Nos. 21 and 45). This section also identifies the commercial firms and printmaking studios that produced these illustrations. In his later years, Matisse was able to insist that his lithographs be printed by Fernand Mourlot, his etchings by Roger Lacourière. Between them they were responsible for printing illustrations in twenty-six of the forty-seven books described in this catalogue.

TYPOGRAPHY. The colophon almost always supplies names of printers and often mentions others involved in manufacturing the letterpress portion of the book. Matisse sometimes claimed credit for the design as well as the illustrations by stating that he had made the maquette for the use of the printers. He liked to have a choice of types, and his personal favorites—Caslon, Didot, and Garamond—figure prominently in this catalogue. I have tried to specify the size and style of typefaces in every one of these books, even those he did not design, to show which faces were fashionable in fine printing circles and which ones were deemed adequate for ordinary trade editions. In some cases, I have been able to ascertain whether a text was set by hand with foundry types or by machine with Linotype or Monotype equipment. Relief cuts for ornaments and initials are noted in this section if they were printed along with the text.

PAPER. Books illustrated by Matisse were almost always issued on several types of paper as was common practice in the book trade at that time. Publishers of limited editions prescribed hierarchies of fine-paper copies and ranked them in order of rarity and prestige. At the top of the list there might be a few copies on Japon accompanied by an original drawing or an extra suite of prints, at the bottom some hundreds of copies on ordinary machine-made wove. The limitation statement assigned sequences of numbers to each of these fine-paper issues in a concatenation of

specials from copy no. 1 to the end of the edition. The Baylson collection has many of the specials, the Morgan has obtained some more to complete the collection, and I have seen some in other libraries. In the course of compiling this catalogue, I have been able to examine almost every issue of every edition, but a few fine-paper specials have been difficult to locate. I have not yet seen a copy of *Alternances* on Montval, *Brocéliande* on Hollande, or *Dessins: Thèmes et variations* on vélin d'Arches. Handmade papers like Montval were highly esteemed, although printers often preferred the more consistent and less expensive mold-mades. Manufactured on cylinder mold machines, mold-mades performed better on the press and could replicate the distinctive features of handmades, such as watermarks and deckles. Matisse often ordered Arches mold-mades for his prints and cutouts. The book trade sometimes referred to mold-mades by the sobriquet *à la forme,* which implies that they had been made by hand. The same confusion exists in English, but hand papermakers in England were more vocal than their counterparts in France when they objected to misleading labels and false advertising practices.

EDITION. This section includes the printing date noted in the *achevé d'imprimer* and the publication information contained in the limitation statement. I have tried to translate this information in a consistent fashion in every entry. As noted above, the printing date may be several months before copies are actually available in the trade, and those copies may not appear on the market all at once. Sometimes I have been able to provide a more precise chronology of publication. I have recorded the prices of these publications whenever I have found that information in advertisements, archival sources, or trade journals such as *Biblio* and *Bibliographie de la France.* Prices can help to measure the elasticity of demand for limited editions. Publishers could charge a huge premium for books

like *Repli,* which cost a hundred times more than the trade edition. On top of that, they could sell the specials for more than twice as much as the ordinary copies. Of course their marketing strategies were not always successful, and sometimes they had to remainder an edition at a lower price. Matisse consigned the leftover stock of *Cinquante dessins* to his son Pierre, who sold it at a discount to American collectors. *Estampes* could be considered to have been impossibly expensive if the price announced in *Biblio* can be believed—248,000 francs, such a large amount that dealers might have been tempted to break up copies and sell the more desirable prints at sums easier to manage. These figures should also be used with caution because of the inflationary forces in the French economy. Nonetheless, they provide a means of comparing the notional value of editions and a sliding scale for gauging the degree of difference between the fine-paper issues of an edition.

COPIES EXAMINED. The copy numbers cited in parentheses can be correlated with the informa-tion in the **EDITION** section to ascertain which of the fine-paper issues have been examined.

REFERENCES. This section lists the sources I have used for writing the catalogue entry and the bib-liographical description. The list is not intended to be comprehensive but contains references that might be useful for further research. Full citations are in Sources and Abbreviations.

EXHIBITIONS. It would be difficult and cumber-some to list all the exhibitions containing exam-ples of Matisse's illustrated work. Nonetheless, some of them should be noted here because they were accompanied by catalogues presenting origi-nal research based on archival sources. The in-depth treatment of the Mallarmé in the catalogue published by the Musée Départemental Stéphane Mallarmé deserves honorable mention in this respect. Likewise proper credit should be given to the survey exhibitions at the State Hermitage Museum in 1980 and the Musée Matisse in 1986, both covering Matisse's entire illustration career.

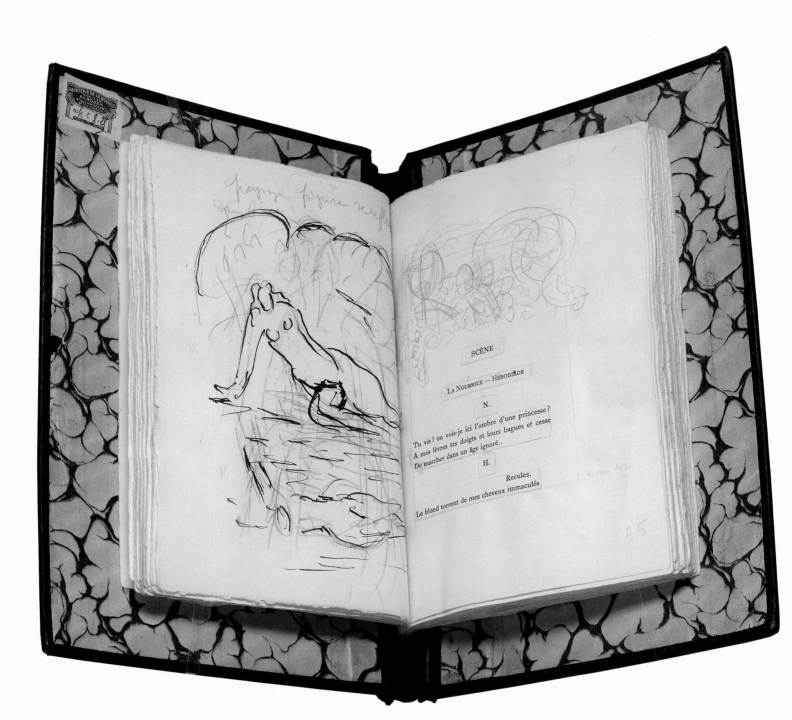

SCÈNE

LA NOURRICE — HÉRODIADE

N.

Tu vis ! ou vois-je ici l'ombre d'une princesse ?
A mes lèvres tes doigts et leurs bagues et cesse
De marcher dans un âge ignoré..

H.

Reculez.

Le blond torrent de mes cheveux immaculés

CATALOGUE

1. Louis Thomas, *André Rouveyre* (1912)
2. *Cézanne* (1914)
3. Pierre Reverdy, *Les jockeys camouflés,* Bernouard edition (1918)
4. Pierre Reverdy, *Les jockeys camouflés,* Birault edition (1918)
5. Marcel Sembat, *Henri Matisse* (1920)
6. Henri Matisse, *Cinquante dessins* (1920)
7. *L'almanach de Cocagne* (1921)
8. Henri Matisse, *Dessins* (1925)
9. Henri Matisse, *Dix danseuses* (1927)
10. *Tableaux de Paris* (1927)
11. Jacques Guenne, *Portraits d'artistes* (1927)
12. Jean Cocteau, Mac Ramo, and Waldemar-George, *Maria Lani* (1929)
13. Stéphane Mallarmé, *Poésies* (1932)
14. James Joyce, *Ulysses* (1935)
15. Ventura García Calderón, *Explication de Montherlant* (1937)
16. *Paris 1937* (1937)
17. Tristan Tzara, *Midis gagnés* (1939)
18. Henry de Montherlant, *Sur les femmes* (1942)
19. Louis Aragon, *Brocéliande* (1942)
20. Henri Matisse, *Dessins: Thèmes et variations* (1943)
21. Henry de Montherlant, *Pasiphaé* (1944)
22. Elsa Triolet, *Le mythe de la baronne Mélanie* (1945)
23. Henri Matisse, *Visages* (1946)
24. *Alternance* (1946)
25. Tristan Tzara, *Le signe de vie* (1946)
26. Paul Léautaud, *Choix de pages* (1946)
27. Gabriel de Guilleragues, *Lettres [de] Marianna Alcaforado* (1946)
28. Henri Matisse, *Vingt-trois lithographies de Henri Matisse pour illustrer* Les fleurs du mal (1946)
29. *Les miroirs profonds* (1947)
30. Franz Villier, *Vie et mort de Richard Winslow* (1947)
31. Charles Baudelaire, *Les fleurs du mal* (1947)
32. André Rouveyre, *Repli* (1947)
33. René Char, *Le poème pulvérisé* (1947)
34. Henri Matisse, *Jazz* (1947)
35. Jacques Kober, *Le vent des épines* (1947)
36. Jules Romains, *Pierres levées* (1948)
37. Tristan Tzara, *Midis gagnés* (1948)
38. Pierre de Ronsard, *Florilège des amours* (1948)
39. *Poésie de mots inconnus* (1949)
40. René Leriche, *La chirurgie: Discipline de la connaissance* (1949)
41. Charles d'Orléans, *Poèmes* (1950)
42. *Estampes* (1950)
43. Colette, *La vagabonde* (1951)
44. Alfred H. Barr, Jr., *Matisse: His Art and His Public* (1951)
45. André Rouveyre, *Apollinaire* (1952)
46. *Échos* (1952)
47. Henri Matisse, *Portraits* (1954)

1.

Louis Thomas (1885–1962), *André Rouveyre, avec de nombreuses reproductions de ses dessins et un portrait par Henri-Matisse.* **Paris: Les Bibliophiles fantaisistes, Dorbon-Aîné, 1912.**

André Rouveyre played an important part in Matisse's typographical ventures. He was one of the artist's closest friends, albeit a junior partner in a relationship dating back to 1896, when they both studied painting under the tutelage of Gustave Moreau. They were neighbors for a while in Vence, where Matisse lived in a villa that Rouveyre found for him. Sometimes writing twice a day, they exchanged more than a thousand letters containing gossip, inside jokes, family news, health bulletins, reports on work in progress, and plans for books they would produce together in a mutually

rewarding exchange of design ideas. The nature and extent of their collaboration varied from one project to the next, but Rouveyre could draw on his experience in printing and publishing to advise his friend on textual questions, illustration techniques, and business arrangements.

While Matisse was still struggling for recognition, Rouveyre was already famous for the caricatures he contributed to the satirical magazines of the Belle Époque. He published monograph collections of his comic drawings, including *150 caricatures théâtrales* (1904), *Carcasses divines* (1907; reprinted 1909), and *Le gynécée* (1909), the last two under the imprint of the *Mercure de France*. He published sketches of contemporary celebrities in that prestigious literary journal and wrote for it as well. One of his victims was so incensed by a bovine profile that she sued him for "physical and moral defamation." He himself became the subject

of caricatures ridiculing his signature bowler hat and monocle. A fixture of Parisian nightlife, he lived on a lavish scale with a substantial income from family sources, never fully explained but possibly connected with a coal mine. He had the means and desire to be completely independent in his choice and treatment of his subjects. His success was founded on the psychological insight of his portraits, the cruelty of his caricatures, and the shocking physicality of his satires against women. Louis Thomas's critical assessment of his work acknowledged that it had been controversial and made no attempt to defend it except to praise the personal virtues of the artist and to note that his sterling character had nothing in common with his creations.[1]

Rouveyre helped to publish this flattering account of his artistic career. He gave an interview to the author, secured reproduc-

Fig. 1. Frontispiece and title page, *André Rouveyre,* Frances and Michael Baylson Collection

tion rights, corrected proofs, and reviewed the pasteups of the illustrations. He commissioned the frontispiece portrait from Matisse, who graciously supplied six drawings from which his friend could pick and choose. Rouveyre selected a design that seemed "most suitable for the book" and supervised the production of a printing plate, which he retained. As a last favor he asked to keep this memento of their friendship and offered a portrait he had made of Matisse in exchange. He liked the way he looked in this picture—dapper and sardonic—and used it again in a German edition of his *Parisiennes* (1923). It remained in his possession until 1939, when it was acquired by the Musées nationaux, and it is now in the Musée national d'art moderne, Paris.[2]

As much as he was involved in the production of this book, Rouveyre relegated most of the design decisions to the printers, who followed the standard format of the Bibliophiles fantaisistes publication series. The Bénard printing firm seems to have had an exclusive contract for the series, issued by Dorbon-Aîné under the editorial direction of the writer and critic Eugène Marsan. Advertisements at the end of the volume invite subscribers to pay 60 francs

in advance for ten books or 150 francs for specials printed on Japon impérial. Each book would be printed in an edition of no more than five hundred copies, and any copies not taken by subscribers would be sold retail at higher prices. Subscribers could expect to receive poetry, fiction, works of literary criticism, monographs on artists, and historical memoirs. The typographical design of these volumes was supposed to vary in accordance with their wide range of content, but the printers often employed the same typefaces in uniform layouts.

This volume deserves serious consideration, even though Matisse did not participate in its design or production. It marks the beginning of his close association with Rouveyre in several book projects (Nos. 26, 32, and 45), including two he designed entirely on his own. It could qualify as his first foray in the field of book illustration, although it was preceded by drawings reproduced on covers of exhibition catalogues. Certainly it set a precedent for other books with frontispiece portraits by Matisse, who developed an interest in this graphic device and portraiture in general. In his hands a character study of an author or artist could be a gloss, a critique, a tribute to genius, a mark of friendship, and a conscientious attempt to express the essence of an individual.[3]

≈

PAGE SIZE: 25.6 × 18.5 cm.

PAGINATION: 127 pp.; the first leaf blank, advertisements on pp. 121–27.

ILLUSTRATION: Halftone reproduction of a charcoal portrait of Rouveyre by Matisse tipped to the half-title verso as a frontispiece.

TYPOGRAPHY: Printed at the Imprimerie Bénard, S.A., Liège. Text in an unidentified 12-point roman, display in various Elzévir types, portions of the advertisements in Deberny et Peignot Série 18.

PAPER: Regular copies on unwatermarked machine-made wove, 15 specials on Japon impérial.

BINDING: Wrappers printed in black and red.

EDITION: Printed 1 November 1912. An edition of 500 numbered copies for subscribers with some copies sold on a retail basis, the regular copies priced at 7 francs, 50 centimes, the specials at 18 or 20 francs.

COPIES EXAMINED: PML 195625 (no. 266); BnF 4-V-8285 (no. 25).

REFERENCES: Mahé 1931, vol. 3, col. 529; Barr 1951, p. 560; Duthuit 1988, no. 39; Monod-Fontaine et al. 1989, no. 55; Monod 1992, no. 10657.

EXHIBITIONS: Nice 1986, no. 53; Paris 1995, nos. 133, 319, and 320.

2.

Cézanne. **Paris: Bernheim-Jeune, 1914.**

In 1909, at age forty, Matisse finally secured a steady source of income when he signed a contract with the Paris art dealers Josse and Gaston Bernheim-Jeune. He gave them exclusive rights for the sale of his paintings, agreed to a scale of prices, and reserved the right to accept commissions on his own. He stayed with the firm until 1926, mainly out of loyalty to his friend Félix Fénéon, who managed the Bernheims' modern art department. By signing Matisse, they took on a line of goods that was more controversial than their usual stock-in-trade. They exhibited two of his paintings in 1907 and organized a major one-man show in 1910, an impressive survey of his work that included a large number of loans from private collectors. The retrospective drew crowds of visitors and ran ten days longer than originally planned, but it provoked critics on both sides of the cultural divide. Journalists of the popular press ridiculed Matisse, and serious commentators failed to see any signs of stylistic development or consistency. The novelist Octave Mirbeau described this succès de scandale to Claude Monet in an account laced with snide remarks about Russian and German visitors "drooling before every picture." He spoke with Matisse, "calm and Olympian" amidst his admirers, and heard him spout nonsense about the simplification of the palette. As far as Mirbeau was concerned, the whole affair was a pathetic folly, although he thought that Monet might have been amused should he have wanted to come up to Paris and see for himself. Mirbeau was well acquainted with contemporary art and collected the work of Cézanne, Monet, Renoir, Rodin, Gauguin, and van Gogh, but he drew the line at Matisse. It could be said

that he was reaching the end of his career as a critic and had become set in his ways. In his last years he wrote valedictory essays about Renoir and Cézanne for lavish monographs published by the Bernheims. The preface he wrote for the present volume faces a lithograph by Matisse—a strange encounter but perhaps a fitting reminder that the up-and-coming artist still had to deal with dissenting voices in the critical community.[1]

With this publication, the Bernheims helped to build a monument to Cézanne. In addition to Mirbeau's preface and other essays, it contains a report on a campaign to raise money for a commemorative sculpture to be erected in the artist's birthplace, Aix-en-Provence. Aristide Maillol received the commission for the sculpture and prepared tentative designs, illustrated here. As it happened, the citizens of Aix rejected Maillol's work (which is now displayed at the Musée d'Orsay, Paris), but the Bernheims had their own reasons for wanting to be involved in this project. Their introductory remarks note that they had carried Cézanne's work since the turn of the century and that they had some examples in their personal collection as early as 1890. They invited collectors not yet entirely convinced of his genius to learn more about his work in their galleries, where they mounted an exhibition of paintings and watercolors to coincide with the publication of this album. They thus staked a claim to Cézanne in competition with Ambroise Vollard, the first to promote that artist and the main purveyor of his work. Head to head against the Bernheims, Vollard published his own book on Cézanne in the same year and with the same trappings of a limited edition—150 copies on Japon and 200 copies on Arches (although his Arches copies were embellished with a Cézanne watermark).

Vollard's book contained more reproductions and a better biography, but the Bernheims succeeded in producing a book with its own artistic merit. They commissioned original lithographs by Bonnard, Denis, Matisse, Roussel, and Vuillard as well as drawings by Signac and Vallotton to be reproduced in collotype. As if making a group effort, each of these artists copied one of his favorite paintings by Cézanne, and most of them copied paintings they had obtained on their own. They may have been doing their part to raise money for the monument, but they also participated in a collective tribute to an individual who had been a source of inspiration, a model of artistic integrity, and a precursor of the avant-garde. They reaffirmed Cézanne's preeminent position as a modern master while sharing in his glory by presenting themselves as his peers and successors. Their unanimous act of homage may have been the idea of Félix Fénéon, who in 1910 organized a Bernheim exhibition featuring masterpieces of the past copied by forty-four artists (including Matisse). Fénéon probably edited this album and had some say about its format and design. Like other Bernheim publications, it was printed by the Moderne Imprimerie, a firm founded by Émile Gaillard in 1905, when he took over the Société Française d'Édition d'Art. The Moderne Imprimerie sustained a thriving business in printing exhibition catalogues and auction sale catalogues for the Paris trade. Its work for the Bernheims is immediately recognizable through the use of extra large Caslon types in covers and titles, a house style used for exhibition catalogues as well as artists' monographs, such as *Courbet* (1918) and *Lautrec* (1920). The Bernheims regularly produced fine-paper copies of their publications, but this is the only one to contain original prints by prominent artists.[2]

Although Matisse had nothing to do with the design or production of this book, it provided a valuable opportunity for him to reach a wider public and to express openly his appreciation of Cézanne. The important part Cézanne played in his artistic development is well known and need not be recounted here except to explain the origins and significance of the lithograph, which, as mentioned above, was a copy of a painting in his possession. Matisse owned five paintings and around eight watercolors by his predecessor. Of these, he placed the greatest importance on the *Three Bathers* he had acquired from Vollard in 1899, when he could hardly afford to spend money on anything besides the day-to-day necessities of life. But after seeing the painting in Vollard's gallery, he could not get it out of his head and finally enlisted a friend to buy it for him, partly with funds obtained by pawning an emerald ring belonging to his wife. The painting occupied a place of honor in Matisse's household, where it was venerated by the entire family, a treasure not to be sold even in the event of a financial emergency. He studied it on a daily basis, showed it to his students, and loaned it to exhibitions. After keeping it for thirty-seven years, he donated it to the city of Paris, stating that "it has sustained me morally in the critical moments of my venture as an artist; I have drawn from it my faith and my perseverance." No doubt he would have copied it for the Bernheims' album if he could, but other variations on the bathers theme had been chosen for the illustrations. Instead he fulfilled his copying assignment with Cézanne's *Fruits and Foliage*, to cite the official name of the painting, although he and his family usually referred to it as *Peaches*.[3]

Matisse bought *Peaches* from the Bernheims in April 1911. He might have been attracted by the rhythmic pattern of the intertwining leaves—a composition so lush and dense that it is difficult to see

where it begins and ends. Perhaps for that reason it was reproduced upside down in the Rewald catalogue raisonné. He made at least one charcoal drawing of *Peaches* while he was working on the lithograph. Like the *Three Bathers*, it was a fixture in his suburban home in Issy-les-Moulineaux. (Leased in 1909, these new quarters were made possible by his contract with the Bernheims.) A drawing by his daughter Marguerite shows how it was displayed in 1923, one of several Cézannes double hung in the family room along with other pictures by Renoir and Matisse. It was placed beneath a Renoir and next to a snapshot of Matisse tucked into a mirror above the mantelpiece. Strictly speaking,

Fig. 1. Title page, *Cézanne*, Frances and Michael Baylson Collection

Fig. 2. Photograph of Matisse in 1913, Alvin Langdon Coburn, *Men of Mark*, The Morgan Library & Museum

Cézanne is not the first book illustrated by Matisse, but it is the first to contain a print by him, and it could be considered an auspicious beginning in view of his close connection to the lithograph of *Peaches*.[4]

PAGE SIZE: Jésus quarto; 38 × 28.5 cm.

PAGINATION: [2] 75 [7] pp.; the first leaf blank.

ILLUSTRATIONS: Plates 1–6: frontispiece etching by Paul Cézanne and original lithographs by Édouard Vuillard, Pierre Bonnard, Maurice Denis, Henri Matisse, and Ker-Xavier Roussel after artwork by Cézanne; plates 7–8: collotype reproductions of artwork by Paul Signac and Félix Vallotton after Cézanne; plates 9–40: collotype reproductions of paintings and watercolors by Cézanne, some in color; plate 41: original lithograph by Aristide Maillol; plates 42–59: collotype reproductions of paintings and watercolors by Cézanne, one in color; photographs of Cézanne and a drawing by Maillol in text.

TYPOGRAPHY: Printed at the Moderne Imprimerie, Paris. Text in 16-point Deberny et Peignot Elzévir Ancien, display in Radiguer Caslon.

PAPER: The Japon is a mold-made or machine-made simili Japon almost as heavy as imitation parchment. The vergé d'Arches is a mold-made imitation laid supplied by Papeteries d'Arches. The *papier à grain* is a good quality machine-made wove.

BINDING: Paper wrappers with a reproduction of a Cézanne watercolor on the front cover, the copies on Japon identified as Édition Japon, the copies on Arches as Édition Hollande.

EDITION: Edition of 600 copies: 100 on Japon numbered 1 to 100; 100 on vergé d'Arches numbered 101 to 200; 400 on *papier à grain* numbered 201 to 600. Priced at 100 francs (Japon), 60 francs (Arches), and 40 francs (*papier à grain*).

COPIES EXAMINED: PML 195588 (no. 95); NYPL MCO+ C42 78-234 (no. 167); PML 195981 (no. 345).

REFERENCES: Barr 1951, p. 560; Duthuit 1988, no. 1.

EXHIBITION: Nice 1986, no. 54.

Fig. 3. Mirbeau's preface and Matisse's lithograph, *Cézanne*, Frances and Michael Baylson Collection

3.

Pierre Reverdy (1889–1960), *Les jockeys camouflés: Trois poèmes par Monsieur Pierre Reverdy, agrémentés de cinq dessins inédits de Monsieur Henri Matisse.*
Paris: Se trouve à la Belle Édition, 1918.

Well connected and congenial, the poet and critic Pierre Reverdy often called on artists of the avant-garde to illustrate his publications. His first book, *Poèmes en prose* (1915), appeared in a limited edition featuring six large-paper copies with original cover designs by Juan Gris and Henri Laurens. Georges Braque contributed two line drawings for *Les ardoises du toit,* published just a few months before *Les jockeys camouflés.* That precedent in mind, Reverdy asked Matisse for two or three drawings to accompany three poems in a pamphlet of thirty-two pages (slightly underestimating the size of the finished product). Matisse provided four line drawings suitable for reproduction with the publisher's letter-press printing equipment. The title page claims that they had not yet been published, even though some had already appeared in the periodical *Les cahiers d'aujourd'hui* and in a program for a meeting of the group Art et Liberté.[1]

The images Matisse selected for this book do not have much to say about its contents, although they must be considered more than merely decorative embellishments. Dating between 1903 and 1916–17, they represent some of the dominant motifs of his work at that time: a seated nude with her hands behind her head, a nude reading a book viewed from above and behind, a series of three figure studies of a nude with a foot on a stool, and a preparatory drawing for the painting *Window at Tangier.* The three figure studies were presented as two drawings because they occupy two facing pages, but they were obviously intended to be viewed together as a set of variations.[2]

Reverdy might have appreciated the bookish allusion in the reading nude as well as the gracious conceit of the open window, which happened to be in just the right proportions to suggest a printed page. (Through which one can also view distant prospects!) Likewise, he might have admired the typically Matissean qualities of repose and serenity in these pictures, but he wrote *Les jockeys camouflés* with a different mood in mind. Some passages could be read as a modernist celebration of speed on horse tracks, thoroughfares, and flyways— where even the clouds are racing across the sky. Reverdy set a breathless pace in long lines devoid of punctuation and employed visual imagery no less kinetic than his prosody: a bedazzled public watches a brilliant cavalcade in the heavens illumi-nated by the moon and stars. The overall effect, however, is more melancholy than triumphant. There seems to be no direction for all this restless movement, and satirical comments about the jockeys imply that they are mostly jockeying for position. One critic views this text as an allegory of dissension and disarray in the avant-garde at the end of the war and after the death of Apollinaire. In this interpretation two jockeys can be identified as Max Jacob and Jean Cocteau, both portrayed as scheming opportunists in contrast to the neglected and isolated Reverdy, who proceeds slowly on foot toward the goal of true and honest poetry. Autobiographical allusions support this interpretation, including a passage referring to the famous tenement of artists, the Bateau Lavoir, where Reverdy resided for a while after he arrived in Paris. The revisions Reverdy made in the authorized edition (No. 4) indicate that he had second thoughts about the polemical thrust of this tract, which one contemporary review rated 9 on a scale of scandalous content ranging from 0 to 11.[3]

The publisher also had opinions about contemporary poetry. François Bernouard resolved to become a "master printer" after a disagreeable experience with a self-publish-ing venture in 1905. He had entrusted a slim volume of verse to trade printers whose clumsy attempts to emulate modern typography were so contemptible and embarrassing that he gave up on the idea of presenting copies "to the poets I admired." He founded his own printing firm in 1909 while editing the literary review *Schéhérazade* in partnership with Cocteau and Maurice Rostand. In addition to pamphlets by the former, Bernouard printed other literary reviews, illustrated books, gift books, and art albums by George Barbier, Paul Iribe, and Jean Émile Laboureur. Many of his publica-tions appeared with the imprint *A la Belle Édition.* To make ends meet, he took on ordinary jobbing assignments, such as labels, letterheads, menus, prospectuses, and exhibition catalogues, but he also had the means to print his own work, including experiments with concrete poetry he proudly declared to have preceded the *Calligrammes* of Apollinaire. He greatly enlarged his manufacturing facilities to issue the complete works of Barbey d'Aurevilly, Courteline, Zola, and other authors in sets totaling about 150 volumes. These overly ambitious publications soon drove him into bankruptcy, although he later reconstituted his printing business on a modest scale and continued to dabble in literary publishing until he died in 1948.[4]

Reverdy had every reason to be confident in Bernouard's typographical style and editorial practices. He praised Bernouard's edition of Blaise Cendrars's *Profond aujourd'hui* (1917) in a review in which he welcomed the opportunity "to proclaim one more time that you have to be absolutely

Fig. 1. Limitation statement and title page, *Les jockeys camouflés,* Bernouard edition, Frances and Michael Baylson Collection

Fig. 2. Illustration and facing text, *Les jockeys camouflés,* Bernouard edition, Frances and Michael Baylson Collection

JUSTIFICATION DU TIRAGE:

Cette édition a été restreinte à :

17 exemplaires sur papier Japon, numérotés de 1 à 17

3oo exemplaires sur vergé d'Arches, numérotés de 18 à 318

Plus 26 exemplaires, faits avec les feuilles cassées, mis hors commerce, lettrés de A à Z

Exemplaire n° 94

LES JOCKEYS CAMOUFLÉS

Trois Poèmes par Monsieur

PIERRE REVERDY

Agrémentés de cinq dessins inédits de Monsieur

HENRI MATISSE

Se Trouve
A LA BELLE ÉDITION
71, Rue des Saints-Pères, 71
à Paris.

Elles venaient de plus loin que
la mer
Et les cavaliers lumineux dont les chevaux
battaient le ciel de leurs sabots lunaires
descendirent en bloc vers le poteau qui
indiquait le but
La dernière chute éclaboussa le
mur où se posaient les taches
claires de la nuit
Tout le reste était dans l'ombre
Et l'on ne vit plus rien en dehors
de la tunique sombre du vain-
queur
On n'entendit plus rien que le grincement
métallique qui accompagnait chaque mou-
vement du cheval gagnant et du jockey
vainqueur

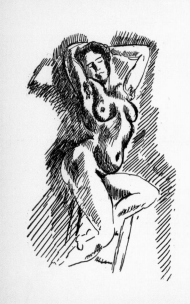

modern!!" Reverdy's friend Fernand Léger illustrated another book by Cendrars, *J'ai tué,* printed at the same establishment just a month before *Les jockeys camouflés.* Like Cendrars, the absolutely modern poet expected Bernouard to provide printing and publishing services in accordance with the new aesthetic of avant-garde poetry, which had a visual impact of its own but could also be enhanced by like-minded illustrations. Reverdy received and approved a first set of proofs. That much proceeded as planned, but Bernouard rushed the pamphlet through the press without consulting him about the title page, the front matter, or the colophon. He complained to Matisse that the printer had ignored the original agreement and had indulged in "ridiculous fantasies," such as the Art Deco rose on the title page and a homage to the king of Italy in the colophon. (The king of Italy was visiting Paris at that time, as was the president of the United States, who inspired a similar compliment in one of the Belle Édition publications.) The indignant author also winced at the affected wording of the title, which referred to Monsieur Reverdy and Monsieur Matisse. In retrospect, he might have objected to other typographical affectations: the decision to print the three poems in three different colors and the extra-large type size, which compelled the compositor to break lines in the wrong places and to break words in

violation of the basic rules of printing poetry. He explicitly condemned typographical eccentricities in his *Self defence* (1919), in which he described his "purely literary" rationale for the layout of free verse and accused his rivals of imitating his innovations in graphic design. "In this state of things," he told Matisse, "I had no other choice but to publish the book myself." He turned to his regular printing firm, which produced a rival edition of *Les jockeys camouflés* under his direct supervision and in a matter of days. Decisive action was required, for he had to get his copies on the market quickly, before it became saturated by the Bernouard edition. Reverdy's colophon warned potential customers not to be deceived: "this original edition is the only one approved by the authors." By that he seems to have implied that Matisse was one of the authors and fully aware of his predicament, although actually he notified the artist about the corrected edition after the fact. The next entry describes the nature and extent of the corrections he made in his edition.[5]

∼

PAGE SIZE: 25 × 22 cm.

PAGINATION: 20 leaves of text, 5 leaves of illustrations.

ILLUSTRATIONS: 5 photoengraved relief-block reproductions of ink drawings.

TYPOGRAPHY: Printed by François Ber-

nouard, Paris. Text in a 20-point Elzévir, various sections in black, green, orange, and blue. Front and back matter in Deberny et Peignot 18-point Elzévir. Title page with a printer's device designed by Paul Iribe.

PAPER: The limitation statement calls for copies on Japon and vergé d'Arches, although the Arches copies contain only a few leaves of wove with that watermark and are actually printed on a mold-made imitation laid supplied by Montgolfier, Luquet et Compagnie, Annonay.

BINDING: Printed wrappers. Front cover printed in blue and black.

EDITION: Printed ca. 19 December 1918. Edition of 344 copies: 17 copies on Japon numbered 1 to 17; 301 copies on vergé d'Arches numbered 18 to 318; 26 copies hors commerce on spoiled sheets marked *A* to *Z.*

COPIES EXAMINED: PML 195627 (no. 94); HRC PQ 2635 E85 J6 (no. 206); Beinecke Library 2006 +338 (no. 208); MoMA M28 R4a (no. 26); NYPL Spencer Collection (no. 251); NYPL 8*ISGK (no. 97).

REFERENCES: Skira 1946, no. 255; Barr 1951, p. 560; Duthuit 1988, no. 41; Dassonville 1988, p. 25; Guillaud 1987, pp. 472–73; Rothwell 1989; Hattendorf 1991; Monod 1992, no. 9682; Capelleveen et al. 2009, pp. 29–30; Hubert 2011, no. 69.

EXHIBITIONS: Philadelphia 1948, no. 261; Boston 1961, no. 195; Saint-Paul de Vence 1970, no. 28; Nice 1986, nos. 55 and 55bis.

4.

Pierre Reverdy (1889–1960), *Les jockeys camouflés & Période hors-texte, édition ornée de cinq dessins inédits de Henri Matisse.* Paris: [Imprimerie Paul Birault], 1918.

Reverdy did not have the right, the means, or the opportunity to suppress the Bernouard edition of *Les jockeys camouflés* (No. 3). After deciding that it was unacceptable, he took the next best course of action: he would publish a corrected version so obviously superior that it would be acknowledged as the one and only authoritative text. He could not afford to omit or replace Matisse's illustrations, which had become a selling point of the book. Bernouard must have surrendered the blocks to Reverdy, who would not have had the time to make new ones for his edition and seemed content that the reproductions looked exactly the same. Reverdy changed the sequence of the illustrations in response to the revised design of his text but otherwise let them speak for themselves. They appear here in a more congenial setting, the sober typography more in keeping with Matisse's drawing style, although the simili Japon paper has not aged as well as the mold-mades used by Bernouard.[1]

Determined to get it right this time around, Reverdy dictated his design ideas to printers he could trust to carry out his instructions precisely and promptly. The Imprimerie Paul Birault had produced his first book as well as most of his other early publications preceding and following *Les jockeys camouflés.* Mme. Birault managed the firm in the absence of her husband during the First World War and after he died in July 1918. Her compositors set the text in a type size large enough to look luxurious but small enough to deploy the long lines of these poems without jarring interruptions. By this means Reverdy could indent his lines where he wanted and employ other spatial effects for emphasis and rhythm. A ragged left layout, gaps between words, and a generous amount of white space arrested the attention of the reader in ways that made it possible to dispense with punctuation. He claimed credit for these "new methods" in a review of *Les jockeys camouflés,* now attributed to him writing under a pseudonym, by which he praised his own work and observed that it had already been imitated by other poets.[2]

Authors often profit from the opportunity to revisit a text by making corrections, improvements, and adjustments. While repairing the depredations of the Bernouard edition—and in order to compete with it—Reverdy put some finishing touches on his poems and inserted some new material. He rewrote a few lines, changed some of the section breaks, and added another section, "Période hors-texte," to fill out the space he saved by using the smaller type size. His edition had exactly the same number of leaves and nearly the same dimensions as its predecessor, all the better to display its advantages in form and content. At a glance one could see why he would want to repudiate the defective version. He also eliminated an entire paragraph to tone down his attacks against Max Jacob and Jean Cocteau, whose transgressions may not have seemed quite so dire after he had a few days to reflect on what he had written. By 1925 they no longer inspired such an outpouring of resentment: he dedicated books to each of them in return for services rendered. Many years later he revised the text again to remove other ad hominem remarks. At this time, however, he could be content with the changes he had made in the authorized edition—an attractive and accurate representation of his work that he could give to friends, submit to critics, and sell on his own account within his coterie of artists and authors. His pseudonymous review of *Les jockeys camouflés* mentioned that it could be purchased at the author's residence at 12, rue Cortot—the perfect place to buy this book. Renoir, Utrillo, Dufy, and Bernard also lived at that address, now the site of a neighborhood museum that documents the vibrant artistic milieu in that part of Paris.[3]

PAGE SIZE: 25.5 × 19 cm; a copy on Japon impérial at the Bibliothèque littéraire Jacques Doucet measures 28.8 × 23.7 cm.

PAGINATION: 20 leaves of text, 5 leaves of illustrations.

ILLUSTRATIONS: 5 photoengraved relief-block reproductions of ink drawings.

TYPOGRAPHY: Printed at the Imprimerie Paul Birault, Paris. Text in 14-point Deberny et Peignot Cochin.

PAPER: Text and illustrations printed on a stiff and heavy simili Japon, the special copies on Japon impérial.

BINDING: Printed wrappers.

EDITION: Printed 30 December 1918. Edition of 105 copies: 5 copies on Japon impérial numbered 1 to 5, priced at 75 francs for subscribers; 100 copies on simili Japon numbered 6 to 105, priced at 10 francs for subscribers. Signed by Reverdy with his monogram.

COPIES EXAMINED: PML 195626 (no. 50); MoMA M28 R4 (no. 24); NYPL Spencer Collection (no. 92); HRC PQ 2635 E85 J6 1918 (no. 98).

REFERENCES: Barr 1951, p. 560; Duthuit 1988, no. 41; Rothwell 1989; Hattendorf 1991; Monod-Fontaine et al. 1989, p. 399; Monod 1992, no. 9681; Hubert 2011, no. 71.

EXHIBITIONS: Saint-Paul de Vence 1970, no. 26; Nice 1986, no. 56.

Fig. 1. Title page, *Les jockeys camouflés,* Birault edition, Frances and Michael Baylson Collection

Fig. 2. Illustration and facing text, *Les jockeys camouflés,* Birault edition, Frances and Michael Baylson Collection

PIERRE REVERDY

LES JOCKEYS CAMOUFLÉS

&

PÉRIODE
HORS-TEXTE

Édition ornée de cinq dessins inédits

DE

HENRI MATISSE

PARIS
1918

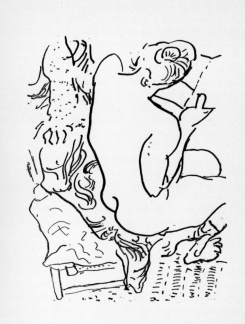

Sans se douter du drame qui se passe dehors
 et si loin là-bas en regardant par la portière sans rien voir

Ni les yeux ni la lumière n'ont changé
 Pourtant quelque chose change

A PRÉSENT
 La rampe qui descend ne mène plus au lavoir
 où les femmes se disputaient dès le réveil
 Là il n'y a plus rien et des bateaux passent
 sous l'arche du pont en repliant leurs ailes

ON NE PARLE PLUS

Tout est encombré par le silence
que notre situation malheureuse ne supporte pas

 Ne regarde pas nous sommes au
bout de la ligne et il faut descendre
 Il fait froid
 Le feu se refroidit dans
 les glaces où il reste pris
Mais sur tes joues quelle lumière
Voici le moment de chanter
 Sans t'occuper des larmes qui coulent
 dans ton ventre pour te désaltérer
Je regarde passer le monde et je m'ennuie
 Il n'y a plus personne
La ville s'est vidée d'un coup
 derrière les portes
Il n'y a plus que mon sommeil
Et les deux ivrognes titubants que l'on emporte

5.

Marcel Sembat (1862–1922), *Henri Matisse.* **Paris: Éditions de la Nouvelle Revue Française, 1920 (Les peintres français nouveaux, no. 1).**

This is the first monograph on Matisse and the first in a series of artists' monographs published by the prestigious literary journal *La nouvelle revue française.* Edited by poet and critic Roger Allard, the Peintres français nouveaux series amounted to more than thirty volumes, each containing a critical study, biographical notes, around thirty illustrations, and a portrait of the artist. They appeared in a uniform format—64 pages in raisin 16mo—and at a standard price, the first numbers at 3 francs, 50 centimes, seven numbers at 4 francs, and the rest at 3 francs, 75 centimes. These inexpensive booklets proved to be so popular that the Gallimard publishing house, the parent company of *La nouvelle revue française,* kept some of them in print at higher prices and launched companion series devoted to sculptors and engravers. Allard knew how to choose the subjects and recruit authors who could write on them with a knowledge and appreciation of their work. He had been one of the first proponents of the Cubist movement in 1910 and continued to stay in touch with the artistic community in Paris, although he fell behind the avant-garde during the First World War. He wrote the texts for the volumes on Yves Alix, Roger de la Fresnaye, Marie Laurencin, and Luc-Albert Moreau. Among the other artists in the series are Marc Chagall, Giorgio de Chirico, André Derain, and Albert Marquet, whose monograph was originally assigned to Allard's former colleague Jules Romains. Romains, however, dropped out and had to be replaced by François Fosca. The poet Pierre Reverdy wrote on Picasso, an inspired combination given the poet's accomplishments in art criticism and his long friendship with the artist. Allard was equally adroit in starting off the series with Matisse, a name constantly cropping up in newspapers and periodicals. Here, for the first time, readers could learn what the fuss was about and try to rise above the fray by consulting this convenient, comprehensive, and succinct appraisal of his achievements, beginning with his artistic apprenticeship in Paris and including his latest work in Nice.

Allard enlisted Marcel Sembat to write the monograph on Matisse. Like Reverdy, Sembat had struck up a firm friendship with his subject, whose career he could trace with inside information about motives, influences, and biographical background. Art historians frequently rely on his testimony, although parts of it have been skewed by his own mannerisms and predilections. A journalist and politician, Sembat had been elected to the Chamber of Deputies and was appointed to a ministerial position. He got to know Matisse in 1904 when he was persuaded to seek government support for the struggling artist. The politician's wife, Georgette Agutte, was an artist herself and kindly disposed toward Matisse, who had studied under Gustave Moreau just as she had at the beginning of her career. She encouraged her husband to collect contemporary art, including a dozen works by Matisse as well as paintings by the Fauves and the Neo-Impressionists in their acquaintance. At a time when Matisse seemed to be appreciated solely by Americans, Russians, and other foreigners, Sembat rose to his defense and spoke as a fellow countryman convinced of the native genius, creative fervor, and internal logic in his work. A socialist deputy, he had espoused his share of controversial causes in the political arena, and he welcomed the opportunity to plead this notorious case in the tribunal of public opinion. In April 1913 he published an essay on Matisse in *Les cahiers d'aujourd'hui* beginning with the premise that most people considered the artist to be a madman, a fraud, a swindler, or worse. "He has been the source of scandal, fear, pity, envy, and rage." Sembat then described the beauty and ingenuity in paintings such as *La danse* and *La musique,* but it seems that he relished his rhetorical trope for its own sake rather than using it to contrast his more perceptive analysis with the philistine reviews and sensational pronouncements in the press. His journalistic instincts tempted him to dwell on the exciting part in this story—the furor caused by Matisse's early exhibitions.[1]

Seven years later Sembat was still greeting the revolutionary newcomer to the Paris art scene and still gloating over the shock value of his work. The text in *Henri Matisse* recapitulates parts of the article in *Les cahiers d'aujourd'hui* as if harkening back to an earlier, happier, and smarter era before the war. Once again Sembat portrayed his subject as a controversial figure:

At that time they were saying that Matisse was the leader of the Fauves. The general public saw in him Disorder incarnate . . . half anarchist, half charlatan! How amazed they were when they saw him in person! What? This serious professor in gold-rimmed glasses? Did he come from some kind of German university?

That comparison to a German professor was carried over from the article, much to the annoyance of Matisse, who read an advance copy of *Henri Matisse* on his fiftieth birthday, 31 December 1919. He also objected to some new material in the text, which acknowledged that his reputation was now secure but in terms that denied him the possibility of future stylistic development. He could at least be grateful

Fig. 1. Covers of the fine-paper and regular issues of *Henri Matisse,* Frances and Michael Baylson Collection

Fig. 2. First page of text, *Henri Matisse,* Frances and Michael Baylson Collection

for Sembat's cogent remarks about his principles and goals, independent spirit, and individualistic approach to painting unaffiliated with current artistic movements. Sembat noted his sympathetic relationship with the Cubists and quoted Allard to show the charismatic influence of that sect but made it clear that Matisse would follow his own way and cultivate a purely personal aesthetic. To provide examples, the critic described pieces in his own collection, including a drawing on the theme of *La danse* cited as evidence of the artist's desire to attain an art of "equilibrium and purity." He contrasted the elegant serenity of his drawing with the "orgiastic" painting of *La danse,* which made him think of Apollonian and Dionysian dichotomies

in Nietzsche. Matisse regretted the reference to Nietzsche, but it was a means of introducing his famous comment that he wanted people to enjoy the "calm and repose in his painting." Sembat's essay ends with praise for the work he had seen during a visit to Nice in May 1919, the painting *Interior with a Violin Case* and a drawing of the model Antoinette Arnoux wearing an enormous plumed hat. In the "perfect composition" of that drawing, he saw an "all powerful synthesis" with no reduction of the "brutal force" he had extolled at the beginning of his text. That was what Sembat liked best in Matisse and missed most in the later paintings he saw a few months before he died in September 1922. Then as in 1920, his critical writing was

tinged with nostalgia for the Fauve period—the glory days of a cultural revolution that could have brought out the best in a radical politician.[2]

Dated December 1919, the prospectus for the Peintres français nouveaux series stated that the reproductions in each of the monographs would include characteristic examples of the artists' work at every stage of their careers. The illustrations in *Henri Matisse* proceed in chronological order from 1898 to 1918. As Sembat noted, many of these pictures belonged to foreigners, such as the Danish collector Christian Tetzen-Lund, some of whom were situated as far away as Moscow and New York. Although difficult to see, if not completely inaccessible, they could be studied in greater detail than was possible in this monograph if readers were willing to purchase larger reproductions from the publisher. Bibliophiles could also subscribe to the series and obtain copies on fine paper with an additional print of the author's portrait on Chine. This *édition de luxe* sold well enough that the publisher increased its print run in later numbers of the series.

The prospectus also announced that these monographs would contain artists' portraits engraved on wood after designs supplied by the artists themselves. Matisse took this assignment to heart and made at least two preliminary pen-and-ink draw-ings sometime in October or November 1919. Even at that early date, he was thinking in typographic terms and designed various types of an oval cartouche for his portrait so that it would fit with the text on the page. The other artists' portraits are less successful, with the exception of a frontal view of Albert Marquet in which the rounded outline of the face is almost ornamental in its proportions. Jules Germain engraved most of the portraits in the first part of the series and received a similar commission from Gallimard for André Gide's *La tentative amoureuse* (1921), for which he made color illustrations after Marie Laurencin. He signed the proofs on Chine, a mark of respect for his skills as a reproductive wood engraver. His name appears prominently in the advertisements, but he quit after a few numbers and was replaced by Georges Aubert, who produced the portraits for the rest of the series. Germain's rendering of the Matisse portrait seems accurate enough and admits whimsical touches intended by the artist, although they confirm Sembat's quip about the bespectacled professor.[3]

PAGE SIZE: Raisin 16mo; 16.5 × 12.3 cm (fine-paper copies), 15.5 × 12 cm (ordinary copies).

PAGINATION: 63 pp.

ILLUSTRATIONS: 5 line drawings in text, including a self-portrait of Matisse on the first leaf; 24 halftone plates included in the pagination. The fine-paper copies contain an additional tipped-in proof of the self-portrait signed and numbered by the wood engraver Jules Germain.

TYPOGRAPHY: The printer is not identified. Text in an 8-point French round face in the style of Deberny et Peignot Série 16 and 20.

PAPER: The letterpress of the fine-paper copies is printed on a mold-made imitation laid pur fil Lafuma supplied by Papeteries Navarre, the letterpress of the regular copies on a low quality machine-made wove. The plates of the fine-paper copies are on coated paper. The proof of the portrait in the fine-paper copies is on Chine.

BINDING: The fine-paper copies in white wrappers, printed in red and black with an ornamental vignette; the regular copies in beige wrappers printed in red and black with the self-portrait of Matisse.

EDITION: Advance copies were available at the end of 1919. Edition including 150 numbered copies on fine paper with the portrait on Chine, of which 10 copies are hors commerce, the regular copies priced at 3 francs, 50 centimes, the specials at 10 francs or 8 francs for the subscribers to the Peintres français nouveaux series.

COPIES EXAMINED: PML 195628 (no. 3); PML 195714 (ordinary copy).

REFERENCE: Duthuit 1988, no. 42.

6.

Henri Matisse (1869–1954), *Cinquante dessins.* **Paris: Album édité par les soins de l'artiste, 1920.**

Published by the artist, *Cinquante dessins* was Matisse's first independent bookmaking venture and his first known attempt at typographical design. He had just signed his fourth contract with the Bernheims, who granted higher prices for his paintings and were glad to help with promotional efforts that might further his reputation and increase their sales. They mounted an exhibition to coincide with the publication of this book, which was stocked in their gallery. Both the book and the exhibition were intended to display the artist's recent work, although both contained a couple of earlier examples. "Take a look at these fifty drawings," said Charles Vildrac in the exhibition catalogue. "Most of them are much more than mere sketches, and some are veritable portraits." Like Sembat (No. 5), Vildrac was taken with the famous *Plumed Hat* portraits of the model Antoinette Arnoux (also Arnoud) executed in Nice around 1919. He knew that they represented a new direction for Matisse, who had started to work in a more naturalistic style in his Nice period and had also taken a greater interest in drawing as a self-sufficient form of artistic expression. They appear here as a set of variations featuring the hat bedecked with a white ostrich feather and a cascade of black ribbon, a decorative framework for the model—a beguiling and temperamental creature with expressive features, sometimes stern and imperious, sometimes childish and vulnerable. Vildrac also wrote the preface to *Cinquante dessins,* in which he remarked on Matisse's desire to bring out the personality and moral character of

the model. More than just compositional exercises, these drawings were to demonstrate the stylistic versatility and psychological insight of the artist.[1]

Matisse relied on Vildrac for advice and assistance in the publication of *Cinquante dessins.* Poet and proprietor of his own art gallery, Vildrac could speak with some authority about the artist's achievements, although he made it clear that he did not want to use the customary platitudes. His preface and the text he contributed to the exhibition catalogue are far less ebullient than Sembat's monograph published earlier in the year. Matisse would later turn to other poets for texts to accompany his illustrations, possibly because Vildrac drifted away from the fashionable literary circles of his day and pursued a less prestigious career in children's books and the theater. But in 1920 he could assist with

the distribution of *Cinquante dessins* by selling copies in his gallery, and he could help at the planning stage by providing some typographical guidance on the basis of his own publishing experience. The cover design and the title owe something to his opinions about spacing and type size, which he felt were not as important as the correct and tasteful arrangement of words on the page. He recommended that the text begin with a simple initial instead of a heading or headpiece. Matisse heeded his advice, even though he had made a tentative drawing for an ornamental headpiece (Fig. 2). That drawing, carefully calculated to fit the line length of the book, is the earliest evidence of his typographic sensibility.[2]

The colophon identifies Victor Jacquemin as the printer of this volume. It is possible that Jacquemin printed the frontispiece etching (a portrait of Marguerite Matisse)

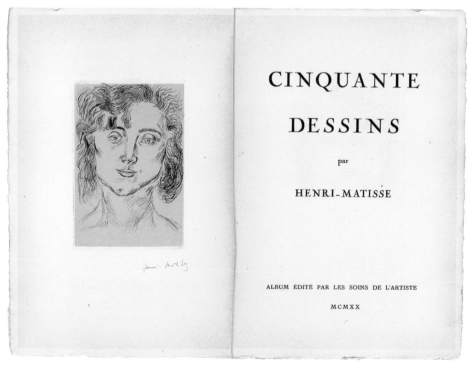

Fig. 1. Frontispiece and title page, *Cinquante dessins,* Frances and Michael Baylson Collection

and maybe even the photogravure plates, although his artisanal intaglio printing facilities would have been hardly adequate for such a large job. But he is almost certainly responsible for the letterpress, which is stylistically similar to his work on Vladimir Ghika's *Les intermèdes de Talloires* (Paris, 1923). Jacquemin printed Ghika's letterpress text in one shop and the intaglio plates in another to produce an edition of 255 copies, an undertaking less demanding than the thousand-copy edition of *Cinquante dessins*. The Morgan has proofs for the plates in *Cinquante dessins* stamped *H. Geny-Gros*, probably Henri Victor Célestin Geny-Gros (1869–1942), one of several members of the Geny-Gros family engaged in an art printing business situated on the rue de la Montagne Sainte-Geneviève in Paris. They specialized in the production of trade art books with photogravure (*héliogravure*) illustrations. As printers to the trade, they would not have expected to be named in the colophon of a book with limited edition pretensions. Nonetheless Matisse demanded, and they provided, faultless reproductions of his drawings with an expertise clearly apparent in the proofing process. Some or all of the proofs were pulled from the original copper plates before they received the protective steel-facing for the regular production run. Despite the expense of handmade paper, all the proofs are on Van Gelder so that Matisse could judge the image quality in the finished product. On that basis, he sometimes asked for a darker or lighter impression while giving his approval with a signed *bon à tirer*. Ink stains, smudges, and other marks of rough handling show that the proofs were consulted when the plates were on press.

Sales of *Cinquante dessins* appear to have been slow at best. The high price may have discouraged customers who did not share Matisse's fascination with drawing and did not wish to invest such a large sum in an art

form less accessible and less publicized than his paintings. André Gide bought a copy, but he was a friend of a friend and could appreciate the artist's intentions. Furthermore, Matisse did not have the means to market a large edition, a perennial problem with self-published books. He kept the unsold copies in storage until 1932, when he sent them and the original drawings on consignment to his son Pierre.[3]

In some ways, his timing could not have been worse. The art market in America was in the throes of the Depression, which Pierre Matisse acknowledged in his letters to his clients, but he urged them to think of it as an opportunity. "I know the times are not favorable," he conceded, but "the real question is w[h]ether one can afford to miss the chance of securing works of art in the class of these drawings at the prices I am offering them." He organized an exhibition that was well received by the critics and well attended by collectors. It ran from 22 November to 17 December 1932 and then went on to the Cincinnati Art Museum, the Albert Roullier Art Galleries in Chicago, and the Albright Art Gallery in Buffalo, New York. Even before it opened, John S. Newberry, Jr., surveyed the consignment and acquired the best of the lot, the most finished of the *Plumed Hat* drawings (now in the Detroit Institute of Arts). Etta Cone purchased two other versions of that subject for her Matisse collection (now in the Baltimore Museum of Art). An inventory drawn up not long after the exhibition lists thirteen sales (including a *Reclining Model* now in the Yale University Art Gallery), nine drawings still in stock, several on consignment in Chicago, and more than twenty returned to the owner. List prices for the Buffalo venue ranged from $125 to $700, although favored customers could procure the most expensive items at a generous discount.[4]

One or two drawings had already been sold to American collectors in the 1920s, but Pierre Matisse's publicity ignored this shortfall to retain the cross-marketing connection with the book. The "fifty drawings" exhibition did not quite live up to its name, but it did provide an opportunity to sell copies at a bargain price. He sold some during the exhibition and gave away a few to customers who had purchased drawings and wished to see them in context. After the traveling exhibitions had run their course, he prepared a form letter offering the book at $17.50 to individuals and $15 to institutions. He noted that it had been selling for 500 francs, or $20, in France and as much as $60 in America because of its "luxurious appearance" and its museum-quality reproductions. His letter quotes a glowing account of the New York exhibition by the art critic Henry McBride, who commended this "masterly" collection of drawings and the "exploring mind" of the artist, "one of the outstanding draftsmen of the world." The gallery had copies in stock as late as 1944, some of them selling for $25. When Matisse came to America to install *La danse* in the residence of Albert Barnes, he stopped by his son's gallery to send out eight copies as gifts to friends and acquaintances. Among the recipients were Henry McBride and Clarence Joseph Bulliet, critics who helped to introduce modern art to America, and the philosopher John Dewey, author of *Art as Experience* (1934). What occasioned the gift to Dewey is not recorded, but it was probably more than a hospitality present or a token of esteem. Matisse made several charcoal portraits of the philosopher in 1930 at the suggestion of Barnes, who had espoused Dewey's aesthetic theories and enlisted him to direct the educational program of the Barnes Foundation. These portraits were studies for a lithograph that was never completed but raises the question whether it was to be a frontispiece in another

book illustration project. Three years later, Matisse may have heard about Dewey's forthcoming *Art as Experience* and dispatched a copy of *Cinquante dessins* to convey in graphic form his own thoughts on the art experience and the function of art objects in libraries and museums.[5]

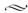

PAGE SIZE: 30.5 × 20.5 cm.

PAGINATION: 7 [9] pp.; pages [9–10 and 15–16] blank (letterpress).

ILLUSTRATIONS: Frontispiece etching on tinted Chine contrecollé, signed by Matisse. 50 full-page photogravure reproductions of drawings printed by Henri Victor Célestin Geny-Gros.

TYPOGRAPHY: Printed by Victor Jacquemin, Paris. Text in 14-point Deberny et Peignot Cochin, display in Deberny et Peignot Nicolas-Cochin.

PAPER: Handmade wove supplied by Van Gelder Zonen, Apeldoorn.

BINDING: Blue-gray wrappers; the front cover containing the same text and layout as the title, the back cover containing a reproduction of a drawing and the addresses of three distributors in Paris: Galerie Bernheim-Jeune, Galerie Georges Bernheim, and Galerie Vildrac.

EDITION: Printed 18 September 1920. Edition of 1,000 copies numbered 1 to 1,000 plus 3 copies with canceled plates numbered I to III. Priced at 500 francs on publication; remaindered in 1932 by the Pierre Matisse Gallery, New York, at $10 to the trade, $15 to institutions, and $17.50 to individuals.

COPIES EXAMINED: PML 195589 (no. 125); Baltimore Museum of Art (no. 244); PML RRG 416 M433 V69 (no. 880).

REFERENCES: Mahé 1931, vol. 2, col. 841; Barr 1951, pp. 197 and 569; Duthuit 1988, no. 2; Monod 1992, no. 7846.

EXHIBITIONS: Saint Petersburg 1980, no. 26; Fribourg 1982, no. 17; Nice 1986, no. 45.

Fig. 2. Rejected design for a headpiece, *Cinquante dessins,* Frances and Michael Baylson Collection

Fig. 3. Proof of plate 31 in *Cinquante dessins,* Frances and Michael Baylson Collection

7.

L'almanach de Cocagne pour l'an 1921. **Paris:
Éditions de la Sirène, 1921.**

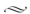

Food and fine printing were the two main
interests of Bertrand Guégan, artistic
director of the Éditions de la Sirène. Born
in 1892, he studied medicine for a while but
then dropped out, wrote some poetry, and
became involved in the literary life of Paris.
He was one of the founding members of
the Compagnons de Cocagne, a gourmet
dining society for which he designed
elegant and distinctive menus. After
performing editorial tasks for various
publishers, he eventually obtained a
full-time position at La Sirène, founded by
Paul Laffitte in 1917. Perhaps the most
important title he produced for that firm
was *La fleur de la cuisine française,* an
anthology of recipes dating from the
thirteenth to the nineteenth centuries
accompanied by his commentary and a
glossary. It went through at least ten
editions and is still a standard text. He went
on to work for other publishers, edited the
graphic design journal *Arts et métiers
graphiques* (May 1928–July 1929), and helped
to see through the press two volumes of a
monumental three-volume history of
medicine (1936–49). After the Second
World War broke out, he joined the
Resistance and fell into the hands of the
enemy, who deported him to Germany,
where he died in 1943.[1]

Guégan left La Sirène in March 1923,
while the firm was embroiled in one of its
periodic financial crises. Laffitte's entrepreneurial instincts were to blame for the firm's
instability but should also be credited for its
literary achievements. Before going into
publishing, he managed a chain of movie
theaters and established a film production
company. Both ventures were overly
ambitious and doomed to fail, although
they both played a part in the development
of commercial cinema. He invested in the
invention of a laminated security glass and
founded a journal, *Eurêka,* to foster
industrial applications of modern technology. At one point he lived in opulent
quarters as would befit a wealthy industrialist, but he was frequently out of pocket and
was finally reduced to odd jobs in the book
trade at the age of seventy. He died in a
retirement home in 1949.[2]

Laffitte directed La Sirène between 1917
and 1922, although he stayed mainly in the
front office and depended on others to set
editorial policy. Blaise Cendrars claimed
that the financier put him in charge of
startup operations and gave him carte
blanche to deal with authors and artists.
Cendrars took pride in recruiting Jean
Cocteau and Guillaume Apollinaire, each at
opposite ends of the political spectrum, as
well as Max Jacob, André Salmon, Pierre
Mac Orlan, and Raymond Radiguet. One
of his own texts is the firm's best-known
publication, *La fin du monde filmée par
l'Ange N.-D.* (1919), a modernist cinematic
apocalyptic fantasy with Cubist pochoir
illustrations by Fernand Léger. That book
marked the end of Cendrars's partnership
with Laffitte, who then hired Félix Fénéon
to take his place. Laffitte stepped down as
director in 1922 but retained a position on
the board. Not sorry to see him go, one of
his associates observed that "I am just about
as qualified to drive a tank as he is to run a
business." The new management contracted
with Georges Crès to distribute their
publications, which dwindled to one or two
volumes a year after 1924. The firm was
liquidated in 1937. Altogether it published
180 volumes, not counting a successful
sideline in sheet music, including Stravinsky's *Rag-Time* (1919) and compositions by
Les Six.[3]

La Sirène published three editions of
L'almanach de Cocagne between 1920 and
1922. These almanacs contain recipes,
anecdotes, advice, art, music, and poetry
celebrating the pleasures of food and drink
such as one might enjoy in the land of
Cockaigne. The 1921 edition begins with a
calendar, each month including a description of dishes suitable for the season as well
as the traditional list of saints' days facing a
full-page illustration. Raoul Dufy designed
the woodcut *Le jardinage* for May. Following the calendar are essays by various
authors, including Guégan on the feast of
Epiphany, Édouard Nignon on cooking
skills, Darius Milhaud on cocktails, and
Laffitte on culinary inventions. Max Jacob
wrote an account of a dinner party, Erik
Satie composed a drinking song, and
Cocteau contributed instructions on how to
make do when there is no more alcohol in
the house. Precedent for this kind of
miscellany can be traced back to Grimod de
la Reynière's gastronomical classic,
L'almanach des gourmands (1803–12), which
Guégan would have encountered in the
course of his antiquarian researches and
which he acknowledged with a graceful
dedication to Grimod in the 1920 edition.
Like Grimod, he compiled a directory of
highly recommended groceries, bakeries,
and butcheries in Paris. Before starting on
L'almanach de Cocagne, he tried out the
almanac concept with another publisher,
Maurice Boussus, who issued under his
direction *L'armoire de citronnier* in 1919.

Matisse provided two line drawings of
langoustes to be reproduced as ornamental
tailpieces in this volume. One of them
reappears in *L'almanach de Cocagne* for 1922.
Cendrars named Matisse as one of the
artists he had persuaded to illustrate books
for La Sirène, but he left the firm before
Guégan started to assemble the 1921
edition. It is more likely that this commis-

Fig. 1. Title page, *L'almanach de Cocagne,* The Morgan Library & Museum

Fig. 2. Illustration and facing text, *L'almanach de Cocagne,* The Morgan Library & Museum

L'ALMANACH
DE COCAGNE
POUR L'AN 1921
SE TROUVE A PARIS, A LA
SIRÈNE. 7 RUE PASQUIER

— C'est ici que le vrai voluptueux sépare
Le monde en deux : dans l'un il fume son cigare,
 Et de l'autre, il n'a point souci.
La fumée en rêvant lui communique à l'âme
 Un bien-être agréable. — Ainsi,
Laissant la cigarette et l'anisette aux dames,
 Digérons à bras raccourci !...

 EMILE HENRIOT.

190

DODEKAGÉNÉTHLIAKOTECHNIE
CULINAIRE

1° L'année astrologique commence le 21 mars, lorsque le soleil entre dans le signe du Bélier. Les personnes nées entre le 21 mars et le 20 avril seront prédestinées à aimer le poivre et la moutarde, condiments Martiens. Le lait de chèvre leur sera bénéfique. Voici une recette de sauce Barbe Robert que me fournit l'Ecole parfaite des officiers de bouche (1680, chez Jean Ribou, à Paris) :

Prenez des oignons, hachez-les bien menus, et les faites frire dans du sain de lard ou dans du beurre, selon le jour gras ou maigre : prenez aussi du verjus, du vinaigre, de la moutarde, du poivre, des menues épices et du sel, faites bouillir le tout ensemble, et servez votre sauce avec des

191

sion came by way of Cendrars's successor, Félix Fénéon, who broached the idea in a letter at the end of October 1920 and went so far as to suggest a seafood motif. Fénéon was a friend of the artist and transacted business with him while managing the modern art operations of the Bernheim gallery. Surely, a couple of pen-drawn vignettes were not too much to ask. They may not have required a great amount of thought or effort, but they fit perfectly on the page and reveal the predilections of someone not indifferent to the pleasures of the table.

~

PAGE SIZE: 16.5 × 11 cm.

PAGINATION: 232 [4] pp.; pages 1–2 and [235–36] blank.

ILLUSTRATIONS: 12 full-page line illustrations and 27 vignettes in text by Raoul Dufy, Othon Friesz, Jean Émile Laboureur, André Lhote, Gaspard Maillol, Albert Marquet, Henri Matisse, Paul Signac, and other artists.

TYPOGRAPHY: Printed by Henri Diéval, Paris. Text in a 10-point French round face, display in fat-face types.

PAPER: The ordinary copies are on a pure rag machine-made wove supplied by Papeteries Navarre, Voiron. The papier des Manufactures impériales de Shidzuoka is a strong and stiff Japanese handmade.

BINDING: Rose-printed wrappers.

EDITION: Printed 29 December 1920. Edition includes 3 copies on papier ancien du Japon numbered 1 to 3 with a suite of prints on Chine, priced at 250 francs; 10 copies on papier ancien du Japon numbered 4 to 13, priced at 125 francs; 20 copies on papier des Manufactures impériales de Shidzuoka numbered 14 to 33, priced at 85 francs; and 50 copies on vélin pur fil Lafuma numbered 34 to 83, priced at 35 francs; ordinary copies priced at 15 francs.

COPIES EXAMINED: PML 195986 (ordinary copy); PML 195989 (no. 32); HRC TX 637 A43 LAK (ordinary copy).

REFERENCES: Fouché 1984, no. 85; Duthuit 1988, no. 43; Monod 1992, no. 185; Laroche 1999, pp. 22–27.

8.

Henri Matisse (1869–1954), *Dessins.* **Paris: Éditions des Quatre Chemins, 1925.**

Matisse published reproductions of his drawings to make a case for this medium and to show where it stood in relation to his paintings, an important distinction he wished better understood by his customers and critics. He discovered that he could reach them directly with these publications instead of depending on dealers to exhibit and promote his work. By necessity, art galleries were the marketplace of paintings, which were harder to reproduce with the color printing technologies available at that time. The tried-and-true photogravure and collotype processes could render the subtle tonalities and crisp outlines of black-and-white drawings with astonishing detail and precision. Issued in limited editions on fine paper, these prints looked and felt like works of art, prestige items palpably superior to the halftones in textbooks and magazines. If not content with the sales of *Cinquante dessins,* he could be proud of its physical appearance and pleased with its reception in the international art market during the 1920s. He told his son Pierre that he could have sold all the drawings in that book to the Christiania Museum (now the National Gallery of Norway). He refused to part with them at that time, but he did agree to break up the set and send two to Pierre, who hoped to start out as a dealer in New York with a small stock of prints and drawings. He advised his son to put a high price on them, considering that "drawings always increase in value after they are published," a factor that might have influenced his decision to launch a similar collection. This time he knew not to publish it on his own account but allowed others to take on the risk and expense of book production while reserving the right to set standards and approve the results.[1]

The Quatre Chemins bookstore and gallery ran a small publishing business on the side, a joint venture supervised by Wladimir Walter in association with the Russian art historian Vladimir Rakint. Walter appears to have been the chief proprietor, although Rakint might have had an interest in the concern. They set up shop in Paris around 1924 after spending some time in Berlin, where they produced at least one book with the imprint Walter, Rakint and Company. Perhaps relying on their Russian connections, they started out with a limited-edition album of theater designs by Georges Braque for the Serge Diaghilev production of *Les fâcheux* (1924). This is the earliest book I can attribute to them, but their editions were so small that an earlier one may have escaped my notice. In September 1925 they signed a contract for the publication of *Dessins,* which was to contain between 64 and 80 unpublished drawings. They agreed to pay the artist 20 percent of the trade price as well as 1,500 francs for the frontispiece in the specials. In addition they undertook to sell the original drawings in their gallery.[2]

For a brief period, Walter and Company carried a line of publications under the name of the infamous Maurice Sachs, author of scurrilous memoirs about his spendthrift escapades during the heyday of the Parisian avant-garde. Sachs brought to the firm books by his friends Max Jacob and Jean Cocteau but then quit to seek his fortune as a dealer in first editions and literary manuscripts. He abandoned that trade as well after he had been caught stealing from Cocteau and embezzling the library funds of Coco Chanel. The misadventures of Maurice Sachs were of no concern to Matisse, who gave him a copy of *Cinquante dessins* in 1933, when they both were in America. How they became acquainted is not clear, but Sachs knew enough about Matisse's work to write a review of his 1931 exhibition at the Museum of Modern Art. Sachs may have been among those who persuaded Matisse to illustrate *Maria Lani* (No. 12), another highly dubious transaction.[3]

Walter had a more stable relationship with the art critic Waldemar-George, who wrote the prefatory essay for *Dessins* as well as many other pieces commissioned by Quatre Chemins. Born in Poland as Jerzy Waldemar Jarocinski, he changed his name after he emigrated to France and started to write art reviews for the Paris press. His preface for *Dessins* appears to have been a work for hire intended mainly to summarize the artist's career but displays some wit and verve at the end, where it describes the intimate allure of drawings. Like chamber music, they are intended for a select audience in a restricted space. Some effort is required to understand them: "They are written in a secret language." A year later Waldemar-George produced a similar preface for an album of drawings by Picasso, a companion volume uniform in size and style. Both albums offer the same number of plates and the same inducements to collectors—a hundred fine-paper copies with original prints. The main difference between the two is the role assigned to Waldemar-George, who receives author credit on the title page of the Picasso album, as if he was mainly responsible for the publication. The Matisse volume, however, puts his name on a section title to make it clear that he is the author only of the preface. Walter kept him employed as author of other artists' monographs and as art director of the journal *Formes: Revue internationale des arts plastiques,* published in French and English editions between 1929 and 1933. While occupied with *Formes,*

he developed a "neohumanist" theory of art founded as much on political as aesthetic principles and characterized by an adamant rejection of modern art movements such as Cubism and Surrealism. In a book not published by Quatre Chemins, he revealed his true opinions about Matisse and Picasso: one a pedant whose art "only expresses retinal perceptions," the other a "fundamentally vicious satanic genius." He veered to the right in his political writings, renounced his Jewish heritage, adopted a fascist ideology, and became an ardent admirer of Mussolini. After the war broke out, he suffered a crisis of conscience and tried to suppress an injudicious treatise he had written under the title *L'humanisme et l'idée de patrie.* He survived the Holocaust and, with a chastened view of modernism, continued to write on art in the 1950s and 1960s. Still a pen for hire, he produced catalogues for galleries, coffee-table books for the trade, and even revisited Matisse's work in a text commissioned by a pharmaceutical company for a series of promotional keepsakes, *Médecines et peintures.*[4]

Waldemar-George had some say in the production of *Dessins,* but the final word was left to Matisse. The writer helped to choose the drawings and decide how to organize them in the volume—groups of landscapes, nudes, and portraits at the beginning, a selection of recent work at the end. Once he knew what he was working with, he had eight days to write the essay, which was to be reviewed by the artist. Acting as production manager, Rakint assured Matisse that he could make last-minute changes in the order of the drawings when he saw the maquette, a mock-up of the book showing every page in its proper position. No doubt the artist also saw proofs of the collotypes and gave them his *bon à tirer* just as he approved the photogravure plates in *Cinquante dessins.* In

the course of the proofing process, he asked for adjustments in the background tint of the collotypes—darker in some proofs, lighter in others—a question of some concern because he wanted the plates to match the ivory color of the Chine employed in the frontispiece. He could have complete confidence in the quality of the reproductions, printed by Daniel Jacomet et Compagnie, a firm renowned for its facsimiles of artwork. Jacomet even succeeded in printing certain kinds of color facsimiles by combining his collotype facilities with a pochoir studio, where the colors were applied by a highly sophisticated stencil process. Publishers paid a premium for his labor-intensive limited-edition facsimiles. The Trianon Press relied on outside funding to finance his work on the illuminated books of William Blake. Pierre Matisse hired him to replicate the gouaches in Joan Miró's *Constellations,* despite the formidable sums he demanded for the collotypes and pochoirs. The collotypes cost more than the pochoirs, even though Jacomet predicted that it would take 400 hours to cut the stencils and 1,100 hours to apply the colors.[5]

Matisse was duly impressed by the quality of the collotypes in *Dessins.* He complimented the publishers after receiving his copies, even though they failed to meet their publication deadline. They had planned to promote it with an exhibition in the Quatre Chemins gallery, 13–28 November 1925, but the exhibition opened while they were still pondering the proofs, and they did not have books in hand until the beginning of 1926. *Dessins* was further delayed when the sheets were being folded and gathered because each plate had to be mounted on a tab. Books assembled in this way present an obvious temptation to dealers and collectors, who can break them up and dispose of the plates individually as

fine art reproductions. Even more tempting is the opportunity to pass off the reproductions as originals. In June 1934 the American collector Etta Cone paid a visit to Matisse and showed him an example of his work she had recently acquired, a pen-and-ink drawing of a nude (Fig. 1). He immediately recognized it to be plate 13 of *Dessins,* with the collotype background cleverly concealed by additional pen strokes in the same style as the drawing. To set the record straight, the artist annotated the sheet with an explanation of how the forgery was accomplished and then authenticated his inscription with his name and the date, thus making the bogus drawing more valuable than before. Cone brought it back to America and included it in her bequest to the Baltimore Museum of Art, where it can be seen as evidence of the persuasive power of collotype reproductions.[6]

PAGE SIZE: 26 × 21 cm.

PAGINATION: [4] 16 [12] pp.; the first 2 leaves and pages [27–28] blank.

ILLUSTRATIONS: Frontispiece etching signed and dated by the artist in the fine-paper copies; 64 full-page collotype reproductions of drawings printed by Daniel Jacomet et Cie., Paris.

TYPOGRAPHY: Printed by F. Dutal et Cie. Text in Deberny et Peignot 14-point Cochin, most of the display in Deberny et Peignot Nicolas-Cochin.

PAPER: The vélin d'Arches is a mold-made wove supplied by Papeteries d'Arches. The vélin Lafuma is an unwatermarked machine-made wove supplied by Papeteries Navarre.

BINDING: Dark blue paper wrappers with a title label on the front cover. Possibly a later issue, the HRC copy is in pink wrappers.

EDITION: Printed 15 December 1925. Edition of 1,120 copies: 100 copies on vélin

d'Arches numbered 1 to 100 and priced at 300 francs; 1,000 copies on vélin Lafuma priced at 125 francs; 20 copies hors commerce on vélin d'Arches numbered I to XX.

COPIES EXAMINED: PML 195982 (no. IX); Princeton University Library ND 553.M35 W3 (no. 78); PML 195590 (ordinary copy); HRC NC 1135 M34 W343 LAK (ordinary copy).

REFERENCES: Mahé 1931, vol. 2, col. 841; Barr 1951, p. 569; Duthuit 1988, no. 3.

EXHIBITIONS: Fribourg 1982, no. 18; Nice 1986, no. 46.

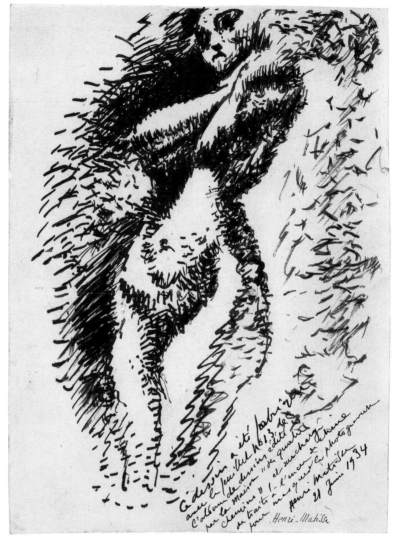

Fig. 1. Reproduction of a drawing with annotations by Matisse, *Dessins,* The Baltimore Museum of Art, BMA 1950.12.465

9.

Henri Matisse (1869–1954), *Dix danseuses, lithographies de Henri Matisse, notice de Waldemar George.* **Paris: Éditions de la Galerie d'Art Contemporain, 1927.**

Dix danseuses is more a print portfolio than an illustrated book. It can be found in museum print departments just as easily as in libraries, if not so often in the trade. (The edition is not large, and dealers have broken up some sets to sell the pieces for a higher profit.) Duthuit did not include it in his catalogue raisonné of illustrated books, but the ten lithographs are described in his catalogue of prints. It is included here because it contains a text and displays other attributes of a fine printing venture: a title page with the usual publication information, a typical slipcase of the period, and the standard limitation statement specifying a hierarchy of special copies.

Once again the text is by Waldemar-George, the journalist and critic who wrote the front matter for the previously described *Dessins* (No. 8). How he was hired and what instructions he received must be a matter of conjecture, although he regularly performed similar services for Paris galleries. He wrote appreciative comments about the artwork reproduced in *Dessins* but had nothing to say about the contents of this portfolio. That Matisse's prints are a microcosm of his artistic achievements was the premise of his essay and the pretext for an account of recent developments in the world of modern art. There is hardly a word about the work at hand. Lithographs of ballet dancers did not provide sufficient scope for the issues Waldemar-George wished to address—the innovations of Matisse, their precedents, and their relationship to the work of other notable modernists in Paris. These were exciting

times, he explained, now that Matisse had come upon the scene. He described Matisse as having followed in the footsteps of Gauguin, Degas, and Cézanne, who were the first to throw off the fetters of the past. Matisse, too, was a revolutionary, although not a leader of a movement or the exponent of some "predetermined doctrine." His techniques were not to be confused with those of the Impressionists. The radical nature of his work in this "heroic epoch" could be compared with early Christian art, which overturned the canons of classical civilization, yet he had done a better job of deflecting criticism than Picasso, whose shocking deformation of the human figure had antagonized the public. The eclectic critic also pointed out analogies with the works of Ingres in the quality of line, Persian illuminated manuscripts in the use of color, and Mycenaean wall paintings in the refinement of decorative motifs. These accolades reached a crescendo at the end, where the painter was credited with shamanic powers. Modern as he may have been, Matisse restored art to its original function and reinvigorated it with magical properties that formerly served the spiritual needs of tribal cultures but now fulfilled the intellectual and emotional requirements of a secular society. Waldemar-George was more interested in theory than in practice, an approach perfectly acceptable at that time, judging from the number of commissions he received from the Galerie des Quatre Chemins and the Galerie d'Art Contemporain.

The proprietors of these galleries adopted a similar business model. Jacques Levi Alvares (1883–1951) founded the Galerie d'Art Contemporain in 1926, a few years after Walter and Rakint set up shop in Paris. Like his predecessors, Alvares operated a bookstore and a publishing firm on the side. He may not have been the sole

owner, at least not at first, because one of his exhibition catalogues states that his firm had been incorporated with capital of 150,000 francs. In 1928 he further diversified his activities by selling phonograph records in an adjacent space he called the Boîte à Musique. Django Reinhardt and other jazz musicians performed in his store, the first home of the Hot Club de France. The music side of his business proved to be so successful that he closed the art gallery in 1934 and established a record label, B.A.M., with a catalogue that encompassed a range of artists—from medieval troubadours up to the popular song stylists of the day.[1]

The printers of this portfolio also achieved some renown, although one reputation was beginning to fade, and the other had not yet emerged. The lithographs were editioned at the Atelier Duchâtel, a highly respected firm established by the master printer Édouard Duchâtel. He worked in one of the great lithography shops of the nineteenth century, the Imprimerie Lemercier, where he collaborated with Odilon Redon and other artists. He wrote a highly regarded *Traité de lithographie artistique* (1893), which helped to popularize color printing at the turn of the century. His career has been difficult to date, but he had probably died by this time, leaving the firm in the hands of his widow, who delegated the work to journeymen. The Atelier Duchâtel was fairly prominent in the 1920s and won the contract to print the lithographs in *Tableaux de Paris* (No. 10). It appears, however, to have fallen on hard times by 1934, when Matisse commissioned it to provide technical support for the lithographs he was designing for *Ulysses* (No. 14), but the proofs turned out so badly that he gave up and made soft-ground etchings instead. He blamed this setback on the "idiot lithographer" and henceforth took his illustration business elsewhere.

The letterpress printing of *Dix danseuses* was more auspicious. Henri Filipacchi (1900–1961) supervised the composition and presswork of the text at the Imprimerie du Livre, Rueil, an imprint often found in demiluxe books of the 1920s. Like others of its kind, the Imprimerie du Livre dropped out of the fine printing market during the Depression. Filipacchi had to fend for himself until he joined the staff of the Messageries Hachette book distribution service. As secretary general of Hachette, Filipacchi attained a commanding overview of the trade, a prestigious position, except that it put him in a compromising predicament during the war. The German censors turned to him for advice on how to compile a catalogue of banned books—the ominous *liste Otto*—and he invited others to help him identify titles that might displease the occupying forces. After the Liberation he asserted that he was not responsible for those oppressive measures but actually succeeded in sparing some politically innocuous works of literature. This awkward episode does not detract from his real claim to fame, an achievement quite the opposite of censorship. In 1953 he introduced the first fully formed paperbacks in the French-speaking world by launching Hachette's line of *livres de poche.* Printed on rotary presses in huge editions, these cheap and convenient mass-market softcover books dominated the publishing industry during the second half of the twentieth century. They changed reading habits, fostered new literary genres, revitalized the classics, and redefined the role of bookstores in the retail sector of the trade. They could be considered the last great innovation in publishing practices before the advent of e-books at the end of the century.[2]

Filipacchi went from one extreme to the other during his long career in the printing business. Initially he made his living from

Fig. 1. Title page, *Dix danseuses,* Smith College Museum of Art

Fig. 2. Canceled lithograph, *Dix danseuses,* Smith College Museum of Art

expensive limited editions; ultimately he flooded the marketplace with low-cost goods bearing no pretension to artistic quality. Likewise Matisse understood the price differentials in the sale of his graphic work. He sometimes allowed his designs to be reproduced in easily affordable trade editions, several of which are described in this catalogue. But he made a special effort to protect the value of original prints produced with his participation and approval. That is one reason why his most important books were numbered and signed. Sometimes he stipulated in his contracts that the lithographic stones or the intaglio plates be canceled after completing the edition, the traditional method of certifying the accuracy of a limitation statement. *Dix danseuses* is a prime example of this practice. At the end of the print run, Matisse rubbed out the center of the image in at least eight of the stones and inserted the limitation statement in that space. Then a few additional proofs were pulled to show that these precautionary measures had been taken. These proofs testify that none of the principals in this venture and no one with access to the Atelier Duchâtel could ever procure the means to make extra copies of *Dix danseuses*.[3]

PAGE SIZE: 50.5 × 32.5 cm.
PAGINATION: 5 [3] pp. (letterpress).
ILLUSTRATIONS: 10 full-page lithographs printed at the Atelier Duchâtel.
TYPOGRAPHY: Printed at the Imprimerie du Livre, Rueil-Malmaison, under the supervision of Henri Filipacchi. Text in an 18-point Didot italic.
PAPER: The Arches is a mold-made wove.
BINDING: Issued loose in a portfolio of white or cream boards with a label on the front cover printed in black on brown paper, the portfolio contained in a slipcase of beige boards with a similar label on the front cover.
EDITION: Printed 25 April 1927; deposited at BnF, 25 November 1927. Edition of 158 copies: 5 copies on Chine numbered 1 to 5; 15 copies on Japon impérial numbered 6 to 20; 130 copies on Arches numbered 21 to 150; 8 copies on Arches hors commerce numbered I to VIII (but actually lettered *A* to *H*).
COPIES EXAMINED: BnF KD-5 (G)-Fol (hors commerce copy D); Smith College Museum of Art 1972: 50–66 (no. 9); University of Virginia Library ND553.M37 G4 1927 (no. 16); MoMA 19.1932.1–10 (no. 40).
REFERENCES: Duthuit 1983, nos. 480–89; Smith College 1985, no. 86.
EXHIBITION: Fribourg 1982, nos. 436–45.

10.

Tableaux de Paris. **Paris: Éditions Émile-Paul Frères, 1927.**

Twenty artists and twenty writers contributed to this book, a collaborative effort directed by Jean-Gabriel Daragnès. Matisse enjoyed his part in the project and appreciated the opportunity to work with Daragnès, who enlisted the artist's services for a similar book in 1937 (No. 16) and conferred with him about the design of the long-delayed edition of Baudelaire's *Les fleurs du mal* (Nos. 28 and 31). Daragnès was a master of Art Deco book design fully the equal of François-Louis Schmied and no less influential in setting the style and standards of French fine printing between the wars. Born in 1886, he was trained as a metal engraver and served his apprenticeship in the shop of the jeweler Christofle, where he cut monograms on silverware. Early on in his career he cultivated a love of lettering that would inspire the choice of types and the design of the decorative initials in his books. He started painting in 1907 and practiced nearly all of the printmaking processes. He could select the illustration method best suited for the text he had in hand—wood engravings for Oscar Wilde's *Ballad of Reading Gaol* (1918), color etchings for a romantic idyll in the South Pacific (1928), mezzotints for the poems of Edgar Allan Poe (1949), and a lithograph for the present volume, a view of the Place Pigalle at night. At first he kept a small proof press in his apartment, but he then looked for larger quarters where he could install a printing shop capable of taking on bookwork in limited editions. He built a new home in Montmartre with a pressroom on the ground floor and studio space upstairs, a construction project financed by the sale of his personal library containing special copies of his books and the original drawings for his illustrations. His shop became a convivial meeting place for the creative community of Montmartre, including many of the people involved in the production of this book.[1]

For a while Daragnès belonged to a small concern producing luxury illustrated editions, but it proved unprofitable, and he usually printed books on his own account or on commission from commercial firms and bibliophile societies. He served as an art director for the publishers Georges Crès et Compagnie from 1918 to 1923 and then for Émile-Paul Frères. Beginning in 1901, Robert and Albert Émile-Paul issued regular trade books, including Alain-Fournier's bestseller *Le grand Meaulnes,* but they also built up a line of limited editions under the influence of Daragnès. He designed many of their publications, illustrated more than twenty, and printed at least eight at his press in Montmartre. His typographical designs helped to create a house style for this firm, its imprints easily recognizable by such characteristic features as his calligraphic initials and decorative rules in the headings and running titles. The initials and ornaments were usually printed in a second color, often a blue or a green rather than the reds ordinarily employed for that purpose. He favored the Didot typeface and tight setting, which produced a darker page than usual, but he did not insist on any particular type style or format. *Tableaux de Paris* is a typical example of his work, but similar designs can be seen in other Émile-Paul publications, such as *Le cabaret de la belle femme* (1924) and *Le baiser au lépreux* (1925). More versatile than Schmied, he managed to stay in business during the Depression and produced some limited editions during the Occupation— limited perforce because of the paper shortages at that time. Émile-Paul Frères

Fig. 1. Title page, *Tableaux de Paris,* Frances and Michael Baylson Collection

could afford to retain his services by reinvesting the profits they made on *Le grand Meaulnes,* sales of which reached 4,000 copies a month in 1941. Demand for books in the Daragnès style declined after the war, compelling him to cut back on his commercial work, but he continued in the printing business on a modest scale until he died in 1950.[2]

Daragnès delegated the letterpress printing of *Tableaux de Paris* to the Coulouma firm, but he oversaw the production of the book. It must have been a formidable task to coordinate the work of twenty authors and twenty illustrators, but he could deal with many of them directly as friends and colleagues. The publishers succeeded in recruiting an impressive list of writers: Roger Allard, Francis Carco, Jean Cocteau, Colette, Tristan Derème, Georges Duhamel, Raymond Escholier, Jean Giraudoux, Max Jacob, Edmond Jaloux, Jacques de Lacretelle, Valéry Larbaud,

Pierre Mac Orlan, Paul Morand, André Salmon, André Suarès, Paul Valéry, Jean-Louis Vaudoyer, Charles Vildrac, and André Warnod. The artists are noted below. Among these names can be found several closely associated with the Émile-Paul firm, the illustrator Hermine David, for example, and the writers Giraudoux and Mac Orlan.

They would have been all the more pleased to participate because their assignments were short and simple: a brief essay or a single picture celebrating Paris and its scenic locales. They described the obvious landmarks as well as the hidden charms of neighborhoods such as Montparnasse, Montmartre, the Montagne Sainte-Geneviève, and the Île de la Cité. Usually they only touched on the history and architecture of the city and preferred to dwell on its popular attractions: clubs, cafés, dance halls, sporting events, and the cinema. Larbaud wrote on civic pride, Jaloux on the expatriate experience, Cocteau on sidewalk temptations. Colette contributed a text on fashion accompanied by an etching by Marie Laurencin aptly titled *Frivolités.* Suarès invoked the glories of the capital city in a concluding essay illustrated by *Le cirque,* one of several prints Georges Rouault made on circus themes at that time.

Like Rouault, Matisse selected a subject on the basis of his personal knowledge and artistic interests. His etching, *Le pont Saint-Michel,* shows a segment of the cityscape he had painted repeatedly between 1899 and 1904 while residing at 19, quai Saint-Michel. He rented a studio at the same address in 1914. The composition of the etching corresponds almost exactly to a photograph in Alfred Barr's monograph

on Matisse showing what he would have seen from the window of his studio. Daragnès had to print the image in the landscape orientation, which he told Matisse he was hoping to avoid but could accommodate if necessary. He also had to find a place to put it in the volume not too close to a similar scene, an Edmond Ceria etching of the embankment in that part of town. By process of elimination, it ended up next to an essay by Charles Vildrac on an unrelated topic, the humble pleasures of drinking local wine, but at the very least one could say that it helped to set the mood for that piece. Matisse sent Daragnès the plate and a proof to use as a reference guide when judging the quality of the impression. For his pains the printer was to receive the original drawing, a thoughtful gesture that made him "infinitely grateful," but he advised the artist to hold on to it while the book was still on press. The etchings for *Tableaux de Paris* were printed by Roger Lacourière at his Ateliers de la Roseraie, just next door to Daragnès. Matisse would call on Lacourière to print intaglio illustrations for other books, including *Alternance* (No. 24), another collaborative project involving Daragnès and friends.[3]

PAGE SIZE: Raisin quarto; 32.8 × 25 cm.
PAGINATION: [10] vi [2] 259 [11] pp.; the first 2 leaves and the last 2 leaves blank.
ILLUSTRATIONS: 20 plates: 14 etchings by Edmond Ceria, Hermine David, Kees van Dongen, André Dunoyer de Segonzac, Pierre Falké, Léonard Tsugouharu Foujita, Chas Laborde, Marie Laurencin, Albert Marquet, Charles Martin, Henri Matisse,

Jean Oberlé, Jules Pascin, and Henry de Waroquier printed at the Ateliers de la Roseraie (Roger Lacourière); 6 lithographs by Pierre Bonnard, Jean-Gabriel Daragnès, Luc-Albert Moreau, Georges Rouault, Maurice Utrillo, and Maurice de Vlaminck printed at the Atelier Duchâtel.
TYPOGRAPHY: Printed at the Imprimerie Coulouma, Argenteuil, under the direction of Henri Barthélemy. Text in 16-point Firmin Didot, chapter titles in Deberny et Peignot 24-point Initiales Sphinx Blanc.
PAPER: Japon impérial; mold-made vélin de Rives watermarked BFK RIVES.
BINDING: Brown wrappers with the title printed on the front cover in blue and red, blue cardboard chemise, blue and red cardboard slipcase.
EDITION: Printed 10 June 1927. Edition of 225 copies: 25 copies on Japon impérial numbered 1 to 25, including an extra suite of prints on Arches, priced at 4,000 francs; 200 copies on vélin de Rives numbered 26 to 225, priced at 2,000 francs. In addition several copies hors commerce were printed either on Japon impérial or vélin de Rives.
COPIES EXAMINED: PML 195591 (no. 5); NYPL Spencer Collection French 1927+ (hors commerce).
REFERENCES: Mahé 1931, vol. 3, col. 489; Skira 1946, no. 365; Barr 1951, p. 560; Duthuit 1988, no. 4; Monod 1992, no. 10552.
EXHIBITION: Nice 1986, no. 57.

Fig. 2. Chapter opening, *Tableaux de Paris,* Frances and Michael Baylson Collection

Fig. 3. Etching, *Tableaux de Paris,* Frances and Michael Baylson Collection

TROTTOIR

PAR

JEAN COCTEAU

Il y a un coin de Paris (pas tout à fait au cœur) qui ne ressemble à nul autre. C'est le trottoir entre la Madeleine et l'Opéra. Dans ce parc aux biches, parmi les vrais piétons qui se dépêchent, flânent les putains et les tapettes. Les tapettes, seules ou bras dessus bras dessous, avec des hanches et des profils inquiets, car ces jeunes esclaves portent de faux uniformes, soit de zouaves, soit de marins, et craignent qu'on ne leur demande leur livret militaire. Un agent de la sûreté, déguisé en cul-de-jatte *(sic)*, surveille ces bêtes de luxe.

Parfois, un nègre hagard entre vite dans un édicule, comme s'il voulait développer une photographie.

Les dames descendent de Pigalle, par le Nord-Sud. Je ne connais rien de plus délicieux que de les voir, en face de la marchande de journaux du Métropolitain, se remaquiller devant la glace du distributeur automatique.

19

11.

Jacques Guenne, *Portraits d'artistes: Th. Bosshard, André Favory, Marcel Gromaire, Ch. Guérin, Kisling, André Lhote, Matisse, Simon-Lévy, Vlaminck. Illustré de quarante-huit hors-texte et de neuf reproductions de dessins, eaux-fortes, et lithographies inédits.* Paris: Éditions Marcel Seheur, 1927 (L'art et la vie, vol. 4).

The title and contents of this volume are derived from a series of artists' profiles published in the magazine *L'art vivant* (1925–39). Jacques Guenne and Maurice Martin du Gard founded the magazine as an artistic counterpart to *Les nouvelles littéraires*, which at that time was managed by Martin du Gard. Larousse distributed both magazines. Among other features, *L'art vivant* contained a series of articles by Guenne under the rubric *Portraits d'artistes*, mainly painters known for having exhibited at the Salon des Tuileries, the Salon d'Automne, and the Salon des Indépendants. Most of these articles include a critical appraisal of the painter's work, halftone illustrations, a portrait of the artist, biographical information, and sometimes an interview. By reprinting them here, Guenne hoped to show "different aspects of art today"—no more, no less. He noted that he was not reporting on recent trends in the upper echelons of the profession but would also focus on comparatively obscure Sunday painters "whose talent seems to us to be remarkable" (p. 52). He planned to take a similar approach in future volumes and continued to write *Portraits d'artistes* for *L'art vivant*, although the later articles do not appear to have been collected in book form.

Matisse consented to make a celebrity appearance in this modest publication. He states the theme of the preface, which begins with an epigraph quoting his 1908 essay,

"Notes of a Painter," his first and most influential statement of his artistic principles: "All artists are influenced by their era, but the great artists are those who have been influenced most profoundly." Facing that is a full-page reproduction of one of his most famous paintings, *Dance (I)*. Altogether seven plates document his work; other artists were allocated only five, with the exception of Vlaminck, who was granted six in consideration of the books he had been illustrating for the publisher. Each artist contributed an unpublished drawing or print to be reproduced in photogravure on a supposedly superior mold-made paper embellished with the publisher's watermark. These photogravure plates are the only fine printing ingredients of *Portraits d'artistes*, which could not claim to be a limited edition but might still appeal to collectors because it was "luxuriously presented." That was how a review in *L'art vivant* commended it to readers who might be buying gift books for the Christmas season. In the case of Matisse, however, Guenne and his associates had to settle for a work that had already been published, a lithograph completed in 1924 and produced in 270 copies, of which 225 were designated for the Art Club of Copenhagen. Guenne may have been pleased to receive even this much from Matisse, who had little to gain in publicity and even less in prestige by participating in this publication. He also might have been willing to stretch the definition of an unpublished print, given that this one had been destined for a distant market. Certainly he was not averse to the subject of the print, having already used a similar *Nude in an Armchair* lithograph to illustrate his article on Matisse in *L'art vivant*.[1]

Guenne substantially revised and corrected the article while preparing it for publication in *Portraits d'artistes*. He reshaped the text to make it more of a portrait, a biographical profile of the artist

based on an interview with an introduction and a modicum of commentary. Someone looking for an explication or a critique of Matisse's work could easily obtain the inexpensive monograph of Marcel Sembat (No. 5), which Guenne consulted when he wrote the article. Instead he allowed the artist to speak for himself with anecdotes about his artistic apprenticeship, an account of his teaching experiences, a tribute to Cézanne, reminiscences about art dealers, and reflections on the hardships he endured at the beginning of his career. Expansive, relaxed, loosely constructed, this interview is nonetheless an important source for Matisse scholarship and has been included in two anthologies of his writings.[2]

Portraits d'artistes is the fourth volume in the series L'art et la vie published by Marcel Seheur. The fine-printing entrepreneur Georges Crès established the series in 1926 with a reprint of Daumier caricatures and a monograph on the Salon d'Automne but then turned it over to Seheur, who printed the remaining volumes at his shop in Montmartre. Not long after the First World War, Seheur started his printing business in collaboration with the artist Lucien Boucher, who illustrated some of his books. The colophon of *Portraits d'artistes* states that Boucher was the art director, perhaps the person responsible for seeing it through the press and assuring the quality of the illustrations. During the 1920s, Seheur developed a line of increasingly ambitious bibliophile editions, including Francis Carco's *La légende et la vie d'Utrillo* (1927) issued in 105 copies with 11 lithographs by Utrillo and one by Utrillo's mother, Suzanne Valadon. He printed some books on his own account and some on commission, many of them displaying his device in the watermarks or on the wrappers. Like Crès, he had to abandon the trade in luxury illustrated books during the

Depression, but he managed to stay in business for a while by printing "limited edition" erotica for sale under the counter. He sought to elude the censors' notice by hiding behind false imprints, but bibliographers have been able to attribute to him French translations of *My Secret Life* and *Teleny* (printed for the Ganymede Club of Paris). Meanwhile he continued to publish the L'art et la vie series under his real name and succeeded in producing as many as sixteen volumes as late as 1933. A French version of *The Schoolboy Alcibiades* printed for a Society of Amateurs in 1936 would, however, be his last known publication if the date in that imprint can be trusted.[3]

~

PAGE SIZE: 25.2 × 19 cm.

PAGINATION: 307 [5] pp.; the first leaf blank.

ILLUSTRATIONS: 48 halftone reproductions of paintings, 9 photogravure reproductions of drawings and prints. These plates are included in the pagination.

TYPOGRAPHY: Printed by Marcel Seheur, Paris. 11-point text type and display in the Didot style.

PAPER: All but one of the photogravure reproductions are on a poor-quality mold-made Arches with the publisher's watermark. The photogravure illustrating the Charles Guérin essay is on ordinary plate paper.

BINDING: Gray wrappers printed in black and red.

EDITION: Printed 30 September 1927. Edition of 2,000 copies priced at 75 francs.

COPY EXAMINED: PML 195634.

REFERENCES: Mahé 1931, vol. 2, col. 304; Barr 1951, p. 567; Duthuit 1988, no. 44.

Fig. 1. Title page, *Portraits d'artistes,* Frances and Michael Baylson Collection

Fig. 2. Photogravure illustration and facing text, *Portraits d'artistes,* Frances and Michael Baylson Collection

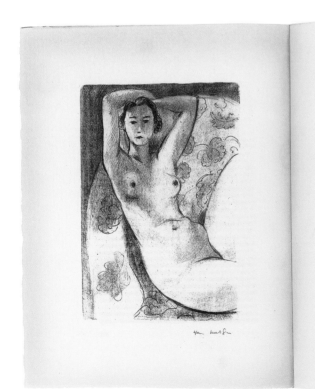

12.

Jean Cocteau (1889–1963), Mac Ramo, and Waldemar-George (1893–1970), *Maria Lani*. Paris: Éditions des Quatre Chemins, 1929.

This book began as a publicity stunt for the actress and model Maria Lani, "woman of a hundred faces." Born in Poland in 1895, Lani came to Paris in 1928 after finding employment on the stage in Berlin, where she might have been associated with the director and impresario Max Reinhardt. What parts she played in his productions cannot be ascertained, but this is not the only loose end in a life story obscured by hearsay, gossip, and deliberate mystification. She claimed that she was to play the lead in a movie, *Le rêve d'un antiquaire.* The many facets of her beauty would drive the plot: an elderly art dealer falls in love with a showgirl and commissions paintings of her to be viewed with an optical device that gives them the illusion of life and movement. Each of these portraits would reveal a different aspect of her mysterious allure. But just as he perfects his invention, the dream girl betrays him, and he dies in a fit of delirium while destroying the paintings, which he believes to have turned against him. Lani's agent called a press conference to muster support for the movie project but ultimately failed to secure funding for it. Subsequently they ran away to America, leaving some outstanding debts. The portraits reproduced in this volume were intended to be used in the film, which was supposed to provide the means to pay the artists. Disgruntled artists referred to the Lani affair as an outright swindle, but it may have been more of a well-meaning speculative venture that disappointed all parties concerned.[1]

This much of Lani's career can be reconstructed from reliable sources: her real name was Maria Abramovitch (or Abramowicz); her agent was her husband Maximilian Abramovitch, who was calling himself Mac Ramo at that time. Ramo commissioned the portraits in association with Maurice Sachs, who was then acting as a consultant to the Quatre Chemins publishing firm and could have persuaded the proprietors to finance the production of this book (see No. 8). The well-connected Sachs advised Ramo on the choice of artists and introduced him to Max Jacob as well as others who would have enrolled to keep up with their friends and rivals. Only two artists refused, says Sachs: "the prudent Picasso" and Marie Laurencin, who preferred to be paid in advance (in which case one could pick any of the generic portraits she had in stock). Sachs later pretended to have been a disinterested observer, but it is clear that he was the publisher's representative and that he was responsible for the participation of Max Jacob, who later reproached him for his part in the "Abramovitch scam." Jean Cocteau also felt that he had been cheated by Ramo, not just in this instance but also in the allocation of author's rights to *La voix humaine.* Several sources imply that the swindlers had to leave town in a hurry, but Lani was still in Paris as late as 1934, when she performed in *Prosper,* a Gaston Baty production at the Théâtre Montparnasse. When France fell to the Germans in 1940, they fled the country and emigrated to America, where they tried to resurrect the movie project, this time titled *The Woman of the Hundred Faces.* Various treatments and screenplays for this film survive in the Louis Bromfield Collection at Ohio State University. Bromfield collaborated on these drafts with Thomas Mann and Maximilian Abramovitch, who had abandoned his Mac Ramo pseudonym but then adopted the name of Maximilian Ilyin. Jean Renoir was to direct the film with Greta Garbo in the starring role. While waiting for her big break, Lani worked in the Stage Door Canteen and performed other charitable deeds on behalf of servicemen. After the war, they returned to Paris, where she died in 1954. Maximilian Ilyin became an art critic and published a book on Utrillo in 1953.[2]

Cocteau explained the rationale of the Maria Lani portraits in a preface he wrote for this volume. Like the other artists, he took his turn at trying to represent her mercurial beauty, but it remained stubbornly just beyond his reach. He professed to have been baffled by the different expressions she could assume and the constantly shifting alterations in her appearance—girlish at one moment, wizened at another, sometimes slight, sometimes stolid, always captivating but never quite definable in graphic terms. He compared his best efforts to those of Matisse, who might encounter similar frustrations but after throwing away eleven drawings would still have eleven good ones in reserve. "As for me, when I fail there is nothing left." If no single artist could decode Lani's secrets, why not recruit a number of them to work in different styles and different media toward a common goal? They could make a virtue of multiplicity, their diverse interpretations of her charms demonstrating the range, depth, and versatility of contemporary art in Paris. She could seem pensive to Bonnard, monumental to de Chirico, impish to Derain, demure to Despiau, furtive to Marquet, anguished to Rouault, and matronly to Valadon. Altogether fifty-one painters, printmakers, and sculptors accepted the challenge and contributed artwork reproduced in this volume. Just as it came off the press, the originals were sent out for exhibition, first at the Brummer Gallery in New York, then the Galerie Alfred Flechtheim in Berlin, the Leicester

Galleries in London, the Galerie Georges Bernheim in Paris, and the Rotterdamsche Kunstkring in Rotterdam. The critical response to these exhibitions was generally respectful, although one reviewer remarked that one might as well forget the subject and concentrate instead on the various approaches to the art of portraiture.[3]

Likewise, someone in the know reviewed the book as if Lani was not so much the miracle as the "publicity campaign" mounted on her behalf and the willingness of fifty artists to participate in it, despite differences in their outlook, talent, and prestige. In his prefatory remarks, Ramo claimed that he had the original idea of collecting the portraits but did not mention the possibility that they might be props in a movie. He suggested that Matisse had advised him to publish them in an album. "The painter fixed on me his grey eyes and said, 'I don't understand very well

what you want to do, but I know one thing: you should publish a book with this astonishing series of portraits, for the book is an indestructible document and only that will endure.'" This conversation was supposed to have taken place in a sidewalk café. In later years, he told the story with additional details contrasting the transience of the creative spirit with the permanence of the book:

As he talked, he slowly sketched four beautiful drawings on the marble of the table top. The book was born that evening, but the four Matisse drawings did not survive. As the two men finished their wine, a waiter who did not recognize the artist casually wiped the drawings from the table top with a dirty cloth.[4]

Cocteau stated that Matisse made a total of eleven portraits, an account accepted by Claude Duthuit, who noted that some

were in charcoal, some in ink and brush. Matisse chose one drawing for the numbered sequence of plates and reproductions of three supplementary drawings to accompany the original prints in special copies of *Maria Lani*. His work appears here more than once in recognition of his fame and reputation, which would help to sell this publication. He was the only contributor accorded this privilege, but he may have been the only one to ask for it, for he had already begun to develop a method of making multiple portrait studies that he would perfect in his later publications. Like Lani, his model Annelies Nelck and his friends Henry de Montherlant and Louis Aragon would each inspire a series of portraits in a sequence probing the character of the subject, revealing a range of moods and charting subtle nuances in facial expression.

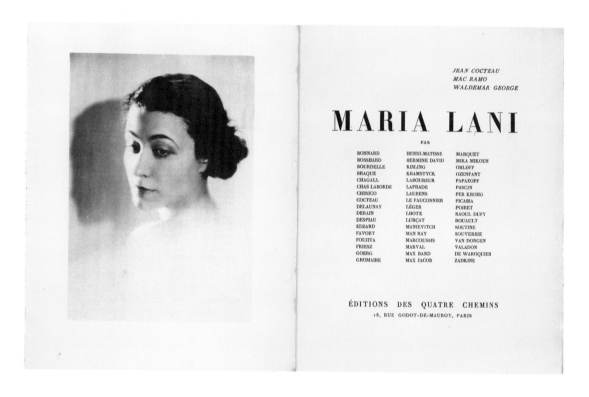

Fig. 1. Title page and frontispiece, *Maria Lani,* Frances and Michael Baylson Collection

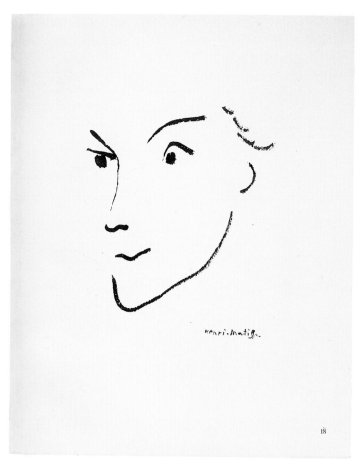

18

Fig. 2. Reproduction of a drawing, *Maria Lani,* Frances and Michael Baylson Collection

~

PAGE SIZE: Carré quarto; 28 × 22.5 cm.

PAGINATION: [4] 20 [4] pp.; the first 2 leaves blank.

ILLUSTRATIONS: Frontispiece reproduction of a photograph of Maria Lani by Boris Lipnitzky, 51 plates with portraits of Maria Lani in various media, the lithographs printed by Chachoin et Desjobert, Paris, the engravings printed by Paul Haasen, Paris, the collotype reproductions printed by Daniel Jacomet et Cie., Paris. The portraits are by Max Band, Pierre Bonnard, Rodolphe Théophile Bosshard, Émile Antoine Bourdelle, Georges Braque, Marc Chagall, Giorgio de Chirico, Jean Cocteau, Hermine David, Robert Delaunay, André Derain, Charles Despiau, Kees van Dongen, Raoul Dufy, Dietz Edzard, André Favory, Léonard Tsugouharu Foujita, Othon Friesz, Édouard Goerg, Marcel Gromaire, Max Jacob, Moïse Kisling, Roman Kramsztyk, Per Krohg, Chas Laborde, Jean Émile Laboureur, Pierre Laprade, Henri Laurens, Henri Le Fauconnier, Fernand Léger, André Lhote, Jean Lurçat, Abraham Manievich, Man Ray, Louis Marcoussis, Albert Marquet, Jacqueline Marval, Henri Matisse, Mika Mikoun, Chana Orloff, Amédée Ozenfant, Georges Papazoff, Jules Pascin, Francis Picabia, Paul Poiret, Georges Rouault, Chaim Soutine, Jean Souverbie, Suzanne Valadon, Henry de Waroquier, and Ossip Zadkine.

TYPOGRAPHY: Printed by the Imprimerie Lahure. 12-point text type and display in the style of Deberny et Peignot Firmin Didot.

PAPER: The copies on Hollande are on a mold-made wove supplied by Van Gelder Zonen, Apeldoorn. The vélin de Rives is a mold-made wove.

BINDING: Printed wrappers and cardboard slipcase.

EDITION: Printed 20 September 1929. Edition of 605 copies: 10 copies on Vieux Japon à la forme with proofs of the plates on Chine and Japon as well as original prints by André Derain, Giorgio de Chirico, Chas Laborde, Édouard Goerg, and Hermine David and reproductions of 3 additional drawings by Henri Matisse; 20 copies on Japon impérial with original prints by Derain, de Chirico, Laborde, Goerg, and David and reproductions of 3 additional drawings by Matisse; 50 copies on Hollande with original prints by Derain, de Chirico, Laborde, Goerg, and David and reproduction of 3 additional drawings by Matisse; 525 copies on vélin de Rives.

COPIES EXAMINED: PML 195629 (no. 80); Doucet C III 1 (4), 3684 (no. 97).

REFERENCES: Carteret 1946, vol. 4, p. 107; Duthuit 1988, no. 45.

13.

Stéphane Mallarmé (1842–1898), *Poésies de Stéphane Mallarmé, eaux-fortes originales de Henri-Matisse.* **Lausanne: Albert Skira & Cie., 1932.**

Matisse referred to the Mallarmé as "my first book" in his 1946 account of his illustration projects. It was his first independent work of art in conjunction with a literary text, a major effort with a scheme of illustrations and a typographic layout conceived as a fully integrated visual experience. Strictly speaking it was not his first illustrated book, for he had already provided drawings to accompany *Les jockeys camouflés,* nor was it his first bookmaking venture, for he had already published *Cinquante dessins* on his own initiative and at his own expense. He participated in the design of *Cinquante dessins,* saw it through the press, and decided how it would be sold. Likewise he checked the proofs and approved the maquette of the 1925 *Dessins,* more of an album than an illustrated book but posing some of the same typographic challenges and problems. With the Mallarmé, however, he embarked on a new phase in his book arts career and started to make luxury illustrated editions that could be considered *livres d'artistes.*[1]

Around the turn of the nineteenth century, publishers like Ambroise Vollard and Daniel-Henry Kahnweiler began to commission illustrations from artists who had already made their reputation in other fields. Pierre Bonnard, André Derain, Raoul Dufy, Aristide Maillol, and Pablo Picasso were among those who produced ambitious *livres d'artistes* printed to the most exacting standards with the highest-quality materials. It is difficult to imagine today how shocking it must have been to present the artwork of the Parisian avant-garde with sumptuous typographical appurtenances customarily reserved for literary classics. Among the first and most influential of these publications is Paul Verlaine's *Parallèlement,* published by Vollard in 1900 with lithographs by Bonnard. The letterpress portion was executed by the venerable Imprimerie Nationale, although it appears to have taken on that job by mistake. Belatedly the government printers learned about the lesbian subject matter of the text and forced Vollard to remove their *République française* device from the wrappers and the title page lest this book should seem to have been sanctioned by the state. Less controversial but still provocative, Picasso's etchings for Ovid's *Metamorphoses* (1931) and Balzac's *Le chef-d'oeuvre inconnu* (1931) are in his classicizing style of the 1930s, a suitable counterpart to the grand, strict, and austere typography of those volumes. Picasso had been working on *livres d'artistes* for years before Matisse attempted anything on that scale. We shall see that Matisse followed his friend and rival's example more than once in regard to book production and design. Unlike Picasso, he had no desire to work with Vollard, who had been a perspicacious art dealer—and had given him his first one-man show—but also confirmed his worst opinions of that profession by treating artists in ways he believed to be underhanded and exploitive.[2]

Matisse was perfectly willing to illustrate books for a fee or for the benefit of a friend such as André Rouveyre or Pierre Reverdy. Some time around 1928, the Dutch printer and publisher Alexandre A. M. Stols asked him to work on an edition of André Gide's *L'immoraliste.* By that time Matisse knew precisely what to charge for his services and quoted Stols the price of 2,400 francs for each of his prints and demanded a 20 percent royalty on the sales of the edition. Inasmuch as he was a friend of Gide, he might have been favorably disposed toward the project, but he approached it purely as a business proposition. He did not expect to take a leading role in the conceptualization and production of *L'immoraliste,* although he would have wanted to choose a format for his illustrations on the basis of Stols's design and would not have permitted them to be printed before he had checked the proofs. In any case, Stols decided that he could not afford to deal with Matisse on those terms, which would drive the total cost of his book up to 60,000 francs. He abandoned the idea and proceeded to publish other books by Gide. In comparison to these figures, the payment promised by the Mallarmé contract would amount to a small fortune, not just a financial inducement but also a pledge of good faith by the publisher Albert Skira. Publishers have always taken risks, but this one seemed especially daring and resolute by making a huge commitment at the beginning of the Depression. Matisse joined forces with Skira instead of Stols because Skira succeeded in capturing his imagination with lavish expenditures on a magnificent book that could become one of his most important artistic achievements.[3]

Skira's invitation to work on a *livre d'artiste* arrived at just the right time for Matisse, who needed a change of scene and a change of pace. At the end of the 1920s, he was becoming increasingly dissatisfied with his painting and sought other outlets for his creative energies while he rethought his outlook and priorities. He may have been responding to critics who believed that he had lost momentum during his Nice period and had begun to repeat himself with his odalisques and other richly colored sensual subjects. In 1929 he turned against color and produced more than a hundred etchings and drypoints with a renewed interest in graphic expression that would carry over to

his intaglio illustrations. Some scholars interpret this abrupt break in his routine as an artistic crisis. If that was the case, it would explain his decision to visit Tahiti in 1930—an act of desperation, perhaps, but also an adventure, an opportunity to refresh the spirit and recharge the imagination. He savored the exotic scenery, praised the peculiar quality of the light, and recorded what he saw with drawings and photographs for future reference. The Mallarmé contract was waiting for him when he returned from his tropical sojourn. Visual reminiscences of Tahiti appear in some of the illustrations and many of the remarques he engraved for the additional suites of prints in the special copies.

Skira came to Paris with grand plans for *livres d'artistes* just when Matisse was most receptive to that idea. Originally named Alberto Schira, he was born in Geneva of Italian parentage and first earned his living as a taxi dancer or an entertainment director in Swiss resort hotels. He changed his name after starting a small bookselling and publishing firm in Lausanne around 1928. Despite his modest background, he set his sights high enough to solicit illustrations from Picasso, who failed to return his calls and sought to discourage him when they finally met face to face. "Young man, I am very expensive," Picasso warned the aspiring publisher and named a price of 20,000 francs a plate. Skira called his bluff and ordered fifteen plates, even though he had no ready cash to pay for them. When it came time to choose a text, Pierre Matisse is said to have recommended Ovid's *Metamorphoses* in view of Picasso's penchant for violent themes and the symbolic potential he might see in transformations of a woman's body. Skira insisted on a contract over the objections of the artist, who claimed that he never needed one in his dealings with Kahnweiler or Vollard. Without the assurance of a contract,

Skira explained, he would not be able to recruit the subscribers who would guarantee the financial viability of the publication. In short, Picasso's reputation would serve as his collateral and allow him to raise the money to keep this enterprise afloat. He would rely on a similar business model to market his edition of Mallarmé as well as other books illustrated by such artists as Salvador Dalí, André Derain, and André Masson. Sometime before June 1931 he announced the forthcoming publication of the Mallarmé with the intention of obtaining subscription commitments in advance. He strengthened his alliances in the modern art milieu by setting up an office in Paris, where he published the periodical *Minotaure* in association with Tériade between 1933 and 1939. Matisse designed his first magazine cover for *Minotaure* in 1936. After the war broke out, Skira retreated to Geneva and founded a short-lived avant-garde journal, *Labyrinthe,* which contained contributions by Sartre and Malraux as well as articles on Matisse and Picasso.[4]

In addition to publishing *livres d'artistes,* Skira launched a line of commercial art books notable for the high quality of their color reproductions. Swiss printers excelled in this kind of work. Formerly employed by Crès, Achille Weber distributed his books in France and invested heavily in his firm as it grew larger during the 1950s and 1960s. Skira published English-language series, such as Great Centuries of Painting, The Taste of Our Time, and Paintings of the French Masters. At some point his multinational operations overstretched his resources, but it is not clear what the financial consequences were except that Weber had to quit or reorganize his business.[5] After he died in 1973, his family ran the firm and then surrendered it to Flammarion, which passed it on to the Swiss newspaper and magazine conglomer-

ate Edipresse. The family bought it back from Edipresse and then sold it in 1996 to the Italian publishers Massimo Vitta Zelman and Giorgio Fantoni, who moved the corporate offices to Milan while retaining the editorial operations in Geneva. Since then the Skira Group, "a supernational imprint," has developed a number of publishing partnerships in Italy, France, England, and America and continues to produce commercial art books in editions as large as 300,000 copies.[6]

Skira never lost interest in luxury limited editions, even though he made his name in a marketplace larger and more reliable than the bibliophile community. After publishing Mallarmé, he produced one other great *livre d'artiste* with Matisse, the Ronsard of 1948. The arduous progress of that book through the press will be recounted in entry No. 38. Chronically short of cash, Skira somehow managed to finance these ambitious books while sometimes shirking his other obligations. He bought an automobile from Pierre Matisse and tried to pay for it with copies of the Mallarmé and the *Metamorphoses.* Fifteen years later, Pierre calculated the balance due at 28,400 francs, interest included, and complained that Skira's business agent would not even acknowledge the debt because "such a document would make it too easy to strangle his client." On the other hand, Matisse counted on Skira to help with the construction costs of the chapel he was designing for the Dominican nuns in Vence. He signed a contract to produce a book about the chapel but then thought better of it and asked Skira to annul their agreement. Dismayed by this turn of events, Skira pleaded with him to reconsider his decision, for a large amount of money was at stake, but finally acquiesced "not without sadness" to this unfortunate situation. After nearly twenty years, their relationship ended more in sorrow than in anger. Nonetheless

Skira deserves some credit for lasting that long with a partner who tested his patience, resilience, and resources to the utmost while preparing two difficult and expensive books for publication.[7]

Their business relationship began with a contract dated 28 April 1930. Matisse was in Tahiti at that time, and in his absence Skira seems to have visualized a book not unlike his edition of the *Metamorphoses:* it too would be in the raisin quarto format; it too would be issued in an edition of 145 copies with 20 copies hors commerce, 95 copies on Arches, 25 on Japon with an extra suite of prints, and 5 specials with original drawings and 2 suites of prints. The text was to be La Fontaine's *Amours de Psyché et de Cupidon,* which also harkens back to classical mythology. Two and a half years after signing the contract, the artist was to deliver 30 etchings as well as the 30 original drawings, which would become part of a maquette containing proofs and preliminary studies. For this he would receive 500,000 francs, half to be paid on the spot, the balance two years later with an additional 40,000 francs for the five drawings in the special copies. He would also have 10 of the hors commerce copies to dispose of as he pleased. Matisse would later learn to insist on retaining the preparatory artwork, but he seemed to have appreciated these generous terms and even submitted his illustrations more or less on time. Most of the provisions of the contract were observed by both parties with one significant exception: Matisse changed his mind about the text and decided to illustrate the *Poésies* of Stéphane Mallarmé instead.[8]

How he came to this decision is not clear. La Fontaine may have seemed quaint and trite in comparison with Mallarmé, whose work had an innovative spirit and an adventuresome quality greatly revered by contemporary writers. Matisse knew it well

POÉSIES
DE
STÉPHANE MALLARMÉ

EAUX-FORTES ORIGINALES
DE
HENRI-MATISSE

LAUSANNE
ALBERT SKIRA & CIE, ÉDITEURS
M. CM. XXXII

Fig. 1. Title page, Mallarmé, *Poésies,* Frances and Michael Baylson Collection

enough to quote it on occasion and even ventured an opinion on how it should be read out loud. In a letter to André Rouveyre, he told the story of a literary banquet he attended in the company of Apollinaire and Marie Laurencin. This was in 1912, when some degree of exuberance was customary in these festive gatherings. One of the guests performed a libation by emptying a goblet of champagne on the middle of the table, and another kicked out a door in a fit of pique after someone ordered him to pipe down and take a seat. An actor in the Comédie-Française consented to recite some Mallarmé during dessert and chose to declaim the last lines of *"L'azur"* at top voice ending in a crescendo: "l'Azur! l'AZUR! l'A Z U R!" Matisse then turned to Apollinaire and queried that interpretation of the poem: surely a measured, severe, and "almost impersonal" reading would be preferable for a text that depended so much on musicality

and cadence. Apollinaire agreed and observed that spoken poetry was nearly always distorted in that way. True to his word, the artist would try to instill kindred virtues of sobriety, deliberation, poise, and harmony in his visual interpretation of the *Poésies.* With this in mind, he sent a critic some reproductions of the etchings along with a note apologizing for their poor condition but noting "the balance and proportion in relation to the page are scrupulously exact, for these two elements are essential."[9]

Mallarmé's *Poésies* also spoke to Matisse's personal and artistic preoccupations at that time. Some passages evoked pleasurable memories of his recent ocean voyage, the source of the bowsprit image in the plate for *"Brise marine"* and the view of the schooner *Papeete* in the plate for *"Les fenêtres."* A plate

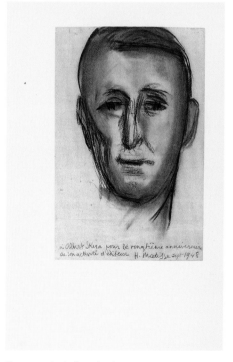

Fig. 2. Portrait of Albert Skira by Matisse in Skira's *Vingt ans d'activité,* Frances and Michael Baylson Collection

derived from the *Plumed Hat* portraits of Antoinette Arnoux references the line "the fairy with a hat of light" in the poem *"Apparition."* Arcadian themes in the painting *Joy of Life* have been detected in the nymph and satyr illustrations for *"L'après-midi d'un faune."* But of all the resonances with his work past and present, nothing mattered more to him than the connection with *The Dance,* the great three-panel wall painting he was making for Albert C. Barnes, now a centerpiece of the reconstituted Barnes Foundation in downtown Philadelphia. The Mallarmé begins with an etching of a leaping figure resembling one of the dancers in the Barnes mural who reappears in some of the remarques. Despite the great differences in scale, Matisse believed that the book illustrations and the wall paintings were closely related in concept and enjoyed working on them in tandem. He had to abandon his first designs for *The Dance* because of a mistake in the measurements but, undeterred, started again with a new composition and reported on his progress to Pierre with a touch of satisfaction. "It's been going very well," he wrote, "and now I realize that I have greatly benefited from the first version and from the Mallarmé illustrations."[10]

The book and mural projects temporarily supplanted easel painting because they posed new and different challenges. Both were decorative in the best sense of the word and performed that function by accommodating other factors—contingencies, such as the size of the room, the height of the wall, the width of the windows, the size of the page, the weight of the text, and the width of the margins. He referred several times to the decorative motifs in Mallarmé as arabesques, perhaps most evident in the flowing hair framing the women's portraits. He may have picked up that expression from a trip to Spain, where he studied the architecture and interior of the Alhambra. In discussions with an art critic, he elaborated on the distinction between an illustrated book and a decorated book, the latter a superior art form in his opinion. He maintained that the mimetic function of illustration could only impoverish a literary text, which should not have to be "completed" by visual images. Decoration, on the other hand, could provide a separate avenue of interpretation through which the artist could complement the work of the author in a harmonious ensemble. Mallarmé would have approved of this approach. "I am against illustration," he declared when considering the idea of juxtaposing photographs with novels, "anything a book evokes ought to be in the mind of the reader." As emphatic as it might seem, that statement should not be taken as an across-the-board rejection of pictorial possibilities but rather as an expression of skepticism about the mimetic style then favored by the commercial book trade. Mallarmé solicited artwork from friends like Manet and Renoir to accompany his writings and did not give up on that idea even in his last months, when he was coaxing Vollard to produce an illustrated edition of his *"Hérodiade."*[11]

Matisse's plans for his Mallarmé edition can be recounted in some detail on the basis of *planches refusées,* preliminary studies, and a maquette in the Cone Collection at the Baltimore Museum of Art. Jay Fisher's prefatory essay uses those materials as a means of retracing his train of thought and reconstructing his procedures for designing the etchings. At the end of this essay, I will suggest some reasons why the artist would have wanted to assemble and preserve an authoritative record of his work. Otherwise I will refer to the Baltimore maquette only as evidence for his typographical decisions.

Before he produced the Baltimore maquette, Matisse sketched out ideas in an earlier one now in the collection of the Pierre and Tana Matisse Foundation. He constructed the earlier maquette by cutting apart a copy of a standard trade edition of Mallarmé and pasting portions of the text on loose leaves of paper held together in a clamp binder he procured at a stationery shop in Paris. The binder could be pried open to insert or remove leaves at will (see pp. 21 and 50). I cannot state exactly which edition of Mallarmé he used, although it is likely that it was one of the many reprints derived from the Nouvelle Revue Française 1913 edition.[12]

He traced on each leaf a rectangle designating the type area, in which he pasted the titles and individual stanzas of the poems. About 24 centimeters tall, the octavo leaves in the binder bear no relation to the size of the raisin quarto leaves in the published book, but they were correctly proportioned for the text cuttings and provided a template Matisse could use to decide on the placement of illustrations. He could designate pages for the full-page plates and identify blank spaces where he might want to insert a head- or tailpiece. He thought carefully about the pacing of the pictorial matter throughout the volume and rejected illustration ideas that would have resulted in awkward groupings of etchings. At one point he intended to produce something to accompany *"L'azur"* but then realized that the plate would be too close to the one he was making for *"Brise marine."* He was tempted by the sonnet *"O si chère de loin,"* but he preferred to make an etching on a previous page for *"Feuillet d'album,"* which caught his attention with the couplet

Votre très naturel et clair
Rire d'enfant qui charme l'air.

He transcribed the couplet on the page he reserved for that etching and reminded himself of the subject he had chosen, not a

literal interpretation but something more conducive to his taste and temperament, *"Rire de femme."* This process of elimination explains why the book contains only twenty-nine etchings instead of thirty as called for by the contract. He originally planned to have thirty etchings, even though it was an arbitrary figure that Skira had suggested when they were still thinking of *Les amours de Psyché et de Cupidon.* Matisse reached that number while he was adding and subtracting the Mallarmé illustrations but then concluded that it would interfere with the layout of the text.

Matisse described how he made some of these design decisions in his essay "How I Made My Books" (reprinted in the appendix). As he saw it, his main challenge was to balance the letterpress with the illustrations. He knew that he was dealing with text pages of a certain weight and density determined by size of the type, the amount of leading, the width of the margins, and the spacing between the stanzas. Skira appears to have chosen the 20-point Garamond italic, a typeface of august lineage (although it should be correctly attributed to the seventeenth-century punchcutter and printer Jean Jannon rather than Claude Garamond, one of the leading type designers of the French Renaissance). Matisse preferred Garamond roman, whereas Skira used the 20-point italic again a few years later in his *livre d'artiste* edition of Virgil's *Bucoliques,* also printed in the raisin quarto format. Facing the Garamond italic would be etchings with large areas of blank space, leaving the page "almost as white as it was before printing." These etchings were composed of a pure and simple line with no shading or attempts at tone, no indication of contour except what was construed in the mind of the viewer. Matisse rendered them in a style consonant with his belief that an artist should study a

Fig. 3. *Les fenêtres,* Mallarmé, *Poésies,* Frances and Michael Baylson Collection

subject and then reduce it to the essentials. They could hold their own in a two-page opening because he made a conscious effort to fill the page with the image, which extends right up to the edge of the paper. He configured the etchings to eliminate the plate mark, usually a desirable trait of intaglio prints, but here it would interfere with the all-over effect he was trying to achieve. By going to the limit in this way, he broke the rules of graphic design and paid the price—in at least one copy, the outer portions of the larger images were trimmed away by a binder who did not understand this unconventional approach—but he did succeed in producing a visually compelling counterpart to the text.[13]

Matisse compared his attempts to balance a darker text and a lighter image with the dexterity of a juggler who could toss black and white balls back and forth so swiftly that they seem to blend together in a pleasing pattern. Like the juggler, he hoped that his two-page openings would make "a harmonious whole in the eyes of the spectator." He designed two openings with a full-page etching on the left next to letterpress on the right ornamented with a red initial and an etched headpiece on the top of the page. This layout signals the beginning of a section. His portraits of Poe and Baudelaire face the verses concerning those poets in the manner of the traditional portrait frontispiece, formerly a standard fixture at the beginning of an author's works. It should be noted, however, that most of his etchings are oriented so they precede rather than face the text. They occupy the recto of a leaf, and the blank verso faces the text to which they refer. Here the image and text do not communicate directly across a two-page opening but are intentionally separated by the artist, who compels the reader to turn the page to learn what meaning, mood, or sensation

might be transferred from one opening to the next. The reader is more likely to look at those etchings as self-sufficient works of art. This distancing stratagem can be seen as an outcome of Matisse's theoretical position on illustration as well as his attempts to set a steady pace for the etchings in alternation with sections of the text.[14]

Skira probably made most of the decisions about the letterpress typography in consultation with his art director Tériade and the printer Léon Pichon. If Skira chose the Garamond italic typeface, he would have wanted to make the most of its calligraphic quality, which the extra large 20-point font would show to the best advantage. The most freely imaginative and extravagant character in that font is the ampersand (*&*), which Pichon's typesetters substituted for the conjunction *et* throughout the text as a way of lending it additional lilt and flair. Like many old style fonts, Garamond italic includes a number of ligatured letters such as *fl, fi,* and *ffi,* special sorts designed to ensure optimum spacing between characters. The typesetters would have known to use them as a matter of course, but they overlooked an additional *&* ligature in this font, which could also be a desirable calligraphic accessory. While reviewing the proofs, Pichon or one of his assistants noticed that those ligatures were missing and instructed the compositors to insert them. The Baltimore maquette contains proofs in an early state before those revisions had been made. Matisse and his typographical advisors also used it to judge the effect of the red initials. By pasting them in position, they could visualize the layout of the page and assess what it might gain in visual appeal without tipping the balance between image and text. Matisse learned from this exercise to calibrate the color value of initials, a matter of grave importance to him when he was

designing the aggressively black-and-red openings of *Pasiphaé* (No. 21).

Léon Pichon may not have contributed much to those discussions. A perfectionist and something of a snob, he ran one of the most prestigious printing firms in France during the heyday of demiluxe illustrated books in the 1920s. He followed his father in the trade and set up shop on his own around 1917. He issued some books under his own imprint and accepted commissions from the amateur bibliophile publishing societies that were flourishing in this period. Two of these organizations regularly called on his services, Les Exemplaires and La Compagnie Typographique, both committed to the highest standards of letterpress printing. He worked closely with artists such as Carlègle and Hermann-Paul, always insisting that their engravings and woodcuts should meld with the text in a tightly regulated and completely consistent typographic scheme. Not shy about expressing his opinions, he wrote disapprovingly of Art Nouveau designers who "evinced the greatest contempt for the order and architectural sense which are indispensable to good typography." Fauves, Cubists, and Simultanéistes were even worse as far as he was concerned, although he admitted the possibility that their "rash modernism" might be favorably received over the passage of time. What he thought of Picasso and Matisse is not recorded, but he collaborated with them at the instigation of Skira, who sought him out precisely because he was a printer in the grand tradition. Ovid's *Metamorphoses* and Mallarmé's *Poésies* were the only full-fledged *livres d'artistes* printed by Pichon. Like other demiluxe publishers, he lost most of his business during the Depression, and he retired in the midst of labor troubles caused by the General Strike of 1936.[15]

Pichon's pressmen worked off the last sheets sometime around 25 October 1932, the

date of the official *achevé d'imprimer*. While staying in Nice, Matisse enlisted his daughter, Marguerite Duthuit, to supervise the printing of the intaglio illustrations in the Paris workshop of Roger Lacourière, who had not yet finished as of 8 November. Lacourière failed to meet a deadline in December, when a Mallarmé exhibition opened in the New York gallery of Marie Harriman. Wife of the diplomat Averell Harriman, Marie Harriman ran this gallery between 1930 and 1942, specializing mainly in French paintings but also doing book business with Skira. She organized a similar exhibition of the *Metamorphoses* in 1931 and acquired the rights to distribute it in America. She helped to finance the Mallarmé on similar terms, which were duly acknowledged in the colophon. Her exhibition catalogue advertises a book of thirty etchings but lists only twenty of them because she had not yet received the finished product or even the full complement of etchings. But she knew what the special copies would contain and what prices she should ask in dollars comparable to the cost in francs. Few Americans could afford to buy such an expensive book at that time, perhaps one reason why Harriman did not participate in the publication of other *livres d'artistes*.[16]

The publication of the Mallarmé inspired mixed emotions in Matisse. He came to regret the etching he did for *"L'après-midi d'un faune"* and thought that his illustration for *"Le cygne"* was a better example of his work. He received a copy of the book on 2 December and unwrapped it anxiously—here was the result of so much thought and labor—but he was appalled at the quality of the prints. In a letter to Lacourière, he described his feelings of shock and dismay at seeing them for the first time. He did not expect perfection—his daughter had warned him that they might not be satisfactory. Even so, they

Fig. 4. List of illustrations, maquette for Mallarmé, *Poésies,* The Pierre and Tana Matisse Foundation, New York

seemed dull and listless in comparison to the proofs, far inferior in rendering the robust character of the line he believed to be an essential ingredient of his illustration scheme. "In a word," he concluded, "they look to me like cadavers." The best he could do at that point was to think how he could salvage the situation:

I don't know what will be the fate of the edition, but I try not to be so dejected thinking that if the book reflects badly on me there will be some bons à tirer in America and France, and I will be vindicated by my maquette, which I hope will be accepted by the Bibliothèque nationale.[17]

As it turned out, his fears were unfounded, but this episode reveals how important it was for him to prepare and preserve a definitive record of his work. The contract compelled him to give Skira the final maquette, the proofs, the preliminary studies, and "everything else involved in the production of the book." While it was in press, he bought back these materials as well as thirty *planches refusées* and thirty-four canceled copperplates. In addition, he purchased copy number 1, the first of the five specials on premium paper with a preparatory drawing and several suites of prints. Altogether this comprehensive

archive of the Mallarmé designs cost him 150,000 francs. No doubt he would have been pleased to see it in the Bibliothèque nationale, but he eventually sold it to the Baltimore collector Etta Cone, who put it on deposit in the Baltimore Museum of Art, where it is today. Not long after it arrived, the curator of prints Adelyn Breeskin wrote a perceptive account of the Mallarmé illustrations, tracing the genesis of *Le cygne* as a prime example. The museum has sponsored other scholarly studies of Matisse's book illustration methods, the sort of analysis he hoped to encourage by forming this collection.[18]

All in all, Matisse could be content with the critical reception of this book. After the exhibition in the Marie Harriman Gallery, the Baltimore maquette and other preparatory materials were displayed in Paris at the Galerie Pierre Colle in February 1933. While waiting for that exhibition to open, Marguerite reported to Etta Cone that her father's book had already created a stir in literary circles: "Some writers have gone so far as to call it the one great illustrated book of our time." A reviewer declared that it was a "hallucinatory success" testifying to the genius of the poet. A year later, Paul Valéry admired it when he paid a call on Matisse, and André Gide looked at it not once but twice during various visits to the studio. Lacourière borrowed some of the proofs to display in the Paris Exposition of 1937. When he failed to return them, Matisse tried to track them down, for he had become "very attached to them."[19]

Any doubts Matisse might have had about the Mallarmé illustrations were dissipated by 1946 when he wrote his essay "How I Made My Books." They inspired another influential statement about his illustration theories that is often cited but is usually misinterpreted because of a confusion as to its source and date. In 1931 Tériade interviewed him about a retrospective exhibition and also asked him about the Mallarmé edition, which had been announced by the publisher but was still in an early stage of planning and production. Matisse responded with some observations on how an artist should interpret a literary text:

Poetry, when it represents a good poet, has no need of the declamatory art of a good reciter, or even the extraordinary qualities of a good composer, or the plastic virtues of a good painter. But it is agreeable to see a good poet inspire the imagination of another artist. This latter could create an equivalent. Then, so

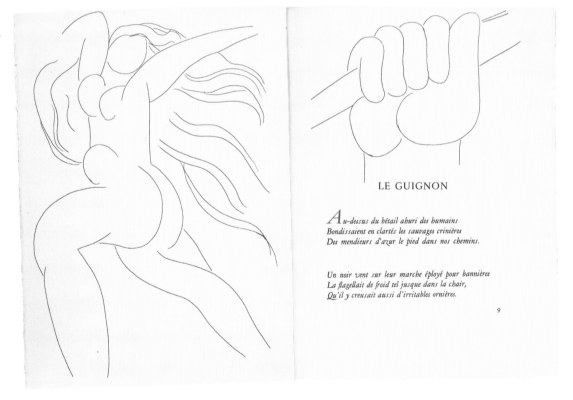

Fig. 5. *Le guignon* and headpiece, Mallarmé, *Poésies,* Frances and Michael Baylson Collection

LE GUIGNON

*Au-dessus du bétail ahuri des humains
Bondissaient en clartés les sauvages crinières
Des mendieurs d'azur le pied dans nos chemins.*

*Un noir vent sur leur marche éployé pour bannières
La flagellait de froid tel jusque dans la chair,
Qu'il y creusait aussi d'irritables ornières.*

9

that the artist can really give himself to it entirely, he must be very careful to guard against following the text word for word; but, to the contrary, he must work with his own sensibility enriched by his contact with the poet he is illustrating.

I would love to be able to say simply, after having illustrated the poems of Mallarmé: "This is what I have done after having read Mallarmé with pleasure."[20]

That last remark about reading Mallarmé "with pleasure" has come to epitomize his interpretative approach and figures prominently in scholarly accounts of this book. Speaking to Tériade in 1931, he meant it to be understood as a compliment to the author and a modest expression of his goals for a work in progress. Adelyn Breeskin quoted it in her 1935 article "Swans by Matisse," with the text translated in such a way that it is hard to tell whether he was looking back in satisfaction or looking forward to a job well done. She did not cite a source for the quotation, which led unwary readers to assume that she was reporting a recent conversation with the artist. Alfred Barr quoted her translation in his monograph on Matisse to show that the artist was proud of the book he had completed, "one of his happiest works in any medium." Dominique Fourcade translated Breeskin's text back into French when she compiled her anthology of Matisse's writings. Although she knew about other Tériade interviews, she did not realize that she could have transcribed an earlier and more accurate version of that text. Two authors of essays in an exhibition catalogue relied on the Fourcade version to compare the semantics of Mallarmé and Matisse, both drawing apt analogies, although one author believed that the artist had adopted those ideas after finishing the book. The correct sequence of events can be seen in Jack Flam's anthology, *Matisse on Art*, which contains a translation of the original interview as well as an account of its circumstances and a useful commentary. Nonetheless, Barr and other critics were right to say that Matisse enjoyed his work on the Mallarmé edition and saw it as the starting point of a new phase in his artistic career.[21]

PAGE SIZE: Raisin quarto; 33.2 × 25 cm.
PAGINATION: [4] 1–92 [2] 93–153 [15] pp.; the first 2 leaves and the last 3 leaves blank.
ILLUSTRATIONS: 29 etchings printed by Roger Lacourière, Paris.
TYPOGRAPHY: Printed by Léon Pichon, Paris. Text in 20-point Deberny et Peignot Garamond italic.
PAPER: The colophon states that the handmade wove Arches was produced specially for this edition.
BINDING: Cream wrappers printed on Japon, contained in a tan slipcase and a chemise composed of cardboard sides and a beige leather back with lettering stamped in brown.
EDITION: Printed 25 October 1932. Edition of 145 copies numbered and signed by the artist: 5 copies on Japon de la Manufacture impériale containing a suite of prints on Japon with remarques in black, a suite on Chine with remarques in black, and an original drawing by Matisse, numbered 1 to 5, priced at 28,000 francs or $1,200; 25 copies containing a suite on Japon with remarques in black, numbered 6 to 30, priced at 16,000 francs or $700; 95 copies on Arches, numbered 31 to 125, priced at 10,000 francs or $400; 20 copies hors commerce reserved for the artist and participants in the publication, numbered I to XX.
COPIES EXAMINED: PML 195592 (no. 41); PML 77200 (no. 96); Baltimore Museum of Art 1950.12.691 (no. 1); Ursus Rare Books (no. 3).
REFERENCES: Skira 1946, no. 256; Skira 1948, p. 66; Barr 1951, pp. 244–46; Strachan 1969, p. 338; Chapon 1973, pp. 369–70; Guillaud 1987, pp. 517–56; Duthuit 1988, no. 5; Monod 1992, no. 7679.
EXHIBITIONS: Philadelphia 1948, no. 262; Geneva 1959, no. 6; Boston 1961, no. 196; Paris 1970, nos. 195 and 196; Baltimore 1971, nos. 48–51; New York 1978, pp. 140 and 217; Saint Petersburg 1980, no. 1; Fribourg 1982, no. 1; Nice 1986, no. 1; Le Cateau-Cambrésis 1992, no. 2; New York 1994, pp. 92–93 and 241; Florence and Le Cateau-Cambrésis 1996, pp. 91–95; Vulaines-sur-Seine 2002, no. 1; Baltimore 2009, pp. 21–23; New York 2011, no. 16.

14.

James Joyce (1882–1941), *Ulysses, by James Joyce, with an Introduction by Stuart Gilbert and Illustrations by Henri Matisse.* New York: Limited Editions Club, 1935.

The Limited Editions Club *Ulysses* was an artistic disappointment, a lost opportunity all the more regrettable because it combined two of the greatest names in the modernist movement. The publisher George Macy can be blamed for most of the problems with this book, but he deserves some credit for his business prowess, negotiating skills, and marketing strategy. He succeeded in recruiting Matisse and Joyce when both were riding a crest of publicity in America. Matisse appeared on the cover of *Time* magazine in 1930, the Museum of Modern Art mounted a retrospective exhibition of his work in 1931, and he was the subject of a 480-page monograph issued in 1933. Joyce created a cultural sensation in 1933, when *Ulysses* was declared not obscene in a landmark case that affirmed its literary merit in a learned opinion now considered a classic of legal literature. No publisher could ask for a better alliance of artist and author, both renowned and respected but also sufficiently controversial to pique the curiosity of potential customers.[1]

Macy quickly obtained the right to produce a luxury edition, relying on his close connections with Bennett Cerf of Random House, who issued the first American edition in January 1934. Often associated with Cerf in publishing projects, Macy had written a testimonial to be used in defense of *Ulysses* and had even advised on the choice of a suitable text for setting the Random House edition. In February he wrote to Joyce asking for his permission, promising him a fee, and noting that this

venture had been authorized by Random House. He also expressed a desire to print a "corrected text" with an introduction by the author. Although tempted by his proposals, Joyce did not contribute directly, and Macy had to settle for an introduction by Stuart Gilbert, an expert interpreter of *Ulysses,* who did in fact help to correct the text. The contract stipulated that the author would receive a payment of $500 plus $2 for every copy he agreed to sign. His failing eyesight prevented him from signing every copy of the edition, and he eventually decided that he would set the limit at 250 copies, each of which was then priced at a $5 premium for members of the Limited Editions Club. To this day antiquarian booksellers claim that Joyce refused to sign all the copies of the book because he was angry about the illustrations, but that is just one of the myths and misunderstandings concerning the publication of *Ulysses.*[2]

The operating principles of the Limited Editions Club require some explanation here. Macy founded the club in 1929 as a subscription publishing scheme similar to other book clubs of the era, most obviously the Book-of-the-Month Club, although his offerings were not intended for the general public but for collectors interested in the arts of the book. Starting with the private presses of the 1890s, the revival of fine printing was still going strong despite the Depression and the failure of several eminent concerns at the upper end of the market. The Limited Editions Club survived the Depression by counting on its subscribers for a reliable revenue stream and a steady demand for its products, the writings of classic and recently fashionable authors packaged with an eye toward quality in design and execution.

Members of the club received a book in the mail once a month for a payment of $10 upon delivery or an annual subscription of

$108 in advance. Macy commissioned illustrations from prominent artists such as Eric Gill, Frans Masereel, Arthur Rackham, and Edward Steichen. He engaged distinguished typographers to see these volumes through the press at printing firms well known to the bibliophile community, including the Merrymount Press of Daniel Berkeley Updike and the Oxford University Press, under the direction of John Johnson. Members could expect a wide variety of texts, bindings, illustrations, and typography at a predictable price, well within the means of middle-class Americans. Macy contained the cost of his books by relying on mass-production letterpress printing techniques, hot-metal composing machines to set the texts, and power presses to produce editions at the regulation size of fifteen hundred copies. Only a few of his publications were set by hand, and only a few were printed on a hand press. Contemporary critics pointed out that these editions were too large to be truly limited, but he contrived a semblance of exclusivity and prestige by having every copy signed by one or more people associated with the book, usually the author or illustrator. This publishing formula proved sufficiently profitable that he could afford the fees commanded by art world celebrities such as Picasso and Matisse.

Picasso agreed to furnish six etchings and a number of drawings in text for Aristophanes' *Lysistrata,* published in 1934. Macy promised to pay 10,000 francs upon the delivery of each plate, a sizable sum, but he also had the right to reprint the book and to publish a separate portfolio of the plates for print collectors. He complained—or rather boasted—about the "stiff price" he had to pay Picasso, who refused to hand over the plates unless he was paid in person and in cash. This anecdote may not be accurate in its particulars—the club's

advertising copy is full of half truths and exaggerations—but it is true that the artist and his client had quarreled over money matters and did not part on good terms. Despite these aggravations, the tightfisted American praised *Lysistrata* as one of his most successful publications, and its critical reception vindicated his opinion. He looked to *Lysistrata* as a typographical model for *Ulysses* and treated Matisse like a temperamental artist no more reliable than Picasso.[3]

At first Macy failed to interest Matisse in an illustration project. He presented his original proposals through his Paris agent, Albert Lévy, in the summer of 1933 and in December asked Lévy to arrange a meeting with Matisse. He offered the artist a choice of texts—not just *Ulysses* but also *Manon Lescaut, Madame Bovary, Mademoiselle de Maupin, Carmen,* and the *Aeneid.* Except for the first and last, these titles were all acknowledged classics of French literature, some slightly daring and one, *Madame Bovary,* arraigned on charges of obscenity not unlike those leveled against *Ulysses.* He solicited ten or twelve lithographs to accompany one of these texts as well as a suite of the prints to be sold separately. These terms did not appeal to Matisse, mainly because he feared that the print portfolio would glut the market. He expressed his regrets by way of Lévy and his daughter, Marguerite Duthuit (who was taking care of his Paris business affairs while he was living in Nice).[4]

Undeterred, Macy sought the assistance of another member of the family, Pierre Matisse, proprietor of an art gallery in New York. Admitting that his initial overtures had failed, the publisher offered the art dealer a commission of $500 if he could convince his father to take on the job. Pierre wrote to his father a long account of the club's publishing program and assured him that the director was an astute businessman,

that the subscribers were worth cultivating, and that the work could be highly profitable. Picasso, he noted, had already signed a contract with the club and had agreed to provide preliminary designs in addition to his plates. Ordinarily the club paid illustrators the equivalent of 25,000 francs, but, realizing that he would have to do better, Macy proposed the sum of 60,000 francs for six lithographs plus a portfolio of the prints signed by the artist. Pierre correctly stated that Macy would be paying handsomely for Matisse's services—approximately $3,900 at that time, a sizable amount in comparison to his usual illustration expenditures, which ranged from $500 to $1,500 a volume. To put this price in context, just a month later Pierre would sell his father's painting *Odalisque with Magnolia* to the movie star Miriam Hopkins for the equivalent of 55,000 francs. Macy was so overcome by his own munificence that he would later tell the art historian Alfred Barr that he had offered $5,000. As to a suitable text, Pierre urged his father to consider the attractions of *Ulysses,* a serious work of literature formerly banned in the United States because some passages had been thought to be pornographic. He predicted that the American editions would now sell in the hundreds of thousands. "All the literary types, the snobs, the people who are worth knowing, and those who aren't, will buy it. I thought that if the text does not put you off, it would be a perfect prospect for illustrations."[5]

Pierre's letters and Macy's repeated pleadings finally convinced Matisse to take on *Ulysses.* On 1 May 1934, he signed a contract similar to the *Lysistrata* agreement in that he could expect a payment of 10,000 francs upon the delivery of each of the lithographs and that he agreed to provide an unspecified number of drawings to be reproduced in text either as wood engravings or photomechani-

cal illustrations. He allowed Macy to publish a separate portfolio of the lithographic prints, issued in 150 copies, which he would sign as he would the 1,500 copies in the book edition. In turn he could expect the stones to be canceled after they were printed and the extra drawings to be returned to him after they were copied. The page size was specified for his guidance, and Lévy was authorized to be the project manager in Paris. He could charge the publisher for the cost and transport of the stones while he was working on the illustrations, which were to be completed by the end of the year. Matisse ordered the stones while the contract was being negotiated and was ready to begin even before he signed the final version.[6]

First, however, he needed advice on how to choose illustration subjects for this large and complex book. While waiting to sign the contract, he asked for assistance by way of his friend Simon Bussy, whose English wife Dorothy was an expert in contemporary literature, perhaps best known as the translator of André Gide. She was well acquainted with *Ulysses*—"a universe in itself," from which, she said, the painter could pick any number of subjects according to his taste, although she warned him that it was hard to read, even in French. Nevertheless, Macy arranged with Stuart Gilbert to send him a copy of the French translation and proudly announced that he had been able to master the concept of the book overnight, "an understanding which comes to few men indeed!" Macy only half believed what he had written. In fact, Dorothy Bussy reported that Matisse was in a "complete fog" about the contents of the book and that she needed to coach him in its intricacies by lending him a copy of Gilbert's commentary volume, *James Joyce's "Ulysses:" A Study* (1930).[7]

Matisse later admitted that he had never read *Ulysses,* but art historians and literary

critics have failed to credit him for his diligent attempts to learn about its structure, imagery, and symbolism. Relying on Dorothy Bussy's advice and referring to Stuart Gilbert's book, he realized that Joyce had created a parallel narrative, ostensibly relating incidents in the lives of Dublin residents during a single day in 1904 but also subtly linking those quotidian events with the heroic deeds of Odysseus during his voyage home from Troy. He knew that Joyce had drawn up a schematic chart explaining the connections between chapters in the novel and the corresponding Homeric episodes and that a copy was or had been in the hands of the French translators, "Larbaud et Cie." Joyce gave him permission to see it. Either by consulting the chart or a synopsis in Gilbert's book, he developed a plan for his illustrations whereby he would select six subjects from the *Odyssey* and only occasionally allude to the action of the novel. He expected the reader to understand the Homeric parallels, which were succinctly explained in Gilbert's introduction to Macy's edition. "I think that I can deal with this book," he mused in a letter to his daughter, "by relying on the *Odyssey* for designs on the subjects of Calypso, the Sirens, Cyclops, Nausicaa, Circe, and Penelope without regard to Joyce's particular ideas, which cannot be represented in visual terms." He later changed his mind about two chapters and decided to illustrate Aeolus instead of the Sirens and Ithaca instead of Penelope, but he became increasingly confident about his approach while working on the project. He began in March 1934 and finished in early or middle November.[8]

Some Joycean ingredients can be detected in his designs. His Nausicaa drawings indicate some acquaintance with the voyeuristic seaside encounter of Leopold Bloom with Gerty MacDowell.

He knew that the Circe chapter took place in a Dublin brothel, *"scène de maison publique."* An evening out on the town provided a suitable idea for that setting. While he was in Paris, he attended a music hall performance at the Concert Mayol, which had just begun to present nude showgirl spectacles on the model of the Folies Bergère. One act featured a woman acrobat who descended a staircase on her hands, an image clearly rendered in one of his preliminary drawings and still perceptible as the central figure in the Circe composition. One can easily follow his train of thought from the *Ulysses* text to the finished product—but this is an exception. The Homeric subtext dominates the design of the other plates.[9]

Matisse was reassured to learn that the author completely approved of his reticent interpretation. At first Joyce assumed that he would portray the characters in the novel and tried to help him with local color by seeking out magazines that might have pictures of Dublin circa 1904. Macy was also expecting him to take that approach and asked Lévy to arrange a meeting so that "Joyce might be able to give Matisse some ideas." An attempt was made to arrange a rendezvous in Paris, but they were able to confer only by telephone. With some trepidation Joyce awaited the call on the 13th of August ("O Lord, the one day I feel so shivery-shaky!"), but their conversation appears to have been cordial and productive. No doubt he was relieved to hear that Matisse would not try to depict the scenery and characters he had invented but would help to develop the epic theme of the novel by presenting graphic analogies between Homer and Joyce in six of the chapters.[10]

In addition, they discussed the project through intermediaries, Eugene Jolas and Paul Léon, both confidants of Joyce, both residing in Paris at that time. Jolas viewed

the work in progress, listened to an explication by the artist, and spoke favorably about the scheme to Joyce. He was one of the first to see the completed illustrations. Léon tended the author's business affairs in Paris and took a special interest in this project, having learned about Matisse's work in Moscow and having seen a recently published monograph about the artist. He greatly pleased Matisse by noting similarities in the *Ulysses* designs with the mural made for Albert Barnes, a challenging commission completed the previous year and still very much in mind. Léon agreed that the designs should not contain any "anecdotal allusions" to the novel. His knowledge and enthusiasm encouraged the artist to show him a mock-up of the book, which was revealed only after he showed himself not to be an "ignoramus." He inspected drawings as well as proofs of the plates. Fully convinced by these preliminary plans, Léon promised to commend them in his communications with Joyce, who then authorized him to deal with Macy on that matter. He made it clear to Macy that his client "is in agreement with Mr Matisse and has full confidence in his plan with the illustration and design of the book. Mr Matisse seemed eager on having me write this to you. I am glad that thus the thing is settled from the artistic point of view." Léon loyally supported the project even after it was done. When books were in hand, Joyce expressed a desire for more copies—sufficient evidence, Léon told Macy, that the Matisse *Ulysses* had found favor in the author's eyes.[11]

In the course of these discussions, Matisse sometimes touched on his theories of illustration. Although he disliked interference with his work, he adopted a surprisingly deferential stance that might have appealed to a modernist writer. In letters to Simon Bussy, he used musical

metaphors to explain how he expected to support the symbolic structure of *Ulysses*. He believed that his designs should play a bass part in accord with themes introduced by Joyce. Or, to put it in another way, the illustrator should take on the role of second violin in a string quartet, a subordinate member of the group, except that the second violin should reply to the first violin and that he intended to "accompany the author on a parallel track but in a somewhat decorative manner."[12]

With these thoughts in mind, he started to work on the lithographs, obviously enjoying the change of pace from his previous illustration project, the *Poésies de Stéphane Mallarmé* (No. 13). The Mallarmé edition contained twenty-nine etchings, a medium Matisse declared to be no longer suitable for his purposes: "I need to conceive form in other terms than the arabesque." He sought to achieve a richer effect with lithography, which would allow him to set values working from black to white instead of white to black. He was plainly dissatisfied with line drawings as well as with the paintings he had been making "with my usual colors." Although he knew that he could surmount these difficulties, he felt that his health was not at its best and that his strength had been sapped by the mural he had been making for Barnes. Pierre realized that his father had been revitalized by the *Ulysses* commission but argued against lithographs, which he believed too laborious and too likely to turn out "rather limp." The Mallarmé illustrations had not exhausted the potential of line etching, another reason his father should reconsider his choice of technique. He almost sent a cable to express his views with greater urgency and to make his case before it was too late. Instead he proposed to consult with Picasso and write back with a report. Matisse took note of his son's objections but wanted to try his hand at a stone before deciding. He had already

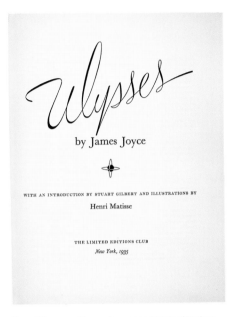

Fig. 1. Title page, *Ulysses,* Frances and Michael Baylson Collection

made some preliminary studies with that process in mind. Furthermore, he had been waiting for Macy to send him a contract, which he intended to amend with a clause reimbursing him for the transport of stones between his printer in Paris and his studio in Nice. Meanwhile he remained in Paris, hoping "to inure my hand and spirit to the stone" and trying to perfect his work in a medium "where mistakes are nearly impossible to correct."[13]

His lithographic sojourn in Paris ended badly, just as his son had predicted. If he conceded defeat to his son, that letter has not survived, but he told Simon Bussy about his misadventures in the Atelier Duchâtel, where he had been working on three stones. One he dismissed out of hand, one he had not yet seen, and one produced proofs so dark that he went back and reworked it with acid and a burin to bring out the highlights and insert contour lines in white. He blamed the "idiot lithographer" for allowing him to

work with unpredictable materials and for wasting his time. The six weeks he had spent in Paris were so frustrating that they seemed like six months in comparison to his regular routine. Despite this setback, he succeeded in retaining some density and tone in his designs for *Ulysses* by rendering them as soft-ground etchings, an intaglio equivalent to lithographs. He was glad to have moved on to a different method after the Mallarmé and deemed the results to be "very rich and enticing." Apparently he never consulted the publisher about this change of plan, which would later become an excuse for breaking a contract already violated by the other party. Making the best of a bad lot, Macy's publicity noted that the etchings were "highly reminiscent of the texture of a lithograph." Two of the rejected lithographs were included among the preliminary studies

Fig. 2. Matisse at the Atelier Duchâtel working on *Ulysses,* photograph possibly by Pierre Matisse, July 1934, The Morgan Library & Museum

reproduced in the book, one in the Nausicaa chapter, the other in the Calypso chapter, the latter printed from the stone that had to be repaired with acid and a burin.[14]

In June Macy asked to have copies of preliminary drawings, ostensibly to use in his publicity materials but perhaps also to keep tabs on the artwork he was buying at such great expense. As an additional inducement, he announced that *Lysistrata* had been a "big success" and that the suite of Picasso's prints was completely sold out. He assumed that he would be getting line art easily reproducible in advertisements. Matisse sent designs for the Nausicaa and Calypso chapters and finished the plates based on them, in return for which he expected a first installment of his payment. Macy professed to be pleased by the plates, but he was "worried" at finding no perceptible connection with *Ulysses* and was disappointed by the tonal drawings, which would have to be reproduced by offset or collotype. He neglected to send money, much to the irritation of the artist, who finally refused to continue until the publisher honored the terms of his contract. Macy was known to drive a hard bargain and on this occasion lived up to his reputation. He hesitated to loosen the purse strings because he had serious reservations about the plan of illustrating the Homeric parallels, even though it had been approved by the author. He agreed to it in principle but insisted that there had to be some direct relationship with Joyce's text. In rejoinder, Matisse pointed out that the two women brawling in the Calypso plate symbolized discord and named Joyce's characters Gerty MacDowell as Nausicaa and Leopold Bloom as Odysseus. (The two attendants in the Nausicaa design correspond to Gerty's girlfriends in the novel.) Only to that extent did he meet the demands of the publisher, who thought that these illustrations might

antagonize subscribers already affronted by a difficult and controversial text. If Macy expected these plates to be of some assistance in comprehending Joyce, he would be sorely disappointed.[15]

Finally Macy lost confidence in Matisse and hired another artist to illustrate *Ulysses*. The last-minute substitute was Lewis C. Daniel, an up-and-coming printmaker and painter who had just been awarded a fellowship at the MacDowell Colony. He had some experience with book illustration and would go on to take other commissions, most notably Whitman's *Leaves of Grass* (1940). More malleable than Matisse, he studied *Ulysses* carefully, chose a key incident in every chapter, and prepared representational drawings intended to delineate character and explain the action of the novel. Some were so explicit that they were seized by prudish customs agents after they had been mailed abroad for the inspection of Stuart Gilbert. Daniel devoted his "fullest efforts" to this three-month rush job but failed to satisfy Macy and Gilbert, even though he had consulted Gilbert's commentary. The arch-interpreter of *Ulysses* rose to its defense against Daniel's drawings, which reduced it to "a satire or a caricature" contrary to its true "outlook [which] is *humane* in every sense of the word." In his opinion, Daniel should have adopted a different style for every chapter instead of portraying the characters with "misshapen faces" in a lockstep sequence of pictures that were too uniform, too topical, "too much in the Grosz manner"—in short, the opposite of the approach approved by Joyce and his advisors. Like it or not, Macy had to persevere with his original plans and try to justify them to his subscribers. "If you do not like modern art," he warned them, "you will not like these illustrations."[16]

In this regard the twenty preliminary studies can be seen as a palliative to the subscribers. It is not clear when or how the

decision was made to insert reproductions of studies before each of the plates, nor does there seem to have been any discussion as to the purpose they should serve. There was some debate during October about printing them in sanguine, an idea stoutly resisted by the artist, who prescribed that they should not be reduced and should not appear on facing pages. Macy or a member of his production staff forgot about the dense gray-level gradations in the drawings and drew up RFP specifications calling for twenty full-page line illustrations with blank versos. When the printer asked for the zinc blocks, Macy realized that he would have to print them by a tonal process and bind them in as plates, as with the six etchings. He asked for a quote from the Duenewald Printing Corporation, which initially offered to print some by offset and some by gravure, each with its advantages and disadvantages. "Gravure hasn't the detail and tone value," Duenewald opined, "but it has far more contrast and punch. Such awful art work as Matisse and Picasso draw requires *something!*" Eventually the decision was made to print them by gravure on blue and yellow paper and to present them as preparatory designs that would help the explain the imagery in the etchings. By January 1935 both parties were counting on them to compensate for a project that had gone awry. Increasingly frustrated by payment problems, Matisse was ready to ask an American lawyer when he would be able to repossess the original artwork for an exhibition in London. Meanwhile Macy decided that he did not like the plates at all, that his subscribers would not detect in them "any relation to James Joyce's book," and that he would have to rely on the studies in hopes that they might be "more attractive."[17]

One critic shared Macy's point of view. She preferred the preliminary studies to the

finished etchings as being more representa-
tional and more conducive to interpreta-
tion, better for her purposes because they
show the progression of ideas. Indeed they
make it possible to view the process of
abstraction and reconceptualization that
had become vital to Matisse at that time.
After finishing *Ulysses,* he commissioned
photographs of paintings in various stages
of development and allowed the photo-
graphs to be displayed in public. He did not
hesitate to reveal his methods of reinven-
tion either in this book or in his later work.
"I can't simply copy myself," he remarked
while pondering how to make the transition
from the preliminary drawings to the
finished etchings. Nevertheless that critic
and her publisher were so dismissive of
these abstract compositions that they
reproduced one of them upside down.[18]

Every party concerned had a reason to
be dissatisfied with this book. Matisse
eventually disavowed it because he objected
to the way it had been designed and
printed. At first he believed that he would
be making typographical decisions in
consultation with the publisher and hoped
that the book could be printed in Paris. He
knew that he would have to balance the
weight of his illustrations with the text type
of the book, an important first step in the
planning process. While proofing his
etchings at Roger Lacourière's shop, he
started to construct a maquette, a mock-up
of the book comprising a specimen of the
text along with plates and a photograph of
drawings. For the text type, he and Lacour-
ière chose a 14-point Didot from the
Deberny et Peignot foundry, no doubt
generously leaded in the French style. He
showed the maquette to Léon, who seemed
to like it and asked Lévy to send it to New
York. Matisse also tried to gauge Macy's
typographical taste by looking at *Lysistrata*.
The quality of paper in that book would be

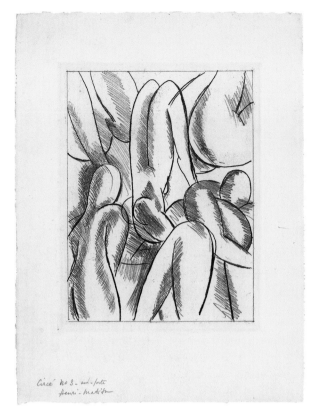

Fig. 3. A preliminary study for the etching in the Circe chapter, The Pierre
and Tana Matisse Foundation, New York

suitable for *Ulysses,* he believed, and he also
liked the type, a large Linotype Caslon. If
Macy could send him a specimen of that
type along with paper samples, he would be
able to use those materials to produce a
maquette, perhaps intended to supersede
the layout he made in collaboration with
Lacourière. In letters to Marguerite and
Pierre, he reported on his typographical
experiments. Both letters noted that Joyce
had instructed Macy to give him a free
hand in matters of layout and design.[19]

Macy rejected the artist's ideas and
instructed him to confine his contributions
to the job for which he had been hired.
"While we want to make a book which will
please him, he is certainly not to consider
himself the designer of the text." The

maquette was totally unacceptable because
he had ignored the hard realities of casting
off copy, considerations that should have
influenced his specifications of type size
and page dimensions. (These calculations
were mandated by the length of the book,
amounting to approximately 265,000
words.) If Macy took the maquette as his
model, his edition would have to be printed
in several volumes. Instead he proposed to
use an American type stylistically similar to
Didot and suggested that Lacourière
compose a sample page with it to see how it
would stand up to the illustrations. The
alternative turned out to be 11-point
Linotype Scotch Roman, a modern face
like Didot, albeit less elegant and more
economical. Also in the spirit of compro-

Fig. 4. Preliminary studies for the etching in the Calypso chapter, *Ulysses,* Frances and Michael Baylson Collection

mise, he proposed that Matisse choose the papers for the etchings and the separate suite of prints, a promise he fulfilled inasmuch as he employed French papers for those components, but he resorted to a standard American product for the reproductions of the preliminary studies. He agreed that the portfolio of etchings should be printed at Lacourière's workshop in Paris but then had the plates shipped to New York, where they were entrusted to Charles Furth, who could supply the book illustrations at a rate significantly lower than the going price in Paris. Even those savings were not enough for Macy, who bemoaned the expense of printing the plates by hand. To Matisse, the American prints were another cause for regret because they were poorly printed with insufficient strength and character to hold their own inside the book.[20]

Despite his assurances and prevarications, Macy made all the design decisions himself and took credit for them in the colophon. He succeeded in designing *Lysistrata* with no perceptible interference from Picasso and doubtlessly did not expect such attention to typographical detail on the part of Matisse. He never sent the specimen pages or a dummy, even though Joyce's daughter-in-law had been enlisted to intercede. Cost control was a paramount consideration because of the artist's fees, the superfluous payment to Lewis C. Daniel, and the unanticipated expense of printing the preliminary studies by gravure. The Yale University Press submitted a quote of nearly $5,000 to print the letterpress portion of the book. Yale's proposals were rejected out of hand, and the contract was then awarded to a less prestigious but more accommodating firm, E. L. Hildreth &

Company of Brattleboro, Vermont. The Hildreth printers estimated their price to be just over $2,000 and ultimately billed Macy for that amount, despite a large number of last-minute alterations.[21]

They followed his instructions to the letter and even had some inspired ideas of their own. While setting the last chapter, they discovered that a line or two would run over the page break, making an unsightly widow at the end of the book. They reset the last two facing pages with an extra line each so that the text would conclude neatly at the bottom of the page. This may have been standard practice in their typesetting department, but Joyceans might appreciate a typographical stratagem particularly appropriate to the chapter containing Molly Bloom's late-night stream-of-consciousness ruminations. The last page makes a solid block of disjointed phrases while she is

drifting off to sleep, and the verso is blank, as if she is now dead to the world. More concerned about his bottom line, Macy only grudgingly acknowledged their excellent proofreading and their attempts to cope with his belated design ideas. He challenged their invoices, demanded rebates, and subjected them to the ultimate humiliation by not even mentioning them in the colophon. Their contributions are attributed to a nebulously named "Printing-Office of The Limited Editions Club," the same wording he used in the *Lysistrata* colophon.

Matisse wanted his "plain and classical" illustrations to be complemented by typography "in the classical French tradition," but Macy had quite a different design in mind. He began with an eight-page layout specifying a text set in 12- and 14-point Monotype Bell ornamented with hand-lettered chapter openings and running heads and folios in red. Text types in these sizes would produce a book of around 440 pages—more than Macy felt he could afford. Instead he decided on a utilitarian two-column format in 11-point Scotch Roman embellished with an "unconventional, highly modern" round-hand script in the chapter headings and running heads. This attempt at a modern decorative motif violated Matisse's wishes and caused troublesome delays to the printers, who had to wait for the zinc block lettering to be delivered and had to fit it on a single line instead of a four-line indented space as originally intended. Whoever did the lettering also had to contend with this placement of the headings by lopping off the descenders, the tail of the *y* and portions of other letters extending beneath the base line. Perhaps Macy thought that these truncated letters would also attest to his unconventional typographical bravado.[22]

Macy employed the same script sprawled across the title page. The title is so large that it might have been inspired by Ernst Reichl's now highly acclaimed modernist concept for the title page of the Random House *Ulysses,* comprising a double-page spread with the letter *U* occupying the entire lefthand page. For the binding, Macy commissioned from LeRoy H. Appleton a gilt-stamped cover design with a globe and clock symbolizing the hours of the day recounted in *Ulysses.* The globe contains the Nausicaa illustration somewhat redrawn to make it more palatable to Macy's clientele. Here too he was following a precedent set by *Lysistrata,* which displays on the binding a Picasso drawing adapted by Appleton. Macy may have wanted the overall effect to be highly modern, but it looks dated in retrospect. This encounter of the modernists Matisse and Joyce must be counted among Macy's accomplishments, but he must also be held responsible for the book's defects: the typographical infelicities, false economies, lapses of taste, and failures of nerve.

≈

PAGE SIZE: 29.7 × 22.5 cm; sheet size 36 × 47 inches, printed in 16-page forms.

PAGINATION: [2], v–xv, [3], 363 [3] pp.; pages [364] and [366] blank.

ILLUSTRATIONS: 20 gravure reproductions of preliminary studies printed by the Duenewald Printing Corporation, New York, and 6 soft-ground etchings printed by the Photogravure & Color Company, New York. Ten numbered artist's proofs were printed on Arches at the Paris workshop of Roger Lacourière (Duthuit 1983, nos. 235–40).

TYPOGRAPHY: Designed by George Macy. Text in 11-point Linotype Scotch Roman, title and headings in roundhand lettering, running titles and folios in red, printed at E. L. Hildreth & Company in Brattleboro, Vermont, although the colophon credits

The Printing-Office of The Limited Editions Club.

PAPER: The letterpress portion printed on an unwatermarked wove supplied by the Worthy Paper Company of Mittineague, Massachusetts; the reproductions printed on yellow and blue Chieftain Bond papers supplied by the Neenah Paper Company, Neenah, Wisconsin; the etchings printed on Canson Gravure supplied by Papeteries Canson et Montgolfier.

BINDING: Full brown buckram by George McKibbin & Son, New York, with gilt embossed vignettes on spine and front cover by LeRoy H. Appleton; the front-cover design of a clock and globe reproduces part of Matisse's etching for the Nausicaa chapter; publisher's cardboard slipcase.

EDITION: Published 22 October 1935. 1,500 numbered copies signed by Matisse, of which 250 were also signed by Joyce. Priced at $10 or $15 for copies with both signatures. A suite of the 6 etchings was printed on Arches by Lacourière in 150 copies and was issued by the Print Club of New York.

COPIES EXAMINED: PML 135631 (no. 55); PML 195593 (no. 104); HRC q PQ 6019 O9 U4 1935 Knopf (no. 367).

REFERENCES: Macy 1935a; Skira 1946, no. 257; Barr 1951, p. 560; Slocum and Cahoon 1953, no. 22; Limited Editions Club 1959, no. 71; Guillaud 1987, pp. 474–79; Duthuit 1988, no. 6.

EXHIBITIONS: Philadelphia 1948, no. 263; Geneva 1959, no. 7; Boston 1961, no. 197; Saint Petersburg 1980, no. 2; Paris 1981, nos. 51–57 and 155–61; Fribourg 1982, no. 2; Nice 1986, nos. 3 and 4.

15.

Ventura García Calderón (1886–1959), *Explication de Montherlant, portrait original par Henri Matisse, croquis et pages inédites de Montherlant.* **Brussels: Les Cahiers du Journal des Poètes, 1937 (Collection 1937, no. 41).**

Henry de Montherlant's best known and most popular works frequently appeared in illustrated editions. The illustrators of these books are now mostly forgotten with the exception of Matisse and Marie Laurencin, who contributed color lithographs for an edition of his breakthrough bestseller *Les jeunes filles* (1937). Montherlant originally approached Matisse with the idea of illustrating his novel about colonial North Africa, *La rose de sable,* but his publisher thought that it would be too expensive, and he had not yet come to terms with his text, which had sensitive political implications. He printed up a few copies for private distribution in 1938 and did not authorize a commercial edition until 1951. Even then he was not ready to reveal the full extent of his anticolonial convictions and expurgated that version by turning it into a love story with sultry color illustrations by Édouard Chimot. He waited until after the Algerian War to release the so-called definitive edition. Matisse was just as glad to be absolved of this assignment, although he felt that the novel was "extremely interesting." He claimed that its visual imagery was already so compelling that an artist would not have much to add in the way of conventional interpretative illustration. They continued to discuss the choice of a text and eventually settled on *Pasiphaé* (No. 21), but years passed before they could find a publisher willing to bear the costs of that project.[1]

While they were conferring about *La rose de sable,* Matisse asked Montherlant to pose for him in a series of sittings that were rewarding in some ways, frustrating in others. In 1937 a journalist interviewed Matisse about these sessions and quoted his comments verbatim in an article now cited as a case study of his portrait drawing methods. He told the journalist how he met Montherlant and why he abandoned *La rose de sable.* He recounted some of the precautions he took in order not to be influenced by outside factors when he started to make the portraits. Keeping an open mind, he wanted to record what he saw, not what he knew of Montherlant by reputation and acquaintance. As much as he admired the author's work, he tried not to think about it while concentrating on his subject's features and expression. He noted that he had become "interested by the face of Montherlant" and had studied it diligently, but at the eighth sitting he realized that something had eluded him, something that placed the whole person beyond his reach. "I had to give up after two hours of fruitless labor." Nonetheless he retained some of his drawings and used them as the basis of a linocut in *Pasiphaé* and three reproductions in *Sur les femmes* (No. 18). He also made three lithographs of the novelist in profile, each in a slightly different pose but all employing the same economy of line to portray the striking features of the great man—his receding forehead, arched brow, and Roman nose.[2]

The interview implies that these portrait sessions were purely an artistic exercise, but they also provided the means to fulfill a commission. Dated 1937, one of the drawings was reproduced as the frontispiece of *Explication de Montherlant,* which was printed just a few weeks after the interview was published. Montherlant probably asked for the drawing because it was already available and because he was directly involved in the publication of that book. He did all he could to encourage a sympathetic interpretation of his work, even to the extent of contributing supplementary material. Some of his own drawings appear as illustrations, and some of his childhood writings were included as an appendix. The publisher claims to have solicited the pictures and the texts, but it is more likely that Montherlant volunteered them while he was discussing this project with his friend and colleague Ventura García Calderón, the author of the *Explication.* García Calderón wrote most of it at the beginning of 1936, just before the sensational success of *Les jeunes filles,* a matter of timing important to the publisher, who was glad to have a reason to review the career of a famous and controversial author but needed to explain why this survey did not include the cause of the controversy. We shall see that Montherlant also had to explain the timing of *Sur les femmes,* which addressed some of the ethical and social questions raised by *Les jeunes filles.*

The friendship of García Calderón and Montherlant was based on shared values and mutual esteem. The *Explication* is more an appreciation of Montherlant than a critical overview, more of a personality profile than a biography. It describes formative influences, traces the origins of recurring themes, and sketches a philosophical basis for ideas that might seem off-putting or obscure. Any interpretation of his works had to account for the character of a loner, a dandy, a student steeped in the classics, and a sportsman smitten with the drama of bullfighting. In this last regard, García Calderón perceived a kind of *espagnolisme,* a fascination with the Spanish spirit, which he evoked in his own writings about his homeland of Peru. He was one of the leading modernist authors in that country. An avowed Francophile, equally fluent in French and Spanish, he published

literary criticism, fiction, and drama in both languages, although he is probably best known for his short story collection *La venganza del cóndor* (The Condor's Revenge). He entered the diplomatic service at an early age and occupied a succession of ambassadorial posts until the end of the Second World War, after which he settled in Paris as his country's permanent delegate to UNESCO. He was ambassador to Belgium when he wrote this book, ostensibly at the instigation of a publisher in Brussels. Certainly it would have been more convenient for him to work with a local firm, visiting Paris now and then to consult with the subject of his research. These consultations would have been congenial because he was already on cordial terms with Montherlant, who praised his stories in articles and a pamphlet published in 1934. At García Calderón's invitation, the novelist came to

Belgium for the carnival of Binche and joined in the festivities (wearing a cardboard mask of a bull). Loyal to the end, Montherlant attended the funeral of his friend, "a poet" with a generous spirit and a selfless disposition not often found in literary circles or the diplomatic corps.[3]

This publication appeared as part of a series edited by Pierre-Louis Flouquet (1900–1967), a leading member of the Brussels avant-garde. He started off as a painter sufficiently successful to merit a one-man show in 1919 and an exhibition in partnership with René Magritte in 1920. He published a linocut in *Der Sturm,* produced a series of linocut portraits of modernist architects, and engraved a portrait of Matisse in the same medium.[4] A Brussels gallery organized a commemorative exhibition of his work in 1975. Having quit painting around 1929, he joined the editorial board of the *Journal des poètes,* in

which he found his true calling as a skilled publisher and tireless promoter of French-language poetry. Founded in 1931, the *Journal des poètes* was conceived as an inexpensive, easily accessible periodical eclectic in taste and international in scope. Flouquet replaced it with the quarterly *Courrier des poètes* and the Cahiers du Journal des Poètes, a series of monographs intended "to present and defend authentic poetry with no constraints in regard to style and doctrine." Subscribers could receive ten to fifteen Cahiers a year. The 1937 series included poetry by Reverdy, an essay on Rimbaud, Pushkin in translation, two issues of the *Courrier,* and this account of Montherlant, an author more renowned for his fiction than his verse, but an exception could be made for someone of his stature. Flouquet might have also liked the idea of working with a Latin American author who had francophone literary credentials and a

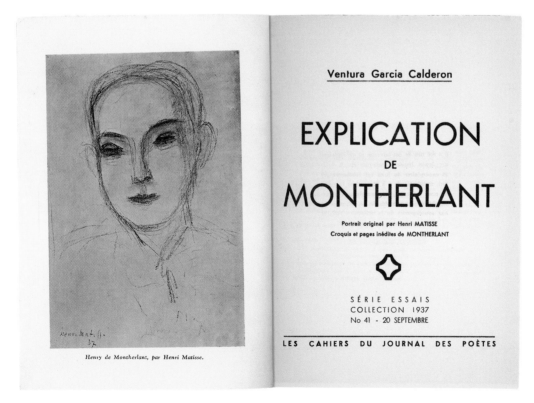

Henry de Montherlant, par Henri Matisse.

Ventura Garcia Calderon

EXPLICATION
DE
MONTHERLANT

Portrait original par Henri MATISSE
Croquis et pages inédites de MONTHERLANT

SÉRIE ESSAIS
COLLECTION 1937
No 41 - 20 SEPTEMBRE

LES CAHIERS DU JOURNAL DES POÈTES

Fig. 1. Frontispiece and title page, *Explication de Montherlant,* Frances and Michael Baylson Collection

Fig. 2. Pierre-Louis Flouquet, linocut portrait of Matisse, *Pierre Louis Flouquet* (1975), Marquand Library of Art and Archaeology, Princeton University

Imported from an English or Scottish mill, the Featherweight léger paper appears to have been a standard ingredient in these publications, which were usually printed by the Van Doorslaer firm. Flouquet was more of a proselytizer than a typographer. He had some acquaintance with printmaking, layout, and design but was more concerned with reaching a wide audience of readers and building a broad constituency for the art of poetry.

PAGE SIZE: Jésus 16mo; 19.2 × 14 cm.
PAGINATION: 97 [3] pp.; the first leaf blank.
ILLUSTRATIONS: Halftone reproduction of a charcoal portrait of Montherlant by Matisse inserted as a frontispiece; line drawings of Montherlant reproduced in text.
TYPOGRAPHY: Printed at the Imprimerie Van Doorslaer, Brussels. Text in bold 10-point Goudy Old Style, title page and a section title in various sizes of Semplicità.
PAPER: The Featherweight léger is a machine-made unwatermarked wove.
BINDING: Wrappers printed in black and blue.
EDITION: Printed 20 September 1937. Edition of 835 copies: 10 copies on Japon impérial designated *A* to *J*; 25 copies on Featherweight fort with the mark of a crowned heart, numbered 1 to 25; 150 copies on Featherweight léger for subscribers, numbered 1 to 150; 650 unnumbered regular copies priced at 10 francs.
COPIES EXAMINED: PML 195635 (no. 24); BnF 8-Z-27312[41] (unnumbered).
REFERENCES: Place 1974, p. 113; Duthuit 1988, no. 47; Monod 1992, no. 5120.

prestigious diplomatic position in his country. While tending these publication projects, he established the Biennale Internationale de Poésie with Arthur Haulot, who succeeded him as the executive officer of this organization, now operating as the Maison Internationale de la Poésie–Arthur Haulot. It continues to publish the *Journal des poètes,* which was revived after the war, and it retains the laissez-faire, syncretic, international outlook of its founders in its public programs and outreach activities.[5]

Flouquet and Matisse did not have to invest very much effort in the production of this frontispiece. The Cahiers series had some pretension to fine printing inasmuch as it offered special copies on premium paper but otherwise stayed within the parameters of a uniform style and format.

16.

Paris 1937. **Paris: Jean-Gabriel Daragnès, 1937.**

∾

Paris 1937 follows the example of *Tableaux de Paris* (No. 10), a book on the same subject and constructed on the same principle: a series of essays by different authors, each illustrated by a different artist. Jean-Gabriel Daragnès directed the production of both books, but this time he obtained the means to proceed on a more ambitious scale with thirty-one texts instead of twenty, three times as many illustrations, extra typographical embellishments, and a larger sheet specially watermarked with his printer's device and the heraldic arms of Paris. Civic pride made this publication possible. Daragnès took the original concept and applied it ten years later to produce a truly monumental volume celebrating the city of Paris on the occasion of its last and largest world's fair: the Exposition internationale des arts et techniques dans la vie moderne Paris 1937.

The Paris exposition attracted more than 30 million visitors. The fairgrounds occupied 2 square miles on both sides of the Seine and accommodated as many as 300 pavilions designed by 400 architects working with a legion of muralists and sculptors. Picasso painted *Guernica* for the Spanish pavilion, Robert and Sonia Delaunay helped to decorate an aeronautics pavilion, Fernand Léger depicted progress in power generation for a science pavilion, and Raoul Dufy produced for the Palace of Light and Electricity a huge panorama once thought to be the largest painting in the world. The Germans and the Russians constructed colossal buildings in the totalitarian style, one surmounted with an eagle and swastika, the other with a hammer and sickle. Those were temporary structures, but the French

commissioned an even more expansive edifice, the Palais de Chaillot, which now functions as a museum complex and stands as a permanent record of the architectural style of the exposition. Matisse thought it was an eyesore and protested against it in a petition signed by Braque, Picasso, Maillol, and other artists. Nonetheless, he had to appreciate the magnitude of the endeavor—an act of patriotism and a symbol of fortitude at a difficult time when the glories of the French nation were overshadowed by social unrest, financial distress, and the prospect of war.[1]

Part of the Palais de Chaillot was given over to a group of exhibitions about literature, books, and the graphic arts. Visitors could view displays of trade books, fine bindings, prints, and portraits of authors along with first editions, manuscripts, and proofs. An organizing committee confided some of these topics to experts, including Daragnès, who supervised a section devoted to illustration and *livres d'art*. He selected the "most interesting" examples of French achievements in this field during the last ten years. Among the artists represented were Matisse, Picasso, Maillol, Schmied, Derain, Dufy, and many of the lesser names who contributed to *Paris 1937*. A contemporary critic complimented him on his imaginative installation. He showed books in vitrines and sample pages mounted on wooden panels (preferring not to frame them lest they should look like prints). He commissioned illustrators to paint reproductions of their work on a stretch of empty space between the picture rail and the ceiling of the gallery. Not averse to some tasteful self-promotion, he painted one of the reproductions on the wall and put two of his own books on display.[2]

As *Président* of the book arts section, Daragnès had the ear of city officials who helped to organize and fund the exposition. He persuaded them to sponsor the publica-

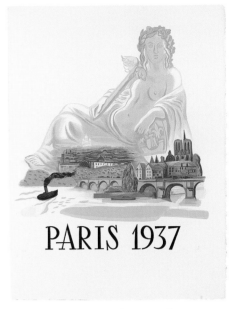

Fig. 1. Title page, *Paris 1937,* The Morgan Library & Museum

tion of *Paris 1937* and provide the financial assurances he needed to take on such an expensive publication project. Although he published it, he gave them most of the credit in the dedication and the imprint, which states that he designed and printed it for the city of Paris. He could also call on their patronage for an enviable marketing opportunity. On the ground floor of the newly constructed Palais de Tokyo, the exhibition *Paris Through the Ages* recounted the history of the city in fourteen rooms containing Gallo-Roman artifacts, dioramas, maps, prints, and books. Visitors passed through a vestibule where Daragnès displayed the makings of *Paris 1937*, the autograph manuscripts of the essays and the original drawings for the etchings. He could not have asked for better product placement in a setting that might tempt fairgoers to purchase a lavish memento of the exposition.[3]

The contents of *Paris 1937* are configured to present a topographical tour of the

metropolis, beginning in the center of town and proceeding through the suburbs. Essays on the Île de la Cité and the Hotel de Ville are followed by descriptions of Belleville, Passy, and other outlying districts. The authors of the essays were Gérard Bauër, Maurice Bedel, Abel Bonnard, Jean-Jacques Brousson, Julien Cain, Francis Carco, Jean Cassou, Pierre Champion, Paul Claudel, Colette, Léon Daudet, Tristan Derème, Lucien Descaves, Georges Duhamel, Raymond Escholier, Léon-Paul Fargue, René Gillouin, Jean Giraudoux, Louis Hautecoeur, Charles-Henry Hirsch, Gérard d'Houville, Georges Huisman, Pierre Mac Orlan, Paul Morand, Jean Robiquet, Jules Romains, André Suarès, Jérôme and Jean Tharaud, André Thérive, Paul Valéry, and Jean-Louis Vaudoyer. Many of them wrote on parts of town they knew from longtime personal experience, sometimes with a touch of nostalgia for quaint customs and picturesque landmarks obliterated by the march of progress. Pierre Mac Orlan reminisced about the glory days of Montmartre, a hive of artistic activity before the First World War. Paul Morand noted how the Champ de Mars had been transformed by the building projects of the exposition. Gérard d'Houville related stories about the Champs Élysées he had heard from his father and grandmother. The politician Léon Daudet reported on the economic conditions in the area around Les Halles. The poet Jean Cassou eulogized famous residents of Père Lachaise. In addition, leading experts wrote on museums, churches, gardens, and the Bibliothèque nationale. There was something for everybody in this compendium of social commentary, local history, and urban lore.

Daragnès approached artists on the same principle, allowing many of them to pick congenial subjects in the city and its environs. Some opted for the familiar sights highlighted in tourist guides—views of the Seine, scenic prospects along the boulevards, famous monuments, and historic buildings. Others revealed the hidden charms of neglected neighborhoods and portrayed common Parisian types at both ends of the social scale. In his negotiations with Matisse, Daragnès proposed a plate on the theme of *La cité* because the artist knew that part of town so well and had undertaken a similar scene for *Tableaux de Paris*. Other ideas would be welcome, but he needed to plan for them before he commissioned the plates from other artists. To give an example, he noted that Matisse's friend Albert Marquet had already consented to do the Louvre. He asked for a plate larger than the page to eliminate the platemark and specified the dimensions of the image area. By that time—12 November 1936—he was already worried about his deadline in April 1937 (which, in fact, he missed by more than two months because he did not finish the letterpress portion of the book until July). He could not wait for Matisse to draw *La cité* in springtime but could give him 2,000 francs to buy pictures that might help him to visualize the scene in that time of year.[4]

Matisse submitted an etching showing the south side of Notre-Dame de Paris viewed through trees in full foliage (Fig. 3). His signature on the plate is in reverse, which is not unusual—it is also reversed in the plate for *Tableaux de Paris*—but the cathedral building is in the wrong orientation, the towers on the right and the rose window on the left, a rather surprising way to render a major monument. This was not a careless error but the result of several studies, one of three plates Matisse made in the same configuration. Nonetheless Daragnès ridiculed the slipshod workmanship of the great artist, who could not be bothered to execute an etching the right way around. Of course he would not have dared to mock Matisse before other members of the Paris artistic community, but he could show his true feelings before his journeymen employees while they prepared to print the etching. A former apprentice tells that story as evidence of the professional pride, high standards, and underlying frustrations of his master, who had done his time as a journeyman and was now a successful artist, yet not so famous and revered that he could overlook the fundamentals of his craft.[5]

This book marks the highpoint of Daragnès's career. An adroit publisher, he succeeded in raising money to cover the costs of printing and illustrating a sumptuous publication comprising contributions by nearly a hundred artists and authors. A skilled typographer, he devised a colorful layout for the letterpress texts with blue ornaments and red in-line initials. Many of the chapters end with texts composed in decorative shapes to fill out the bottom of the page, a typesetting tour de force in the style of Renaissance imprints. He supplied one of the etchings, produced a color wood engraving for the title, and designed the entire book himself with the exception of the box case, which was devised by the Art Deco binder Rose Adler. Certainly a collaborative volume needs a guiding hand, a presiding genius capable of maintaining order and preserving continuity. Like the organizers of the exposition, he was purposely eclectic in his choice of artists, believing that he should distribute his largesse widely and that he could count on the whole to outweigh the weaknesses of its parts. Daragnès did his best, but in the end the book was simply too large, busy, and unwieldy to compensate for the overwhelming quantity and uneven quality of the illustrations. A less grandiose book would have been more coherent. It was well received, however, and fulfilled its political mandate to the satisfaction of the govern-

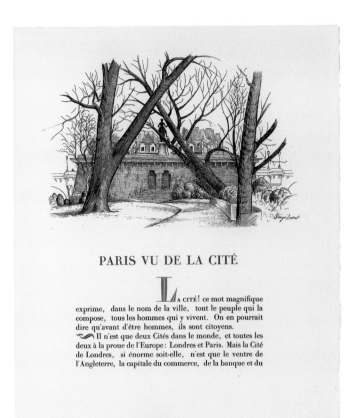

Fig. 2. Chapter opening, *Paris 1937,* The Morgan Library & Museum

Fig. 3. Etching, *Paris 1937,* The Morgan Library & Museum

ment authorities, who rewarded Daragnès by making him an officer of the Légion d'honneur.[6]

PAGE SIZE: 35.2 × 27.2 cm.

PAGINATION: [28] 294 [10] pp.; the first 3 and the last 2 leaves blank.

ILLUSTRATIONS: Color wood engraving on the title by Jean-Gabriel Daragnès; the preface and each of the 30 chapters contains a full-page etching and an etched headpiece, 62 etchings altogether, each by a different artist: Gérard Ambroselli, Louis Robert Antral, Maurice Asselin, Gabriel Belot, Maurice Berdon, Charles Berthold-Mahn, Gus Bofa, Pierre Bonnard, Christian Jacques Boullaire, Jean-Louis Boussingault, Laure Bruni, Charles Camoin, Edmond Ceria, Chériane, Clément-Serveau, Eugène Louis Corneau, Jean-Gabriel Daragnès, Hermine David, André Derain, Georges-Olivier Desvallières, André Dignimont, Kees van Dongen, Pierre Dubreuil, Georges Léon Dufrenoy, Raoul Dufy, André Dunoyer de Segonzac, René Durey, Pierre Falké, Jean Frélaut, Othon Friesz, Demetrios Galanis, Paul-Élie Gernez, Édouard Goerg, Roger-Maurice Grillon, Marcel Gromaire, Georges Guyot, Gabrielle Kayser, Moïse Kisling, Chas Laborde, Jean Émile Laboureur, Marie Laurencin, Henri Baptiste Lebasque, Constant Le Breton, Joseph Marie Le Tournier, Léopold-Lévy, André Lhote, Robert Lotiron, Jean Marchand, Albert Marquet, Henri Matisse, Luc-Albert Moreau, Louis Neillot, Roland Oudot, Charles Alexandre Picart Le Doux, Jean Puy, Jean Constant Raymond Renefer, Carlos Reymond, Maurice Savin, Louis Touchagues, Henri Vergé-Sarrat, Maurice de Vlaminck, and Édouard Vuillard. The etchings were printed by Daragnès.

TYPOGRAPHY: Printed by Daragnès in red, blue, and black. Text in 18-point Deberny et Peignot Firmin Didot.

PAPER: The subscribers' copies on a Canson et Montgolfier mold-made wove watermarked with the arms of Paris and Daragnès's printer's device above the text VIDALON; the other copies on a Rives mold-made wove watermarked with the arms of Paris and Daragnès's printer's device above the text RIVES; the wrappers on a laid handmade.

BINDING: Wrappers decorated in red, blue, and gray; blue and red clamshell box designed by Rose Adler.

EDITION: Printed 14 July 1937. Edition of 500 copies, of which the first 200 were reserved for subscribers.

COPIES EXAMINED: PML 195706 (no. 119); BnF Res FOL-LK7-43794 (copyright deposit copy).

REFERENCES: Duthuit 1988, no. 7; Monod 1992, no. 8849; Daragnès 2001, p. 103.

EXHIBITION: Sens 2007, no. 81.

17.
Tristan Tzara (1896–1963), *Midis gagnés, poèmes, six dessins de Henri Matisse*. Paris: Les Éditions Denoël, 1939.

Midis gagnés presents in chronological order a selection of poems that had been published between 1934 and 1937. In some ways it serves as a poetical testament of Tzara, who started out as a leading member of artistic movements and then withdrew from them to cultivate his own voice and vision. Now he is mainly recognized for his part in bringing Dada to Paris and his role in organizing other avant-garde initiatives of the 1920s. He composed Dada manifestos and exchanged Surrealist polemics with artists and writers such as André Breton, Louis Aragon, and Paul Éluard. Tzara broke with the Surrealists in 1935 and turned his attention to the political situation after the outbreak of the Spanish Civil War. His progression of ideas and increasing politicization can be traced in *Midis gagnés*, which begins with verse written while he was still affiliated with the Surrealists. Premonitions of war appear in the later poems, although Tzara also included a tribute to Matisse, *"Le jour apprenti,"* in which one can perceive some signs of hope. His elegy for the Spanish poet Federico García Lorca, *"Sur le chemin des étoiles de mer,"* was his best-known poem at that time and can still be found in anthologies. Other poems allude to the tragic events in Spain, and the collection ends with a grim account of death and destruction.[1]

Tzara's relationship with the Denoël firm began in 1934, when it purchased the stock of Éditions des Cahiers Libres, which had issued two of his books. The new proprietor published his *Grains et issues* (1935) as well *Midis gagnés*, but his

dealings with the firm stopped there. Robert Denoël and Bernard Steele founded it as a joint venture in 1930. Denoël was Belgian by birth, a legal technicality that would help to keep him out of trouble after the war, and Steele came from a wealthy American family that provided much or most of their start-up capital. They made a name for themselves by publishing the novels of Louis-Ferdinand Céline, although Céline's increasingly overt anti-Semitism affronted Steele, who left the firm in 1936. Denoël built up a thriving trade in controversial books of all kinds, some of which were equally repugnant to the Germans. After they invaded France, they closed down his business and seized a large portion of his stock. Eventually they allowed him to start up again and encouraged him to print even more Céline as well as the work of other anti-Semitic authors. Denoël published Hitler's speeches in an official and unabridged French translation. He even tried to raise capital for his firm by taking a German partner, although he insisted on retaining editorial control of his publications.[2]

After the Liberation, Denoël had to answer accusations of collaborating with the enemy and tried to clear his name by turning himself in for a judicial inquiry. Grateful employees testified on his behalf as did character witnesses, such as Louis Aragon and Elsa Triolet, who had taken refuge with him when they were hiding from the Germans. Triolet was one of Denoël's authors and won the Prix Goncourt while the court was considering his case. The publisher pointed out that he had been selling books banned by both sides of the conflict, that his competitors had also catered to the Germans, and that he had reprinted Céline only to satisfy the demands of the author. The court dismissed the charges against him, but as an addi-

Fig. 1. Title page, *Midis gagnés* (1939), Frances and Michael Baylson Collection

tional precaution he transferred the firm to his mistress, the lawyer, novelist, and publisher Jeanne Loviton. Just before the deed was registered, he was murdered under mysterious circumstances, shot in the back on a city street one night in December 1945 when he had been driving to the theater and had stopped to fix a flat tire. Despite numerous investigations, no one has been able to solve this crime, although Loviton has been named as a prime suspect, and the victim was known to have had enemies in the publishing business and the Resistance. No solid evidence emerged to quash the conspiracy theories debated in the newspapers at that time, and the police could do no better than suggest that Denoël had been the victim of a random act of violence. He left an aggrieved widow and a tenacious mistress to battle over the control of his

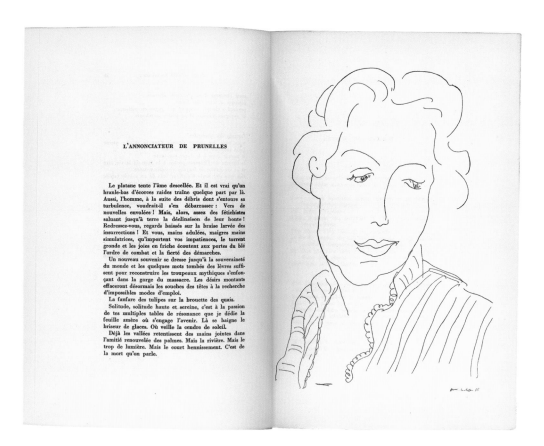

Fig. 2. *Midis gagnés* (1939), Frances and Michael Baylson Collection. This drawing faces the same text in both of the Denoël editions.

estate, the disposition of which had been complicated by his attempts to protect his assets and manage them behind the scenes. His widow challenged the validity of the deed to Loviton, which had not been completed properly, but Loviton prevailed in court and then sold the firm to Gallimard. The Gallimard group has retained the Denoël imprint and still employs it in about a hundred titles a year, mainly in fiction, science fiction, and current events.[3]

Denoël sometimes published books with original illustrations during the 1930s. André Lhote contributed an original lithograph for the special copies of his collection of critical essays *La peinture, le coeur et l'esprit* (1933). The special copies of Tzara's *Grains et issues* contain an etching by Salvador Dalí. Matisse agreed to provide an etching for large-paper copies of *Midis gagnés,* and Tzara gave him instructions on how to calculate the size of the print. As yet no evidence has been found for the publication of large-paper copies, and it appears that the author and publisher decided to issue fine-paper copies instead. The letterpress portion of the book was printed by the Imprimerie Chassaing, a firm outfitted for the mass production of large editions and not likely to undertake the delicate readjustment of margins a large-paper issue would require. Chassaing's compositors were already at work on the text in April 1938, when Tzara wrote to Matisse about the illustrations for *Midis gagnés.* He reminded the artist about his promise to provide an etching and somewhat apologetically requested six more illustrations, a last-minute idea on the part of the publishers. These were not to be illustrations per se, he explained, but rather reproductions of preexisting drawings, for any attempt to interpret the text in a literal or descriptive fashion would not conform to their present ideas about painting and poetry. He believed that "corresponding tendencies" in their work could develop into a sympathetic relationship with an expressive potential transcending their individual intentions. Matisse approved this approach and selected from his store of artwork six drawings amenable to letterpress printing. He decided against an etching and produced a drypoint instead, printed as usual by Roger Lacourière.[4]

A set of proofs in the Bibliothèque Doucet contains notional titles of drawings

in the author's hand—as if he was deliberating where to place them—but he was more concerned with their cumulative effect than any meaning they might suggest in juxtaposition with his work. He kept them in the same order when he was laying out the 1948 Denoël edition (No. 37) and sought to space them evenly throughout the volume. With one exception, they face different texts, and that exception may have been made purely for typographical reasons: in both editions the drawing faces a prose poem that fits neatly on a single page. More important in Tzara's mind was the alliance of art and literature in book form, a common ground of graphic expression. Readers could look in *Midis gagnés* for the "corresponding tendencies" he mentioned in his letter to Matisse. He valued his association with an artist whose name on the title page helped to validate his work

and promised a richer, more resonant reading experience.[5]

PAGE SIZE: 25 × 18 cm.

PAGINATION: 134 [2] pp.; pages 1–2 blank.

ILLUSTRATIONS: 6 full-page reproductions of drawings in text; 28 copies containing a drypoint engraving printed by Roger Lacourière and signed by the artist.

TYPOGRAPHY: Printed by the Imprimerie Chassaing, Nevers. Text in 10-point Linotype Bodoni Bold; title-page display in script and a type in the Didot style.

PAPER: The drypoint is on Chine; the letterpress portion of the 28 fine-paper copies is on mold-made wove Hollande supplied by Van Gelder Zonen, Apeldoorn; the rest of the edition is on an unwatermarked machine-made wove.

BINDING: Printed wrappers. Front cover printed in red and black.

EDITION: Printed 30 May 1939; PML 195595 has a presentation inscription dated 21 July

1939. Edition of 1,178 copies: 28 on Hollande signed by the artist and author and numbered 1 to 25 as well as 3 hors commerce designated for the author, artist, and publisher; 1,150 on ordinary paper of which 1,000 numbered from 26 to 1025 and 150 hors commerce numbered I to CL. In addition to the copies cited in the limitation statement, there are ten on blue paper initialed by the author and lettered *A* to *J*.

COPIES EXAMINED: PML 195594 (no. 22); PML 195595 (no. CXXVI); Beinecke Library 2206 +289 (no. 925); MoMA M28 T9 (no. 771); HRC PQ 2639 Z3 M491 LAK (no. 649).

REFERENCES: Skira 1946, no. 258; Barr 1951, p. 560; Berggruen 1951, no. 19; Harwood 1974, no. 28; Tzara 1975, vol. 3, p. 577; Duthuit 1988, no. 8; Monod 1992, no. 10803.

EXHIBITIONS: Philadelphia 1948, no. 264; Geneva 1959, no. 14; Fribourg 1982, no. 19; Nice 1986, no. 58.

18.

Henry de Montherlant (1895–1972), *Sur les femmes, avec 3 dessins d'Henri Matisse.* Marseille: Sagittaire, 1942.

This slim volume of essays was an incidental project, a gesture of good will through which Matisse and Montherlant reaffirmed their friendship and demonstrated their continuing commitment to their plans for a major illustrated book. In this respect it follows the precedent of *Explication de Montherlant* (No. 15), which contains a halftone reproduction of a charcoal portrait made in 1937. One or two years later, Montherlant went back to his friend and asked for more designs to be used in this publication—a profile on the cover, another profile in text, and a halftone reproduction of another drawing dated 1937. Matisse explained at some length why he was dissatisfied with those drawings, but he did not discard them and could easily supply several more without suffering any distractions or inconvenience. Although glad to have them, the author did not forget their previous conversations about *Pasiphaé* (No. 21). He urged his friend not to give up on that idea and to consider other illustration possibilities in hopes that some day they might finally produce a book together— even if it contained just a single picture.[1]

In the meantime Montherlant had to cope with an awkward delay in the publication of *Sur les femmes.* He made a point of noting in the preface that he had signed a contract for it and arranged for the illustrations three years before it went to press. If he had had his way, he would not have allowed it to appear during the war, but he was obliged to respect the rights of the publisher. He warned readers that some passages would seem "inopportune" at that time of crisis and sought to excuse them on the grounds that they had been written some years ago under drastically different conditions. The potentially offensive passages concerned the status of women, their role in society, their attitudes toward love and marriage, and their capacity for friendship. His opinions on the war between the sexes might not be welcome when other conflicts were tearing the world apart and setting new priorities in human relationships. Even in his own day, Montherlant had to defend himself against accusations of misogyny. Readers and critics objected to his characterization of women in *Les jeunes filles,* a bestseller partly because of the controversy it inspired. He commented on that novel several times in *Sur les femmes,* a tract originally intended to be a rejoinder to these reproaches and a justification of his views. It missed its mark because the publisher failed to bring it out while it could still contribute to the debate (and profit from the publicity).

The publisher was Léon Pierre-Quint, the covert proprietor of the Éditions du Sagittaire. He was the reason for the delay, though through no fault of his own: he had to flee Paris and reconstitute the firm after the outbreak of the war. Born Léon Steindecker, Pierre-Quint started in the publishing business as a literary advisor to members of the Kra family, who founded the firm and adopted the Sagittaire device for a notable series of publications, including André Breton's first Surrealist manifesto, John Maynard Keynes's treatise on monetary reform, and F. Scott Fitzgerald's *Great Gatsby* in its first French translation. He succeeded André Malraux (who had a hand in Sagittaire publications during the early 1920s) and worked in tandem with the journalist and editor Philippe Soupault. The Kra family sold the firm to him and a silent partner in 1931. He had to decide whether to leave the country after France fell in 1940, a

Fig. 1. Title page, *Sur les femmes,* Frances and Michael Baylson Collection

question of some urgency because he was Jewish, homosexual, and a drug addict (as a result of taking painkillers to cope with the effects of childhood tuberculosis). After considering several destinations and trying to obtain a visa, he resolved to stay in France and lie low in the Free Zone, where he could continue to publish on a modest basis. He arranged for the aryanization of his firm to fulfill the legal formalities and selected Marseille as the nominal base of operations. One can easily imagine that *Sur les femmes* and other publishing projects had to wait while he ensured his personal safety and provided for the future of Sagittaire. The production of his books could proceed as usual because he had been doing business with a printer in the Free Zone, Charles-Albert Bédu, a resident of Saint-Amand-Montrond and sometime mayor of that town. Bédu's employees did not have any

great difficulty with *Sur les femmes,* although the halftone portrait of Montherlant is rather faint, a defect duly noted by Matisse.[2]

PAGE SIZE: Jésus 16mo; 19 × 13.5 cm.

PAGINATION: 93 [3] pp.; pages 1–2 blank.

ILLUSTRATIONS: Full-page reproductions of 2 drawings in text, 1 in line, the other a halftone.

TYPOGRAPHY: Printed by Charles-Albert Bédu, Saint-Amand-Montrond. Text in 11-point Linotype Ronaldson Old Style.

PAPER: The copies on vélin Navarre on an unwatermarked machine-made wove supplied by Papeteries Navarre, which also produced the pur fil Lafuma; Hollande supplied by Van Gelder Zonen, Apeldoorn.

BINDING: Wrappers. Front cover printed in red and black with a portrait of Montherlant by Matisse.

EDITION: Author's preface dated April 1942. Edition of 1,500 copies: 14 on Hollande, of which 10 numbered 1 to 10 and 4 lettered *A* to *D;* 86 on Arches, of which 70 numbered 11 to 80 and 16 lettered *E* to *T;* 18 on pur fil Lafuma, of which 14 numbered 81 to 94 and 4 lettered *U* to *X;* 16 on simili Japon, of which 14 numbered 95 to 108 and 2 lettered *Y* and *Z;* 1,366 on vélin Navarre, of which 1,322 numbered 109 to 1430 and 44 lettered *AA* to *AZ* and *BA* to *BS.*

COPIES EXAMINED: PML 195630 (no. 689); BnF Res 8-Z DON-609[175] (no. 918).

REFERENCES: Place 1974, no. 55a; Duthuit 1988, no. 48.

EXHIBITION: Nice 1986, no. 59.

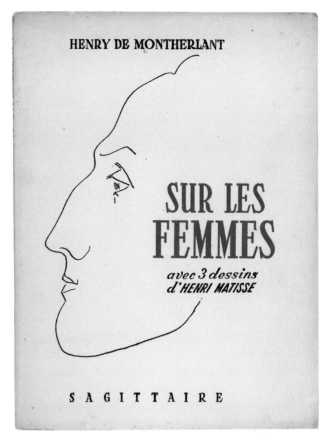

Fig. 2. Front cover, *Sur les femmes,* Frances and Michael Baylson Collection

19.

Louis Aragon (1897–1982), *Brocéliande, poème*. Neuchâtel: Éditions de la Baconnière, 1942 (Les Poètes des Cahiers du Rhône, no. 3).

The fortunes of war brought Aragon to Nice, where he met Matisse for the first time in December 1941. He sent some of his poems to the artist, who had wanted to make his acquaintance and was glad for this pretext to invite him for a visit. Aragon had already made a name for himself as one of the leaders of the Surrealist movement and as a politically engaged poet, active in the Communist Party and the French Resistance. A loyal party member, he broke with André Breton and the Surrealists, whom he accused of harboring counterrevolutionary tendencies. He affirmed his political convictions even in his marriage to Elsa Triolet, a Russian writer and sister of Lili Brik, who had been the muse of the Futurist poet Vladimir Mayakovsky. In turn Triolet would be Aragon's muse for more than forty years. A Jewish immigrant, she was in danger of being deported and was one of the reasons they had to go into hiding during the war. For fear of censorship, reprisals, or worse, he employed the pseudonym Blaise d'Ambérieux in the first of his essays about Matisse, published by Pierre Seghers in *Poésie 42*. He treasured his relationship with Matisse and would make it a lifelong project culminating in his two-volume monograph *Henri Matisse: A Novel*, an account of the artist's work so personal in tone and setting that it reads like an autobiography. Illustration projects were always at the core of this relationship.[1]

The essay in *Poésie 42* was to be accompanied by reproductions of drawings. While planning how to photograph and print the drawings, they touched on other topics—on one afternoon they talked for four hours straight—and Aragon even went so far as to question the wisdom of illustrating Ronsard, an author he thought wasn't quite right for the modern master and perhaps too demanding for someone in frail physical condition. Matisse respected Aragon's opinion and asked him to propose an alternative. He recommended the poetry of Charles Cros, an idea seriously considered but ultimately rejected for the very good reason that few people were reading Cros even then. Much more marketable were the drawings of Matisse, which were to be published in a moderately priced and easily accessible album of reproductions (No. 20) with a preface by Aragon. This project occupied most of their attention at this time, but Matisse agreed to help with *Brocéliande* mainly as a favor to the author, who had become a close friend over the course of their collaboration.[2]

Brocéliande is a poem about place, an occupied territory transposed into a land of legend. The title alludes to an Arthurian enchanted forest where Merlin was confined for eternity by a magic spell. Like Merlin, the heroes of the Resistance had been vanquished by evil spirits and remain transfixed on the spot, as if interred beneath a stone or trapped within a tree, but they did not die in vain, for "the flower is plucked so the fruit can grow." Some of those eulogized here had been executed by German firing squads in 1941 and 1942. The text is composed of terza rima alexandrines interspersed with sections in free verse, seven sections altogether, concluding with stanzas urging patriots not to lose heart and warning the "children of fear" not to countenance the current regime. Aragon wrote parts of *Brocéliande* in Nice and the rest in Villeneuve-lès-Avignon, where he sometimes stayed in the company of the publisher Pierre Seghers. The publisher was present when Aragon gave a reading of the text and later confessed feelings of regret that he had allowed the poem to slip through his hands. Also present on that occasion was the literary critic Albert Béguin, editorial director of the series Cahiers du Rhône. Béguin thought it was a "great and splendid poem but [ended] in verses on the level of Victor Hugo at his worst preaching democracy and 'scientific progress.'" Nonetheless he agreed to publish it and succeeded in selling the entire edition by the end of the war.[3]

Obviously it would have been impossible to publish a text like that in France. Based in neutral Switzerland, the Cahiers du Rhône afforded a means of free expression to French writers during the Occupation. In that respect it was an idealistic publishing venture not unlike the Cahiers du Silence in London and the Éditions de la Maison Française in New York. Béguin intended this series to compensate for censorship in France by allowing authors to protest the crimes of Hitler and the "monstrous complicity" of petit bourgeois intellectuals, against which they could "raise their voice in unison in the name of Liberty, Fraternity, Justice, and the dignity of the individual." He issued the first numbers in 1942. A teacher by profession, he depended on the publisher Hermann Hauser, proprietor of the Éditions de la Baconnière, to provide production facilities, a distribution network, and political connections with Swiss government officials. Hauser had to obtain permits to export books across the border and did not always succeed with some of the more strident texts in this series. *Brocéliande* was allowed to enter France through the "incomprehensible indulgence" of the censors, including one who went to prison for having sanctioned suspect books. By 1945 more than sixty Cahiers had appeared in various subseries: *Brocéliande* in

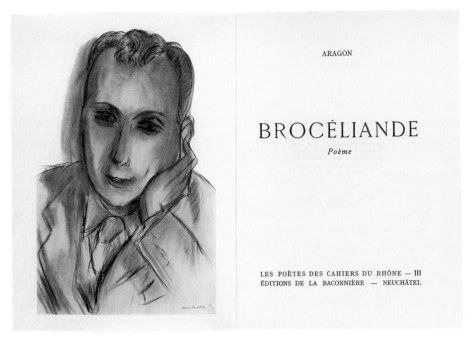

ARAGON

BROCÉLIANDE

Poème

LES POÈTES DES CAHIERS DU RHÔNE — III
ÉDITIONS DE LA BACONNIÈRE — NEUCHÂTEL

Fig. 1. Frontispiece and title page, *Brocéliande,* The Morgan Library & Museum

the Série rouge, some of Béguin's own writings in the Série bleue, and several noteworthy titles in the Série blanche, including Aragon's *Les yeux d'Elsa* and a French translation of T. S. Eliot's *Murder in the Cathedral.* Béguin moved to Paris after the war and brought with him the Cahiers du Rhône, which he continued to publish in association with the Éditions du Seuil. He added another subseries, the Série grise, and issued the last of the Cahiers in 1958, having produced almost a hundred altogether.[4]

Most if not all of the Cahiers du Rhône of this period were printed in Geneva at the Imprimerie Kundig, a family firm dating back to 1892. In that year William Kundig and his son Albert took over a thriving printing concern that had already been in operation for sixty years. Albert Kundig became sole proprietor upon the death of

his father in 1906. He established the firm's reputation for fine printing with a series of notable illustrated books, including some of the wordless novels by the woodcut artist Frans Masereel. His sons succeeded him in 1923 but continued to use their father's name in their imprints out of deference to his accomplishments. One of the sons, André Kundig (b. 1903), appears to have been managing the business when *Brocéliande* was printed.[5]

The frontispiece portrait in *Brocéliande* is a reproduction of a charcoal drawing made in March 1942. Matisse gave the drawing to Aragon with the understanding that it would be used in this publication and asked only that it be printed better than a recently published portrait of Henry de Montherlant (No. 18). He may have been equally displeased with this halftone reproduction,

which lacks depth and contrast in comparison to a larger, full-page version in *Henri Matisse: A Novel.* That version contains an inscription to Aragon not present in the *Brocéliande* frontispiece, an alteration in the course of printing no doubt requested by the author, who would not have wanted to presume on his friendship with Matisse. He allowed the inscription to stay when he published his memoir of the artist because it had then become part of the story. Another version of the portrait appeared on French postage stamps in 1991, part of a series commemorating the great French poets of the twentieth century.[6]

PAGE SIZE: Jésus 16mo; 19 × 14 cm.
PAGINATION: 55 [9] pp.; pages 1–4, 57–58, and 63–64 blank.
ILLUSTRATIONS: A halftone reproduction of a drawing inserted on coated paper as a frontispiece portrait of Aragon.
TYPOGRAPHY: Printed at the Imprimerie Kundig, Geneva. Text in 12-point Old Style, display headings in Deberny et Peignot Elzévir italic.
PAPER: The vélin copies on good-quality machine-made wove.
BINDING: Red printed wrappers with the publisher's motto and device.
EDITION: Printed 30 December 1942. An edition of 4,080 copies: 50 copies on vélin numbered 1 to 50; 30 copies on Hollande numbered I to XXX; 150 copies hors commerce. Regular copies priced at 4.80 CHF. La Baconnière issued a second edition in 1945 limited to 3,000 copies (PML 195631).
COPY EXAMINED: PML 195967 (no. 27).
REFERENCE: Duthuit 1988, no. 49.

20.

Henri Matisse (1869–1954), *Dessins: Thèmes et variations, précédés de "Matisse-en-France" par Aragon.* **Paris: Martin Fabiani, 1943.**

This was the first of two books published for Matisse by Martin Fabiani, a prominent art dealer during the Occupation. Fabiani thrived in those troubled times and gained the means to make books of the highest quality, despite the material shortages, economic dislocations, and social upheavals of the war. Matisse was glad to be given carte blanche in the design and production of his books and did not inquire about the origins of Fabiani's fortune except to note that his patron had married into money. At some point he may have learned some unsavory details about the sources of these funds, for he dismissed the dealer after a year or so without wanting to explain the reasons for his dissatisfaction. He, like many others, must have heard disturbing rumors about looted artwork, collaborationist activities, and dubious attempts to export French cultural property. Even to this day it has been difficult to retrace Fabiani's brief and mysterious career, but some biographical information will be useful here to show how he got into the business of publishing artists' books and why he succeeded in those unlikely ventures.[1]

Corsican by birth, Martin Fabiani came to Paris to study law, as had other members of his family, but then decided that he would rather take up the trade of buying and selling modern art. Through family connections, he became acquainted with Ambroise Vollard, who threw some business his way and got him started as a runner for Paris galleries. After Vollard died in 1939, the bereaved family made him their agent for the dispersal of an immense stock of paintings, many of which he tried to sell in America, although his shipment was intercepted and impounded as suspect merchandise. He took over the gallery of a Jewish dealer for the duration of the war, a subterfuge through which he helped to protect a refugee's property from the depredations of the Nazis. In this locale and then in spacious quarters on the Champs-Élysées, he built up a business prosperous enough that he could buy a villa in a seaside resort near Monaco and dabble in horse racing with a stable of thoroughbreds, some of which he put out to stud. Matisse hired Fabiani to be his Paris agent for a trial period of one year beginning in September 1941. "It looks like he is quite the salesman," he told his son Pierre, "I am happy to be doing business with him for my peace of mind." The assiduous salesman helped to procure painting supplies and once made vague promises to intercede with the German authorities when the artist's

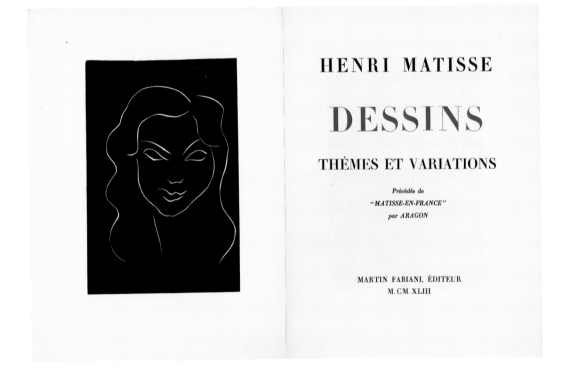

Fig. 1. Frontispiece and title page, *Dessins: Thèmes et variations,* Frances and Michael Baylson Collection

HENRI MATISSE

DESSINS

THÈMES ET VARIATIONS

Précédés de
"MATISSE-EN-FRANCE"
par ARAGON

MARTIN FABIANI, ÉDITEUR
M.CM.XLIII

daughter was arrested by the Gestapo. What influence he might have had with them is hard to tell. He sold a number of paintings to German collectors and acquired twenty-four belonging to the Rosenberg gallery through illicit connections so obviously discreditable that he agreed to return them after the war. Hoping to recover his reputation, he organized a gala exhibition for the benefit of a charitable organization patronized by the Allies but his ingratiating tactics did not avert accusations by the U.S. Art Looting Intelligence Unit and the French government, which fined him 146,000,000 francs for tax evasion. Nonetheless he was able to stay in business for a while and years later wrote breezy reminiscences of his dealings with the celebrities of the Paris art world without divulging any details about his finances or business methods.[2]

Fabiani backed into the publishing business while trying to liquidate the Vollard estate. Beginning with Bonnard, and the epochal *Parallèlement* of 1900, Vollard worked closely with the newly fashionable artists of the Paris school to produce illustrated books radically different than the standard fare supplied by bibliophile publishers during the nineteenth century. He lavished time and money on these projects for which he enlisted painters of the caliber of Émile Bernard, Maurice Denis, Picasso, and Rouault. They could expect complete freedom of expression unprecedented in the limited-editions market of their day, yet many opted for a grand and strictly classical typographical accompaniment, as if to put their achievements in greater contrast with the monuments of the past. The luxurious letterpress framed the illustrations and attested to their value, prestige, and preeminent position in a cultural sphere far removed from the cheap and transient experiments of the avant-garde. A perfectionist to the end,

Vollard died leaving a number of books unfinished, including Ronsard's *Livret de folastries* with etchings by Maillol, which was still in press, even though the title page is dated 1938, and the cover is dated 1939. Fabiani was authorized to complete the book and publish it in association with the heirs of the Vollard estate. He also assumed responsibility for another work in progress, Picasso's *Eaux-fortes originales pour des textes de Buffon*, which he issued under his own name in 1942. Matisse entrusted to him the *Thèmes et variations* project with the expectation that he would produce an edition comparable to the Vollard publications.[3]

Drawing became increasingly important to Matisse during this period. He felt that he had reached a new stage in his artistic career in which his sketches in charcoal and pen and ink were fully the equal of his painting and deserved serious consideration as works of art in their own right and on their own terms. "Above all I have made major, essential progress in my drawing," he reported to Pierre in the first of several letters describing the book he had in mind. This book would record a "flowering" of his work in this medium representing fifty years of effort. If he could achieve similar results in his painting, he declared that he would be able to "die content." It is possible that he expected this publication to serve in some way as a substitute for paintings, which were difficult to exhibit in wartime conditions, and as a way of reaching out to the artistic community while he was isolated in the Free Zone and physically unable to travel as much as he would have liked.[4]

To be precise, *Dessins: Thèmes et variations* is not so much a work of illustration as an album of reproductions with lengthy letterpress commentary at the front. Some copies have been bound, but Matisse expected the book to function in a different way, with the loose-leaf reproductions easily

at hand so that groups of them could be viewed at once. He assembled seventeen suites of drawings, almost every suite beginning with a charcoal drawing to state a theme and then continuing with a series of variations in crayon or pen and ink. Each of the variations had something different to say, but they all referred to the first drawing in the series and were "reunited" by his emotional response to the work at hand. At one point he compared the experience of viewing an entire suite to the ripple effect of a stone thrown into a pool of water. Several times he used the metaphor of a movie, or as Aragon expressed it in the preface, "a cinema of sensations": the spectator might almost believe that the model is in motion, taking a new pose in one sheet after the next, but that is only an optical illusion created by a rapid succession of images. Matisse might have gotten that idea after scanning suites of drawings hung up on the wall—an impressive array, said Aragon, who admired the way the massed white sheets lit up the "high bright room looking out over Nice and the sea and the palm trees and the birds . . . some hundred drawings in which the white virginity of the paper is, as it were, confirmed by the artist's line."[5]

Aragon wrote the preface while he and his wife were hiding from the Nazis in Villeneuve-lès-Avignon some 160 miles away from Nice. Starting at the end of 1941, Aragon visited the master on a regular basis to see his latest work and to submit portions of the text for his approval. The text in the Fabiani edition is not entirely accurate or complete because the author could not correct proofs while he was on the run and because he cut some passages to oblige Matisse. He restored them, made some corrections, and added another level of commentary in the version printed in *Henri Matisse: A Novel*. Fabiani thought it might be wise to publish the preface under a

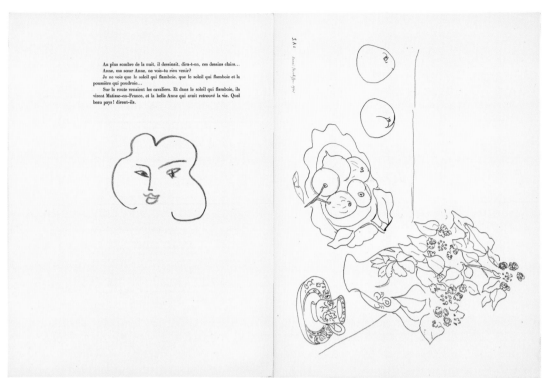

Fig. 2. Last page of text and first plate of *Dessins: Thèmes et variations,* Frances and Michael Baylson Collection

pseudonym, but Aragon steadfastly refused "if only because it is infinitely too personal and particular for that kind of treatment." This effusive expository essay was for him an act of patriotism, not just a tribute to a friend but also a defiant proclamation of national ideals as embodied in this artist's work, hence the title "Matisse-en-France."[6]

Matisse became more ambitious as the project progressed. He found a reliable photographer and contended with the scarcity of high-quality photographic plates. At first he expected to print lithographic reproductions of his drawings and had proofs made in a job shop at Nice but then decided that a more sophisticated printing process was in order and engaged Lacourière to oversee the production of collotype prints in Paris. The contract specified that Lacourière would assure the quality of the reproductions, that Matisse would have the right

to check the proofs, and that Fabiani would bear all the expenses of book production. Fabiani agreed on an edition of a thousand copies, including a hundred specials, the edition to be split evenly between the two because it was better to be paid in kind than to take a specified amount in cash when currency values were gyrating wildly from day to day. They planned to print in quantity to keep prices down, within the reach of art libraries, where this album would be accessible to students. In the same spirit, the artist donated seven or so suites of the original drawings to French museums in hopes that the entire group would be displayed together.[7]

The letterpress portion of the album was executed by the firm of Fequet et Baudier, which already enjoyed a high reputation in artistic circles. The principals of the firm were Marthe Fequet, daughter and successor of a

distinguished printer, and Pierre Baudier, son of the artist Paul Baudier and graduate of the École Estienne, where he received instruction in the book arts and graphic design. They printed books with illustrations by Braque, Chagall, Miró, Picasso, and Rouault, among others, until 1979, when the firm was taken over by the printmakers Robert and Lydie Dutrou. This was Fequet et Baudier's first book for Matisse. He seems to have been pleased by their work inasmuch as he would bring other jobs to them, although during the printing of this volume he rejected a round of proofs because someone had disregarded his "most precise" instructions. Perhaps this was the fault of Fabiani rather than negligence on the part of the printers, who knew how to collaborate with artists. Matisse conferred with Fequet about a suitable visual device to make the transition between the last page of text and the first of

the reproductions. He began with a leaf ornament, which would be paired with a decorative seashell motif at the end of the album, but he then decided to employ a series of stylized heads with feminine features echoing the woman's portrait in the frontispiece. The Duthuit catalogue describes the head ornaments as lithographs, but, unless some other documentary evidence should emerge, it is more likely that they were drawn with lithographic crayons and then reproduced as collotypes. The colophon acknowledges the participation of the printmaker Roger Lacourière, who supervised the printing of the ornaments, which had been made with a "litho crayon." One of the suites of drawings had been made with litho crayons on transfer papers, which had dried out before they could be applied to the stones, but they were salvaged by reproducing them along with the other collotypes.[8]

The sales and reception of this publication were disappointing in the opinion of Matisse's assistant, Lydia Delectorskaya. She believed that a better advertising campaign would have informed the public about its didactic purpose instead of confining its circulation to a market composed mainly of bibliophiles and collectors. Fabiani might be blamed for not publicizing it properly, but she also faulted Aragon for a preface so long and laudatory that it did not clearly explain the meaning of the successive themes and serial variations. In his defense, it could be said that Aragon learned his lesson by viewing his own portraits by Matisse, who made a suite of them in the same style as those reproduced in the album. The artist gave the author four charcoal drawings and more than thirty pen-and-ink variations, which appear in a numbered series on successive pages of *Henri Matisse: A Novel*. Both parties were proud of their part in that transaction. A few days after finishing his marathon bout of portraiture, Matisse wrote about it to Pierre, who could pass on the news to Aragon's former friend André Breton—and "watch him throw a fit!"[9]

～

PAGE SIZE: Raisin quarto; 32.5 × 24.5 cm.
PAGINATION: [8] 39 [5] pp.; the frontispiece is included in the pagination.
ILLUSTRATIONS: Linocut frontispiece, 3 collotype ornaments in text, 158 full-page collotype reproductions of drawings printed by Georges Duval under the direction of Roger Lacourière.

TYPOGRAPHY: Text and frontispiece printed by Fequet et Baudier, Paris. 12-point text type and display in the Didot style, display in black and red.
PAPER: Specials on Japon impérial and vélin d'Arches, ordinary copies on machine-made wove.
BINDING: Paper wrappers and cardboard album printed in red.
EDITION: Printed 27 February 1943. Inscribed to Lydia Delectorskaya in October 1943. An edition of 950 numbered copies: 10 copies on Japon impérial, numbered 1 to 10, signed by the artist; 20 copies on vélin d'Arches, numbered 11 to 30, signed by the artist; 920 copies on vélin pur fil, numbered 31 to 950.
COPIES EXAMINED: PML 195596 (no. 10); PML 195597 (no. 854).
REFERENCES: Philadelphia 1948, no. 265; Barr 1951, p. 268; Duthuit 1988, no. 9; Monod 1992, no. 7847; Delectorskaya 1996, pp. 283–97.
EXHIBITIONS: Geneva 1959, no. 10; Paris 1970, no. 193; Saint Petersburg 1980, nos. 28 and 95; Nice 1986, no. 47; Paris and Humlebaek 2005, nos. 38–59.

Henry de Montherlant (1895–1972),
Pasiphaé, chant de Minos (Les Crétois),
gravures originales par Henri Matisse.
Paris: Martin Fabiani, 1944.

Montherlant finally persuaded Matisse to
make a major illustrated book of his poetic
drama *Pasiphaé* and a companion text, *Le
chant de Minos.* They had already produced a
small volume of essays with portraits of the
author (No. 18), but that was only a diversion
while they planned a more ambitious
bibliophile publication to be printed in a
strictly limited edition with original
typography and artwork. They sought in
these texts a literary foundation of the right
size and structure for the book they had in
mind as well as subject matter that might
appeal to the artist's visual imagination.

Pasiphaé and *Le chant de Minos* were
parts of a larger dramatic work, *Les Crétois,*
centered on the story of Minos, king of
Crete and husband of Pasiphaé. Monther-
lant started to write *Les Crétois* in 1927 or
1928 but found that this richly symbolic
legend had so many levels of meaning that
he could not keep it within the bounds of a
unified and coherent piece of theater. He
set it aside until he could put it in the
proper focus for the stage. But he continued
to be interested in the Minos myth,
especially Pasiphaé's strange infatuation
with the white bull sent by Poseidon, a
monstrous act of forbidden love that would
produce the Minotaur and prepare the way
for the adventures of Theseus and Ariadne.
All his life Montherlant was fascinated by
the cult of the bull, the divine power it
represented in antiquity and its role in the
modern spectacle of the corrida. He tried
his hand as an amateur toreador and came
to relish the dignity, courage, and choreo-
graphed violence of the sport, which

inspired his first successful novel, *Les
bestiaires* (1926). In Montherlant's personal
mythology, Pasiphaé was a heroic figure
who defied engrained social taboos to join
with a force of nature. She faced her fate
and accepted her punishment with no trace
of remorse. "Deep inside me," she confides,
"I don't think that what I'm going to do is
evil." He extracted that portion of *Les
Crétois* to make a one-act dramatic poem, a
moral fable expressing his anti-Christian, or
rather pre-Christian, religious beliefs. The
piece was first performed in 1938 along with
a reading of another excerpt, *Le chant de
Minos.* Both texts had been published
before he brought them to Matisse, and
Pasiphaé reappeared in editions illustrated
by Jean Cocteau (1947) and Pierre-Yves
Trémois (1953). Montherlant never finished
Les Crétois because he had already received
an ample reward from these publications.[1]

Several publishers offered to take on
Pasiphaé, and one refused for fear of the
effort, expense, and risk it would entail.
Tériade declined to pursue the matter
because he had to tend the affairs of *Verve.*
Montherlant claimed that Gallimard was
interested, but nothing came of those
discussions, which probably were side-
tracked by the outbreak of the war. He also
approached Robert Laffont, who had just
set up shop in Marseille and had already
shown some signs of success. Flush with
cash, Laffont had asked him about printing
one of his books with illustrations by
Matisse and agreed that *Pasiphaé* would be
a good prospect for a top-of-the-market
livre d'artiste. By return mail Matisse
responded to Montherlant's proposals for a
Laffont edition with guarded enthusiasm.
He believed that he could make five
lithographs based on that text, which he
had recently reread, but he was not sure
when he could get around to it. First he had
to deal with other obligations: a book in

H. DE MONTHERLANT

PASIPHAÉ
CHANT DE MINOS
(LES CRÉTOIS)

Gravures originales par

HENRI MATISSE

MARTIN FABIANI, ÉDITEUR

Fig. 1. Title page, *Pasiphaé,* Frances and Michael Baylson
Collection

progress, a Baudelaire project, and the
Florilège des amours of Ronsard, which he
was just about to see through the press in
Switzerland. It is possible that he wanted to
buy time before deciding on a publisher. For
all he knew, Laffont would give Matisse and
Montherlant the means to print *Pasiphaé* in
the style they desired, but Matisse much
preferred to work with someone already
acquainted with fine printing ventures and
reliably disposed to grant him complete
control over the production of the book.
Martin Fabiani had the necessary qualifica-
tions, a congenial working relationship with
the artist, and a record of successful
publications, beginning with the books he
had taken over from Vollard and going up
to *Dessins: Thèmes et variations.* Matisse
chose to do business with Fabiani, who at
first demurred but then consented to
publish *Pasiphaé* on terms similar to those
in the contract for *Thèmes et variations.* The
artist would retain the rights to his prelimi-
nary designs, and the author would receive

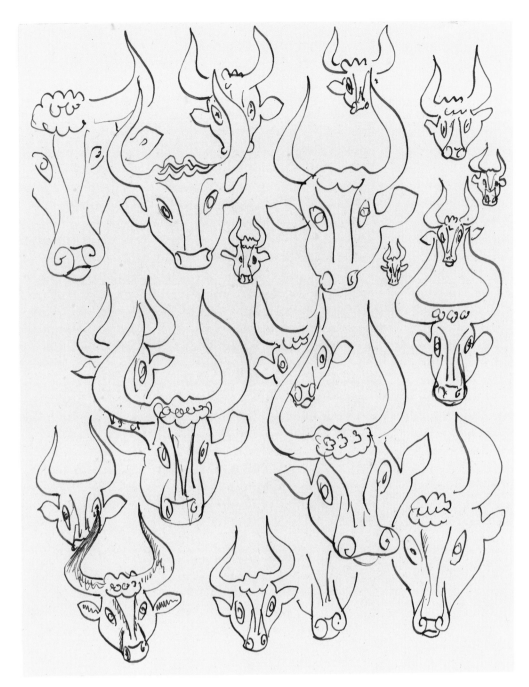

Fig. 2. Preliminary designs, *Pasiphaé,* The Pierre and Tana Matisse Foundation, New York

twenty copies in lieu of payment in cash. For better and for worse, these contractual provisions influenced later attempts to publish the *planches refusées* of *Pasiphaé*.[2]

Hesitant at first, Matisse soon became totally committed to the project, even to the exclusion of his painting, "which is nonetheless the most important part of my life." Ronsard and Baudelaire would have to wait while he devoted to Montherlant "ten months of effort, working all day and often at night." Some studies for the book date back to 1940 or 1941, but he started in earnest at the end of March 1943 after he had the contract in hand. Although Matisse spoke about lithographs in his letters to Montherlant and Fabiani, he also experimented with linocuts, a printmaking medium he had been using for portraits and other subjects since 1938. Writers in English usually refer to his work as linocuts, and here I will follow their example, although these prints may be more accurately described as linoleum engravings in regard to the technique employed and the effects achieved. Instead of cutting out nonprinting areas to make black on white prints the usual way, he relied on a fine v-shaped gouge to make incisions in the linoleum that would appear white on black, a process similar in principle to scratchboard and white-line wood engraving. He liked the simplicity of this process, he could easily procure the tools and materials, and he could get proofs pulled for him at a local job shop at a moment's notice. Its main drawback was the flimsiness of the printing surface, which could produce no more than 110 satisfactory impressions, but he was willing to replicate linocuts with photoengraved relief blocks if he had to produce a larger edition. He believed it to be a means of artistic expression fully the equal of other printmaking methods and predicted that it would gain more recognition in the future.[3]

The linocuts take on a special significance in the tragedy of *Pasiphaé*. They help to express her dark thoughts and her decision to transcend black-and-white notions of good and evil. One of them shows a jagged profile contorted in pain (*"L'angoisse qui s'amasse en frappant sous ta gorge"*), one of the very few images of human suffering in the work of Matisse (Fig. 2, p. 5). Others are more elegant and sensual, but they too convey the theme of defiance and rebellion. Montherlant at first resisted the idea of linocuts and mentioned some poor examples he had seen in another artist's work, but Matisse defended "this simple and direct process, which requires someone of the right sensibility to make the most of its exceptional quality." After seeing proofs, the author wrote a graceful retraction in which he praised the brilliant imagery "on the background of cosmic night" and declared it to be perfectly in accord with his "Faustian conception of that piece." He changed his mind about the linocut medium when he realized how well the artist understood his text and what efforts he had made to assess its pictorial potential. A close reading had been the basis of a faithful interpretation in general and particular. Each of the full-page plates refers directly to its characters, scenery, and action, a one-to-one relationship indicated explicitly by the captions. Of all the books described here, this one comes closest to a traditional work of illustration, where the pictures reiterate the story with telling details.[4]

Matisse could be confident about the dramatic impact of his linocuts, but he did not want them to be obtrusive or forbidding. He worried that a page of solid black might seem funereal or even sinister to the reader unless something could be done to relieve the featureless, monochrome appearance of the text. He saw this as a graphic problem and looked for a solution compatible with his

illustrations and the conventions of book design. By a pleasant coincidence, he found it in a historical survey of fine printing recently published by his friend André Lejard, *Le livre: Les plus beaux exemplaires de la Bibliothèque nationale* (Paris: Éditions du Chêne, 1942). He wanted the page layout of *Pasiphaé* to follow the precedent of "designs in the books of the sixteenth, seventeenth, and eighteenth centuries" and selected one of the reproductions in *Le livre* to be a model for the guidance of his printers. They were to study a text page in Gilles Corrozet's *Hecatomgraphie* (Paris: Denis Janot, 1540), an excellent specimen of French Renaissance typography notable for its elegant proportions and tasteful ornamentation: a single four-line decorated initial. He decided that he would design his own Renaissance initials and have them printed in red.[5]

The red initials would ensure the integrity and the vitality of the book by adding a cheerful color to alleviate the linocuts and by providing a graphic link between image and text. They too would be linocuts and would thus complement the facing illustrations. At one point he was working on the initials while laid up in bed, where he could compare them to proofs of the linocuts affixed to a wall across the room. But they would also be part of the text, signaling changes of tone in the *Chant de Minos* monologue and denoting the alternation of speakers in *Pasiphaé*. For them to fit properly, he had to adjust their weight and develop a suitable style through trial and error: he started by making historiated initials but then abandoned that approach and opted for classic letterforms in a simple frame. Then, in a later stage of production, he rejected some of the plain initials and substituted for them a series with star ornaments in the corners of the frames. He struggled to achieve the proper tint of red, an essential element in his

Fig. 3. Proofs of initials, *Pasiphaé,* The Pierre and Tana Matisse Foundation, New York

Fig. 4. Matisse's marked-up copy of the 1938 edition of *Pasiphaé,* Bibliothèque nationale de France, Paris

P A S I P H A É

répond pas.) Pourquoi « Pauvre reine ! » ? Maudite race des petits, tout oiseau perd ses couleurs dans vos mains. Ce mot de « pauvre » est entré en moi et a défait toute ma joie. Cette force que je m'étais forgée dans la solitude... tellement seule... si peu aidée... Malheureuse, malheureuse que je suis ! De tous côtés je bute contre les barreaux d'une cage. Pourquoi suis-je enfermée ? Pour quelle faute m'a-t-on punie ?

LE CHOEUR

 Malheureuse, oui, malheureuse ! Non pas d'être encagée, mais de croire l'être. Malheureuse, oui, malheureuse, de buter contre des barreaux qui n'existent pas.

42

P A S I P H A É

PASIPHAÉ

 J'ai lutté, mais le gouffre m'aspire. Ténèbres de moi-même, je m'abandonne à vous !

LE CHOEUR

 Il n'y a ni ténèbres, ni gouffres, ni rien de la sorte. Il n'y a pas de partie obscure de l'âme. A supposer qu'elle commette une confusion [1], toute la nature est confusion. Ce n'est pas sa passion qui est malsaine ; ce qui est malsain, c'est sa croyance que sa passion est malsaine [2]. Mi-femme, mi-déesse, son infirmité humaine la fait

(1) « *Celui qui couche avec une bête comme on couche avec une femme commet une confusion.* » (Lévitique.)

(2) « *Nous appelons contre-nature ce qui advient contre la coustume.* » (MONTAIGNE, *Essais,* lib. II, XXXI.)

« *Ce que nous appelons monstres ne le sont pas à Dieu,* qui

43

decorative scheme (although it should be noted that he also tested different shades of black). He wanted that red to be "gay as a poppy" and counted on it to make a harmonious blend with the black and white as well as the blue background he devised for the wrappers. "If we can't get that quality of red," he warned the printers, "we will have ruined the entire effect just as a sour note from the trumpet can spoil a lovely piece of music." One contemporary critic objected to the red initials, believing them to be a jarring interruption in an otherwise perfect ensemble, but the general consensus has been that they succeed in countering the gloom of the linocuts and in providing place markers for the page.[6]

A series of maquettes documents the planning process and shows how Matisse formulated his specifications for layout and design. By making mock-ups of the book, he could think through the sequence of its constituent parts—the front matter, introduction, text, appendix, notes, and colophon—and evaluate the size and shape of the finished product. He could visualize two-page openings and decide on the placement of the illustrations. He could calculate where a particular text would start and stop, and if it stopped too soon, he could design a linocut ornament to occupy the blank space on the bottom of a page. To ensure that his printers understood his instructions, he sent them maquettes for reference, although he revised in proof so frequently that it was hard to take him at his word when he claimed to have completed his plans for *Pasiphaé*. He was already thinking about the design of the title and the arrangement of the front matter in April 1943 while he was still working on the linocuts. His first maquette was really nothing more than a marked-up copy of the 1938 trade edition of this work, but it contains crayon sketches in the margins, initials drawn in red, and underlining of passages to be used as captions. The page layout evolves in three other maquettes, including one composed of pasted-in proofs of the text, initials, and ornaments printed on the Arches paper intended for the edition. Matisse apologized to the printers for the delay in preparing this final maquette, confessing that he and Fabiani had no idea how long it would take to prepare, but he finally sent it off with his *bon à tirer* in early February 1944. Mindful of how much work it represented, he dispatched it by two couriers to minimize the risk of it being lost in transit.[7]

His long-suffering printers belonged to the firm Fequet et Baudier, which also supplied the letterpress for *Dessins: Thèmes et variations*. Matisse dealt mainly with Marthe Fequet and sent his typographical instructions directly to her in a series of at least eighteen letters, which she is said to

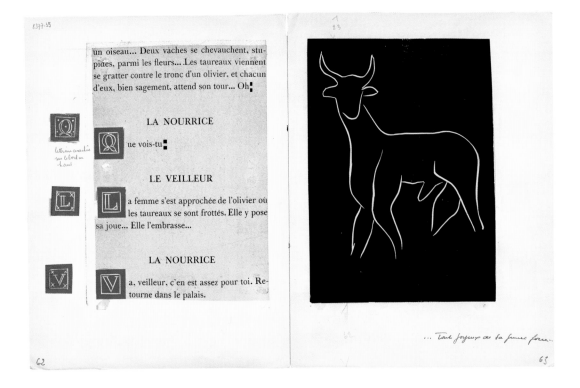

Fig. 5. Maquette for *Pasiphaé*, Bibliothèque littéraire Jacques Doucet, Paris

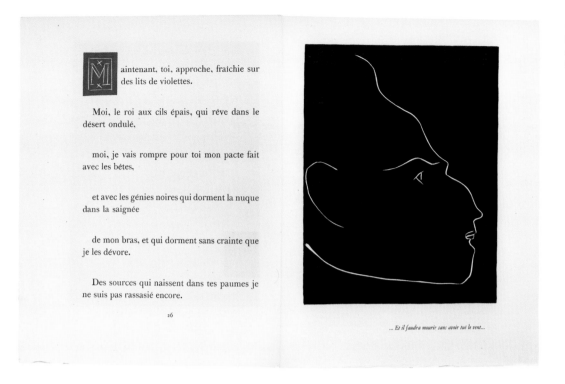

aintenant, toi, approche, fraîchie sur des lits de violettes.

Moi, le roi aux cils épais, qui rêve dans le désert ondulé,

moi, je vais rompre pour toi mon pacte fait avec les bêtes,

et avec les génies noires qui dorment la nuque dans la saignée

de mon bras, et qui dorment sans crainte que je les dévore.

Des sources qui naissent dans tes paumes je ne suis pas rassasié encore.

26

... Et il faudra mourir sans avoir tué le vent...

have preserved in her copy of *Pasiphaé* along with several suites of prints, four original linoleums, and a drawing inscribed by the artist "in homage to Mademoiselle Marthe Fequet." (This copy came up at Christie's, Paris, 11 May 2012 but was then withdrawn from the sale.) In several of the letters, he urged her to be patient and explained why he was not yet ready to go to press. "Thus I hope that you can bear the delays caused by my revisions given that the excellence of the book will profit all parties concerned." He originally intended to take credit for the design in the colophon, as he did in some of his later books, but then dropped that idea and let his typographical ingenuity speak for itself. Marthe Fequet must have had some say in the choice of types if only because he had to use what she had in stock. He liked the title-page design for Picasso's *Eaux-fortes originales pour des textes de Buffon* (which Fequet printed for Fabiani in 1942) and adopted it for his book with special

attention to the letter-spacing of the words in caps. The large 20-point text type in the Picasso volume also appealed to him. By his reckoning, he could produce a respectable volume with that type for the text, a smaller Garamond italic for the introduction, and paper the same weight as the handmade Arches in his Mallarmé. It could amount to at least a hundred pages in a format of 30 × 21 or 35 × 25 cm provided that the margins were wide enough (a feature that would also help to unify the two-page openings). He eventually settled on the larger format and larger types, 20-point Garamond italic for the introduction and 24-point Baskerville for the text. The enormous double pica font of Baskerville is impressive and strong enough to stand up against the linocuts, but typographical purists might complain that the French version had been adulterated by recut characters out of keeping with the original Neoclassical design. The font was not large enough for the compositors to set

the text all at once, and they had to resort to placeholders when they ran out of the characters most frequently in demand—the capital *P* in *Pasiphaé,* for example. After one form was worked off, they took from it whatever sorts they needed for the next form and inserted them in the proper places. Although inconvenient for the printers, the double-pica Baskerville contributed to the volume's fine printing credentials by virtue of its exceptional size and peculiar combination of French and English typographic styles.[8]

Pasiphaé was a commercial success and is still considered one of the best of Matisse's illustrated books. The entire edition was sold out by April 1945, despite the turmoil at the end of the war. Pierre Matisse showed a copy to his printer, who said it was of a quality impossible to emulate in America. "When you see a book like that, you might as well close up the shop." Matisse suggested an exhibition in America, and Pierre reported back that the

Museum of Modern Art would like to obtain a copy for that purpose. Likewise, Montherlant wanted it to reach a wider public and recommended that it should be exhibited somewhere so that book collectors would not be "the only ones to enjoy it."[9]

An edition of 250 copies was not sufficient to meet the demand for *Pasiphaé.* As early as June 1943, Matisse was thinking of a companion volume containing the *planches refusées,* maybe thirty altogether printed on large paper or a special paper like Chine or Hollande. It could also include the original linocuts, which might be deemed more desirable on better paper even in a reprinted version. Nothing came of those plans, although he set aside the *planches refusées* with the expectation that they might be used in a future publication. After he died, the linoleum artwork became the property of his estate. His children, Marguerite Duthuit, Pierre Matisse, and Jean Matisse, decided to carry out their father's wishes by producing a set of prints in a format almost identical to the Fabiani edition. They could replicate the typography by going back to Fequet et Baudier, which was still in business and quite capable of printing their edition with the same types and similar paper.[10]

In 1966 the Matisse heirs sent an account of their project to Montherlant and asked his permission to print the captions that had been excerpted from his text. He understood that they did not intend to reprint the entire text and realized that they conceived their edition more as a continuation than an imitation of the original. Nevertheless he believed that their proceedings might injure his financial interest in *Pasiphaé*—the twenty copies he had received as payment in kind. He had held on to them all this time and planned to sell them some day, but they might depreciate

in value if he were to put them on the market in competition with a similar publication. For him to grant permission, he would first need to know what business arrangements had been made and what share of the profits he might expect. The Matisse heirs informed him that they were not engaged in a commercial venture and that they had decided to shelve the project for the time being while reserving the right to publish the *planches refusées,* which were their property, free and clear.[11]

Ten years later, after the death of Montherlant, they resumed work on the project and after many more delays finally published the *Gravures originales* in 1981. The linoleum had begun to deteriorate, and Fequet et Baudier suggested the substitution of photoengraved relief blocks (*clichés*) made from proofs of the linocuts. Marguerite Duthuit agreed that the *clichés* did a better job of preserving the quality of line Matisse had sought in this printmaking medium. In addition to these technical problems, they also had to commission an introduction, enlist a publisher, and decide how to organize the portfolio. By this time, they were able to use the captions, which Matisse believed to be indispensable for the proper appreciation of his prints. They put together suites of prints in folders labeled with the captions, each folder containing *variants* on a theme, a word chosen to prevent confusion with the *variations* documented in *Dessins: Thèmes et variations.* As much as Montherlant balked at the concept of a companion volume, he might have been pleased by the first suite of prints, twelve portraits of the author in succession not unlike the Aragon portraits inspired by *Thèmes et variations.* The concatenation of drawings in that publication explains why a profusion of linocuts could be assembled nearly forty years later for a re-creation of *Pasiphaé.*[12]

⁓

PAGE SIZE: Raisin quarto; 33 × 25 cm.

PAGINATION: [4], 121 [11] pp.; pages [1–4, 127–128 and 131–132] blank.

ILLUSTRATIONS: 18 full-page linocuts included in pagination; 39 headpieces, 26 of which printed in black, 13 in red; 6 tailpieces; and 84 decorated initials in red.

TYPOGRAPHY: Printed by Fequet et Baudier, Paris, the design based on maquettes made by Matisse. Text in 24-point Deberny et Peignot Baskerville roman and italic, preface in 20-point Deberny et Peignot Garamont italic, display in Deberny et Peignot Garamont and Astrée.

PAPER: Mold-made wove vélin d'Arches with the publisher's watermark.

BINDING: Wrappers decorated with linocuts printed in blue, contained in a slipcase and a matching cardboard chemise with a cloth back bearing the title *Pasiphaé.*

EDITION: Printed 20 May 1944. Edition of 250 copies signed by the artist: 30 on Japon ancien with an extra suite of 12 plates on Chine numbered 1 to 30; 200 on vélin d'Arches with the publisher's watermark numbered 31 to 230; and 20 on vélin d'Arches hors commerce numbered I to XX.

COPIES EXAMINED: PML 195598 (no. 40); Beinecke Library Whitney +17 (no. 203).

REFERENCES: Skira 1946, no. 259; Barr 1951, pp. 271 and 560; Strachan 1969, pp. 92–94 and 338; Place 1974, no. 67a; Guillaud 1987, pp. 454–70; Duthuit 1988, no. 10; Monod 1992, no. 8395; Delectorskaya 1996, pp. 129–32.

EXHIBITIONS: Philadelphia 1948, no. 266; Geneva 1959, no. 13; Boston 1961, no. 198; Paris 1970, nos. 197–98; Saint Petersburg 1980, no. 3; Geneva 1981; Fribourg 1982, no. 3; Mexico City 1983; Nice 1986, no. 5; Le Cateau-Cambrésis 1987; New York 1994, p. 113; Paris and Humlebaek 2005, nos. 84–86; New York 2011, no. 24.

22.

Elsa Triolet (1896–1970), *Le mythe de la baronne Mélanie, avec deux dessins de Henri Matisse.* **Neuchâtel et Paris: Ides et Calendes, 1945.**

Matisse became acquainted with Aragon's wife, Elsa Triolet, while conferring with Aragon about illustration projects, mainly *Dessins: Thèmes et variations.* He drew her portrait for a book they eventually abandoned, but his portrait studies are reproduced in *Henri Matisse: A Novel.* Over the course of their conversations, she enlisted him to work on a new edition of her novella *Qui est cet étranger qui n'est pas d'ici? ou, Le mythe de la baronne Mélanie* (1944). The *étranger* mentioned in the title is Albert Camus's *L'étranger* (1942), which inspired this philosophical essay about death, old age, and the eternal question whether life is

worth living. Triolet addressed that question with a story about a noble lady who was able to live her life in reverse: she crawled out of her tomb, returned to her deathbed, and slowly regained her health day by day. Although she could not see into her past, she could endure cheerfully her infirmities, adversities, and disappointments with the knowledge that they would pass and she would eventually attain an earlier and happier state of mind. She relived her passionate youth, recovered her innocence, and retraced her route through infancy up until the moment of conception, whereupon she finally disappeared into nothingness. The new edition omits the first part of the original title, but Triolet's preface and concluding remarks refer explicitly to the concept of *L'étranger* as the opposite of the equally absurd premise of *Baronne Mélanie.*

This lighthearted critique of Camus might have appealed to Matisse, who had his

own reasons to reflect on the problems of old age and mortality. He found a drawing he had done in February 1942 to serve as a frontispiece portrait of Mélanie, a sketch in graphite and Conté crayon showing her in the full flower of youth and beauty. Her luxuriant, wavy hair provides a natural frame for the picture. While the book was on press, he had second thoughts about the portrait and proposed a substitute in the same style that would be better suited for halftone reproduction. He realized that the first portrait would seem faint in juxtaposition with the title page. It was too late to replace it, but Aragon retained the preferred version and used it in a reprint edition.[1]

Matisse also agreed to make a cover design for the book. For the centerpiece of the design he drew two fleurons in a red-crayon rectangle that could be printed in relief beneath the name of the author and the title in capital letters and above the

Fig. 1. Frontispiece and title page, *Le mythe de la baronne Mélanie,* The Morgan Library & Museum

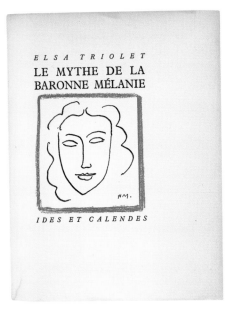

Fig. 2. Front cover, *Le mythe de la baronne Mélanie,* The Morgan Library & Museum

publisher's imprint, also in capital letters. He then decided against the fleurons and replaced them with a line drawing of Mélanie framed in a red-crayon rectangle as in the original design. He charged the publisher 5,000 francs for the frontispiece and the cover design, which he completed sometime between the beginning of October and the end of November 1945.[2]

Like the Cahiers du Rhône, the Ides et Calendes firm was a Swiss publishing house founded in response to the censorship of French authors during the war. It began as a part-time occupation of a lawyer, Fred Uhler, who issued the first book with his imprint in 1941: Henry de Montherlant's *La paix dans la guerre.* Uhler engaged the literary scholar Richard Heyd to work with

him on some publications, most notably the complete dramatic works of André Gide and *Noces et autres histoires russes* by Charles Ferdinand Ramuz and Igor Stravinsky. The composer's son Theodore Stravinsky illustrated this and several other books for Ides et Calendes. After the war, Uhler redirected the firm's operations to concentrate mainly on law, photography, and art books. He retired in 1980, the firm continued under the direction of Alain Bouret, and it became part of the Bibliothèque des Arts of Lausanne after Bouret died in 2011.

Richard Heyd managed the negotiations with Matisse. The original cover design for *Baronne Mélanie* contains the imprint *RICHARD HEYD EDITEUR NEUFCHA-TEL,* apparently because Matisse believed Heyd to be in charge of the publishing firm. Both parties appear to have been pleased by this transaction, which led to another commission, a cover design for the publisher's Collection du fleuron series. Matisse took his original idea for *Baronne Mélanie* and adapted it with the same rectangular composition, author and title above, the imprint below. Instead of the two fleurons, he made a fleuron pattern on a background of pen-and-ink hatching. This fleuron device first appears in André Gide's *Jeunesse* (1945) and can be seen in other Ides et Calendes publications. The firm reprinted *Baronne Mélanie* in 1996, and that too retains the original cover design, although the frame is printed in black instead of red and the format has been reduced. Matisse's elegant design is still evident, despite these economies, and an attempt has been made to cope with the problems of the frontispiece by heightening the contrast and emphasizing the darker tones of the portrait.[3]

PAGE SIZE: 22.8 × 16 cm.

PAGINATION: 55 [9] pp.; pages 1–4, 57–58, and 63–64 blank.

ILLUSTRATIONS: A halftone coated-paper reproduction of a portrait drawing tipped onto the verso of the half title as a frontispiece.

TYPOGRAPHY: Printed at the Imprimerie Kundig, Geneva. Text in 14-point Monotype Plantin, display in Plantin.

PAPER: The mold-made laid Hollande supplied by Van Gelder Zonen, Apeldoorn; the mold-made laid Ingres Guarro supplied by Guarro Casas, Barcelona; the vélin copies on a mediocre-quality machine-made wove.

BINDING: Wrappers, cover design with a portrait vignette by Matisse.

EDITION: Printed 1 December 1945. Edition of 5,182 copies: 13 copies on Hollande numbered 1 to 13 priced at 45 CHF; 100 copies on Ingres Guarro numbered 14 to 113 priced at 25 CHF; 5,000 copies on vélin blanc numbered 114 to 5113 priced at 7.50 CHF; 7 copies on Hollande hors commerce numbered I to VII; 12 copies on Ingres Guarro hors commerce numbered VIII to XIX; 50 copies on vélin blanc hors commerce numbered XX to LXIX.

COPIES EXAMINED: PML 195978 (no. 1); PML 195977 (no. 14); PML 195632 (no. 1127); University of Delaware PQ 2639 .R585 M96 1945 (no. 1554).

REFERENCE: Duthuit 1988, no. 50.

EXHIBITION: Nice 1986, no. 60.

23.

Henri Matisse (1869–1954), *Visages: Quatorze lithographies de Henri Matisse accompagnées de poésies par Pierre Reverdy.* **Paris: Les Éditions du Chêne, 1946.**

This book began with a lithograph portrait of the model Annelies Nelck, *Fillette*, printed for a benefit auction in 1944. Taking part in a worthy cause, Matisse and Bonnard each contributed a painting and twenty-five copies of a lithograph to be sold for the support of evacuated children in southeastern France. Fernand Mourlot printed the lithographs and claimed in his memoirs that he had obtained that commission through the good offices of André Lejard, artistic director of the Éditions du Chêne. While working on *Fillette*, Matisse made fourteen variations of the Nelck portrait, standard practice at that time (see No. 20). Lejard proposed to issue the fourteen drawings as an album of lithographs, a tempting prospect, although Matisse believed that they should be associated with some kind of text. The more he thought about it, the more he liked the idea of a book illustrated in reverse, with the visual component presented as a fait accompli to an author who would then produce a suitable literary accompaniment. Here the image could take pride of place before the act of writing, which would take a subservient position, no longer an entirely original creation but rather a response to an antecedent and autonomous work of art. "This time it is the poet who is the illustrator," he told an interviewer while describing his various publication projects.[1]

The poet he chose for this reversal of roles was Pierre Reverdy, whose *Les jockeys camouflés* he had illustrated in 1918 (Nos. 3 and 4). Reverdy returned the favor in 1919 with a laudatory free-verse review of an

exhibition and remained on friendly terms with the artist ever since. He remembered that book fondly—"Ah! the Jockeys Camouflés! What a happy memory. I am so proud of that first and unforgettable sign of your esteem for me." In the meantime he continued to publish his work with illustrations by such artists as Braque and Picasso, an array of books that would be all the more impressive with another Matisse in the sequence. He gladly accepted the invitation and allowed his friend to decide on the placement of his texts, although he did request an asymmetric layout consistent with his previous publications.[2]

Both were pleased by their renewed collaboration and were eager to be agreeable—so much so that they failed to discuss the basics of the book. They misunderstood each other completely about the rationale of Reverdy's literary illustrations, which Matisse believed to have been made expressly for this publication. Twice he consulted with Rouveyre on how to describe the situation: should the title say that his work had been illustrated or accompanied by the text he had commissioned? Apparently Reverdy did not tell him that the fourteen poems in *Visages* had been previously published—five in *Sources du vent* (1929) and nine in *Plein verre* (1940). Both appeared in extremely limited editions, the first in 116 copies, the second in 60 copies, quantities so small as to seem inconsequential. Even so, it was important to know which came first, the image or the text. The order and type sizes of the names on the title page indicate that Matisse was the progenitor of *Visages*. He may have learned the truth before it was too late because he chose the noncommittal "accompanied" wording, which suggests parity more than precedence. Nonetheless there is a kind of poetic justice in his dealings with Reverdy, who committed a

similar mistake in the titles for the two editions of *Les jockeys camouflés,* both claiming that the books contained "unpublished" drawings of Henri Matisse.[3]

Visages appeared when Matisse's interest in typographical book production was at its peak. After finishing *Pasiphaé* in 1944, he had two other major book projects under way along with this one: *Lettres portugaises* and the Ronsard *Florilège des amours,* "all done according to the same principles." He insisted on complete control of every aspect of design, down to the minutiae of page layout, which he specified in a maquette prepared for the guidance of the printers. The maquette was probably a page-by-page pasteup of the text with ruled guidelines to define the page proportions and rudimentary sketches indicating the placement of initials and illustrations (see, for example, the maquettes made for Nos. 21 and 38). He proposed that if the printers followed his instructions exactly, he would take full

QUATORZE
LITHOGRAPHIES
de

HENRI MATISSE

accompagnées de
POÉSIES
par
PIERRE REVERDY

LES ÉDITIONS DU CHÊNE

Fig. 1. Title page, *Visages,* Frances and Michael Baylson Collection

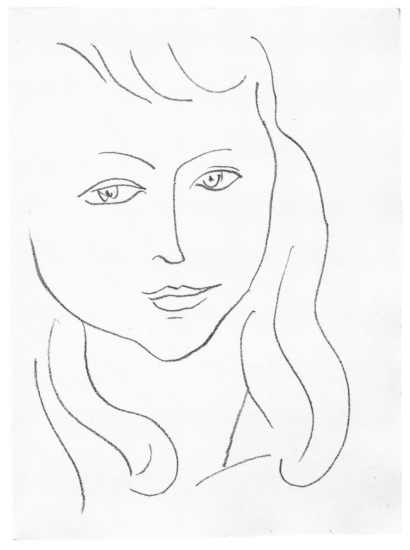

Fig. 2. Lithograph illustration, *Visages,* Frances and Michael Baylson Collection

responsibility for the design of the volume and claim credit for the maquette in the colophon—which he did with an explicit account of his contributions that would also appear in some of his later publications. He wished it to be known that he was, so to speak, the artist of the book, completely in charge of planning and manufacturing the finished product.[4]

Each of the fourteen poems begins with a large pen-drawn initial. Matisse relied on these ornaments to enliven two-page openings in which the text faces the blank verso of the preceding lithograph, just as the lithograph faces the blank verso of the preceding section title. The lithographs, therefore, are to be viewed on their own but are linked to the text by the initials, which form a calligraphic counterpart to the line drawings. At first he experimented with square red initials in the style of *Pasiphaé* but rejected them as being too heavy for the look he was trying to achieve. He decided instead on letters in an English round hand extending into the margin on the left and into a space on the right shaped by indenting four, five, or as many as seven lines of text. A stepped series of indents accommodates slanted letters pitched in a diagonal direction across the page as if to foster the act of reading from left to right. Decorative flourishes lend an additional lilt to a dynamic typographical composition. Matisse gave precise instructions on the violet tint of the initials, based on the Parker ink he had been using in his penmanship studies and intended as a transitional color between the black letterpress and the sanguine lithographs. Above all he wanted to preserve the "sensibility of the hand" and express the velvety nuances of pen on paper. He considered several different reproduction methods, including wood engraving and photogravure, but eventually had to settle for photoengraved line blocks printed in relief, a

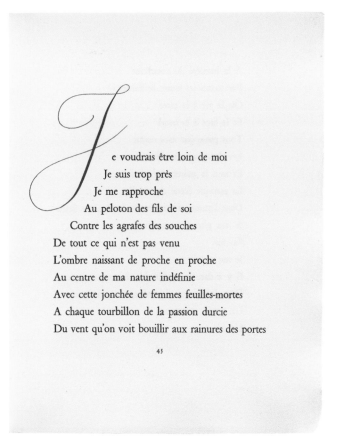

Je voudrais être loin de moi
Je suis trop près
Je me rapproche
Au peloton des fils de soi
Contre les agrafes des souches
De tout ce qui n'est pas venu
L'ombre naissant de proche en proche
Au centre de ma nature indéfinie
Avec cette jonchée de femmes feuilles-mortes
A chaque tourbillon de la passion durcie
Du vent qu'on voit bouillir aux rainures des portes

45

VISAGES

Fig. 3. Ornamental initial, *Visages,* Frances and Michael Baylson Collection

Fig. 4. Linocuts on front cover, *Visages,* Frances and Michael Baylson Collection

process he thought might be too crude for the delicate effects he desired. In any case he seems to have been satisfied by the results: he liked the lettering in *Visages* and used the same style in *Les fleurs du mal* (No. 31).[5]

Displaying white-line decorative patterns on a solid black background, the linocut tailpieces present a striking contrast to the svelte curvilinear initials. Matisse may have been following the precedent of *Pasiphaé* by using linocuts in this way, but he later decided that they threw the book off balance. They overpowered the rest of the page and demanded more attention than was merited by their space-filling function. He sought a less obtrusive decorative scheme for *Les fleurs du mal,* a book similar to *Visages* in the

weight of the initials and illustrations, and found it in a series of tailpieces composed of pen-drawn arabesques, a successful solution to a persistent problem in graphic design. Harmonious or not, the *Visages* linocuts were well served by the impeccable presswork of the printers Fequet et Baudier, who had to contend with the difficulties of achieving a rich and dark impression on two types of handmade paper. They even managed to cope with the passive-aggressive behavior of Montval, an "authentic" (i.e., unpredictable) handmade paper developed by Aristide and Gaspard Maillol for the Cranach Press in 1910–15 and then adapted for commercial production in 1925. Fequet et Baudier received several commissions from Matisse

in this period, as did Fernand Mourlot, who developed an efficient routine for printing lithographs in the absence of the artist. Instead of drawing on the stone and transporting it between Nice and Paris, Matisse produced his designs on sheets of transfer paper and sent them to Mourlot, whose skilled craftsmen prepared the stones and pulled proofs that were then sent back to Nice. Several round trips might be necessary before the final approval could be obtained. Transfer paper is an unforgiving medium, rarely able to admit erasures or revisions, but those constraints were of no consequence in portraits based on an aesthetic of instinct and spontaneity. More important to the artist were the quality of his materials and the

fidelity of the printing processes he employed for the ornaments and illustrations.[6]

The publication of *Visages* and the painstaking efforts to print it properly were made possible by André Lejard. He deserves credit for giving Matisse the means to implement his own ideas about illustrated books at a time when the bookselling business was just beginning to recover from the war and the Occupation. Lejard's publishing company thrived during the Occupation owing to a peculiar set of circumstances that should be explained here if only to show the accidental origins and precarious financial position of fine printing ventures in this period.

Founded in 1940, the Éditions du Chêne was one of several publishing companies directed by Maurice Girodias, who made his reputation, good and bad, by publishing pornographic books along with works of Henry Miller, J. P. Donleavy, William Burroughs, Samuel Beckett, and Vladimir Nabokov. He learned this business model from his father, Jack Kahane, proprietor of the Obelisk Press in Paris, which issued *Tropic of Cancer* and other books condemned by the censors. Girodias's father died at the beginning of the war, and he stayed on in Paris after having changed his name to hide his Jewish ancestry from Occupation officials. Much to the envy of his competitors, he secured a source of coated paper, an essential ingredient of art books, which became a specialty of his firm. He entrusted the management of that part of his business to André Lejard, previously the editor of *Arts et métiers graphiques.* An ardent admirer of Matisse, Lejard published reproductions of his paintings in a handsome album (1943), which sold well enough to justify one or more subsequent editions as late as 1950. He also wrote the preface for the album, which was reprinted without

changes in the 1950 edition, even though it referred to the astonishing youthfulness of the artist "at seventy years of age." (Matisse was eighty-one in 1950.) Girodias was more interested in literature than art, although he was proud to have published a monograph on Picasso's sculptures with photographs by Brassaï. His memoirs barely mention Matisse but contain extensive commentary on his favorite authors interspersed with accounts of his own amorous adventures in the style of Frank Harris and Henry Miller. Eventually he dismissed Lejard at the insistence of a business associate with whom the promiscuous publisher had been having an affair. Not long afterward, the firm fell into the hands of its creditors, who ejected Girodias and turned its assets over to the Librairie Hachette. Girodias then went on to found the Olympia Press in Paris and successfully defied the censors with *Lolita, Candy,* and other plain-brown-wrapper novels until that business, too, was liquidated by the lawyers. *Visages* may be the masterpiece of Éditions du Chêne—but only because Girodias allowed Lejard to deal freely in expensive art books and paid the bills without worrying too much about balancing his books.[7]

PAGE SIZE: Raisin quarto; 33.5 × 25.5 cm.
PAGINATION: [8] 95 [9] pp.; the first and the last leaves blank; the full-page lithographs are included in the pagination.
ILLUSTRATIONS: Lithographs in sanguine printed by Mourlot Frères, Paris, linocut tailpieces and cover ornaments printed by Fequet et Baudier.
TYPOGRAPHY: Printed by Fequet et Baudier, Paris, the design based on a maquette made by Matisse. Text in 24-point Deberny et Peignot Garamont, title page in 48-point Deberny et Peignot Initiales Garamont and

36-point Deberny et Peignot Astrée, section titles in 32-point Deberny et Peignot Initiales Anciennes. Calligraphic initials designed by Matisse and printed from relief blocks in black tinted with violet.
PAPER: Handmade vélin de Montval supplied by Canson et Mongolfier, Annonay; handmade vélin de Lana supplied by Papeteries de Lana, Docelles.
BINDING: Loose sheets in printed wrappers, the title *Visages* on the front cover along with two linocuts, another linocut on the back cover, contained in a beige cardboard slipcase and a matching cardboard chemise with a cloth back bearing the title *Visages.*
EDITION: Printed 27 February 1946. Subscription proposals appeared in the summer of 1945, at which time the publication date was expected to be sometime in September. Matisse inscribed a copy to André Rouveyre on 14 July 1946. 250 copies: 30 copies on vélin de Montval numbered 1 to 30, 200 copies on handmade vélin de Lana numbered 31 to 230, 20 copies on vélin de Lana numbered I to XX. Signed by the author and artist in pencil. Priced at 20,000 francs; a copy sold at the Hôtel Drouot in May 1948 for 12,500 francs.
COPIES EXAMINED: PML 195599 (no. 27); NYPL Spencer Collection (no. 118).
REFERENCES: Skira 1946, no. 261; Barr 1951, pp. 273–74 and 560; Guillaud 1987, p. 471; Duthuit 1988, no. 11; Monod 1992, no. 9688; Hubert 2011, no. 260.
EXHIBITIONS: Geneva 1959, no. 23; Paris 1970, no. 201; Saint-Paul de Vence 1970, no. 89; Saint Petersburg 1980, no. 4; Fribourg 1982, no. 4; Nice 1986, nos. 12 and 13; Le Cateau-Cambrésis 1992, no. 6.

24.
Alternance. **Paris: Le Gerbier, 1946.**

Alternance is a collaborative volume in the same spirit as *Tableaux de Paris* and *Paris 1937* (Nos. 10 and 16). Here, however, the purpose was to cultivate variety for its own sake with no attempt to develop a common theme. The publishers did not specify a subject when they solicited contributions to this book—a series of sixteen texts on different topics, each prefaced by an etching. They looked for uniformity only in the length of the texts and size of the etchings. Each etching occupies the first page of a four-leaf gathering containing just enough printed matter to fill the allotted space, leaving the last page free for the name of the artist whose work appears on the facing page of the next gathering. This is what they meant by *Alternance,* an alternation of artistic and literary work in a precisely regulated sequence intended to maintain the visual coherence and internal logic of the book. An introductory note explains the alternation concept and invites the reader to think of it as a metaphor for change in the cadence of night and day, war and peace, and other phases of human experience.

By giving carte blanche in the choice of subjects, the publishers were able to recruit an impressive list of authors: André Beucler, Pierre Bost, Jean Cassou, Paul Éluard, Léon-Paul Fargue, Jean Giraudoux, Max Jacob, Jacques de Lacretelle, Pierre Mac Orlan, Gabriel Marcel, Thierry Maulnier, François Mauriac, Henri Mondor, Jean Paulhan, Georges Pillement, and Georges Ribemont-Dessaignes. Some of them wrote on what was uppermost in their mind at that moment—the end of the war. Fargue evoked the charm and mystique of liberated Paris, Mauriac remembered what it was like after the First World War, Ribemont-Des-

saignes pondered what it meant to be truly free, and Bost noted that people had developed a taste for travel after they had begun to look abroad over the course of the conflict. Arrested by the Gestapo, Max Jacob died in an internment camp, but two of his letters about his Catholic faith during those trying times were published here posthumously. Others contributed verse, short stories, and literary criticism. Some of the essays were so short that extra leading had to be inserted between the lines to fill out the four-leaf gatherings.

Likewise the artists might have appreciated the opportunity to display their recent work rather than having to fulfill the obligations of an illustration assignment. They submitted landscapes, portraits, an interior, a city scene, and a semiabstract composition. An etching by Jacques Villon precedes verse by Paul Éluard, who dedicated what he had written to Villon; otherwise the reader is free to imagine thematic connections between pictures and texts or else enjoy them on their own as a harmonious ensemble more or less consistent in outlook and style. That was the understanding between Matisse and Pierre Reverdy when they collaborated on *Les jockeys camouflés,* and it was the theoretical basis for the etchings in the Mallarmé, which Matisse viewed more as decorative embellishments than as illustrations in the technical sense of the word. Dated 1945, the etching he made for *Alternance* is a portrait head of a young man rendered with the artist's characteristic simplicity of line, a trait eminently suitable for decorative applications. The etching accompanies an essay on Jean-Baptiste Colbert's political achievements under Louis XIV, but it could have been situated anywhere in this volume. Matisse would resort to another interchangeable portrait when he was called upon to furnish a frontispiece for Jules Romains's *Pierres levées* (No. 36).

Fig. 1. Title page, *Alternance,* Frances and Michael Baylson Collection

The artist Jacques Maret published *Alternance* in association with his wife Marguerite. The Duthuit catalogue states that they had founded a bibliophile society, Le Gerbier, which figures in the imprint of this volume, but I don't know of any other publications issued by this organization. Born in 1900, Jacques Maret came to Paris in the 1920s, became acquainted with the Surrealists and under their influence issued a small-press review titled *Feuillets inutiles* containing his poetry, etchings, and collages as well as contributions by friends such as Max Jacob, André Salmon, and Pierre Mac Orlan. He and his wife printed at least some of the *Feuillets inutiles* by hand on premium paper following the eccentric example of François Bernouard (No. 3). This serial publication does not seem to have been very remunerative, and his other artistic endeavors were not successful. *Alternance* may have been a financial failure, given that it was the first and only book with the Le Gerbier imprint. A book of this size would have required a considerable capital investment in

materials and labor, but the Marets did not stint on the letterpress component, printed on fine paper in three colors at the press of the highly respected typographer Georges Girard (who would later print other books for Matisse). Either Girard or the Marets devised a clever way of expressing the concept of the book by printing the title and contents in alternating colors. Jacques Maret included two of his own etchings at the beginning and the end, as if to demonstrate his proficiency in that medium. Well-connected, versatile, and ingenious, Maret could have made a career for himself in the graphic arts, like Bernouard or Daragnès, but he lacked the means and motivation to run the publishing side of the business.[1]

~

PAGE SIZE: Raisin quarto; 33 × 25 cm.

PAGINATION: 134 [6] pp.; the first and the last leaves blank.

ILLUSTRATIONS: 16 full-page etchings by Jean Cocteau, Jean-Gabriel Daragnès, Hermine David, André Dignimont, Pierre Dubreuil, Édouard Goerg, Valentine Hugo, Jean Émile Laboureur, Marie Laurencin, André Lhote, Robert Lotiron, Jacques Maret, Henri Matisse, Roger Vieillard, Jacques Villon, and Henry de Waroquier. Etched vignette on p. 7 probably by Maret. All of the etchings printed by Camille Quesneville except those of Matisse and Dignimont, which were printed by Roger Lacourière, and the etching by Daragnès, which was printed by Daragnès.

TYPOGRAPHY: Printed by Georges Girard in black, red, and blue. Text in 12-point Monotype Garamond.

PAPER: Handmade Montval supplied by Canson et Mongolfier, Annonay; mold-made Lana à la forme supplied by Papeteries de Lana, Docelles. The BFK Rives is a mold-made wove.

BINDING: Wrappers printed in red and blue, contained in a tan cardboard slipcase and a matching cardboard chemise with the title printed on the spine.

EDITION: Printed 21 March 1946. Edition of 340 copies: 38 copies on Montval numbered 1 to 38, 262 copies on BFK Rives numbered 39 to 300, 40 copies hors commerce on Lana numbered I to XL. Priced at 10,000 francs.

COPIES EXAMINED: PML 195600 (no. 140); BnF Res G-Z-142 (no. V).

REFERENCES: Skira 1946, no. 370; Barr 1951, p. 560; Duthuit 1983, no. 268; Duthuit 1988, no. 12; Monod 1992, no. 206.

EXHIBITION: Nice 1986, no. 66.

Fig. 2. Contents, *Alternance,* Frances and Michael Baylson Collection

Fig. 3. Etching, *Alternance,* Frances and Michael Baylson Collection

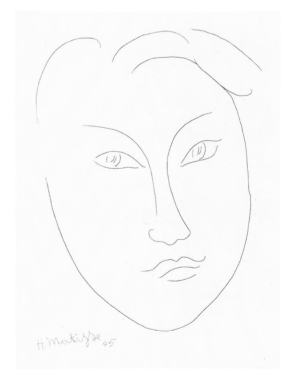

25.

Tristan Tzara (1896–1963), *Le signe de vie,*
avec six dessins et une lithographie originale
de Henri Matisse. **Paris: Bordas, 1946.**

Like *Midis gagnés* (No. 37) this volume
contains six drawings by Matisse reproduced
in line. He selected them on the same
principle, seeking to provide a pleasing visual
accompaniment to the text without referring
to its particulars. He may have read it only
after the fact. Nevertheless he had to choose
images of a suitable size and in a consistent
style that could meet the technical require-
ments of letterpress printing. This task must
not have been too difficult, given the
quantity of drawings he accumulated just a
few years before when he rediscovered that
medium and produced the work docu-
mented in *Dessins: Thèmes et variations.* The
illustrations here, a still life and several
portraits of women dating between 1942 and
1944, could just as easily have been part of
that volume and would not have been out of
place in *Midis gagnés.* In addition, Matisse
agreed to supply artwork for a frontispiece
lithograph, which he signed in the fine-
paper copies. The frontispiece is a portrait of
his grandson Claude Duthuit, who appears
in several almost identical lithographs
printed at that time.[1]

This is one of five collections of poetry
Tzara published in 1946 (each one illus-
trated by an artist of his acquaintance—
Jean Arp, Max Ernst, Henri Laurens,
André Masson, and Henri Matisse). With
these volumes Tzara returned to the public
eye after having to go into hiding during
the Occupation, a hunted man because he
was Jewish and known to have leftist
political persuasions. He escaped more than
once from the police and the Gestapo while
moving from town to town until he found a
refuge of relative safety in a village of

southwestern France, where he became an
active member of the Resistance. As a poet
he was mostly silent during this difficult
period, although he allowed his work to be
printed at a clandestine press and in
journals sympathetic to the cause. He
continued to write and waited for a more
propitious time to resume his literary career.
Dating between 1938 and 1945, the twenty
poems in *Le signe de vie* are mostly about
the war, the fall of France, and the distress
of the defeated nation. There seems to have
been no hope for the salvation of the
country, no place to turn for relief or
protection. In the midst of all this, he took
some solace in the confraternity of the
avant-garde with an affectionate tribute to
the Czech Surrealist Vítězslav Nezval and a
eulogy of the Spanish poet Antonio
Machado. The tribute to Nezval begins and
ends with a pastiche of Apollinaire's famous
love poem, "I think of you my Lou," in
which Tzara remembers a romantic
adventure he had in Prague and acknowl-
edges the influence of Apollinaire, who
acted as a "mill of knowledge" and a
"crossroads" for the modernist writers of his
generation. His memories of poets past and
present and his pride in his vocation took
on a new meaning after the Liberation. To
give a title to this book Tzara could look
back at the verse he had written while living
underground and think of it as an affirma-
tion—a sign of life.[2]

Le signe de vie was the first book pub-
lished by Éditions Bordas with illustrations
by a major artist. The brothers Henri and
Pierre Bordas founded this firm when they
came to Paris in 1946. They had already
learned something about the publishing
business in Grenoble, where they issued
some books with the imprint Éditions
Françaises Nouvelles. The BORDAS EFN
watermark in this volume is a vestige of their
former venture. They started with an eclectic

list—novels, poetry, children's literature, and
some demiluxe illustrated books—but soon
discovered a profitable market in school
books, steady-selling merchandise with a
predictable clientele. Their competitors had
been content to produce the same tired texts
on dismal paper and in a rote, old-fashioned
format unrelieved by graphic features that
might encourage students and help them to
comprehend the subject matter. The colorful
and enticing Bordas publications arrived just
in time to capitalize on the growth of public
education during the baby boom of the 1950s.
Henri Bordas looked after the core business
of the firm, while Pierre Bordas sought new
opportunities in related fields such as
reference books, study guides, an atlas, a
dictionary, and reprints of classic texts. After
the death of Henri Bordas in 1967, his
brother carried on alone, although he became
increasingly dependent on bank financing to
support the expansion and modernization of
the firm. He fell out with his financial
partners and quit in 1977, but Éditions
Bordas still retains his name and continues to
publish educational texts at learning levels
from infancy up to college.[3]

Pierre Bordas built up a sideline in
contemporary literature after becoming
friends with Tristan Tzara, who introduced
him to artists and authors in his circle.
Through Tzara he became acquainted with
Paul Éluard, Balthus, and Picasso. He
published Éluard's *Le dur désir de durer* in
an edition illustrated with pochoirs after
Marc Chagall in 1946 and a second edition
with an English translation by Stephen
Spender in 1950. It was Tzara's idea that he
should deal with Matisse directly in regard
to the lithograph frontispiece for *Le signe de
vie.* This way, apparently, the artist would be
less likely to reconsider the somewhat
reluctant promise he had made to take on
this commission. Bordas called on him as
instructed and received a sheet of litho-

Fig. 1. Frontispiece and title page, *Le signe de vie,* Frances and Michael Baylson Collection.

Fig. 2. Illustration and facing text, *Le signe de vie,* Frances and Michael Baylson Collection

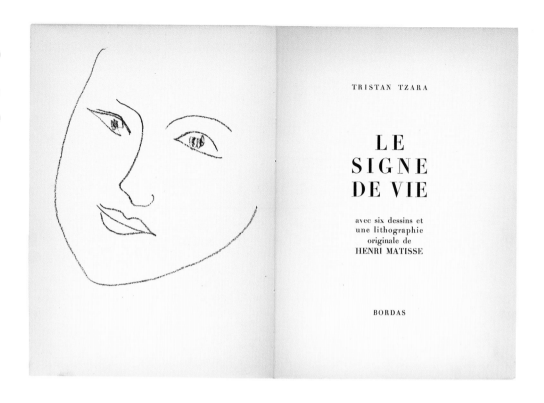

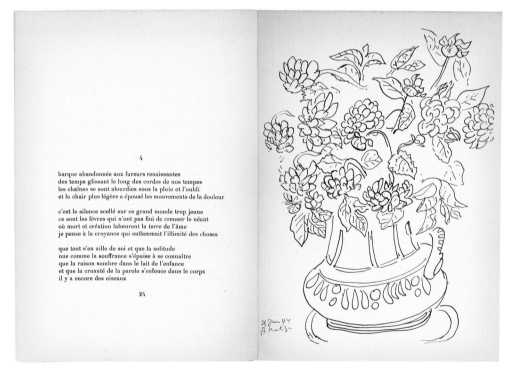

graphic transfer paper containing a "miniscule" register mark, which he inadvertently neglected during the proofing process. When Matisse saw the proofs he declared that the image was out of alignment and reproached the novice publisher for his ineptitude. In his own defense, Bordas brought out a ruler, which confirmed that the artist was right: the image had shifted by half a millimeter. Some years later Bordas would produce another book by Tzara with lithographs by Picasso, who already knew the publisher by reputation. "Ah," he said at their first meeting, "you are the one who skews pictures."[4]

As usual the lithograph was printed by Fernand Mourlot. Bordas hired him to print lithographs for other publications, a cordial relationship cemented by Bordas's marriage to his daughter. These family ties reassured artists who respected Mourlot and trusted him to obtain the best possible results in partnership with his son-in-law. Léger, Miró, and Cocteau are among those who did business with both members of the family. Mourlot sometimes furnished lithographs to accompany text printed by Joseph Zichieri, who produced at least three books for Bordas during 1946: *Le signe de vie*, Serge Lifar's *Pensées sur la danse* with illustrations by Maillol, and Philippe Soupault's *L'arme secrète* with six reproductions of drawings and an original lithograph by André Masson. Zichieri seems to have been active as a master printer mainly in the 1940s and 1950s. Austrian by birth, he had planned to emigrate to America, but on his way in 1914 he passed through Paris and was

detained as an enemy alien. He stayed in France after he was released, married a French woman, learned the printing trade, and practiced it successfully enough to set up on his own. He worked at various addresses in Paris, except during the Second World War, when he was employed at the Imprimerie Oberthur in Rennes. He executed the presswork and supplied the typographic hardware for *Le signe de vie* but looked to someone else for design ideas. Tzara no doubt approved the design and must have had some part in the decision to print the entire text in lower case with no punctuation. The elegant layout of the title page may have been the work of André-Charles Gervais, production manager and chief designer of the Bordas firm. One of Bordas's first books is Gervais's *Propos sur la mise en scène* (1943), which has a letterspaced title design similar to this one. Gervais collaborated on the page layout of *Le dur désir de durer* and received sole credit for that task in the colophon of *L'arme secrète*. His grateful employer regarded him as his right-hand man and called him "the artisan of our first success" in recognition of his role in producing the attractive school books that made Bordas a household name.[5]

❧

PAGE SIZE: Raisin octavo; 25 × 17.5 cm.
PAGINATION: [3] 56 [8] pp.; pages [3–6 and 63–64] blank.
ILLUSTRATIONS: Frontispiece lithograph printed by Mourlot Frères; 6 full-page photoengraved relief-block reproductions of ink drawings included in the pagination.

TYPOGRAPHY: Printed by Joseph Zichieri. 14-point text type and display in the Didot style.
PAPER: The BFK Rives is a mold-made wove with the watermarks of the Rives and Bordas firms. (The EFN watermark refers to an early publishing venture of the Bordas brothers, Éditions Françaises Nouvelles.) The Rives vélin à la forme is a mold-made wove with the Bordas watermark, the same weight and grain as the BFK Rives but of lesser quality and now somewhat browned.
BINDING: Printed wrappers, the front cover design same as the title page.
EDITION: Printed 15 May 1946. Edition of 540 copies: 10 copies on air-dried, hand-made chiffon d'Auvergne lettered *A* to *J*; 330 copies on BFK Rives, of which 30 are numbered I to XXX, including 3 designated by name, and 300 copies numbered 1 to 300 and signed by the author and artist; 200 copies on Rives vélin à la forme numbered 301 to 500. Inscribed to Lydia Delectorskaya in July 1946. Priced at 1,500 francs.
COPIES EXAMINED: PML 195601 (no. 333); PML 141542 (no. 104); HRC PQ 2639 Z3 S545 LAK (no. 482).
REFERENCES: Skira 1946, no. 260; Barr 1951, pp. 261 and 560; Berggruen 1951, no. 25; Harwood 1974, no. 34; Tzara 1975, vol. 3, p. 606; Duthuit 1988, no. 13; Monod 1992, no. 10815.
EXHIBITIONS: Geneva 1959, no. 19; Saint Petersburg 1980, nos. 29 and 97; Fribourg 1982, no. 21; Nice 1986, nos. 67 and 67 bis.

26.

Paul Léautaud (1872–1956), *Choix de pages de Paul Léautaud par André Rouveyre, avec une introduction, des illustrations et des documents bibliographiques*. Paris: Éditions du Bélier, 1946.

Matisse was already working on *Repli* with Rouveyre when he agreed to supply a frontispiece portrait for *Choix de pages*. He initially refused the commission but then accepted it for reasons of friendship and professional courtesy. He followed his usual procedures and seemed pleased by the results but did not reckon with the legendary irascibility and intransigence of his subject, who disliked the portrait and proceeded to criticize it openly. During several sittings, Léautaud had listened to the artist's explanations of his methods but rejected them out of hand and refused to accept some of his basic artistic principles. Matisse wrote an apologia for his portrait drawings a few months after this awkward episode, which caught him by surprise and convinced him that he needed to prevent similar misunderstandings. This account of *Choix de pages* will show how he became involved in that publication and what he learned from it.

During the war years, Matisse renewed his friendship with Rouveyre, who was also living in the south of France. They corresponded frequently about literary subjects, reflecting new interests on the part of Rouveyre, who had changed careers and now considered himself more of an author than an artist. He had been writing a theater column for *Le mercure de France* and published two novels, which failed to sell because of his convoluted style, an unfortunate affectation he had acquired from studying the rhetoric of Baltasar Gracián. Several publishers rejected his work; André

Gide broke with him after losing patience with one of his novels; and not even Matisse could read his prose. To make matters worse, he suffered from a kind of writer's block, and his family income had dwindled to the point where he had to cut back on his expenses and find cheaper accommodations. He rarely referred to his financial problems, but Matisse knew about them and tried to help by collaborating on some of his projects. Rouveyre was all the more grateful for the frontispiece portrait in *Choix de pages* because it enhanced the prestige and salability of a book intended to produce extra income for him as well as Léautaud.[1]

Léautaud also suffered privations during the war. For fifty years he had been a fixture on the Paris literary scene, an author of memoirs and a novel, a writer for *Le mercure de France*, where he had published poetry, essays, and reviews since 1895. He had become famous for his fiercely reclusive lifestyle, his distrust of the establishment, his unconventional and implacable opinions, and his outspoken criticism of people in power. Jules Romains never forgave him for a blistering review (reprinted in *Choix de pages*). It was well known that he had been writing his memoirs, a monumental work amounting to thousands of pages in manuscript, which was supposed to be published posthumously. It was to be not so much a diary as a chronicle of cultural affairs by someone who had viewed them from behind the scenes. No doubt it would contain piquant insights and scandalous revelations. As one might expect, Léautaud had made his share of enemies over the years and was sometimes left to fend for himself. In 1941 he lost his job at *Le mercure de France* and had nothing to live on except a meager pension. At one point he had to do without bread for eleven days. Rouveyre made it his business to look after the "dear cynic" and sought to help

him with gifts of cash as well as shipments of emergency provisions, which he solicited from Matisse.[2]

From the very beginning, Léautaud was dubious about the *Choix de pages* project and consented to it only because he felt indebted to Rouveyre. It was to contain a sampling of his theater criticism, choice extracts from his memoirs, some autobiographical remarks, and other writings with a commentary and an introduction by Rouveyre. Léautaud disliked the idea of publishing his selected works, a concept better suited to a successful author with an established reputation. He refused to read the introduction but heard that it was going to be a panegyric that would make him look ridiculous. In general he objected to fine editions. Apprehensive remarks about the book, "its pretentious dithyrambs, its masquerade, its array of illustrations," recur regularly in the journal entries he made when he was conferring with Rouveyre and the publisher Mathias Tahon. Rouveyre could barely contain his excitement about the money they would receive, although he habitually exaggerated the amount until finally Tahon proposed in writing to pay each of them a lump sum of 109,830 francs upon publication. Years later Léautaud would note in his journal that he had, in this transaction, paid off his moral debts to Rouveyre, who was originally supposed to receive only a third of the proceeds, but Léautaud insisted on splitting them fifty-fifty.[3]

Tahon granted generous terms, hoping that *Choix de pages* might lead to other more lucrative or prestigious publications. He had already published a pamphlet by Léautaud in a large edition, which sold out in less than a year. At least twice he asked for the rights to publish the memoirs and tried even more persistently to obtain permission for an edition of letters between Léautaud and Rouveyre, who demanded an

exorbitant sum for his side of the correspondence. Léautaud repudiated both of those projects after deciding that he owed the journal to *Le mercure de France* and that Tahon lacked the taste, talent, and commitment to succeed in the publishing business. The Éditions du Bélier were in fact only a part-time occupation for Tahon, an official in the Ministry of Finance, who nonetheless built up a strong list of steady sellers featuring the complete works of the playwright Georges Feydeau. Tahon began in 1930 with limited editions printed or illustrated by the Schmieds, father and son. His fine printing sideline foundered when the economy collapsed in 1932, but he started again in 1942. Just before *Choix de pages,* he published a book with reproductions of unpublished drawings by Picasso; just after, he commissioned another frontispiece portrait from Matisse (No. 30).[4]

How much he paid Matisse is hard to say, although Léautaud wanted to know the cost of his portrait and tried to get accurate information from Rouveyre. At first Rouveyre said that the artist would retain twenty of the special copies to sell at a later date. A few days later he put the price of the specials at 1,000 francs and assured the fretful Léautaud that not all of that profit would go to the publisher. But then Léautaud discovered that only five copies had been designated hors commerce and that Matisse took only two of them, one of which he gave to the Bibliothèque Doucet. Angrily he upbraided his informant, who then changed his story and declared that the mercenary artist would insist on payment in cash, as much as 30,000 or maybe even 40,000 francs. He decided that these figures also could not be trusted, assuming at that point that the specials would fetch 2,000 francs each or 90,000 francs altogether, leaving at most only 60,000 francs for the publisher, who would

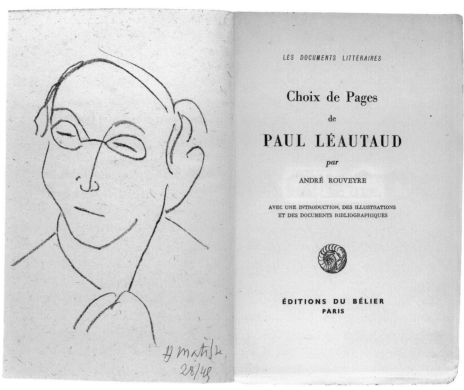

Fig. 1. Frontispiece and title page, *Choix de pages,* Frances and Michael Baylson Collection

still have to defray the cost of the paper and printing. Rouveyre told him not to worry about the portrait because Matisse produced it purely as a commercial transaction, but he could not reconcile these cynical assurances with evidence of Matisse's generosity to him, Tahon, and other people involved in this publication.[5]

At first Rouveyre asked for a portrait drawing he might reproduce as a frontispiece, presumably expecting to use it in all copies of the edition. Matisse was in Paris at that time and was too busy preparing for his return trip to Vence to take on this assignment. He expressed his regrets but then changed his mind and invited Léautaud to visit for a series of sittings during August 1946. Rouveyre was present on some of these occasions, perhaps also in

the company of the librarian of the Bibliothèque Doucet, Marie Dormoy, a devoted friend and sometime lover of Léautaud. While working on the portrait, Matisse exchanged pleasantries and gossip with his sitter, who recorded some of their conversations in his journal along with his own observations on the artist's working methods. He noted when he had to change his pose and when he maintained the same pose for sittings on successive days. At the end of one session, Matisse laid out a dozen drawings on his bed and requested the opinion of Rouveyre, who picked out three "particularly interesting and remarkable" examples. The selection process would recommence the next morning, after the artist had put them up on his bedroom wall. "The likeness doesn't matter," he told

Léautaud more than once, "but rather the cumulative effect in the mind of the painter resulting from all these studies and drawings, from a certain familiarity with the model acquired by research and knowledge, in a word, the outcome of everything that contributes to the definitive portrait." If he wished, he could do it in the style of Quentin de La Tour, or he could produce a suitably recognizable design in half an hour, but "that doesn't interest me. I want, I seek something else." They also discussed the printing of the portrait, which would not be a photolithographic reproduction as originally proposed but an original signed lithograph inserted in a small number of fine-paper copies. The lithographer Fernand Mourlot came to call one day just before the departure of Léautaud, who got confused and thought that Mourlot was a paper merchant supplying a quantity of Chine for the lithographs. Similar lapses occur in other journal entries, but some of them contain technical information sufficiently reliable to be used in the following bibliographical description of *Choix de pages*.[6]

After a couple of sittings, Léautaud began to express doubts about the portrait project. He conceded that a picture of photographic accuracy would not be very interesting, but he believed that artists like David and Ingres had succeeded without any attempt at interpretation or any alteration of perceived reality. He insisted on some traits of resemblance in his portrait. "How am I going to fare in the hands of Matisse?" he wondered. "I have not yet been given a true likeness. It will be amusing to see if it will be this time around." Finally, on the 27th of August, Matisse showed the drawing he had chosen for the frontispiece, expressed his satisfaction with the selection, and recounted once again his philosophy of portraiture.

Léautaud did not describe how he behaved at that meeting but in the privacy of his journal declared the portrait a disaster, a shameful travesty he would hate to see in *Choix de pages.* "I can't say anything and I will have to let it happen." The more he thought about it, however, the more resentful and suspicious he became. Although he did not stop the picture from being published, he complained about it repeatedly in his journal and in conversations with Dormoy and Rouveyre, whose maladroit attempts to defend Matisse only exacerbated the situation. At first Rouveyre tried to divert attention from the portrait by describing it as a business transaction undertaken purely for mercenary motives. That was why Léautaud was so intent on finding out the terms of payment and so annoyed to discover that Matisse was more generous than he had been led to believe. Under pressure Rouveyre admitted that his friend might be guilty of self-deception and that the portrait might be a failure, which he tried to excuse by saying "Yes, yes, but because of things like that Matisse is considered a very great artist, a very great painter, and enjoys such a high reputation." Léautaud constantly reproached Rouveyre for that last hypocritical remark, and years later, when the culprit denied ever having said such a thing, became even more convinced that he was "a Tartuffe and a total liar."[7]

Léautaud found another reason to be displeased with the frontispiece when a review of *Choix de pages* appeared in *Les nouvelles littéraires.* The editor asked for a portrait to accompany the review, but Matisse rejected the idea of using the frontispiece on the grounds that it was conceived for a limited edition and should not be reproduced in quantity. By refusing this request he gave his aggrieved client an additional reason to accuse him of venality.

Rouveyre agreed to work up a substitute suitable for publication on the basis of sketches he had made a few days before but put aside while these discussions were under way. His portrait was little more than a pen-and-ink caricature like those he had once made for satirical magazines, but Léautaud pronounced it to be greatly superior to the frontispiece and concluded that Rouveyre was "a hundred times" better qualified to draw a likeness. The caricaturist was delighted to see his work in print once again and facetiously compared his impromptu characterization with the arduous labors of the master.[8]

Rouveyre may have mocked Matisse behind his back, but he genuinely liked the frontispiece—the "crowning glory" of *Choix de pages*—and hoped that it would not set one friend against another. He joined in or may have organized an elaborate attempt to appease Léautaud at a tea party hosted by Matisse, who wished to say farewell before heading south for the winter. Marie Dormoy and Matisse's secretary, Lydia Delectorskaya, were also present. The guest of honor enjoyed the artist's hospitality—and the excellent pastries—until he learned the real reason for this festive gathering, a surprise gift of an original drawing for the frontispiece. It was presented in an elegant frame decorated with silver leaf and bore an amicable inscription in verse that had been ghostwritten for Matisse by Rouveyre. The frame was so large that Léautaud could not take it home and gave it to Dormoy, who later picked it up in her car and kept it at her place. He did not bother to read the inscription and gave the drawing only a glance before deciding that it was no better than the frontispiece. Not a word was spoken. Somewhat disconcerted, Matisse later asked Dormoy if he was pleased by the gift, and she did her best to explain away his stony silence: "Pleased? He is more than pleased. He is astonished, speechless, and

extremely touched by such a gift. Never would have he expected it." Léautaud left it with her for a few months and then sold it behind her back, not for the money, he claimed, but for his own critical satisfaction. She had hoped to retain it as a memento and then bequeath it to the Musée d'Art Moderne. Infuriated by his treachery, she told him that he had been paid only a fraction of its true value and that she would have gladly bought it at that absurdly low price, 40,000 francs. Instead, Rouveyre bought it from a Paris bookseller at a significantly higher amount and eventually donated it to the Musée des Beaux-Arts at Nîmes. He finally fell out with Léautaud, who continued to fret about the frontispiece and may have referred to it in a radio interview in 1951. The next day Rouveyre asked Matisse if he had heard the interview and confessed that he could not quite make out the "megalomaniac drivel" his former friend had uttered on the subject of the artist but understood enough to realize that he too had been mentioned in that broadcast.[9]

The frontispiece could be considered a sympathetic likeness in comparison to other portraits of Léautaud. Matisse's lithographer printed proofs of eleven preparatory studies, showing the sitter in various moods, genial at times but mostly bored, belligerent, and maybe even a little melancholy. The decision was made to accentuate his most attractive features, traits one might expect in an author—the rumpled demeanor, the set of his mouth, and the quizzical expression in his eyes suggesting curiosity and intelligence. At best an amiable eccentric, at worst an angry old man, he did not appear to his best advantage in the photographs Rouveyre chose to reproduce in *Choix de pages*. A series of portraits by Jean Dubuffet were even less flattering. Léautaud noticed that Dubuffet had been sketching him on the sly during the literary luncheons hosted

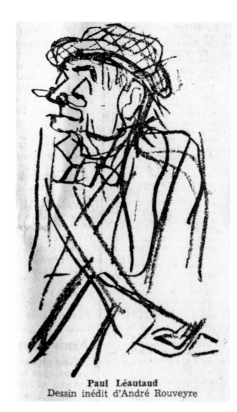

Paul Léautaud
Dessin inédit d'André Rouveyre

Fig. 2. André Rouveyre, caricature of Paul Léautaud in *Les nouvelles littéraires*

Fig. 3. Jean Dubuffet, *Paul Léautaud,* etching and aquatint, Museum of Modern Art

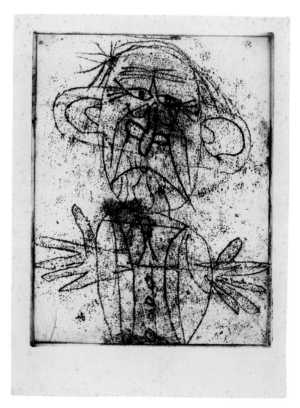

by the art patron Florence Gould. He refused to look at one of these pictures, which, Gould gleefully assured him, was "truly a horror," a prime example of the deliberately crude and provocative designs of Dubuffet in the primitivist style he had adopted at that time. Dubuffet was sufficiently intrigued by his subject to produce two paintings, two etchings, and at least two drawings in different media, including a charcoal drawing consigned to the New York gallery of Pierre Matisse. He tried to obtain a copy of *Choix de pages* with the frontispiece, which he wanted to compare with his own work, but failed because of the expense and scarcity of the fine-paper version. Pierre Matisse helped by interceding with his father, who agreed to provide a photograph. Both artists were curious about each other's ventures in this field. Matisse saw some of Dubuffet's portraits while visiting Gould and praised them in a letter to Rouveyre.[10]

"So much work, so many studies to end up with that. How could someone fall in such an aberration?" This was Léautaud's astonished reaction when he first saw the design Matisse had selected for the frontispiece. Years later he recalled that he had been summoned for twelve sittings, surely an exaggeration, but he was correct about the amount of effort expended on the assignment. The novelist Henry de Montherlant sat for Matisse on at least eight occasions, and the artist still was not satisfied, although he produced seventeen drawings he would later use as the basis for illustrations in several books. This gradual process of trial and error became standard practice for frontispiece portraits. Léautaud's hostile criticism convinced him that

he needed to explain what he hoped to achieve with his portraits, if only to defend himself against accusations of being capricious and insincere. He wrote an account of his working methods for an exhibition catalogue in 1947 and arranged for it to be translated into English a year later. This essay expresses in theory what he intended to accomplish in practice with his multiple studies of Léautaud, all contributing to "the artist's penetration of his subject." Similar remarks about attempts to convey "the character of a face" appear in *Jazz* (1947). Likewise the preface he wrote for *Portraits* (1954) describes the rapport an artist needs to establish with the subject and the instinctive "mental fermentation" required to develop and synthesize visual impressions recorded during several sittings. Published posthumously, this text sums up Matisse's opinions on portrait drawing and shows what an important part it played in his artistic career.[11]

Frontispiece portraits take on a special meaning by their placement in a book—facing a title page, they help it to identify the author, announce the subject, and set the mood of the reading experience. In this context a portrait is a portal, an entryway designed to be inviting and informative. Matisse understood the function of the frontispiece, a traditional typographical device that allowed him to experiment in ways that appealed to his highly cultivated literary sensibility. He enjoyed the company of authors and was glad to participate in the publication of their work, even though he could not always control the results and sometimes had to contend with unexpected repercussions.

PAGE SIZE: 25 × 16 cm.

PAGINATION: 364 [3] pp.; pages 1–2 and 365–66 blank.

ILLUSTRATIONS: The copies on Arches with a frontispiece lithograph printed by Fernand Mourlot, Paris, signed by Matisse in pencil; 10 halftone plates on coated paper.

TYPOGRAPHY: Printed at the Imprimeries Paul Dupont, Paris. Text in 11-point Monotype Garamond, commentary in 11-point Monotype Gloucester (Cheltenham).

PAPER: The lithograph on Chine, 50 copies of the letterpress portion printed on mold-made pur chiffon d'Arches supplied by Papeteries d'Arches, 350 copies on machine-made imitation laid vergé gothique teinté probably manufactured by Papeteries Navarre, 3,000 regular copies on low-quality machine-made wove. Some copies with a pasted-in cancel slip correcting a phrase at the end of the limitation statement, which called for specials on pur chiffon de Rives.

BINDING: Printed wrappers.

EDITION: Printed 30 September 1946 and issued before 7 February 1947. An edition of 3,400 copies: 50 copies on Arches with the Matisse portrait numbered 1 to 45, priced at 2,000 francs, and I to V hors commerce; 350 copies on vergé gothique teinté numbered 46 to 380 and VI to XX; 3,000 ordinary copies priced at 475 or 500 francs.

COPIES EXAMINED: PML 195602 (no. 28); PML 195956 (no. XIV); Princeton University Library PQ 2623 .E14 C465 1946 (ordinary copy).

REFERENCE: Duthuit 1988, no. 14.

EXHIBITIONS: Geneva 1959, no. 40; Saint Petersburg 1980, no. 30; Nice 1986, no. 68; Paris 1995, no. 259.

27.

Gabriel Joseph de Lavergne, vicomte de Guilleragues (1628–1685), *Lettres [de] Marianna Alcaforado, lithographies originales de Henri Matisse.* **Paris: Tériade Éditeur, 1946.**

Illustrated editions of the *Lettres portugaises* were a staple of the book trade during the 1940s. The steady sales of this title encouraged publishers to think of it as a safe investment, even though several different versions were already easily available, some embellished with wood engravings, others with lithographs. That is probably why the poet, critic, and part-time publisher Pierre Guéguen (1889–1965) approached Matisse in 1945 with the idea that they might enter the fray with a new interpretation of that classic text. By enlisting a celebrity, Guéguen could hope to gain a foothold in the luxury market with a maximum of publicity and a minimum of risk. His firm, Éditions Ariel, did not have a reputation in the fine printing business, and he did not have the means, connections, or know-how to assure the success of such a venture. Matisse turned him down but saw the merit in his proposals and decided to take the project elsewhere. He made some preliminary drawings during the spring of 1945 and discussed the book with his friend Tériade, who agreed to publish it, even though both of them were already struggling with *Jazz* (No. 34).[1]

Matisse was well acquainted with the *Lettres portugaises* and had referred to them in a letter to Rouveyre sometime before he concluded his negotiations with Guéguen. He knew about their enduring popularity, their important place in the history of French literature, and their significance as a model of epistolary prose and a rhetorical set piece on the theme of regret and desire. They tell a story of unrequited love in five letters purportedly written by a Portuguese nun to a French military officer who had seduced her while he was billeted near her convent. They begin with pleas and reproaches after he returns to France and end on a note of bitter resignation after she decides to renounce her faithless lover, who turns out to have been less important in his person than the sentiments he inspired in her heart. It is understood that she had been trained in the art of absolute devotion as well as other mental exercises that shape the subtle interplay of feelings and the psychological insights in the letters. Like the letters of Héloïse, they display a tragic intensity of passion, but they attain an anguished eloquence all their own while running a gamut of emotions, from anger to despair.

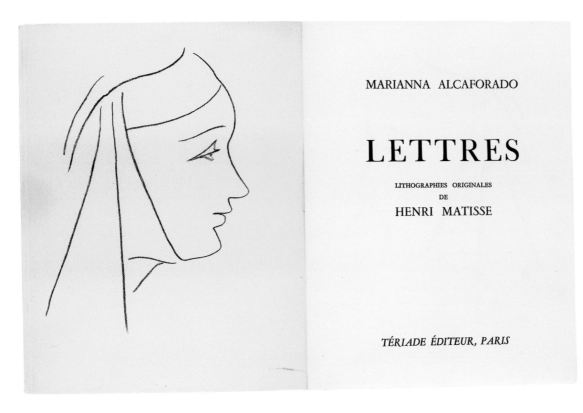

Fig. 1. Frontispiece and title page, *Lettres portugaises,* Frances and Michael Baylson Collection

MARIANNA ALCAFORADO

LETTRES

LITHOGRAPHIES ORIGINALES
DE
HENRI MATISSE

TÉRIADE ÉDITEUR, PARIS

The first edition of 1669 appeared without any indication of its origins or authorship. It created a sensation in literary circles partly because it was so mysterious and tantalizing in the dearth of information it divulged about this illicit affair. Commentators could not resist the temptation of trying to identify the lovers and concluded that the nun was Marianna Alcoforado and the soldier was Noël Bouton, marquis de Chamilly, both historical personages who were at the right place at the right time. Speculation, conjecture, and repeated rounds of wishful thinking continued along these lines for many years. Between 1926 and 1962 scholars began to dispute this romantic scenario on the basis of documentary evidence designating the *Lettres portugaises* a work of fiction attributable to the journalist and diplomat Gabriel de Guilleragues. His name appears in a manuscript recording a royal privilege granted to the publisher of the first edition. Some obstinate Alcoforadists have refused to accept this attribution on the grounds that the letters could not possibly have been written by a man, much less the "pale Guilleragues." Matisse adopted the position that Guilleragues had translated the letters and endorsed that theory in a postscript to this volume. The bibliographical niceties did not concern him as much as the artistic potential of the story, a prime opportunity to try his hand on a series of portraits like *Visages,* except these would have a closer, more compelling relationship with the text.[2]

Matisse brought the *Lettres portugaises* project to Tériade knowing that he could trust his friend to publish it entirely on his terms and in accordance with his specifications. He wrote a draft of the contract that Tériade was to transcribe, sign, and return for him to keep as a record of their agreement. They agreed on its provisions all the more easily because they had engaged in similar transactions since 1928 or 1929. Their long-standing relationship has already been described in detail, and I will only summarize it here to show what expectations they had for this edition and what influence it had on their other publication projects.

Originally named Efstratios Eleftheriades, Tériade (1897–1983) was born and raised in a small village on the island of Lesbos, where he and his family took part in a vibrant Francophile cultural community. He came to Paris in 1915 or 1916 and studied law there for a while but preferred to mingle with artists and writers in the fashionable café society of that time. His countryman Christian Zervos gave him a grounding in journalism by recruiting him to contribute reviews and articles for the magazine *Cahiers d'art* between 1926 and 1931. He wrote for other journals as well and eventually became associated with the daily newspaper *L'intransigeant,* for which he produced a series of interviews with Matisse beginning in 1929. Touching on topics such as the impact of Fauvism, the trip to Tahiti, and the art scene in America, these interviews mark the beginning of their friendship and are now considered a valuable resource for understanding the theoretical basis of Matisse's work.[3]

Tériade probably helped Matisse in the design and production of Mallarmé's *Poésies* (No. 13), published by Skira in 1932. He joined Skira's publishing firm in that year as the artistic director, in which capacity he would have supervised the composition and presswork of the text and the proofing of the illustrations. Several sources credit him with a leading role in seeing the Mallarmé through the press, and he may have influenced the design of other Skira books as well. For many years he championed the work of the painter André Beaudin and may have persuaded his partner to commission etchings from Beaudin for an edition of Virgil's *Bucoliques* in 1936. In that case he would have played a part in the decision to print the *Bucoliques* in the same type and the same format as the Mallarmé, a tried-and-true typographic formula for a luxury *livre d'artiste.* While working on the books, Tériade also collaborated with Skira in the publication of *Minotaure,* a journal serving as a forum for André Breton and the Surrealists, while noticing other modernists such as Matisse, Braque, and Picasso. He parted ways with Skira in 1937 and went into business for himself with the publication of *Verve,* one of his greatest achievements and one of the most ambitious art periodicals of all time.[4]

Verve cemented the friendship of Tériade and Matisse. Although cash was scarce during the Depression, this journalistic venture started out on a secure financial footing with the support of an American silent partner, David Smart, who sought a more prestigious and cosmopolitan adjunct to his holdings in the magazines *Esquire* and *Coronet.* The partners published French and English editions under the same one-word effervescent title, a spirited expression equally engaging in both languages. Smart dropped out after a while, but Tériade continued on his own and produced twenty-six issues between 1937 and 1960. He managed to cope with the paper rationing regulations during the war and succeeded in making top-quality color reproductions of artwork by commissioning lithographs from Mourlot and photogravures from Draeger Frères. Advised and assisted by Angèle Lamotte, he was able to make *Verve* a desirable venue for such authors as Reverdy, Joyce, and Gide. Sometimes he devoted double issues to artists such as Bonnard, Picasso, and Chagall, and he also produced a remarkable series of special issues about medieval illuminated manuscripts. Matisse was

pleased to be associated with this distinguished publication, which frequently contained contributions by and about him as a painter, art theorist, and graphic designer.[5]

Matisse designed six covers for *Verve* using his brilliantly colored paper cutouts, the famous *papiers découpés* that would later be epitomized by *Jazz*. Right from the beginning, he was thinking about how to ensure the purity and intensity of his colors and even went so far as to construct his collages out of papers he found in specimen books of printer's ink manufacturers. It is hard to think of a better example of his direct involvement in the printing process. His cover for the inaugural issue of *Verve* consisted of his cutouts in three unadulterated colors—red,

blue, and black—with brush-drawn lettering of the title, a design so precise and delicate that he instructed Tériade to have it framed for its protection while it was being photographed for the printers. The lithographic printers had to run one cover (*Verve* no. 8) through the press twenty-six times to render all the tonalities in a composition he called a "Chromatic Symphony." He finished his last cover a few months before he died, relying on just a few cutouts to present the title and an ornament in red and orange tints on an orange background—a design daring in its simplicity, according to Tériade, who was delighted by the concept, "hot on hot, light on light. I am truly overwhelmed by it and pleased to have such a lovely thing to put on show." Published in 1958, the orange *Verve*

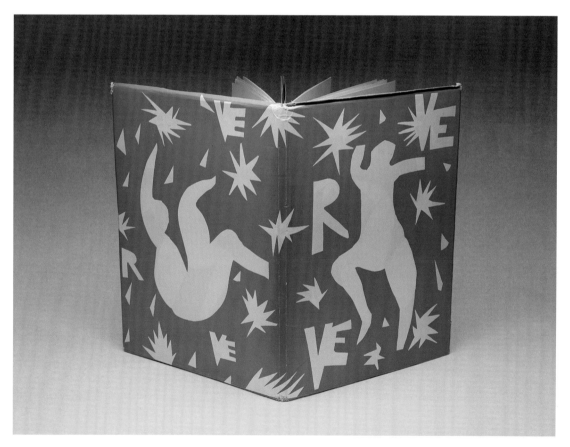

Fig. 2. Front cover of *Verve* no. 35/36, Frances and Michael Baylson Collection

Fig. 3. Cover of *Verve* no. 13, The Morgan Library & Museum

Fig. 4. Matisse and Tériade, © Henri Cartier-Bresson / Magnum Photos

became a posthumous tribute to Matisse with articles on his work and lithograph reproductions of some of his gouache cutouts executed during the 1950s.[6]

These Matisse special issues could be arduous at times. He always insisted that his graphic work be accompanied by a text. In no uncertain terms he expressed his displeasure with Tériade, who had promised an article by André Breton but then thought better of it and purposely neglected to pursue the matter until it was too late. The politic publisher failed to come up with a viable alternative to the Breton piece, which was supposed to have been a prime ingredient of *Verve* no. 21/22 (fall 1948), "Vence, 1944–1948: Henri Matisse." It was a difficult decision to publish a retrospective survey devoid of commentary beyond an introductory statement by the artist, who was sure to be annoyed by the lopsided

makeup of that issue. Better that than to risk dealing with the intransigent Surrealist and ending up with a contentious essay he might later regret.[7]

Awkward as it was, the Vence issue did not tax the publisher's patience and ingenuity as much as *Verve* no. 13, "Concerning Color," a constantly evolving endeavor nearly three years in the making. It started with a simple business proposition on New Year's Day 1943, when he proposed to reproduce a series of paintings in *Verve*. Matisse approved the idea and dictated his terms in a letter countersigned by the publisher and in a typescript contract calling for payment in kind, ten copies out of every thousand. That much proceeded smoothly. Several months passed by, but at the end of the year the artist detected a fundamental flaw in the project. He told Tériade that he had always disliked the four-color halftone printing process, irredeemably deficient in brilliance and intensity. Now he disliked it even more after seeing four-color reproductions of his paintings in a portfolio published by the Éditions du Chêne. His misgivings are understandable in view of his tendency to work with solid blocks of color, the optical antithesis of the dot patterns created by the coarse halftone screens of the day. He seemed ready to back out rather than to compromise with an "inexact reproduction method." Sensing trouble ahead, Tériade dropped everything and took the train to Paris, where he conferred with his printers. He stoutly defended them in a letter, noting that they customarily exceeded the industry standard in the number of plates they employed, sometimes as many as nine altogether. The special issue had already cost him 200,000 francs, not that he would ever stint on production values. "I can only promise you," he averred, "that I will do everything to achieve the best possible results and that no one else could do it better." As if these

reassurances were not enough, he hit upon a way to acknowledge and sidestep the objections of the artist. He conceded the basic drawbacks of current printing technology and put them on the record for all to see by presenting the reproductions of the paintings next to schematic drawings annotated by Matisse with specifications of the colors he wanted in the finished product. Those verbal instructions could be used as a benchmark for judging the performance of the printers. Rouveyre believed that they had failed the test but thought that it was worth the effort: "besides, it's a good thing for you, not so good for the work of that guy Tériade." In that respect he was mistaken because "Concerning Color" turned out to be a great success and inspired two other special issues on the same theme, "The Color Work of Bonnard" and "The Color Work of Picasso."[8]

Verve was a topic constantly recurring in the correspondence between Matisse and Tériade, who relied on it to keep up the momentum of other publishing projects. While struggling with the color reproductions, they were also trying to resolve equally vexing problems in the production of *Jazz,* one of the most innovative illustrated books of the twentieth century. Their collaboration on the Charles d'Orléans *Poèmes* may have been less stressful (and less successful), but it delighted the artist, who welcomed the opportunity to experiment with different decorative interpretations of a favorite text. While checking proofs of the *Charles d'Orléans,* they embarked on an edition of the *Song of Songs* with etchings on Kodak paper and a text in the longhand script that had become their trademark at that time. Matisse completed four plates in 1950 and wrote out some sample pages but put them aside and never got back to them. Tériade salvaged what he could by publishing some of the designs in the posthumous issue of

Fabiani, he took over publication projects begun by Vollard: Gogol's *Dead Souls* (1948), the *Fables* of La Fontaine (1952), and the beginning chapters of the Bible (1956), all three with etchings by Marc Chagall. Also noteworthy are his collaborations with Giacometti, Léger, Rouault, Bonnard, and Miró. His edition of Pierre Reverdy's *Le chant des morts* (1948) contains blood-red, brush-drawn designs by Picasso and a text in the hand of the poet—a use of script not unlike Matisse's earlier calligraphic experiments with the poetry of Charles d'Orléans, although Picasso's abstract compositions are more like hieroglyphs than decorations. With *Jazz* and *Le chant des morts,* Tériade ventured beyond the boundaries of the traditional *livre d'artiste,* but he also countenanced more conventional efforts by artists like André Beaudin, whose color lithographs

Verve. Likewise they never finished a book about the Inuit peoples by Matisse's son-in-law, Georges Duthuit, who was more at fault than they were because he had not yet written the text. In the meantime, the artist consulted secondary sources for a series of lithograph portraits and made some strangely sinister anthropomorphic designs after Inuit masks he had seen in Duthuit's ethnographical collections. In 1960 Duthuit finally reached the conclusion of his story, *Une fête en Cimmérie,* which Tériade then published in an edition of 130 copies including the original lithographs (1963). A year later Mourlot published another edition with reproductions of sketches and preparatory drawings.[9]

Tériade produced twenty-six illustrated books over the course of thirty years. Like

Fig. 5. Rejected designs for initials, The Pierre and Tana Matisse Foundation, New York

Fig. 6. Beginning of the third letter, *Lettres portugaises,* Frances and Michael Baylson Collection

U'EST-CE QUE JE DEVIEN-DRAY, ET QU'EST-CE QUE VOUS VOULEZ QUE JE FASSE? JE ME TROUVE BIEN ÉLOIGNÉE DE TOUT CE QUE J'AVOIS PRÉVEU : J'ESPÉROIS QUE VOUS M'ESCRIRIEZ

he commissioned for an edition of Gérard de Nerval's *Sylvie* in 1960. This book did not bring him any fame or fortune, but he had faith in Beaudin and did what he could to support his work.

Tériade's loyalty, congeniality, and capacity for friendship helped to stabilize his business dealings with Matisse. Of all the publishers included in this catalogue, he was the one who came closest to gaining the trust of the artist, who never let down his guard when signing a contract or settling an account. Sometimes, however, even he fell under suspicion. "Although he is not disagreeable," Matisse remarked in a letter to Rouveyre, "he is just the same a publisher. You never know what this son of Ulysses is hiding behind his back." Nonetheless they became fast friends toward the end, while they were living within easy driving distance of one another, Matisse in Nice and Tériade in a picturesque seaside villa in Saint-Jean-Cap-Ferrat. The artist frequently visited the villa, where a wheelchair was always waiting for him in case he wanted to take a tour of the garden. Henri Cartier-Bresson took pictures of him in the garden and one of him indoors, which appears in *The Decisive Moment* (1952), another Tériade publication worth noting here because Matisse designed the cover and dust jacket. He decorated the dining room of the villa with a stained glass window and a tree design on white ceramic tiles graced with a dedicatory inscription dated 1952. Cartier-Bresson took a picture of that, too, along with a portrait of the smiling host in a characteristic pose—pouring out glasses of champagne.[10]

The contract for the *Lettres portugaises* could have been cause for celebration inasmuch as it marked the beginning of an important project, but it also strictly defined the rights and responsibilities of both parties concerned. It contained the usual boilerplate language stipulating that the publisher would cover the costs of the edition and that the artist would retain control of design and production—that is, he would construct a maquette for the guidance of the printers and would sign each copy on the condition that he could check the proofs and approve them. All the preparatory designs, studies, and maquettes would be his property. After printing the lithographs, they would cancel the stones in his presence and pull three sets of canceled proofs: one for him, one for Tériade, and one for the Bibliothèque Doucet. The edition would consist of 270 copies, including 80 specials each accompanied by a suite of 12 studies for the illustrations. His payment would be half of the edition, to wit 85 ordinary copies, 35 special copies, and 4 copies hors commerce. It would be up to the publisher to submit the deposit copy (which was duly registered in the *Bibliographie de la France*).[11]

Typical of Matisse, he started to work on the book even before he obtained the contract. Tériade signed it two weeks after the printers had begun to compose the text for the first round of proofs. The printers belonged to the firm of Jourde et Allard, founded by Aimé Jourde, who appears to have started around 1920 and retired around 1936. Henri Jourde succeeded him and then joined in a partnership with Allard after the war. Both of the Jourdes specialized in handpress printing, a craft highly esteemed by Vollard, who commissioned them to provide the letterpress for *livres d'artistes* by Bonnard, Picasso, and Rouault. Tériade hired this firm with the intention of producing the *Lettres portugaises* in the Vollard tradition. He is said to have dictated the typographical specifications, although he must have consulted with Matisse about the basics. One source relates an anecdote about the proofs, which are said to have been set too tightly in the opinion of the artist, who had them cut up line by line to readjust the spacing. This attention to detail would certainly be in character, but the typesetting in the printed edition has no more leading than the foundry's specimen of that type.[12]

After the proofs arrived, pages of text were pasted up to make a maquette, which Matisse used to plan his scheme of illustrations. Each of the five letters would begin with a section title composed of a full-page vegetal ornament with a caption in the artist's hand. He made a series of pen-and-ink studies of this decorative leitmotif, which appears throughout the book and on the covers as well. Following the section title, the first page of each letter was to be set in capital letters with a large calligraphic initial beneath a headpiece. Every section would end with a tailpiece unless the text completely filled the last page. Each headpiece would introduce an ornamental theme for the subsequent text pages of that section. The five sectional motifs were pine cones, pomegranates, peaches, hyacinths, and blooming pomegranates. The maquette shows that he was thinking of decorating the first letter with blooming pomegranates but then drew pine cones over them in blue crayon. He changed his mind about other motifs before deciding to assign a consistent theme to each of the five letters. By drawing these designs in the maquette, he could see how they would fit in the spaces allotted to them and could judge their weight and color in relation to the type. He opted for the barest minimum of margin, allowing the ornaments and initials to reach the edge of the page, a concept similar to the Mallarmé layout, although here he was dealing with solid blocks of prose. The weight of the page is much heavier but not oppressive because of the generous type size and the spacious ornamental framework. Only a few pages

contain straight text unadorned by color lithographs, and most of those are facing full-page portraits. One typographical detail seems to have escaped his notice—the page numbers, which were set in such a small size and placed in such an awkward position that they appear to have been inserted as an afterthought at the end of the proofing process.[13]

The initials here are in a different style than those in *Visages;* they are lithographs, not line blocks, but they demanded just as much labor and ingenuity on the part of the artist. Louis Aragon learned that Matisse had been spending sleepless nights creating a new alphabet that would harmonize with the ornaments. At the age of seventy-six he was an old man in love with letters: "I know what a *J* is like now," he told Aragon, "and an *A,* the *A* is difficult . . . well, you shall see." Instead of the attenuated pen-drawn initials in *Visages,* these were made with the same broad crayon strokes he used for the

ornaments and in similarly robust proportions. Some of the strokes curl like ribbons to produce a trompe-l'oeil three-dimensional effect. A large number of rejected trial drawings show how he struggled to render the crossbar of the *A,* the curvature of the *C,* the tail of the *J,* and other traits that ensured the beauty and legibility of his designs.[14]

The portraits in the *Lettres portugaises* also have some precedent in *Visages,* but here, too, perform a different function. Commenting on various illustration projects, Matisse made it clear that he preferred not to depict the incidents and action of a story—a futile and unrewarding chore rarely creditable to the author or the artist. He expressed this conviction while working on the Mallarmé and deciding on subjects for *Ulysses.* For the same reason he refused to illustrate Montherlant's *La rose de sable* and agreed to take on *Pasiphaé* instead. He thought that he had dodged the issue by commissioning a text from Reverdy

to accompany the portraits in *Visages.* The *Lettres portugaises* must have appealed to him because there is no action in the story, no incidents of note, except for the turmoil in the mind of Marianna Alcoforado. Purely a psychological narrative, this text provided an excellent opportunity to implement his illustration theories.

The fifteen portraits of Marianna in this book are each keyed to a line of text as in *Pasiphaé* but without any consistent attempt to construe meaning from the juxtaposition. Rather, these passages help the reader to visualize Marianna in the act of writing and imagine how her expression might change as her train of thought leads her from one idea to the next. Different emotions flit across her face in this sequence of portraits, sometimes showing her at different angles but often retaining the same pose and compelling the viewer to scrutinize her features for clues about her state of mind. Invariably she is dressed in a wimple, which emphasizes her

Fig. 7. Lithograph and facing text, *Lettres portugaises,* Frances and Michael Baylson Collection

features. Matisse tried out several models for Marianna and eventually settled on Doucia Retinsky, the fourteen-year-old daughter of a local grocer. The historical Marianna entered the convent at the age of twelve and took her vows when she was sixteen. In Doucia's face he found just the right mixture of charm, serenity, and intelligence to represent someone who had been in holy orders but was also capable of passion. As usual he came away from his portrait sessions with a large number of drawings from which he could pick and choose. He selected fifteen to be part of the book and twelve to accompany the specials in a separate suite of prints as specified in the contract. In addition he made five lithographs in an edition of four, one proof copy and three numbered copies intended for private distribution. His son Jean Matisse proofed these and possibly other *planches refusées* sometime between 1968 and 1970. It is not clear whether or not the stones were canceled in accordance with the terms of the contract. As before, Matisse drew his designs on transfer paper and sent them to the Mourlot workshop where proofs were pulled for his approval. Jourde et Allard completed a substantial portion of the presswork by the end of 1945, Mourlot was supposed to start making proofs in January 1946, and Tériade predicted that the final proofs would be ready in April or May. The *achevé d'imprimer* is dated 23 October 1946, and books began to arrive at the end of November.[15]

As soon as Matisse received his copies he gave one to Rouveyre, who extolled it highly. "Already I owe you hours of happiness because of it … Ah! I am not thanking you, I am not thanking you any more, I am praising you in my heart as I do so often at levels more or less reaching to the heights, more or less celestial, and today I am praising you to the skies." A couple of days later, he wrote again to say that he had been spending more time with the *Lettres portugaises*, "a great and lovely book" reconceived in such a way that it could bring back to life the personhood of Marianna Alcoforado, the real character of someone who had been lost to the past. Matisse replied that he was flattered by those comments and that he judged the book to be satisfying, although he had already felt obliged to give it some critical scrutiny. He urged his friend to write about it in *Le Figaro*, but the timing wasn't right for the feckless author, who said that he needed two weeks just to get himself in the mood.[16]

The promotion of the *Lettres portugaises* proceeded much more swiftly at the point of sale. The antiquarian bookseller Pierre Berès exhibited the book in Paris and printed a poster to publicize the event, which generated so much excitement that dealers and collectors bought up the edition by the end of the year. Matisse was pleased by the quick return he received on his artistic investment. "The main thing at my end is that everything has been going well for me," he wrote to his son Pierre, "health and work and success (the *Portugaise* has just come out with an important exhibition at Berès, avenue de Friedland. It's sold out, but nonetheless I have a copy for you, which I would very much like to send to you)." Thus encouraged, he could look forward to finishing concurrent publication projects such as Ronsard, *Repli,* and *Jazz.* Other books would be more intensely demanding, some would be more highly esteemed, but the *Lettres portugaises* should be recognized as one of his main typographical achievements and a significant step in his illustration career: he had now hit his stride and could forge ahead in the same direction.[17]

⁓

PAGE SIZE: 27 × 21 cm.

PAGINATION: [6] 109 [17] pp.; the first 4 and the last 3 leaves blank.

ILLUSTRATIONS: Lithograph initials, ornaments, and 15 full-page portraits printed by Mourlot Frères, Paris, the portraits in bistre, the ornaments and initials in violet and russet.

TYPOGRAPHY: Printed by Jourde et Allard, Paris. Text in 24-point Deberny et Peignot Garamont.

PAPER: Mold-made wove vélin d'Arches.

BINDING: Wrappers printed by lithography in violet with the title in hand lettering on the front cover, vegetal ornaments on the front and back covers, contained in a beige cardboard slipcase and a matching cardboard chemise with a printed title label on the spine.

EDITION: Printed 23 October 1946. Edition of 270 copies on vélin d'Arches signed by Matisse: 250 copies numbered 1 to 250, of which the first 80 are accompanied with a suite of 12 *planches d'étude;* 20 copies hors commerce numbered I to XX.

COPIES EXAMINED: PML 195603 (no. 95); HRC PQ 1799 G795 L4 1946 (no. 91); NYPL Spencer Collection (no. 168).

REFERENCES: Barr 1951, p. 560; Guillaud 1987, p. 471; Duthuit 1988, no. 15; Monod 1992, no. 145; Szymusiak 2002, p. 282.

EXHIBITIONS: Philadelphia 1948, no. 268; Geneva 1959, no. 26; Boston 1961, no. 199; Paris 1970, nos. 202–3; Paris 1973, pp. 124–25; New York 1978, pp. 143–45 and 218; Saint Petersburg 1980, no. 5; Fribourg 1982, no. 5; Nice 1986, no. 14; Florence and Le Cateau-Cambrésis 1996, pp. 121–31; New York 1997, pp. 106–33; Paris and Humlebaek 2005, no. 104.

28.

Henri Matisse (1869–1954), *Vingt-trois lithographies de Henri Matisse pour illustrer* **Les fleurs du mal,** *présentées par Aragon.* **Paris: [Henri Matisse], 1946.**

Little suspecting trouble ahead, Matisse began to work on an edition of Baudelaire's *Fleurs du mal* on the prompting of a loosely organized, semicommercial bibliophile society, Les XXX de Lyon. Bibliophile societies like Les XXX published fine limited-edition illustrated books on a subscription basis. The members of these organizations helped to pay the printing costs in advance and often participated in the publication process either directly or indirectly through an executive committee that chose the texts and commissioned the artwork. Many of these books proved to be a lucrative investment during the boom period of the 1920s and were all the more rewarding because they could be planned in a congenial social setting—an annual meeting was often the occasion for a festive banquet. Les XXX operated on a different business model through which they shifted some of the risk and expense on to the artist, who received half of the edition as payment in kind and as an incentive to produce a profitable publication. In theory the edition consisted of 120 copies, 60 copies for the artist and 2 copies for each of the 30 members, 1 special and 1 ordinary copy they might opt to sell on their own. Members did not pay annual dues but subscribed only for the volumes they wished to support. It was up to the executive committee to enlist a new roster of thirty members to raise the 200,000 or 300,000 francs they might need for a typical publication. They began with Charles-Louis Philippe's *Bubu de Montparnasse* (1929), illustrated by André Dunoyer

de Segonzac and printed by Jean-Gabriel Daragnès, who seems to have been their typographical consultant. This sold well enough to encourage them to undertake other books with such artists as François-Louis Schmied and Luc-Albert Moreau. Apparently they contacted Matisse at the end of 1930, not long after he started on his first major *livre d'artiste,* the *Poésies* of Mallarmé. They failed to make substantial progress in their dealings with the artist, however, until 1938, when they negotiated terms for an edition of *Les fleurs du mal.*[1]

For Matisse they would make an exception to their usual practice and would limit the edition to 65 copies: 30 for the artist, 30 for members, and 5 hors commerce for the principal collaborators in the project. It was understood that Matisse would sell his copies mainly in America through the Pierre Matisse Gallery in New York. He would decide which poems in *Les fleurs du mal* he wished to illustrate—the entire text would be too expensive—and he would design forty large original prints to accompany them. Daragnès would print the book, which would be in Les XXX's usual raisin quarto format and would cost around 100,000 francs. Each member would contribute 3,300 francs to defray those costs. To be precise, Daragnès could count on only 93,000 francs to cover his expenses because the committee was setting aside 6,000 francs for contingencies. At that time the executive committee was composed of Maurice Bussillet, Georges Faist, and Étienne Vautheret, all solid citizens of Lyons. Vautheret was the contact person with Matisse, and to him fell the unhappy task of begging and cajoling the artist to get on with the job.[2]

Matisse refused to be rushed but not for any lack of enthusiasm; he had always wanted to illustrate poems by Baudelaire. His teacher and mentor Gustave Moreau

had been acquainted with the poet, whose writings affirmed critical opinions and aesthetic ideals Matisse had learned from his master. He gave a Baudelairean title to one of his most important early paintings, *Luxe, calme et volupté* (1904–5), in which he developed themes of serenity and equilibrium that would be a hallmark of his work. That was precisely the problem, he told Daragnès in an apologetic letter. "I have done absolutely nothing for Messrs XXX," he confessed. "I hope they understand. I am still interested in what they have asked of me, but that just can't be improvised on the spot, and I need the peace of mind to do it calmly." As of 1938, he could not predict the number of plates nor could he specify which poems he would choose, although he expected most of them to be in the "Spleen et Idéal" section of *Les fleurs du mal.* He was thinking of one or more linocuts and reminded Daragnès that he reserved the

The title page reads:

VINGT-TROIS LITHOGRAPHIES DE HENRI MATISSE

POUR ILLUSTRER

LES FLEURS DU MAL

PRÉSENTÉES PAR ARAGON

PARIS · M · CM · XLVI

right to decide on type, paper, and cover design. The outbreak of the war put these plans on hold. His anxieties reached a peak at the end of this traumatic period, when his wife and daughter were arrested by the Gestapo. Food and fuel were in short supply, but his model and assistant Lydia Delectorskaya was able to preserve some semblance of normality in his home and studio. Miraculously his daughter survived a stint of imprisonment and torture. In November 1944 he was back to rights and could make concrete proposals about the contents, illustrations, and design of the volume.³

After years of procrastination, he finally reached a point where he could think it through in convincing detail. He compiled a list of the thirty-two poems he had chosen and enclosed it in a letter to Daragnès reporting on the progress he had made and proposing a plan of action. He asked the printer to send him sample pages in three different types: 20-point Elzévir, 20-point Didot, and 24-point Garamond (roman, not italic). That last he knew to be a favorite of Daragnès and Vautheret, but he insisted on deferring a decision until he could judge the weight of the text next to proofs of the illustrations. He sketched a layout of a typical two-page opening, which he felt should be rich and full like manuscripts of the fifteenth century. He wanted red initials, classical in style and carefully calibrated in tint, a vermillion with not too much orange, rather closer to carmine but not too much of that either. Like the Mallarmé, his Baudelaire would contain illustrations extending almost to the edge of the leaf, which should be 32.7 × 27 cm. He had seen a copy of the Mallarmé in a magnificent designer binding that was so tight one could not pry it open all the way. This time around he hoped to provide an inner margin that would enable the illustrations on the versos and the text on the rectos to be fully visible and in a position

to "kiss" one another even in the unbound copies. The illustrations would be transfer lithographs, proofs of which he expected to receive in a few days. He urged Daragnès to be patient and promised to send him a telegram so that he could see the proofs as soon as possible. If anyone was in a hurry, it was Matisse, who could now visualize the book he had been pondering for years and could not wait to start work on the layout page by page. At the end of this hastily scribbled letter, he reminded the printer of the top priority item of business: "Dear ~~Mr. Daragnès~~ friend, I am waiting for your sample pages adorned with grave and lovely classic initials. Cordially, H. Matisse."⁴

Matisse could proceed confidently after having formulated an illustration concept for the book. The poems would be accompanied by portraits, mostly the heads of female models he had been drawing lately but also a genial self-portrait, a symbolic delineation of Apollinaire, and two pictures of the author to bracket the ensemble. The models he chose each displayed a strain of exoticism that might have pleased the poet, whose verse associates certain types of beauty with an erotic idyll in foreign lands. A Haitian named Carmen posed frequently for Matisse during this period and appears ten times in this volume. She had strange and pungent charms, which he used to set the tone for poems like *"Bien loin d'ici,"* *"À une Malabaraise,"* and *"Sed non satiata,"* the first line of which evokes a musk-scented "bizarre deity" perfectly fitting her description. Russian by birth, Lydia Delectorskaya represented an entirely different temperament—cold, cruel, and aloof—epithets constantly recurring in *Les fleurs du mal.* The Spaniard Nénette Palomarès had a magnificent head of hair, a sensual attraction that stoked torrid fantasies in Baudelaire's *"La chevelure."* The Dutch art student Annelies Nelck was one of Matisse's favorite models at that time. She inspired the

series of lithographs in *Visages* (No. 23) as well as a dozen portraits here, many of them emphasizing the beauty of her eyes. Years later she reminisced about these portrait drawing sessions and described some of the artist's working methods. He made preliminary studies in charcoal to catch a promising expression and then sought to render the definitive version in line. The charcoal drawings might have entailed several days of hard labor. After finishing a series of portraits, he would hang them on the wall and leave them there while looking for qualities he might associate with poems in *Les fleurs du mal.*⁵

He matched portraits with poems using a trial-and-error process documented in a manuscript list of illustrations now in the Pierre and Tana Matisse Foundation. If I have interpreted this list correctly, he numbered each of the portraits in a coding system not unlike the one he used for the suites of prints in *Dessins: Thèmes et variations* (No. 20). Portraits of Annelies Nelck were numbered with an *A* prefix, portraits of Carmen with a *C,* and portraits of Lydia Delectorskaya with an *L.* He could distinguish between two suites of the same model by numbering one in roman numerals and the other in Arabic numerals. Some of the suites seem to have contained as many as ten drawings. He crossed out codes in the list and wrote new ones when he changed his mind about the assignments he had made. For example, he originally intended to illustrate *"La confession"* with a portrait of Annelies Nelck (A VII) but then decided on another drawing in the same series (A VI). At one point he thought that Lydia Delectorskaya might be right for *"Le serpent qui danse"* but then selected one of the Carmen portraits, perhaps thinking of the sea voyage imagery in that poem.⁶

For similar reasons he considered the possibility of matching his linocut *Tahiti*

with Baudelaire's poem *"La chevelure,"* which evoked pleasant memories of his sojourn in that tropical paradise. Lines like "Sweltering Africa and languorous Asia, a whole faraway world" could have reminded him of his 1930 trip to Tahiti. Daragnès had printed around a hundred copies of the linocut for him in 1939, when he was expecting to donate them to an artists' organization. The war broke out, his charitable plans had to be deferred, and Daragnès put the prints aside while waiting for further instructions on how to use them. As much as Matisse might have liked to salvage a printmaking project, he realized that a stray linocut would be obtrusive mixed in with lithographs. Instead he chose a portrait of Nénette Palomarès, whose opulent tresses were closer to the theme of the poem, although at one point he was also prepared to cast Lydia Delectorskaya in that part. *"Harmonie du soir"* is coded *M* in the list, which raises the question whether he planned to insert a self-portrait facing this text. One could conjecture that it appealed to him because it features a plaintive violin among other metaphors of melancholy, a poetic tribute to an instrument that he had sought to master for many years. If that was his idea, he abandoned it for a more logical arrangement placing the author's portrait before the first piece in the book and the artist's before the second one, *"La vie antérieure,"* a sequence symbolizing their respective roles in this endeavor.[7]

Matisse was pleased with the portrait concept and thought of it as an innovative reinterpretation of *Les fleurs du mal*. Writing to his friend Charles Camoin, he reported on his progress with the transfer lithographs. "I have been illustrating your good buddy Baudelaire," he announced. "In connection to the pieces I have chosen, I have made thirty-five expressive heads in litho. It is not what you would usually

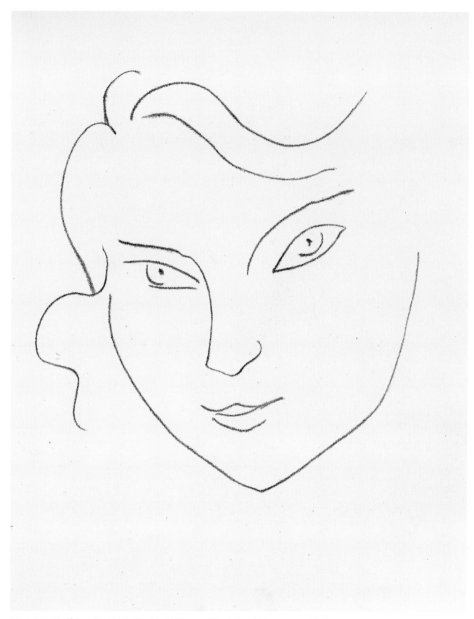

Fig. 2. Portrait of Annelies Nelck, *Vingt-trois lithographies de Henri Matisse pour illustrer Les fleurs du mal*, Frances and Michael Baylson Collection

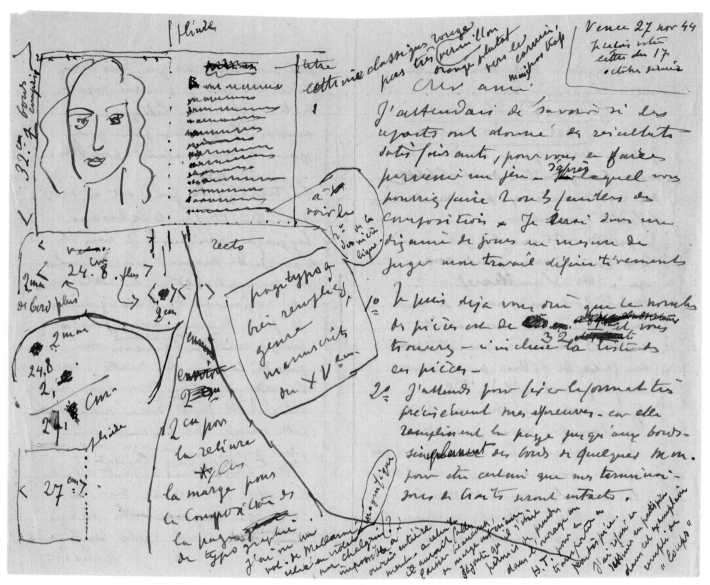

Fig. 3. Typographical specifications for *Les fleurs du mal,* The Harry Ransom Center, University of Texas at Austin

expect as illustration for this poet. You could easily imagine a more or less tormented series of legs up in the air. I hope that the bourgeois aren't going to be so censorious as to hold me accountable for this unexpected treatment." The phrase "legs up in the air" is a quotation from the poem *"Une charogne,"* which Matisse once included in his list but then dropped from consideration because its gruesome subject matter was not conducive to the portrait motif. He probably wrote to Camoin while that decision was still fresh in his mind. Another reject was *"Le beau navire,"* for which he had chosen a picture of Annelies Nelck. Captivating as she may have been, he would not have wanted her to be overrepresented in this book. He relied on the variety in his models, the different types of femininity, to signal the themes he wished to illustrate in Baudelaire's poetry—the seductive mystique of women, exquisite sensations, moments of self-transcendence, exaltations of the spirit rather than torments of the soul. If he had to ration Nelck, then she was better served by verse in *"La beauté,"* which spoke to her most alluring features, "my eyes, my large eyes of eternal light!" He added that poem at a later stage in the planning process and made it

the first of the models' portraits, as if to tell the reader how he would be interpreting the rest of the volume. With that in its proper place, it was easy to do without *"Le beau navire,"* which covered the same territory as some of his other selections. It should be noted, however, that he was constantly adding, deleting, and substituting the portraits he had made and the texts he had selected during the production of *Les fleurs du mal.* I have not been able to date when he arrived at some of these decisions. When he wrote to Camoin, he probably knew how he would use some of the thirty-five lithos, but at that time he had no idea how long it would take or how hard it would be to publish them.[8]

After completing his drawings, Matisse sent them to the workshop of Edmond Desjobert, whose technicians were to transfer them to the lithographic stones and pull proofs for his inspection. It is not clear why Desjobert was chosen for this job. Perhaps the Lyons bibliophiles preferred to do business with him, or perhaps Mourlot was too busy at that time. Certainly Desjobert had the credentials to take on such an important commission, having worked with other prominent artists since the 1920s. Among his customers, he

counted a number of Americans, who continued to patronize the Atelier Desjobert after it passed to his son Jacques when he died in 1963. His relationship with Matisse turned out badly, partly because of his negligence, but mostly because of circumstances beyond his control. During the summer of 1944, the hot weather had dried out the sheets of transfer paper, which had to be dampened before the images could be transferred to the lithographic stones. Desjobert or one of his assistants interleaved the sheets with moistened blotting paper and left the stack overnight. The next morning they pulled the proofs, not realizing that the sheets had swollen during the dampening process and that the images were now distorted by about a centimeter. Apparently Desjobert didn't notice the difference and submitted the proofs to Matisse, who found them utterly unacceptable. Mourlot tells this story not once but twice in his memoirs and embroiders it with details suggesting some amount of pleasure in the discomfiture of a rival in his trade. If he can be believed, the guilty party then allowed some of the bad proofs to fall in the hands of an opportunistic collector, the type of person who sometimes succeeds in scooping up something of value by loitering in print shops and studios. The collector took the proofs to Matisse and offered him a small sum of money in hopes of persuading him to sign them. The indignant artist flew into a rage, tore up the purloined artwork, and showed him the door with the parting words, "Hey, this is what I think of your lithos!" Another account appears to corroborate this story by noting that Matisse had ordered Desjobert to return the proofs and cancel the stones.[9]

The accident at the Atelier Desjobert compelled the artist to find a way of replacing his portrait drawings. As was standard practice, he had called in a photographer to take pictures of them before sending them off to Desjobert. He liked to keep a record of his work, but now he depended on his documentation to reconstruct it. He made a new set of transfer drawings using the photographs as an aide-mémoire, a means of reproducing his original intentions as closely as possible. This approach proved impossible, he told his daughter. "I'm not able to redo what I have done, and what I believe to be well done." Reluctantly Matisse concluded that he preferred the photographs to the replacements he had made, which had some merit but did not adequately perform the function of book illustrations. He sought the advice of Aragon, who had become increasingly involved in this project, and Aragon agreed that something was missing: "Matisse has remained, but Baudelaire has vanished: the portrait is still that of the same man or woman, but the *drama* has gone."[10]

Nonetheless he did not abandon the new set of transfer drawings altogether. With Aragon's advice and assistance, he would persevere with the Baudelaire project by printing an edition illustrated with photolithographic reproductions of the photographs. It would be a large edition of a thousand copies, but it would be accompanied by a hundred specials on Arches or Hollande containing a suite of the replacement transfer lithographs. "You can't put them with the texts," he explained, "but they are good (with a distinguished expression!), and a preface will present a rationale for the volume." Presumably Aragon would write the preface, which would describe the origins of the lithographs and invite the reader to compare them with the photolithographic reproductions. Eventually Matisse and Aragon adopted a less ambitious plan, though similar in principle. They commissioned Mourlot to print the redrawn lithographs in five sets, which were accompanied by a short text by Aragon recounting the accident at the Atelier Desjobert. This edition of five allowed them to preserve a record of an interesting artistic exercise without running the risk of anyone misconstruing their intentions. Almost inaccessible, *Vingt-trois lithographies de Henri Matisse pour illustrer* Les fleurs du mal would be out of reach even for the most determined collectors. It was not sanctioned for general distribution and did not encourage a comparison of portraits contrary to Matisse's original idea, which he may have relinquished after reconsidering the quality of the replacement lithographs. Each of the five copies was designated for a member of the artist's circle: no. 1 for the artist himself; no. 2 for Aragon and his wife, Elsa Triolet; no. 3 for Fernand Mourlot; no. 4 for Lydia Delectorskaya; and no. 5 for the Bibliothèque Doucet, where it was to be the copy of record. The Bibliothèque Doucet online catalog does not mention that copy, but others can be examined in public collections: Matisse's copy is now in the Musée Matisse at Nice; Lydia Delectorskaya gave hers to the Hermitage Museum; and the Aragon-Triolet copy passed through the trade to Michael and Frances Baylson, who donated it to the Morgan in 2010.[11]

Meanwhile Matisse had to think how he was going to fulfill his commission from the Lyons bibliophiles. They were deeply disappointed by the setback with the lithographs, which already required some expenditure on their part. Obviously they would not want to participate in the publication of *Les fleurs du mal* in a large edition with photolithographic reproductions. He would have to propose a title more in keeping with their line of luxury illustrated books. Daragnès urged him to undertake another edition of Baudelaire illustrated with linocuts, etchings, or

drypoints to differentiate it from the larger, more commercial venture, but he declared that he had done all he could do with that text. Instead he proposed to illustrate something by Apollinaire, an edition of *Alcools* or a selection of poems on the theme of Marie (the artist Marie Laurencin, Apollinaire's muse and lover). Vautheret and the executive committee endorsed that idea, but it was too difficult to procure the rights from the publisher. They also agreed to another suggestion, Aragon's *Amour d'Elsa,* a text easily at hand and more feasible, they believed, because Aragon would be supporting the project and could intervene on their behalf.[12]

This time everyone thought that they were back on track. The lithographs would be printed by Mourlot. Matisse would make a maquette for the guidance of Daragnès, who could start planning for a book with a leaf size of 38 × 28 cm printed on a pure white Arches or Rives. Vautheret asked him to submit another round of type specimens following the instructions of the artist, who first asked for a rather large Garamond, which would produce "luminous pages," and then requested a Baskerville font, the same type used in *Pasiphaé.* Daragnès argued against Baskerville as being too light for the size of the page and too difficult to procure from the foundry in the sizes they required. His objections were met with silence. Months passed, and they

tried to arrange a rendezvous, but the timing wasn't right. Finally, a year later, Matisse requested specimens in other types besides Baskerville. Daragnès set two lines of verse by Aragon in 24-point Garamond, 18-point Didot, 16-point Didot bold italic, and a 20-point Elzévir. After viewing those specimens, Matisse requested sample pages in the Garamond and Elzévir. I lose sight of their negotiations after June 1947. Matisse had made substantial progress on this book, for which he designed a series of initials and produced preparatory studies for a frontispiece portrait of Elsa Triolet. He planned a decorative scheme based on hyacinths, her favorite flower, but he could not draw them to his satisfaction, nor was he very pleased by the portraits. Stymied by these difficulties and already engaged in other publication projects, he abandoned *Amour d'Elsa* and gave up on his attempts to produce a book for Les XXX de Lyon.[13]

The publishers and the printer came out empty-handed in this transaction. They were not the only ones to join with Matisse in a bookmaking venture that changed hands or came to nothing. He tried the patience of his partners partly because he was always coming up with new ideas for books and allowed himself the luxury of choosing which ones would be the most feasible and rewarding. Sometimes he had to change his plans or cancel them, having reached an age when he wanted to conserve

his strength for his most important projects. *Les fleurs du mal* ranked high in his esteem and consumed a serious amount of effort, but it appeared in quite a different form (No. 31) than anyone expected.

PAGE SIZE: Raisin quarto; 32.5 × 25.3 cm.
PAGINATION: [34] leaves; the first 2 leaves, leaf 5, leaf 16, and the last 2 leaves blank. The copy described here is gathered in a slightly different order than the copy described in Duthuit.
ILLUSTRATIONS: 23 lithographs printed by Mourlot Frères, Paris.
TYPOGRAPHY: Printer not identified, 6 leaves of letterpress. Text in 18-point Deberny et Peignot Firmin Didot.
PAPER: Handmade vélin de Montval supplied by Canson et Mongolfier, Annonay.
BINDING: Brown wrappers printed in brown, contained in a beige cardboard slipcase and a cardboard chemise covered with a brown laid paper on which is printed the initials of the author and the artist.
EDITION: Edition of 5 copies hors commerce numbered I to V signed by the artist.
COPY EXAMINED: PML 195604 (no. II).
REFERENCE: Duthuit 1988, no. 16.
EXHIBITIONS: Saint Petersburg 1980, no. 6; Fribourg 1982, no. 6; Nice 1986, no. 19; Le Cateau-Cambrésis 1992, no. 20.

29.

Les miroirs profonds. **Paris: Pierre à Feu, Maeght Éditeur, 1947.**

The Pierre à Feu imprint appears on monographs and periodicals published by the art dealer Aimé Maeght. Born in 1906, Maeght learned the trade of a master lithographer and opened a printing shop in Cannes, where he ran a small gallery on the side. He lived in Vence for a while during the war, after having been forced to flee from Cannes under suspicion of forging identity papers for members of the Resistance. In Vence he formed a friendship with his neighbor Matisse, who encouraged him to seek a more prestigious position in the art market by moving to Paris. He bought a gallery near the Parc Monceau, turned part of it into a residence for his family, and opened his new place of business with a Matisse exhibition in 1945. A brochure printed on that occasion has a cover designed by the artist, in which a woman picks up a drawing, holds it at arm's length, and declares, "I like this drawing." Other exhibitions of the postwar era featured the work of Braque, Miró, Calder, Chagall, and Giacometti, just to name a few of the artists Maeght represented during a long and highly successful career. He commemorated his creative relationship with these artists by establishing the Fondation Maeght in Saint-Paul de Vence, a cultural center and museum complex designed by Josep Lluís Sert. Mural mosaics by Chagall, sculptures by Giacometti, and ceramics by Miró are part of the permanent collection of this private foundation, the legacy of one of the most talented and enterprising dealers of the postwar period.[1]

He owed some of his success to his training in the graphic arts and his skill in publicizing his exhibitions. He founded the quarterly *Derrière le miroir,* which functioned as an in-house magazine promoting the activities of the gallery as well as an artistic review containing literary texts and original lithographs. It presented his credentials as someone conversant with contemporary issues in art theory, as a dealer who understood the meaning of the merchandise he put up for sale. For many years his son Adrien supervised the production of *Derrière le miroir,* which appeared in 253 issues between 1946 and 1982. Adrien also engaged in printmaking projects with his father and oversaw the publication of some of his more ambitious *livres d'artistes.* These books were to be viewed as independent works of art, but they also afforded channels of communication with collectors outside the catchment area of the gallery. They helped to position the Maeght name in the marketplace by associating it with the work of prominent artists and authors. Some of the best known titles are Tristan Tzara's *Parler seul* with lithographs by Miró (1948–50), Hesiod's *Théogonie* with etchings by Braque (1955), and Jacques Prévert's *Fêtes* with embossed color etchings by Alexander Calder (1971). Maeght

Fig. 1. Limitation statement and title page, *Les miroirs profonds,* Frances and Michael Baylson Collection

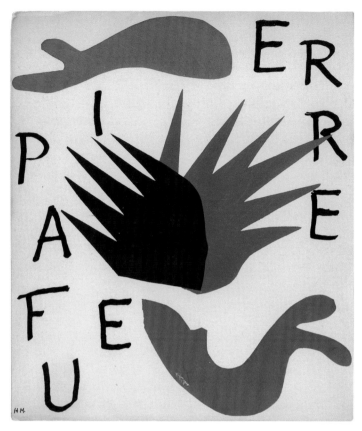

Fig. 2. Front cover, *Les miroirs profonds,* Frances and Michael Baylson Collection

mal. The title is a quotation from Baudelaire's *"L'invitation au voyage."* Kober began to assemble texts for it in 1945 and obtained the lead essay by Aragon by the end of the year. Aragon described the illustration concept for *Les fleurs du mal* and recounted the tortuous progress of that book through the production process. Kober and others wrote appreciations of Matisse, who contributed the illustrations for the volume. Matisse supplied original artwork for a lithograph and a linocut as well as a selection of the Baudelaire drawings suitable for reproduction. Maeght asked him to design a cover on the theme of the *pierre à feu,* combining the motifs of a bird, a fish, and the fire-lighting stone. While working with that idea, he discovered that he had made a drawing almost identical to another one he had made to accompany "The Shark and the Seagull," a poem by René Char that was published in *Cahiers d'art* (1946). Both drawings show a leaping shark superimposed on a seagull in flight, almost the same composition, but Matisse sought to assure Maeght that they did not have the "same signification." In any event Matisse used that design for the frontispiece along with the caption *Pierre à Feu* and an abstract shape that could be interpreted as a burst of light. For the cover, he took a different approach with gouache cutouts in green, blue, red, yellow, and black, but some of the same imagery can be detected in a shark figure at the bottom and an upsurge of sparks in the center. A preliminary study for the cover places the flash point in the lower left-hand corner, the same position as in the frontispiece, and includes a cutout bird in flight, a remnant of the original shark and seagull design. The Fondation Maeght has the final pasteup of the cover, showing that Matisse had written the letters of the caption separately then cut them out and scattered them on the page as

labeled the top of the line *livres d'artistes* as Éditions Maeght and employed the Pierre à Feu imprint for special issues of *Derrière le miroir* as well as less prepossessing limited editions, such as *Les miroirs profonds.*

The poet Jacques Kober managed Maeght's publication program while serving as the director of the gallery between 1945 and 1948. He coined the name of the imprint Pierre à Feu—the fire striker—a metaphor for the creative spark produced by the encounter of art and literature. Maeght and Kober formed a literary group with that name in 1944 and issued the first of their publications in that year. They used the imprint in *Provence noir* (1945), containing texts by Raymond

Queneau, Paul Éluard, and others along with fifty original lithographs by André Marchand. The two books illustrated by Matisse, *Les miroirs profonds* and *Le vent des épines* (No. 35), were Kober's two main accomplishments during his tenure at the Galerie Maeght, although he also helped to organize the International Surrealist Exhibition in 1947. He left Maeght in 1948, joined in a short-lived publishing venture, and then took a teaching position in the public schools. After a long silence, he started publishing his work again in the 1970s, still looking to the Surrealist movement as a source of inspiration.[2]

Les miroirs profonds was a homage to Matisse and a prospectus for *Les fleurs du*

if they had been jumbled by the creative impact of steel and stone.[3]

As always Matisse expected his work to be reproduced with precise accuracy and superior materials. He wanted the printing to be done by Draeger Frères, experts in photogravure illustrations and letterpress typography now best known for their brilliant color work in posters and advertising brochures. They had already displayed their skill in *Verve,* although not entirely to his satisfaction. At one point they quoted a price of 600,000 francs for this job, paper included. Maeght gladly paid a premium for their services because he hoped to curry favor with his patron and impress potential customers with the quality of his wares.[4]

Profitable or not, books played an important part in a marketing strategy designed to uphold the cultural prestige of contemporary art. They conferred value on art by linking it to literature, showing how it related to the intellectual crosscurrents of the day. They brought together artists and authors who espoused similar aesthetic principles and argued for them in graphic form. Less expensive and more portable than paintings, they could tempt a casual visitor to buy on impulse and come back for more. Several Paris dealers operated ancillary bookstores where they displayed their publications along with other books that might help to educate the public about their artistic agenda. Volumes illustrated by Matisse could be purchased at retail outlets affiliated with the Galerie Quatre Chemins (Nos. 8 and 12) and the Galerie d'Art Contemporain (No. 9). Maeght also adopted this business model and implemented it just as *Les miroirs profonds* came off the press. He launched the book at a cocktail party at which he celebrated the opening of his own bookstore, the Librairie Pierre à Feu.[5]

PAGE SIZE: 24 × 20.5 cm.

PAGINATION: 86 [6] pp.; the first 2 leaves and the last leaf blank, plates are included in the pagination.

ILLUSTRATIONS: 1 lithograph printed by Mourlot Frères; 1 linocut and 15 full-page photogravure illustrations printed by Draeger Frères; the layout of the illustrations by Matisse.

TYPOGRAPHY: Printed by Draeger Frères. Text in 14-point Deberny et Peignot Garamond, layout of text by Jacques Kober.

PAPER: Machine-made wove vélin supérieur.

BINDING: Wrappers, front and back covers reproducing gouache cutouts by Matisse, gray chemise, and gray cardboard slipcase.

EDITION: Printed 17 January 1947. Edition of 999 copies: 49 copies signed by Matisse and numbered I to XLIX; 950 copies numbered 1 to 950. Priced at 5,000 francs. A reduced facsimile edition was published in an edition of 10,000 copies priced at 150 francs. Half of that edition is said to have been destroyed (Nice 1986, no. 101; *Biblio,* vol. 14, 1949, p. 559).

COPIES EXAMINED: PML 195605 (no. 227); Doucet G III 1 (6), 8143 (no. 94); HRC N 6853 M33 K624 1947 (no. 69); MoMA PQ 1109 .M57 1947 (H.C.).

REFERENCE: Duthuit 1988, no. 17.

EXHIBITIONS: Washington, Detroit, and St. Louis 1977, no. 41; Saint Petersburg 1980, no. 61; Nice 1986, no. 100; London 2008, no. 124.

30.

Franz Villier, *Vie et mort de Richard Winslow*. Paris: Éditions du Bélier, 1947.

Franz Villier was a pseudonym of Franz Thomassin, one of the more colorful figures in the entourage of Jean Cocteau. He was the eldest of three siblings—two brothers and a sister—living together in Paris, where they had taken refuge after escaping from an arranged marriage and other family obligations. They became acquainted with Cocteau in 1932 and thrived in his louche, avant-garde milieu, where they played the part of adopted children. Extravagant and impulsive, they seemed to inhabit a strange, semi-incestuous world of their own, like characters in Cocteau's novel *Les enfants terribles.* Franz

idolized their mentor and competed for his attention with a jealous passion that was flattering at first but soon became awkward and tiresome. Rebuffed one too many times, he brought two hustlers back to his hotel room, gave them a kitchen knife, and paid them to cut off one of his fingers, which he wrapped up and sent to the object of his obsession. Shocked and frightened, Cocteau let it be known that he was done with the Thomassin threesome but eventually relented and came to appreciate his disciple's self-effacing loyalty. After the war he took pride in the fortitude and courage Franz displayed as a courier for the Resistance, an honorable achievement almost as heroic as that of Cocteau's former lover Jean Desbordes, who died under torture without revealing the names of his confederates.[1]

Cocteau's influence can be detected in *Richard Winslow,* a historical novel beginning in Elizabethan England and ending in the American colonies. Orphaned at an early age, the young Winslow makes his way in the world by performing women's parts on the stage under the protection of an elderly actor and a noble patron, both captivated by his grace and beauty. He forsakes them to marry his one true love, joins a puritanical sect, departs for the New World, and lives out his last years contentedly as the patriarch of a prosperous family. A dramatic interlude halfway through the novel brings on a chorus of gods and goddesses who assist at Winslow's nuptials in a parody of pastoral opera. On the last page, Thomassin noted that he had written it in 1933, 1937, and

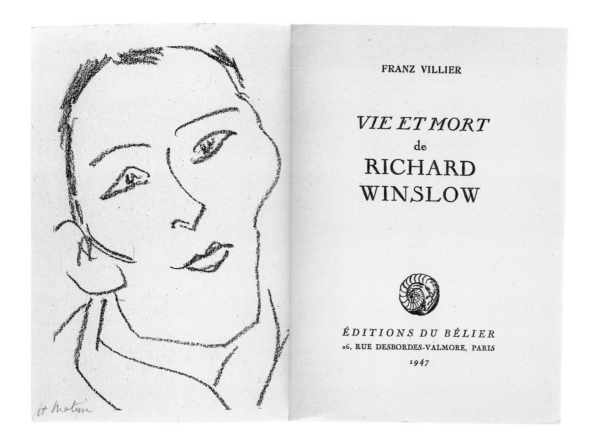

Fig. 1. Frontispiece and title page, Franz Villier, *Vie et mort de Richard Winslow,* Frances and Michael Baylson Collection

FRANZ VILLIER

VIE ET MORT
de
RICHARD
WINSLOW

ÉDITIONS DU BÉLIER
26, RUE DESBORDES-VALMORE, PARIS
1947

1939—a period of literary apprenticeship during which he would have acquired from Cocteau a taste for Shakespeare, the classics, theatrical artifice, and amorous intrigue. No doubt he put the novel aside during the war, but he also had a reputation for neglecting to publish his work. (He is now best known for a dyspeptic travel book about Portugal.) Cocteau may have encouraged him to persevere with *Richard Winslow* inasmuch as he praised it highly in a review comparing it to *Faust Part II* and the Swedish bestseller *The Saga of Gösta Berling*. As if to cement the connection with Cocteau, Thomassin dedicated the book to Desbordes.[2]

Matisse may have executed the frontispiece as a favor to the author, one of his neighbors in Vence. He also may have undertaken this commission to oblige the publisher, Mathias Tahon, not long after completing a similar project for Tahon, André Rouveyre's *Choix de pages de Paul Léautaud* (No. 26). Like the Léautaud frontispiece, the Thomassin portrait was the outcome of numerous preliminary studies, including three charcoal drawings and fourteen lithograph variations. This time, however, Matisse made his work more accessible to the public, who could see reproductions of the portrait in the regular copies of *Richard Winslow* and a reproduction of a charcoal drawing in the journal that carried Cocteau's review.[3]

PAGE SIZE: Jésus 16mo; 19 × 14 cm.

PAGINATION: 378 [6] pp.; pages 1–2 and 380–84 blank.

ILLUSTRATIONS: The special copies with a frontispiece lithograph printed by Mourlot Frères, Paris, of which 15 copies were signed in pencil by Matisse. The regular copies contain a reproduction of the lithograph.

TYPOGRAPHY: Printed at the Imprimeries Paul Dupont, Paris. Text in 11-point Deberny et Peignot Série 16 or an equivalent in that style, display in Deberny et Peignot Naudin.

PAPER: The lithograph on Chine, 40 copies printed on mold-made vélin teinté Malacca supplied by Papeteries de Lana, Docelles. Regular copies on low-quality machine-made wove, the frontispiece on coated paper.

BINDING: Printed wrappers.

EDITION: Printed 5 February 1947 and issued around 27 March 1947. The edition including 40 special copies on vélin teinté Malacca numbered I to V and 1 to 35, ordinary copies priced at 240 francs.

COPIES EXAMINED: PML 195606 (no. 35); Dartmouth College Library 846 V719 Y3 (ordinary copy).

REFERENCE: Duthuit 1988, no. 18.

EXHIBITIONS: Saint Petersburg 1980, no. 114; Fribourg 1982, no. 23; Nice 1986, no. 69.

31.

Charles Baudelaire (1821–1867), *Les fleurs du mal [illustrées par]* **Henri Matisse. Paris: La Bibliothèque Française, 1947.**

No. 28 recounts how Matisse's lithographs for *Les fleurs du mal* were ruined in the Atelier Desjobert. Fortunately he had made photographs of the transfer drawings. At first he tried to make a new set of lithographs by copying the photographs but then decided that the photographs were closer to the spirit of the text and that he could rely on them to produce an illustrated edition. They would be reproduced by photolithography, slightly reduced and with a background tint to ensure that no one would confuse them with original lithographs. For advice on how to publish them in this form, he turned to his friend Louis Aragon, who had already collaborated with him on other publication projects. Aragon would write a note explaining why they were obliged to resort to a "mechanical" printing method. (Instead of that "hideous word," Matisse urged his friend to "think of something better.") Most importantly he would take charge of publishing the book at a firm under his direction, La Bibliothèque Française.[1]

Aragon, Pierre Seghers, and Paul Éluard established La Bibliothèque Française in the Free Zone during the war. They published some classic texts and engaged in some clandestine printing on the side, including Aragon's own writings. After the Liberation, he took over the imprint and turned it into a publishing arm of the French Communist Party. Around 1949 it was absorbed into another firm, Éditeurs Français Réunis, also managed by Aragon. Matisse could count on his friend to respect his design decisions and to look after his interests during the production process. He signed a contract for the book on 12 December 1945.[2]

At first Matisse expected to produce an edition of a thousand copies, a commercial venture commensurate with the menial status of a work dependent on photographic reproductions. Those willing to pay a premium could buy specials containing an original print or a suite of prints. He considered the possibility of using a linocut as a frontispiece for the specials following the precedent of the frontispiece in *Dessins: Thèmes et variations.* He later took a less ambitious approach, probably on the urging of Aragon, who would have preferred to undertake a smaller edition, less expensive and more likely to succeed in a collectors' market. There would be no specials, but every copy would have an original print for a frontispiece, an etching rather than a linocut, and they would all be signed and numbered in the traditional style of bibliophile publications. Printed on Chine, the etching would be a better companion for the reproductions because it would have a similar background color. The contents would be the same as the book Matisse had hoped to make for Les XXX de Lyon, except that it would include one more poem at the end, *"L'examen de minuit."* The text would be based on the centenary edition published by the Librairie des Bibliophiles Parisiens in 1921. Lacourière would print the frontispiece, Mourlot would print the reproductions, and Joseph Dumoulin would print the text, which would be seen through the press by Dumoulin's artistic director Henri Barthélemy. The Dumoulin firm took on some fine printing commissions during the 1940s, but it was best known for the scholarly attainments of its proprietor, who studied at the École des chartes and sometimes corrected the work of his compositors himself. The compositors set up some sample pages, which the artist used as a template to plan the typography and layout.[3]

The poems would begin with large calligraphic initials similar to those in *Visages* (No. 23). They too would be in an English round hand and would be about the same size, although, after experimenting with the sample pages, Matisse decided that they would fit better in rectilinear spaces rather than the stepped series of indents he had prescribed for *Visages.* He also designed a series of calligraphic ornaments to fill out blank areas at the end of poems and empty pages at the end of sections. These abstract interlacing figures would complement the initials and lend a thread of visual continuity to the reading experience. Lydia Delectorskaya recalled that he labored over them at night, when he had bouts of insomnia during the summer of 1946. Somehow he prevailed upon Aragon to print the initials and ornaments as wood engravings instead of zinc cuts, the photoengraved line blocks he had been obliged to use in *Visages.* At least this much of the book would not be "mechanical," although it must have greatly increased Aragon's expenditures on production. Théo Schmied, son of the great Art Deco artist and printer François-Louis Schmied, prepared the engravings to the exacting specifications of the artist, who sometimes insisted on reviewing proofs as many as five or six times. Matisse took an even greater interest in the wood engravings because his grandson Gérard Matisse was working for Schmied as an apprentice at that time. Ordinarily the wood engravings would have been printed by Dumoulin along with the text but Schmied's artistic contributions were deemed so important that he earned the right to do the printing on his own. He received credit for his presswork in the colophon, and a comparison of different copies confirms that the initials were printed separately: their placement vis-à-vis the text varies slightly, and two initials (pages 31 and 103) include flourishes that overlap the text, which would be impossible

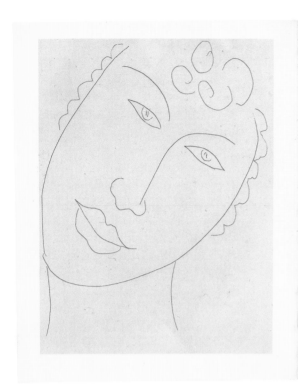

HENRI MATISSE

LES FLEURS DU MAL

CHARLES BAUDELAIRE

LA BIBLIOTHÈQUE FRANÇAISE

Fig. 1. Frontispiece and title page, *Les fleurs du mal,* Frances and Michael Baylson Collection

Fig. 2. Studies for initial *A, Les fleurs du mal,* The Pierre and Tana Matisse Foundation, New York

if the letterpress and wood engravings had been printed together.[4]

Matisse made these designs on the basis of a maquette, which he received in May 1946. If the maquette has survived, its present location is unknown, but one could surmise that it contained the text of the thirty-three poems broken down to pages with blank spaces for the initials and ornaments. The maquette made it possible to visualize the book as a whole as well as to assess the weight of the text page in relation to the decorative elements and the illustrations, photographs of which Matisse had in hand and pasted in the proper places. On the day it arrived, he dropped everything and worked on it from sundown to after midnight. He claimed to have drawn the initials on the spot and to have been satisfied with them as if he had finished the job right then and there, but it is more likely

that these were only the first in a series of studies. After seeing everything in place, he was convinced that it would be "a very lovely volume," although he informed Aragon that the text composition had to be entirely redone. "Obviously that is going to annoy you," he conceded, "but it is absolutely necessary." The type was too thin, in his opinion, and had to be replaced with something more imposing. Whether Aragon followed his instructions I cannot tell, but somehow they decided on a font of Caslon, a robust character of English origin with a stolid demeanor quite unlike the lighter text faces used in France.[5]

Aragon tried to be patient while the artist experimented with different decorative motifs. After the maquette arrived in May, there were no appreciable signs of progress until the end of the year, when Matisse began to work on the cover design.

This was the last item of business on his artistic agenda, but that did not dissuade him from pondering a wide range of possibilities. He filled dozens of pages in a ring binder with pen-and-ink studies for the cover and made just as many drawings on loose sheets, some of which are in the holdings of the Pierre and Tana Matisse Foundation. He churned through a torrent of ideas for the signature image, some more Baudelairean than others. Among the rejected designs is a literal delineation of

the poet incorporating one of his most famous poems: he drew a portrait of a smiling female figure with a chevelure composed of Baudelaire's name spelled out in curls and ringlets. Taking another tack, he acknowledged the canonical status of *Les fleurs du mal* by framing the title in architectural volutes. Noting some of its sinister associations, he sketched out flowers redolent of evil and several variations of a malignant octopus brandishing decorative tentacles. He rendered the title in capital letters on a background of foliage inspired by a local plant, silver ragwort, which grew in his garden in Vence. Finally he chose a

simple semiabstract design similar to his seaweed gouache cutouts with the title beneath it in the same script as the initials. More than a year had passed after he began work on what was supposed to be an unpretentious commercial alternative to a limited edition. If it had been up to Matisse, he would have taken even longer to supply the graphic apparatus he believed essential to the success of the book. The *achevé d'imprimer* is dated 10 February 1947, and he inscribed a copy for Lydia Delectorskaya in March. By June he was still not sure that he liked what he had done. Thinking about problems with his other printing projects,

he told Rouveyre that this one also had its defects. "I already had bad luck with Baudelaire," he reported. "The wood-engraved ornaments do not have all the spirit they should have because the publisher was constantly rushing me, saying that it was a question of life and death."[6]

Critics and collectors have had similar reservations about this labor-intensive artistic interpretation of *Les fleurs du mal.* Alfred Barr thought that the portraits did not adequately express the "dark passion" of Baudelaire. William Lieberman detected a "certain pedestrian sameness" in Matisse's books of the mid-1940s, a reproach perhaps

Fig. 3. Rejected cover designs, *Les fleurs du mal,* The Pierre and Tana Matisse Foundation, New York

most applicable to *Visages* and this edition, which contains illustrations and ornaments in the same style. *Visages* has always ranked higher in the esteem of collectors because of its handmade paper and original lithographs. A copy sold for 12,500 francs at an auction sale in 1948, whereas *Les fleurs du mal* brought only 8,500 francs at that sale, a price differential still evident today. This difficult and protracted project nonetheless deserves some consideration for the sheer amount of effort expended. So immersed was Matisse in the work of Baudelaire that he began to appropriate it, an unconscious side effect Aragon observed in the course of their collaboration and reported in a story that can be corroborated with a hitherto undocumented cover design in the Pierre and Tana Matisse Foundation. While they were proofing the title page, the artist noticed that they had inserted his name but had forgotten to mention Baudelaire. The cover design also credited the artist instead of the author. Matisse corrected his self-centered mistake on the cover and would have overcompensated in a revised title-page design by placing his name below the poet's but eventually

agreed to take precedence in a chaste and balanced typographic composition. Despite the consternation they might have caused, there was some truth in those two rejected designs, which show that he had dwelled so long in the mental space of *Les fleurs du mal* that he had earned a moral right of ownership in that property.[7]

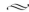

PAGE SIZE: Carré quarto; 28 × 22.5 cm.

PAGINATION: 169 [7] pp.; the first 2 leaves and the last 2 leaves blank.

ILLUSTRATIONS: Frontispiece etching printed by Roger Lacourière; 33 full-page lithographic reproductions printed by Mourlot Frères; 36 ornaments in text, including 10 full-page designs and 33 wood-engraved initials engraved in wood by Théo Schmied, who also printed them.

TYPOGRAPHY: Printed by Joseph Dumoulin, Paris, under the direction of Henri Barthélemy. Text in 18-point Caslon, some display in Garamond italic.

PAPER: Frontispiece on Chine appliqué, letterpress and illustrations on mold-made wove BFK Rives.

BINDING: Cream wrappers with ornaments and calligraphic title by Matisse on the front cover, contained in a green cardboard slipcase and a cream cardboard chemise with a red leather back displaying the title on a red paper spine label.

EDITION: Printed 10 February 1947. Edition of 320 copies signed by the artist, including 20 copies hors commerce allocated to the collaborators and lettered *A* to *T* and 300 regular copies numbered 1 to 300.

COPIES EXAMINED: PML 195607 (no. 247); HRC q PQ 2191 F625 1947 (no. 12); BnF Res M-Ye-404 (lettered *O*).

REFERENCES: Barr 1951, pp. 273 and 560; Guillaud 1987, pp. 445–54; Duthuit 1988, no. 19; Monod-Fontaine et al. 1989, p. 400; Monod 1992, no. 1114; Brown 2013.

EXHIBITIONS: Philadelphia 1948, no. 267; Geneva 1959, no. 29; Paris 1970, nos. 206 and 207; Saint Petersburg 1980, no. 7; Fribourg 1982, no. 7; Nice 1986, nos. 16 and 17; Le Cateau-Cambrésis 1992, no. 1.

32.
André Rouveyre (1879–1962), *Repli, gravures de Henri Matisse*. Paris: Éditions du Bélier, 1947.

≈

The production of *Repli* can be described in detail because Matisse and Rouveyre regularly referred to it in their correspondence. They renewed their friendship in 1941 while Matisse was recovering from a perilous surgical procedure and Rouveyre was coping with financial problems exacerbated by wartime scarcities. They wrote to each other constantly—even when they lived in Vence, within walking distance of each other. Sometimes they exchanged friendly greetings, news, gossip, and reports about their latest endeavors in art and literature twice a day. Hanne Finsen's exemplary edition of their correspondence contains information about *Repli* at every stage of manufacture, from beginning to end—from the first conceptualization of an illustrated edition up to the shipment of the finished product. Documents in the Pierre and Tana Matisse Foundation show how they developed their design ideas and dictated them to the publisher. A full account of the planning process might be useful but is not necessary here. A summary of these sources will explain how this book attracted the attention of the artist and how it fulfilled the aspirations of the author.

Repli is the conclusion of an autobiographical trilogy, a valedictory apologia and moral testament recounting themes Rouveyre developed in two earlier novels: *Singulier* (1933; enlarged edition 1934) and *Silence* (1937). "For me," he told Matisse, "it is a decisive achievement, the culmination of some twelve years of my best work in my maturity." He did not have much to show for his efforts—he had tried and failed to make a book of two hundred pages—but

every word was charged with personal significance. It is about the end of an affair, his liaison with Andrée Pardon, who had lived with him during the early 1930s and still invited him now and then to stay with her and her husband. André and Andrée parted amicably, but in *Repli* their relationship became an object lesson in "the inevitable tragic destiny of love."[1]

Almost all the action of the novel takes place in the mind of the narrator. Seeking closure, he decides to make a final visit to his lover after they have been separated six or seven years. In the first part, *"Retourner,"* he takes the train to her town, stays in the local hotel, meets some mutual friends, and walks by a place where they once lived together. In the second part, *"Revoir et survivre,"* he goes to see her for the last time, engages in inconsequential conversation, makes a parting gift, and then takes the train back to Paris. This is not a sentimental journey but rather a mental exercise, a meditation on love and a critique of the opposite sex not unlike Rouveyre's diatribes early in his career (see No. 1). "When women in the Western world try to think for themselves, they make mistakes, get confused, and nearly always act against their own best interests." In this and other works, he declared himself to be a disciple of the baroque prose stylist Baltasar Gracián, whose intricate rhetorical conceits and convoluted moral subtleties were the model for the exposition of *Repli*. These stylistic considerations left no room for dialogue, description, or any other concession to the reader's curiosity. There is nothing to interrupt the deliberations of the protagonist, who finds in himself the strength of character to undertake this psychological experiment and steel himself for the realization "once again I am totally and incontestably alone."

Fiction as austere as this did not have much commercial potential. Léautaud

believed that *Repli* was an improvement over *Singulier* and *Silence,* but Rouveyre realized that it would be difficult to publish. "I know only too well that my work is arid." Mercure de France declined to take on *Repli* although that firm had issued the two preceding volumes. It had fallen on hard times during the war, paper shortages were a problem, but the director offered to reconsider as soon as conditions improved. Rouveyre claimed that he could wait because he was still in the midst of correcting the text, then in its sixth draft. For that matter, he still could not decide on the title of the book, a "grave problem" that had occupied him for days on end without a satisfactory conclusion. Among the possibilities he considered were *Tard, Résoudre, Dénouement, Non,* and *Envers.* He finally settled on *Repli* because it was one of his favorite words, suggesting a retreat inward and a withdrawal from the outside world. It came to symbolize his outlook and deportment, a situation in which he saw himself to be the exact opposite of Matisse. "I have retired to my cavern while you live life to the fullest in the brightest light of day." For consistency's sake, this account of *Repli* will refer to it by that title even when one of those alternatives was the current favorite. Matisse offered his advice on this issue and asked to see the typescript, which Rouveyre sent to him in February 1942. At first the author was delighted that his friend had expressed interest in his work, but after months passed without any comments or ideas, he took it back on the pretext that he had to revise it yet once again.[2]

Matisse probably never got around to reading *Repli*. He had other publication projects on his mind as well as health problems and other day-to-day concerns triggered by the vicissitudes of the war. Rouveyre knew the limits of their friendship and tried not to impose on the artist's time or

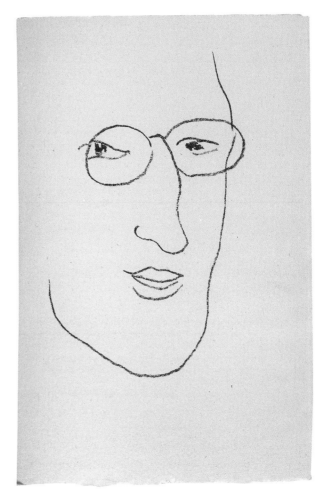

Fig. 1. Title page, *Repli,* The Morgan Library & Museum

Fig. 2. Lithograph illustration, *Repli,* The Morgan Library & Museum

Fig. 3. Tracing of a chapter opening in *Églogues de Virgile,* The Pierre and Tana Matisse Foundation, New York

IX ANS SONT PASSÉS DEPUIS NOTRE SÉPARATION. QUAND MON ESPRIT SE DÉTOURNE DE MON INTENTION VOLONTAIRE ET QUE MES REGARDS RENCONTRENT LES CHOSES, QUEL TRISTE ÉTAT DE MON CŒUR..

Et cette tendresse qui n'a plus son objet.. Que faudrait-il encore, à un autre que moi, pour qu'il abrège sa vie..

Je reviens de Paris. Je t'avais quittée ce matin. Je vais te retrouver tout à l'heure. J'ouvrirai

9

Fig. 4. First page of text, *Repli,* The Morgan Library & Museum

patience. He too had interests elsewhere, but in January 1946 he returned to the subject of *Repli* and asked outright for a frontispiece illustration. He still hoped for a trade edition and thought that he might be able to take his business to Gallimard (which did, in fact, publish it in 1947). If, however, Matisse was willing to contribute an original print for the frontispiece, they could make a fine book on pure rag paper in a limited edition, say two hundred copies, a much more attractive proposition and a token of friendship for which he would always be grateful. While

making this request, he noted that he was having financial troubles and that his wife had succumbed to a mental illness that would require full-time institutional care. Matisse understood that he was in a bad way and asked to see the text once again: "I will see what I can make of it, and I will try to do my best." This time he did read it, at least in part, and professed to understand its "impertinence." How he arrived at that word is hard to tell, unless he was still thinking of Rouveyre's earlier satirical work, which was quite unlike this deadly serious psychological

study of passion and abnegation. He paid Rouveyre the compliment of perceiving parallels with Gérard de Nerval's *Aurélia,* a cult novel that had been praised by the Surrealists. He may have learned more about the book as he went along, but, in any case, he promised to design a frontispiece and asked if it should be a portrait of the author. Rouveyre replied that he appreciated this generous gesture all the more because it would help him to persuade a publisher to act quickly.[3]

With Matisse on board, Rouveyre was able to find a compliant and resourceful publisher, Mathias Tahon, proprietor of the Éditions du Bélier. He was already working with Tahon on an edition of Léautaud's selected works (No. 26) and regarded him as "a very reliable man" always eager to oblige the talented people he needed in his business. The correspondents sometimes called him Head of Gold, a jocose allusion to his mop of blond hair and the quantity of coin in his control. Tahon knew that a Matisse frontispiece would help to sell the book and readily consented to a letter of agreement, which they composed together and sent to him on 24 April 1946. The edition would be composed of 370 copies—250 for the publisher, 100 for the artist, some for the participants in the project, and a gratis copy for the Bibliothèque Doucet. As usual Matisse wanted payment in kind, but Rouveyre needed the money and stipulated that he should receive 10 percent of the list price, which Tahon could determine but was not to be less than 6,000 francs. That was the amount the Head of Gold used to calculate what he owed the author, a total of 150,000 francs paid in three installments, but he eventually set the retail price at 16,000 francs. Rouveyre expected him to offer the usual 30 percent discount to the trade and bought some author's copies at that rate.[4]

Fig. 5. Cutout cover designs, *Repli,* The Pierre and Tana Matisse Foundation, New York

The letter of agreement stated that the illustrations should be twelve lithographs. The artist originally assumed that he was on call for a frontispiece portrait of the author, which would have absolved him of the duty of having to read the text. After becoming better acquainted with *Repli,* he inquired whether he should do a portrait of a woman, perhaps someone with "a passionate and submissive sensibility." In that case he had just the thing, a drypoint he had executed a few months ago, if not quite right in the curve of the nose, a vivid picture of reproach in the depths of the eyes such as might flatter the vanity of that "old cynic." Rouveyre liked the idea of a woman's portrait, but it had to be directly related to the text and his personal experience. He sent the artist two photographs of Andrée Pardon with a plea to use them as the basis of the frontispiece:

If by chance you feel some emotion in seeing them, and think of me, try to do a pen sketch, and it will be reproduced perfectly in photolithography as a frontispiece. But, dear dear Matisse! If that is not possible, ah, let's forget it, we won't think any more of the hope I have to see you somehow involved in this little book, which is nonetheless so important.[5]

On the day Rouveyre sent that plea to Matisse, 14 February 1946, they exchanged five letters on the subject of the illustrations. They had already started on a book about Apollinaire but had reached an impasse in their negotiations with the prospective publisher of that volume for which Matisse had made several lithograph portraits of Rouveyre. Now he had in hand several

portraits of Andrée Pardon. He proposed to abandon the frontispiece concept and combine the two series of lithographs in a much more ambitious scheme of illustrations. Rouveyre was pleased by this change of plan and affirmed that he was deeply moved by the additional commitments his friend was making on his behalf. He thought that this new approach complemented the bipartite structure of the novel. The portraits of the woman could be inserted in the first part, which is "suffused throughout with romantic tenderness," and the portraits of the man could be placed in the second part, which is "a systematic progression of analytic will that eliminates love completely and attains absolute self-possession." To underscore the differences, the woman's portraits could be printed on white paper, the man's on a blued paper almost dark as night. The symbolic potential of the illustrations compelled him to rethink the working title he had been using and consider a more aggressive alternative that might evoke the "Mephistophelean atmosphere" of the second part. Matisse adopted this plan and wrote it into the letter of agreement, which contained a clause specifying the color of the second set of lithographs, the same as a sample he was sending for the guidance of the publisher.[6]

The two friends began to plan for the typography of the volume as soon as they finished the letter of agreement. They made a diagram of the front matter, sketched out the title page, decided on a type size, and devised a decorative scheme for the first page of text. Rouveyre recapitulated their discussions in a long letter to Tahon with instructions on how to start the typesetting and how to construct a maquette for Matisse. He recopied the diagram, showing what text should appear on the first six leaves: the half title, the title, a preface, a dedication page, a section title for

"Retourner," and the beginning of that section. The two parts of the book would each begin with a large initial and text set in capital letters, a design motif they had seen in the *Églogues de Virgile* (1926), printed at the Cranach Press of Count Harry Kessler with illustrations by Aristide Maillol. Just to make sure that Tahon understood their intentions, Rouveyre sent him a partial tracing of a typical page in Matisse's copy of the *Églogues* and indicated what parts of his text should be set in capitals. This tracing speaks to Matisse's friendship with Maillol and his appreciation of Maillol's illustration achievements, which were predicated on fine typography in the private press tradition. It is surely the most explicit evidence of Matisse's acquaintance with that style of typography. Nonetheless, he had his own ideas on how to balance the capital letters with the initial, which was to be printed in a precise shade of red. "A lovely red, just like that," said Matisse after finding a good example of the correct tint in Tahon's stationery.[7]

As his thinking progressed, he decided to insert large black linocut headpieces at the beginning of the two sections and linocut tailpieces at the end. He persuaded Tahon that the letterpress and the linocuts should be entrusted to Fequet et Baudier, whose work on *Pasiphaé* had demonstrated their skill in printing linocuts (or perhaps photographing them to make zinc cuts, which were more durable on press).

Likewise, at the artist's insistence, Mourlot won the contract for the lithographs. He expected the cover to be colored by pochoir, a versatile and sophisticated stencil process greatly in demand during the Art Deco period. By that time, however, it was losing favor because it was thought to be too slow and expensive. The letter of agreement prescribed that the pochoir coloring should be done by Draeger Frères,

a firm that had already earned his loyalty by printing the letterpress and color photogravures in *Verve*. He might have been mistaken in making that stipulation because the Draeger concern did not have the requisite pochoir facilities, at least not in 1947, when it was engaged in the production of *Jazz* (No. 34). It printed the text of *Jazz,* but another firm executed the pochoirs. If it could have done them too, the publisher would have kept all the manufacturing operations under the same roof. The pochoir cover for *Repli* was executed in the workshop of Roger Nervet, who had already worked for Tahon on at least one other job. "Matisse absolutely insists on pochoir for the cover," Rouveyre informed Tahon, because the yellow and white design had to be rendered at a precisely calibrated hue and saturation. If Nervet could replicate that design exactly, the two colors would set in motion a pleasing optical vibration, and the white would take on a violet tinge in concert with the background of "incandescent sulfur." These chromatic effects were to be coordinated with the red initials, black ornaments, and the slate-gray paper for the man's portraits as well as the decorative features of the slipcase, which was to have a pearl-gray label on a beige back with blue sides and white accents on the edges. The slipcase turned out to be not quite so colorful as he had planned, but Matisse got his way on most of the other particulars. The more he thought about *Repli,* the more interested he became in its graphic possibilities. What started out as a simple frontispiece commission grew to become a fully illustrated book which inspired him to take charge of the design in every detail, from top to bottom, inside and out.[8]

If given half a chance, the author would have continued to revise the text until the very last moment. He asked for the right to

review galley proofs, page proofs, and the final proofs, the *bons à tirer,* a request denied by Tahon, who would have had to pay for the extra work. Instead Matisse would be the one to sign off on the *bons à tirer,* a prerogative specified by the letter of agreement. Rouveyre urged him to be vigilant in case the publisher should try to insinuate his own ideas in the layout of *Repli.* Although always agreeable, the Head of Gold might want to be more than just the moneyman in this transaction. Those fears were unfounded, and the proofs were not entirely out of reach. Rouveyre corrected the punctuation in a set of galleys first submitted to Matisse and then forwarded to him. He saw a trial setting of the title page, in which his friend had used the catch-all term *gravures* to describe the linocut and lithograph illustrations. Better consult a dictionary, he advised, for that word might apply to intaglio prints, such as etchings and engravings, rather than lithographs. He would have preferred for the illustrations to be identified as *DOUZE LITHOGRAPHIES ORIGINALES.* That wording would have been more accurate and impressive, but it did not include the pochoir cover or linocut decorations, which were also part of the artwork in *Repli.* The Pierre and Tana Matisse Foundation has a proof of the first page of the second section with a number of variant readings, some discarded and some adopted in the trade edition of 1947. A spot check of the 1947 edition reveals that Rouveyre worked over his text yet again to incorporate more afterthoughts and last-minute inspirations. The prudent Tahon was right to curb the compulsions of an anxious author who would always find room for improvement.[9]

The printing of *Repli* began in January 1947, and the limitation statement was ready to be signed in April. The fabrication of the slipcase caused some delays, but copies of the complete book began to arrive in June. Tahon complained that it was not selling well and inquired if Matisse knew of any booksellers in America who might want to buy it. Possibly he was thinking that Pierre Matisse might put them in touch with someone like Marie Harriman, the American distributor of the Mallarmé edition (No. 13). Rouveyre was not pleased to hear about this setback and accused the publisher of hoarding copies with the intention of forcing other members of the trade to forgo the discount. He believed that sales would pick up as soon as the Paris dealers returned from their summer vacations.[10]

Both Matisse and Rouveyre blamed Tahon for design flaws in *Repli.* At first glance Matisse thought that the book was satisfactory, but over time he noticed a number of minor problems. The slipcase was cumbersome. The spine label was placed in an awkward position. The separate suite of prints needed a proper envelope. The color of the paper for the woman's portraits clashed with that of the text—if only they had been printed on Chine instead. On mature consideration he detected another annoying defect, a miscalculation in the makeup of the preliminary pages. Anyone holding an uncut copy would not be able to see the first page of text—one of the graphic highlights of the book—because it had been allowed to land inside the fold joining the first two leaves of the gathering. Readers were supposed to cut open the folds as a matter of course, but some devotees of first editions wished to preserve the pristine integrity of their possessions—"as much cut off the balls of a book collector, assuming that he still cares about them." Matisse resolved to take the matter into his own hands by opening those leaves in the copies he gave to friends. The Morgan has a copy he presented to the art dealer Paul Rosenberg,

in which the necessary measures have been taken to make that page easily viewable.[11]

Somewhat apologetically, Rouveyre pointed out a lapse on the part of the printers. They had omitted the page numbers on the versos of the lithographs, a minor mistake, except that the lithographs could be moved anywhere in the book, and no one would know the difference. Someone could even go so far as to mix the man's and woman's portraits, which would compromise the fundamental concept of the illustrations. Matisse agreed that they needed to fix the missing page numbers and proposed to have them written in by hand. Rouveyre argued against that makeshift remedy, which would only call attention to their predicament, but they could not think of a better solution. It may have been impossible to print them in the first place. Mlle Fequet reported that the paper designated for the man's portraits was too brittle and her pressmen had already spoiled several sheets while trying to deal with it. They would have to settle for page numbers in pencil, an exasperating turn of events that prompted angry comments about the publisher. "What a piece of shit that Tahon," exclaimed Matisse in a letter expressing disappointment and vowing never again to let that happen if he could help it. In the future he would refuse to sign the limitation statement until he could see the book in its entirety. Rouveyre begged forgiveness for causing so much distress and claimed that he only mentioned it out of frustration. "So I just get a bit disgusted," he said in his defense, "when I see an ignorant imbecile letting himself stick his stupid fingers in the works."[12]

Those were strong words to use about a publisher who had tried hard to follow their instructions and succeeded in making a handsome book that met most of their expectations. They should not forget about its

faults, Rouveyre remarked, but "absolute perfection is impossible when other parties intervene in various capacities." There were things they would have done differently, but they could still be proud of it, and it was obviously "very lovely, very fetching, and very appealing." Besides he still wanted to publish his work on Apollinaire. Matisse had made some lithograph portraits of the poet and constructed a tentative maquette but turned his attention elsewhere after losing confidence in the publisher they had engaged for that project. Rouveyre discussed it with Tahon, who proposed to take it over and repackage it in the form of a print portfolio with a prefatory text laid in. All was forgiven by this time, a year and a half after the publication of *Repli.* "I would love to do it," Rouveyre wrote to Matisse. "You know that Tahon has given us proofs of his probity, for he never betrayed us in any respect while we were working on *Repli,* which is in fact a success of the first order." Finally they did produce the book on Apollinaire (No. 45), although not with Tahon, who lost out to a better connected and more enterprising publisher. They trusted Tahon, but they knew that he lacked the means and motivation to carve out a niche for himself in the luxury market. He did not aspire to be a Skira or a Tériade. He preferred a more predictable line

of business, reprints of steady sellers, and never again would produce a book as ambitious as *Repli.*[13]

PAGE SIZE: Raisin octavo in half sheets; 25.2 × 16.5 cm.

PAGINATION: [6] 163 [11] pp.; the first 3 leaves and the last 2 leaves blank.

ILLUSTRATIONS: 12 lithographs included in pagination, printed by Mourlot Frères; 2 linocut headpieces in black, 2 linocut tailpieces in black, and 2 linocut initials in red, printed by Fequet et Baudier, Paris.

TYPOGRAPHY: Printed by Fequet et Baudier, Paris, the design based on a maquette by Matisse. Text in an unidentified 14-point roman, title page in 20-point and 24-point Deberny et Peignot Europe Gras and a 55-mm light condensed sans serif printed in red.

PAPER: The handmade vélin de Montval was supplied by Canson et Mongolfier, Annonay. Although described as a handmade vélin à la forme, the Arches is a mold-made wove with the characteristic deckles of that type of paper. The lithographs are printed on a whitish handmade wove Papier Île-de-France and a gray handmade laid Lana pur chiffon supplied by Papeteries de Lana, Docelles.

BINDING: White and yellow wrappers with the title on the front cover and a botanical motif on the back cover executed in pochoir by Ateliers d'Art Roger Nervet, Paris, gray cardboard chemise with the title on a spine label, gray cardboard slipcase.

EDITION: Printed 30 April 1947. Edition of 370 copies: 35 copies on Montval with a suite of the lithographs on Chine numbered 1 to 25 and I to X; 315 copies on Arches numbered 26 to 250 and XI to C; 20 copies on Arches designated for the participants in the publication. Priced at 16,000 francs, the copies on Montval at 22,000 francs. Gallimard published a trade edition of *Repli* in 1947 priced at 160 francs.

COPIES EXAMINED: PML 77241 (no. XXXVII); PML 195608 (no. 83); PML 196125 (no. 25); Baltimore Museum of Art 1960.129 (no. XLVI).

REFERENCES: Barr 1951, pp. 274 and 560; Guillaud 1987, p. 470; Duthuit 1988, no. 20; Delectorskaya 1996, pp. 298–301; Monod 1992, no. 10006; Capelleveen et al. 2009, pp. 73–74.

EXHIBITIONS: Philadelphia 1948, no. 269; Geneva 1959, no. 30; Paris 1970, no. 211; Washington, Detroit, and St. Louis 1977, no. 86; Saint Petersburg 1980, no. 8; Fribourg 1982, no. 8; Nice 1986, no. 20; Paris 1995, no. 338; Paris and Humlebaek 2005, no. 126.

33.

René Char (1907–1988), *Le poème pulvérisé*. Paris: Fontaine, 1947.

The poet René Char relived his wartime experiences in the publications he planned with Matisse. Char witnessed the defeat of France while serving in an artillery regiment near the border and assisted in an orderly retreat before the German army. After returning home, he was denounced as a leftist militant and was almost arrested, but he managed to escape and took refuge in a town in the Basses-Alpes. There he joined the Resistance and under the code name of Captain Alexandre organized covert operations against the occupying forces. He developed methods of collecting parachuted supplies, helped to hide munitions, and maintained a clandestine communications network. In July 1944 he was posted in Algeria as a liaison officer with troops preparing for the invasion of Provence. After the Liberation, he received the Medal of the Resistance, the Legion of Honor, commendations from the British crown, and a certificate from General Eisenhower. He resumed his literary career and won fame with a collection of verse, *Seuls demeurent,* published by Gallimard in 1945. An edition of a thousand copies sold out in several weeks. Matisse read it avidly and shared it with Rouveyre by quoting his favorite passages in letters decorated with ornamental initials and calligraphic arabesques. He admired Char, respected his achievements, and knew about his heroic role in the Resistance. Eager to be of service, he gladly contributed a frontispiece for *Le poème pulvérisé* and was fully prepared to illustrate other publications in association with the poet. Three of them were never completed but should be mentioned here as evidence of his illustration methods.[1]

Char and Matisse were already well acquainted with each other's work in *Cahiers d'art.* Both were close friends of its publishers, Christian Zervos and Yvonne Zervos (who had an affair with the poet). Parts of *Le poème pulvérisé* first appeared in that journal. Christian Zervos devoted two special issues to Matisse: a retrospective survey in 1931 and an account of his drawings in 1936. The Morgan has a copy of the drawings issue inscribed by Matisse to Char in April 1946, when they were just beginning to confer about their publication projects. A month later the poet returned the favor by sending the manuscript of "The Shark and the Seagull" to Matisse, who made an illustration to accompany it on a facing page in *Cahiers d'art.* This friendly gesture required some words of explanation because he was using the same design for the frontispiece of *Les miroirs profonds* (No. 29). A note beneath the illustration states that he had "discovered the same theme" in a series of recent drawings. Coincidence or not, this transaction provided an opportunity to thank the artist in public for his "discreet kindness" and another act of generosity, which Char wanted to repay with this poem.[2]

Without going into specifics, Char was expressing gratitude for illustrations he hoped to include in an edition of Roger Bernard's *Ma faim noire déjà.* Bernard had been one of his comrades in the Resistance and had started to write some poetry under his tutelage. While on a secret mission, the apprentice poet was captured by the Germans and was summarily executed when he refused to talk. *Cahiers d'art* published a posthumous edition of his work under the title *Ma faim noire déjà* (1945). Matisse was deeply moved by this tragic episode and wrote to the publishers, who forwarded his letter to Char. In turn, Char was delighted that the artist had taken an

interest in Bernard and told him about the plight of Bernard's widow, Lucienne, then working in a fireworks factory to support herself and a child. To raise money for Lucienne, they considered the possibility of making a luxury edition of *Ma faim noire déjà* illustrated with her portrait and that of her martyred husband. A few months later, she came to Vence and posed for the artist, whose charcoal drawings were then reproduced in an issue of *Cahiers d'art* along with a photograph of him at work on one of the portraits. He also made a series of linocuts and etchings, which might have served as illustrations and a frontispiece for the book. He never finished it, perhaps because he did not have the inducement of a publisher's contract. Some of the preparatory artwork can be seen in the Seghers, 1976 edition of Bernard's poetry.[3]

A similar charitable cause inspired them to plan a new edition of Char's *Artine,* first published in 1930 with a frontispiece after Salvador Dalí. The proceeds of their edition would help to fund relief efforts for the widows of Resistance fighters killed in action. Matisse made some preliminary ink and watercolor studies and tested some sample layouts. *Cahiers d'art* was to publish it, although the expense of reproducing the watercolors was a problem, and it seemed less urgent after the government began to look after the widows and orphans. At one point Char resolved to have it printed at his own expense and inquired about the status of the illustrations without receiving a response encouraging enough for him to proceed. *Artine* fell by the wayside, but he never forgot about it, even after the death of Matisse. In 1968 he arranged for the Jacomet firm to study the feasibility of printing the watercolors. A year later, he contacted the publisher Janine Quiquandon and asked her to negotiate the rights for an edition with the illustrations printed by

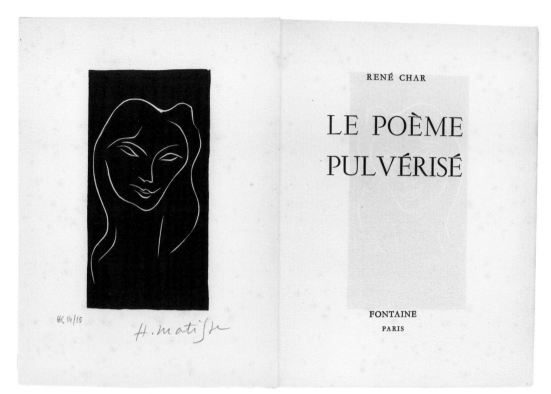

Fig. 1. Frontispiece and title
page, *Le poème pulvérisé,*
Frances and Michael Baylson
Collection

Fig. 2. Eulogy of Roger Bernard
in *Le poème pulvérisé,* Frances
and Michael Baylson
Collection

RENÉ CHAR

LE POÈME PULVÉRISÉ

FONTAINE

PARIS

Jacomet and the text by Fequet et Baudier. The artist's heirs considered the idea but did not act on it, even though André Jacomet wrote them an enthusiastic letter seconding Quiquandon's proposals. Once again the poet failed to resuscitate the project, which is perhaps just as well—this book belongs to an early Surrealist phase more worthy of Dalí than Matisse.[4]

Char approached Matisse with one more illustration idea, which also was abandoned because both parties had options elsewhere. Aimé Maeght had asked him for a manuscript to be printed in a fine edition, an excellent opportunity to be associated with this ambitious up-and-coming publisher. The poet believed he had a promising text in the scenario he had written for a ballet, *La conjuration,* and counted on Matisse to provide the illustrations for the Maeght edition. He sent the text to the artist along with a request for drawings, noting that Maeght had expressed a desire to make

something stylish and refined. Nothing came of his request, but he succeeded in persuading Georges Braque to take on the commission. Braque designed the costumes and painted the curtain for the ballet, which was performed in 1947. Inserted in the program was an announcement that Maeght would publish an edition of *La conjuration* with the set designer's illustrations. That proved to be wishful thinking, although Braque became a close friend of Char and illustrated other books by him.[5]

The publisher of *Le poème pulvérisé* did not have the artistic sensibility of a Maeght or a Zervos, but he made up for it with his war record and political credentials. Max-Pol Fouchet was the director of the journal *Fontaine,* a "monthly review of poetry and French literature" published first in Algiers and then Paris between 1939 and 1947. Despite the threats of Vichy officials, he denounced the Occupation, rejected the status quo, and affirmed the ideals of the freedom fighters.

AFFRES DÉTONATION SILENCE

Le Moulin du Calavon. Deux années durant, une ferme de cigales, un château de martinets. Ici tout parlait torrent, tantôt par le rire, tantôt par les poings de la jeunesse. Aujourd'hui, le vieux réfractaire faiblit au milieu de ses pierres, la plupart mortes de gel, de solitude et de chaleur. A leur tour les présages se sont assoupis dans le silence des fleurs.

Roger Bernard : l'horizon des monstres était trop proche de sa terre.

Ne cherchez pas dans la montagne; mais si, à quelques kilomètres de là, dans les gorges d'Oppedette, vous rencontrez la foudre au visage d'écolier, allez à elle, oh, allez à elle et souriez-lui car elle doit avoir faim, faim d'amitié.

55

He published an editorial, "We Are Not Defeated," in August 1940 and reprinted Paul Éluard's celebrated paean of the Resistance, *"Liberté,"* in June 1942. After November 1942, Algiers stood beyond the reach of censorship,

and *Fontaine* became a voice of free expression like the Cahiers du Rhône (No. 19) but was even more explicit in its attacks against the Nazis. It sponsored a biweekly program on Radio Algiers. Aragon, Albert Béguin, and others devised ingenious ways to procure contributions from authors stranded behind enemy lines. A miniature edition was printed in London for distribution in France by parachute drops from Royal Air Force planes. Fouchet claimed to have reached a press run as large as 12,000 copies, which he shipped as far away as Stockholm, Moscow, and New York. In 1945 he was publishing editions in Algiers and Paris as well as a series of monographs under the imprint Éditions de la Revue Fontaine. Char became acquainted with him when they were both in Algiers and contributed several poems to *Fontaine*. By giving him *Le poème pulvérisé*, the warrior-poet recognized his patriotic services, made a gesture of solidarity, and enjoyed the benefit of a prestigious imprint.[6]

While discussing these other projects, Char solicited a frontispiece for *Le poème pulvérisé*, either an etching or a lithograph to be inserted in twenty-five special copies. "I should say that I took the initiative of asking you for a frontispiece," he explained, "for my friend Fouchet will produce my book, and I won't have any hope of discussing it with him." Thus he took this preemptive action on his own and then asked the publisher to deal with the artist directly. In the meantime he expressed his impatience to see the drawing for "The Shark and the Seagull" and noted that the poem would appear not just in *Cahiers d'art* but also in this book along with other texts, two of which he sent as specimens of his recent writing. Furthermore he enclosed a sample page showing the book's format so that Matisse would know the correct proportions for the frontispiece. Matisse accepted the commission, although he decided to

furnish a linocut instead of an etching or a lithograph. He did not participate in the design of the volume, which was probably left to the printer, Raymond Séguin. The printer is an obscure figure and seems to have been more active in the union movement than in the bibliophile community. He occupied the premises of the legendary sporting newspaper *L'Auto*, which had been obliged to move away and take on a different title after incurring suspicions of collaborationist sympathies. For his peace of mind, Matisse stipulated that the linocuts should be printed by a firm he could trust, Fequet et Baudier.[7]

He took this precaution after realizing that Fouchet did not understand the purpose of the frontispiece. Either ignorant or ill-informed, the publisher had sent him a letter offering to reproduce his drawing with a zinc cut—not an offhand comment but a business proposition broached at the beginning of the letter and repeated at the end. That was not at all what he had in mind, Matisse replied, but rather an original print signed by him and produced in a limited edition only for the special copies. "If I insist on this point, it's because I consider it important for René Char, for you, and for me as a matter of principle." Yes, he wanted to honor the poet but also give him the "material advantages" of a commercially successful publication, which were more likely to be achieved by a genuine work of art than an ordinary reproduction. How much profit it made is not known, but apparently not enough to sustain Fouchet, who closed down *Fontaine* soon after it appeared.[8]

This was not the first time Matisse had to deal with a publisher poorly trained in the trade of fine illustrated books. Clearly Fouchet was not qualified for this job, but it was too late to turn back. As it turned out, he was more of a publicist than a publisher,

now best known for his role in presenting the first television program devoted to French literature, *Lectures pour tous* (Reading for Everybody; 1953–68). His romantic past, telegenic charm, and infectious enthusiasm for "difficult" books endeared him to viewers, who have commemorated his accomplishments with a Web site and a cultural association, "The Friends of Max-Pol Fouchet."[9]

PAGE SIZE: 26 × 19 cm.

PAGINATION: [4] 103 [5] pp.; the first leaf and the last leaf blank.

ILLUSTRATIONS: Linocut frontispiece printed by Fequet et Baudier, Paris.

TYPOGRAPHY: Printed by Raymond Séguin, Paris. Text in 18-point Monotype Garamond roman and italic with pagination in 18-point Cochin.

PAPER: Although described as a pure rag *à la forme*, the Johannot is a mold-made wove with the characteristic deckles of that type of paper.

BINDING: Wrappers printed in red and black.

EDITION: Printed 2 May 1947. Edition of 1,265 copies: 65 copies on Johannot with a linocut frontispiece signed by the artist, the colophon signed by the author, numbered I to L and H.C. 1 to 15; 1,200 copies on simili Japon numbered 1 to 1,200. The ordinary copies priced at 550 francs.

COPIES EXAMINED: PML 195609 (H.C. no. 14); Doucet AE III 11, 517 (H.C. no. 7); Doucet AE III 12, 518 (not numbered).

REFERENCES: Cranston 1973; Duthuit 1988, no. 21.

EXHIBITIONS: Saint-Paul de Vence 1971, nos. 126–35; Fribourg 1982, no. 24; Nice 1986, no. 70; Paris 2007, nos. 145 and 146.

34.

Henri Matisse (1869–1954), *Jazz*. Paris: Tériade Éditeur, 1947.

The fame of *Jazz* puts it in a class by itself. It is a singular achievement in the way it was conceived and constructed: a series of color essays accompanied by a free-form, aphoristic text seemingly improvised for the occasion, like a solo part in a jazz composition. For optimum effect, the color plates were reproduced by a painstaking, labor-intensive printmaking method, and the text was written out by hand to give it an air of intimacy and spontaneity. The text has been read as a fundamental statement of artistic principles, and the plates have been viewed as a culmination of a lifetime devoted to the study of color. Acclaimed by critics and coveted by collectors, it is the most illustrious of Matisse's illustrated books, although his designs are not really illustrations but rather independent works of art linked by common themes and a consistent style. As a concession to the trade, Matisse issued them both in book form and as a portfolio of prints, the so-called "unfolded" *Jazz,* which is easier to disassemble and display. In one form or another, *Jazz* has gone on exhibition in France, Brazil, the United States, Germany, Austria, Japan, Mexico, and England. It has been reproduced in facsimile with scholarly commentaries and at least four English translations of the text. It has been the subject of essays, articles, monographs, a doctoral dissertation, and other writings too numerous to list in a catalogue entry. Its exuberant and playful imagery has inspired a multitude of interpretations, which I will not summarize here unless they have some bearing on the publication process.[1]

Instead of recapitulating previous accounts of *Jazz,* I will take the publisher's point of view and look at it as a bookmaking venture, albeit quite unlike the standard fare of the fine printing business. Like other publishers, Tériade supervised production and paid the bills, but he saw something special in this book and invested an exceptional amount of effort in persuading Matisse to persevere despite technical difficulties and the distractions of the war. The grateful artist recognized his contributions and sought to acknowledge them in his text, which ends with a tribute to Tériade. While drafting his remarks, he mused on the role of the publisher, "a very gifted man, who has a great influence on artists, especially when his passionate love for a book is so great that it becomes part of his life." Personal experience taught him how that kind of influence could sway design decisions, overcome obstacles, and maintain the momentum of a publication project.[2]

As early as 1940 Tériade was urging Matisse to make a book out of colored paper cutouts, the operating principle of *Jazz.* The artist had been using the cut-paper technique for various applications in his paintings and his decorative work, including a curtain for the Ballets Russes de Monte Carlo and cover designs for *Cahiers d'art* (1936), *Verve* no. 1 (1937), and *Verve* no. 8 (1940). "Drawing with scissors" he called it, an artistic endeavor not to be confused with collages or papiers collés. He insisted on that point because those terms suggested an entirely different kind of work—the collage novels of Max Ernst, for example, or the pasted paper ingredients in the Cubist paintings of Braque and Picasso. He preferred the expression *papiers découpés* and sometimes referred to the process as découpage. Seeking purity and accuracy, he made some of his early cutouts with papers he found in printer's ink specimen books, a means of ensuring that the printers could match his colors exactly. He then developed a method of coating his papers with extra fine gouaches manufactured by the Linel firm, once even contacting the firm directly to obtain a special tint discontinued during the war. In some of the lighter tints, one can see the broad brushstrokes left by his studio assistants while they were applying the gouaches. Tériade knew about Matisse's experiments with color and repeatedly inquired about the possibility of publishing the results, either in *Verve* or a large-format book containing an essay on the subject. "Inaction is insupportable," he wrote in 1940, while commiserating about wartime privations, "but I cultivate my dreams. I dream of a book about the 'color of Matisse,' which would contain all your past and present thinking about color as well as large illustrations (much larger than in *Verve*) along the lines of the *Symphonie chromatique* and the *Danse.*" Those two examples can be identified as the cover for *Verve* no. 8 and the maquette for an etching after the painting *La danse I.* During 1941 and 1942, he reminded Matisse about this book and assured him that they would employ an "absolutely faithful" reproduction method. Some of his letters were accompanied with tempting gifts of luxuries, such as two tins of foie gras suitable for someone "not on a diet." These gifts worried Matisse, who thought that he had better pay for them because he had no intention of accepting the publisher's proposals. Tactful as always, Tériade backed off and claimed that he was no longer thinking about the book—which was not true but helped to keep open the lines of communication.[3]

Verve was the vehicle for staying in touch with Matisse. In June 1943 the artist called a meeting to discuss a cover design for the special issue "Concerning Color." Tériade and his assistant Angèle Lamotte were present at the meeting along with Lydia Delectorskaya, who remembered it in

detail. They adroitly steered the conversation around to the topic of the book, which prompted Matisse to show them two of his recent gouache cutouts, *The Clown* and *Toboggan*, both preliminary studies for the Ballets Russes production. They saw a promising beginning in those designs and convinced him to proceed on that basis. *The Clown* and *Toboggan* are the first and last plates in *Jazz* (although the cutouts may have had to be redone in the correct size and proportion for the volume). A contract signed by Tériade specifies an album containing 18 to 20 color plates reproducing "original compositions" by Matisse, who would sign every copy of the edition, 350 copies in all. For payment he was to receive 70 copies and 45 more if he should allow the publisher to retain the originals. The publisher would furnish the materials for the project free of charge and would arrange to have the fragile cutouts framed for their protection. The artist liked to have a clear understanding of his rights and responsibilities. Having put those affairs in order, he set to work and announced a few weeks later that he had completed six of the designs, including *Horse, Rider,* and *Clown.* He predicted that it would be difficult to print that one because of the fine detail in his scissor work, but he hoped that it might be amenable to wood-engraving.[4]

Tériade promised to seek out the best possible printing method or perhaps a combination of different printing processes. He signed a receipt for two cutouts he would use for his experiments, *Pierrot's Funeral* and *The Nightmare of the White Elephant.* In December he reported that he had gone to Paris to supervise the work of the printers, probably Draeger Frères, who produced the color photogravures in *Verve.*

"They understand the importance of the book, they are enthusiastic, and I believe that they will do the impossible in their quest for perfection." Draeger might have been his first choice because he already had a business relationship with that firm and because he believed, at first, that photogravure would be an acceptable reproduction process. He later mentioned it as one of the methods he had tested and rejected. Among the other possibilities, wood-engraving deserved consideration for its excellent performance in rendering saturated colors, an effect amply demonstrated by the Art Deco illustrations of François-Louis Schmied. Schmied's son Théo learned this craft in his father's workshop and set up his own business making fine art reproductions (see No. 42). Tériade hired him to proof the cutouts, beginning with *Pierrot's Funeral.* He engraved seven blocks for each of the

Fig. 1. Frontispiece (*The Clown*), plate I, and title page, *Jazz,* courtesy of Frances and Michael Baylson

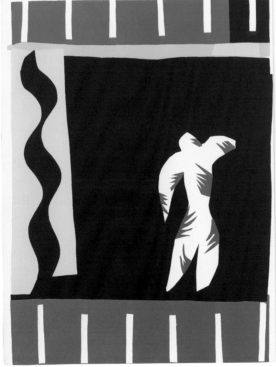

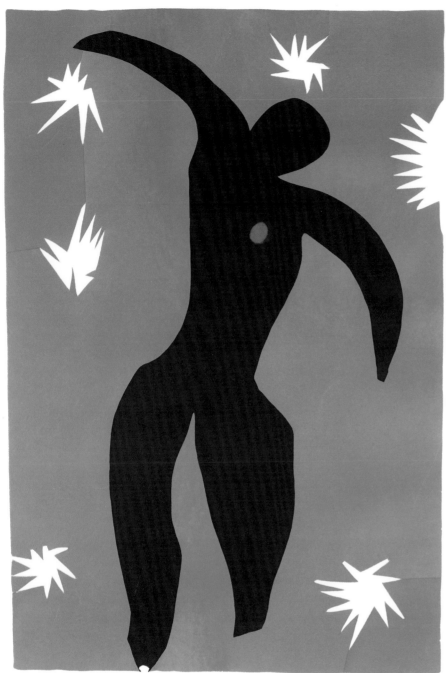

Fig. 2. Preliminary study for the *Icarus* pochoir, plate VIII of *Jazz,* The Pierre and Tana Matisse Foundation, New York

colors in this design and printed them on a hand press, holding the platen down for as long as five minutes to ensure adequate ink coverage in the solid areas. Three of the colors he printed twice over, so each proof required ten impressions and spent a total of fifty minutes in the press. Painstaking as it was, this approach proved to be unsatisfactory because the oil-based inks it required did not match the colors in the gouaches. Tériade knew this would be a problem and proposed to deal with it by using the Linel colors as printing inks, a logical idea that he had to abandon after learning that they were water-based pigments and could not be applied with rubber rollers. At one point he also called on a technical expert, the director of the École Estienne, to make photoengraved zinc blocks of the cutout compositions *Forms* and *The Codomas.* These too failed to render the rich colors of the gouaches. He even tried to print them with linocuts. Although he was running out of options, he wanted Matisse to know how hard he had been working and proposed to send him trial proofs of the different printing methods. "That will be painful to the eye, but it might be amusing."[5]

These setbacks were exasperating. Disenchanted with four-color printing, Matisse told Tériade that he was ready to cancel the "Concerning Color" issue of *Verve* and had serious doubts about the book, a commitment he had undertaken in a moment of weakness. ("I did not foresee the consequences.") Later he complained that the effort of making the cutouts had strained his eyesight so severely that he had taken to wearing heavily tinted sunglasses. ("I am counting on you to get me a white cane in Paris.") Tériade appeased him as best he could and never once betrayed any lack of confidence in the project, but it took a toll on the health of Angèle Lamotte, who fell

sick and died before it could be completed. She struggled with the color printing problem even while she was recuperating from the first onslaught of her illness. Tériade noticed two spots on the surface of *Pierrot's Funeral* and thought that they were traces of her tears—"What a passion for *Jazz!* And in her condition!"[6]

Pochoir was one of the reproduction methods they rejected. They understood the capabilities of this stencil process and knew that it had been used for book illustration as well as facsimiles of artwork. Sample facsimiles can be seen in the *Traité d'enluminure d'art au pochoir* (1925) by Jean Saudé, one of the great masters of this craft and proprietor of one of the leading pochoir studios in Paris. Saudé described highly sophisticated techniques for cutting stencils and applying colors, which could be of any hue, texture, and consistency, ranging from heavy gouaches to translucent watercolors. Matisse and Tériade tested this versatile medium and concluded that it would be their best option for making prints with the Linel gouaches but decided against it because the prints were too fragile and could not be folded. After Angèle Lamotte's death in early 1945, they put *Jazz* aside for a while and concentrated on the production of "Concerning Color" (which contained a tribute to Lamotte). Later that year, they reversed their earlier decision and tried again to make proofs with pochoir. Matisse's critique of mechanical reproduction processes in that issue may have strengthened his resolve to rely on hand craftsmanship, admittedly less accurate in replicating his designs but infinitely more faithful to his colors. The purity and simplicity of the stencil process could have been seen as more in keeping with the ingenuous imagery and improvisatory quality of *Jazz*.[7]

The pochoir prints were made in the studio of Edmond Vairel (1903–1973), student and successor of Jean Saudé. Vairel had the right qualifications for the job but did not have a very prosperous career. His name appears in a number of Paris imprints during the 1940s, though not as many in the 1950s, and in 1959 he left Paris to take a more secure position in Monaco. The pochoir business went into a slow decline after the war, beset by high labor costs and a retrenchment in the market for fine illustrated books. *Jazz* was the beginning of the end. No longer commercially feasible, pochoir has been superseded by other reproduction processes, although it has been revived by private presses now and then for comparatively modest illustration projects.[8]

In April 1946 Vairel's *découpeurs* were still cutting stencils, a long and complicated task, and Matisse was still seeking special colors from the Linel firm, including a shade of violet he deemed indispensable to the concept of *Jazz.* By then he was far enough along in the planning process to begin thinking about a text to accompany his cutouts. Originally it was supposed to express his philosophy of color, but he evaded that assignment. "I am sick of color right now," he confessed, "and I dare not write about it." Instead he compiled a miscellany of short aphoristic meditations on topics he felt would be in the same spirit as his designs—the nature of artistic creation, the act of drawing, the sources of happiness, and the primacy of love. Here again he discouraged attempts to interpret text or image on the basis of one or the other. He intended his writing to be decorative in the best sense of the word. Right at the outset, in his first paragraph, he stated that he expected it to perform a graphic function, separating the colorplates "by intervals of a different character." In a rejected draft, he was even more explicit in saying that he had been using it as filler between the colorplates and had composed it at the insistence of the publisher. He was, of course, making the usual modest disclaimers about his pronouncements on art, but he was also thinking of the overall configuration of the book and the relationship of its constituent parts. In fact he did explain its origin and purpose in his remarks, especially the famous passage in which he compared the incisive strokes of a sculptor with his technique of "drawing with scissors." A rhapsodic expostulation about the allure of lagoons referred directly to the three cutouts with that title. The *Icarus* plate picked up the theme of flight in juxtaposition with an account of airplane travel, a liberating experience and a form of self-transcendence. At the end he described the colorplates as "crystallizations of memories of the circus, of popular tales, or of travel" and reminded the reader that the intervening text was a framing device to preserve the independence of the plates. By this he meant that they should be viewed separately and should not be jumbled together like prints in a portfolio.[9]

Matisse accentuated the decorative function of his text by having it printed in his own cursive script. He considered the possibility of setting it in type and had a sample page prepared for his inspection but decided against that approach, which would have been too formal, impersonal, and pretentious. By this time he had ample experience in designing script initials, and he had already started out to write out by hand another book, *Poèmes de Charles d'Orléans,* which Tériade published in 1950 (No. 41). Precedent existed in books like *Les yeux fertiles* (1936), containing a handwritten text by Paul Éluard and etchings by Picasso, who returned to that concept in Pierre Reverdy's *Le chant des morts* (1948). Tériade also published *Le chant des morts,* a long-term project for which Reverdy completed his text in January 1945, long

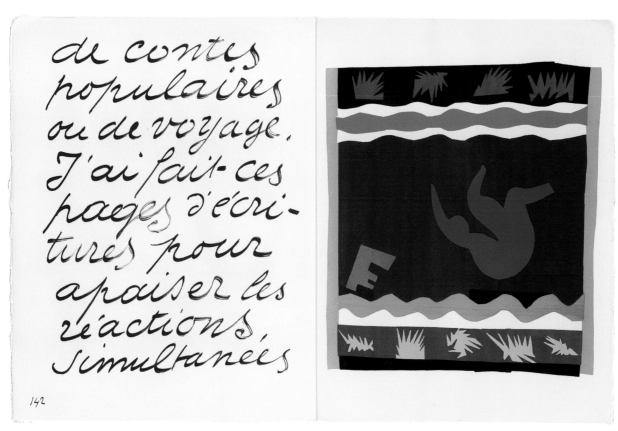

de contes
populaires
ou de voyage,
J'ai fait ces
pages d'écri-
tures pour
apaiser les
réactions,
simultanées

142

Fig. 3. *Toboggan,* plate XX, and facing page of text, *Jazz,* courtesy of Frances and Michael Baylson

before Matisse began his calligraphic exercises for *Jazz.* When asked about its relationship with *Le chant des morts,* he replied that those ideas were in the air at that time. Among other factors, one could mention the cult of the autograph in collectors' circles and the facsimiles of medieval manuscripts in the special issues of *Verve.* In Tériade's opinion, the gouache cutouts had color affinities with manuscript miniatures that argued against a typographic treatment in favor of a monumental script inspired by "the bold pictorial writing of the High Middle Ages." Matisse acknowledged the receipt of writing paper in April 1946 and began to practice with a

reed pen and Chinese ink that summer. His preliminary studies show that he worked by trial and error to fit the text on the page along with headings and arabesque ornaments. Tériade sent him a maquette, but there is no indication how it may have been used in planning the layout of the volume. With a final flourish, Matisse wrote out a table of illustrations elucidated by pen-drawn vignettes designating the salient features of every image, a felicitous design idea and an intriguing example of his penchant for simplification.[10]

His design for the wrappers also testifies to his love of letterforms. I believe that he originally intended to make illustrated

wrappers out of his *Circus* cutout, which is clearly configured to display the word *Cirque* on the front and back cover of some kind of publication. Most commentators don't try to identify it, but Matisse's correspondence reveals that he had been using that word as a working title for the book, even though Tériade consistently referred to it as *Jazz.* He started to come around to Tériade's point of view in March 1944 and mentioned both titles as possibilities in an interview published in April 1944. When he made that design, however, he was thinking of *Cirque* and was expecting to reproduce the gouache cutouts as wood engravings rather than pochoirs (which

Fig. 4. Rejected cover designs, *Jazz,* The Pierre and Tana Matisse Foundation, New York

would not have been feasible on material subject to abrasion). Instead of using *Circus* for the wrappers, he folded it in the other direction to make a two-page opening stating the dominant theme of the book and providing a transition between the *Clown* frontispiece and the portrait of the ringmaster, *Monsieur Loyal.* He would have also preferred *Jazz* to *Cirque* because of its calligraphic potential, the stately capital *J* and the syncopated double *z*, rendered in a lilting cursive on the title page and glyphic block letters on the cover. Numerous preliminary studies for the cover and title page are in the holdings of the Pierre and Tana Matisse Foundation and other Matisse collections.

The bold black-and-white calligraphic cover provides an agreeable contrast to the brilliant color plates inside.[11]

Destiny, The Heart, and *Forms* were also intended to be viewed as two-page openings. One could make a case that these and other two-part compositions could only be read in book form, where facing pages are defined by folded leaves. At first Matisse envisioned *Jazz* purely as a book project and negotiated the contract on that basis. He did not entertain the notion of a separate portfolio of unfolded prints until March 1947, when someone proposed this change of plans. Probably it was urged upon him by Tériade, who would have incurred

substantial manufacturing costs by this time and would have been thinking of ways to maximize the return on his investment. He could try to build a larger customer base by targeting print collectors as well as book collectors with two types of *Jazz,* each packaged for its constituency. He sent Matisse typescript drafts for the limitation statements of the two versions, which were duly corrected in consultation with Rouveyre, who recommended a text suitable for "those who buy albums." The size of the edition remained more or less the same. The 250 copies in the book version and 100 copies of the portfolio add up to the 350 copies stipulated by the contract not

counting the 20 hors commerce copies. When *Jazz* was finally completed in December 1947, Matisse received in payment 60 copies of the book and 20 copies of the portfolio. The original cutouts became the property of Tériade, whose widow, Alice, donated them to the Musée national d'art moderne in 1985.[12]

It is hard to tell how or how much Tériade profited from this venture. He sold the edition to or through the Paris anti-quarian bookseller Pierre Berès, who had also helped him to market *Les lettres portugaises* (No. 27). Berès launched the book with a gala exhibition opening at his shop on 20 December 1947. If he did not buy the edition outright, he acquired exclusive distribution rights in France, America, and maybe elsewhere. He advertised it and exhibited it not just in Paris but also in Rio de Janeiro and New York. His American agent, Lucien Goldschmidt, sold copies of the book and the portfolio to Pierre Matisse, who had tried to buy them at the point of sale in Paris, but all the copies there had been taken. Goldschmidt recalled that he had been allocated forty copies, all of which were gone within a year. His New York exhibition created a stir among collectors, even though his bookstore lacked adequate display facilities. Pierre Matisse much preferred the 1948 blockbuster retrospective at the Philadelphia Museum of Art, where, at the end of the exhibition, an entire room was devoted to *Jazz*. Tériade did not participate in this publicity campaign, although he was delighted by the response. In a telegram to Matisse two days after the Paris opening, he announced, ALL OF PARIS WAS PARADING BEFORE JAZZ FOR FOUR HOURS STOP PAINTERS AND CRITICS THINK THE BOOK IS SENSATIONAL AND ONE OF YOUR GREAT WORKS.[13]

André Rouveyre attended the opening at the urging of Matisse and in the company of Florence Gould. He admired the installation and drew a bird's-eye view of the premises showing how the plates and text pages were displayed. But he was disappointed with the pochoirs, sad to say, because they looked lifeless, dry, and cold ("just the opposite of what is your true genius and what produces the drama and the emotional efflorescence in your paintings and drawings"). After thinking about it for a few days, he repeated his objections to the stencil process, which unlike lithographs, engravings, and other original prints conveys no trace of the artist's hand. "Your work loses its fire as soon as it passes through intermediaries," that is, in this case, the *découpeurs* who cut the stencils and the *coloristes* who applied the pigments. He realized that he was expressing a contrarian opinion and begged the indulgence of Matisse, who, however, readily agreed with the strictures of his friend. "I appreciate your candid remarks about *Jazz*," he wrote in reply:

I share your opinion absolutely. *Despite all the effort I put in it, I never could get it right in principle. It's a* failure *through and through—and I wonder why these cutouts are appealing to me when I make them and see them on the wall and why they don't have that puzzling aspect I find in* Jazz. *I think it is the transposition that ruins them and strips off their sensual quality—without which anything I do is fruitless. For that matter I told Tériade before the exhibition what little sympathy I have for that book. And now you see it is an unprecedented success, a landmark, etc. etc.*[14]

This was not the first time Matisse became disillusioned with a book just after he completed it. He expressed similar reserva-tions about the Mallarmé. Nonetheless he enjoyed the critical acclaim bestowed upon *Jazz* and proudly noted the astonishment caused by this revolutionary development in his work when he was well into his seventies, so long in years that some reviewers had lost count and cited his age as eighty, eighty-one, or even eighty-two. He liked the idea that it was easy to exhibit and that plans had been made to show it in England and Germany.[15]

As to the pochoirs, he had learned his lesson and would no longer try to make reproductions of his cutouts except as cover illustrations. He conceded that the contours of the images didn't have the "purity" of his scissor work, but the colors were correct, and he considered that a major improve-ment after having had to cope with the four-color halftones in *Verve*. Above all he wanted *Jazz* to be a treatise on color, a specimen book demonstrating his theories by example, and in that respect it achieved its "principal purpose." He believed in the instructional value of reproductions and credited them for having a formative influence on artists. Thinking back to his student days, he recalled how he had been inspired by Japanese prints, not the real ones, but rather "those awful reprints you find in the bins by the doors of printsellers on the rue de Seine." Bonnard had told him that the vivid first impressions one received from bright and shiny reprints could spoil one's appreciation of originals that had been discolored over time. In that respect his defense of *Jazz* rings true when the original cutouts appear in an exhibition, a frequent occurrence by popular demand. Some of the colors have faded from light exposure, and some of the cutouts have deteriorated because of the inherent fragility of *papiers découpés*. The book version should be viewed as the definitive statement of the artist's

intentions—all the more reason for him to have acknowledged the perseverance of his publishers, the selfless Angèle Lamotte and the indefatigable Tériade.[16]

PAGE SIZE: 42 × 32.5 cm.

PAGINATION: [4] 146 [14] pp.; the first 3 leaves, pages [153–54], and the last 2 leaves blank.

ILLUSTRATIONS: 20 pochoir prints executed in the Ateliers Edmond Vairel, Paris, calligraphic text and ornaments printed by Draeger Frères in photogravure.

TYPOGRAPHY: Letterpress colophon probably printed by Draeger Frères.

PAPER: Mold-made wove vélin d'Arches.

BINDING: Ivory white wrappers with the title in calligraphic lettering on front cover, ornamental design on the back cover, gray cardboard chemise with a spine label, gray cardboard slipcase.

EDITION: Printed 30 September 1947. Edition of 270 copies signed by the artist: 250 copies numbered 1 to 250; 20 copies hors commerce numbered I to XX. In addition a portfolio of the 20 pochoir prints without the text, numbered 1 to 100 and signed by the artist (Duthuit 1988, no. 22 bis). The bookbinder Rose Adler reported that the retail price of the book was 48,000 francs; in New York the book sold for $350, the portfolio for $375 (Lavarini 2000, pp. 241–42).

COPIES EXAMINED: HRC fNC 980.5 M35 A66 1947 (no. 18); Indiana University Art Museum (no. 125); NYPL Spencer Collection (no. 229).

REFERENCES: Barr 1951, pp. 274–75 and 560; Matisse 1957; Matisse 1983; Schneider 1984, pp. 661–69; Guillaud 1987, pp. 558–83; Duthuit 1988, no. 22; Monod-Fontaine et al. 1989, no. 145; Monod 1992, no. 7848; Delectorskaya 1996, pp. 510–15; O'Brian 1999, pp. 143–49; Lavarini 2000, p. 250; Matisse 2009a; Matisse 2009b, vol. 1, pp. 137–55.

EXHIBITIONS: Philadelphia 1948, no. 270; Geneva 1959, no. 31; Boston 1961, no. 200; Paris 1970, nos. 208–10; Washington, Detroit, and St. Louis 1977, nos. 16–37; New York 1978, pp. 150–52 and 219–20; Saint Petersburg 1980, no. 9; Fribourg 1982, no. 9; Mexico City 1983; Nice 1986, no. 22; Paris 1988, no. 2; New York 1994, pp. 96–97; Florence and Le Cateau-Cambrésis 1996, pp. 133–84; London 2004; Paris and Humlebaek 2005, pp. 195–209; Nuremberg 2007, pp. 58–85.

Jacques Kober, *Le vent des épines, illustré par Bonnard, Braque, Matisse.*
Paris: Pierre à Feu, Maeght Éditeur, 1947.

Fresh out of school, Jacques Kober was twenty years old when he started to work for Aimé Maeght. He took on the job of gallery director and publications manager as a way of making his living until he could realize his ambitions to become a poet and critic. His employer paid him 25,000 francs a month at a time of rampant inflation and gave him an apartment in what were once the maids' quarters of the gallery building. His was a modest position, but it had the potential to advance his career. First of all, he could move to Paris, where he could meet members of the avant-garde literary elite, such as André Breton, René Char, and Paul Éluard. He could do some writing on the side, mainly poetry in the Surrealist vein but also a theoretical tractate with the working title "From Bonnard to Surrealism." And, most importantly, he could publish his writing in the periodicals and monographs he produced for the gallery. It was his prerogative to write the concluding essay in *Les miroirs profonds* (No. 29), a valuable opportunity to display his work in the company of Aragon and other prominent authors. He had top billing in *Le vent des épines,* a slim volume of verse illustrated by Bonnard, Braque, and Matisse. A sort of a father figure to Maeght, Bonnard introduced the fledgling dealer to Matisse and helped him find his gallery premises in Paris. Matisse and Tristan Tzara introduced him to Braque. The three artists each contributed a drawing to be reproduced in *Le vent des épines,* thus expressing their

support of Maeght's business venture and their approval of Kober's poetry. For Kober it was the chance of a lifetime. In gratitude he dedicated this book to Maeght, one of the poems to Bonnard, and a prose poem to André Breton, who had been working with him on the next Pierre à Feu publication, *Le surréalisme en 1947.*[1]

Maeght and Kober commissioned the Imprimerie Union to produce *Le vent des épines, Le surréalisme en 1947,* and other gallery publications. The Russian émigrés Volf Chalit (1878–1956) and Dimitri "Jacques" Snégaroff (1885–1959) founded the firm in 1910 and ran it until 1957, when it passed into the hands of Louis Barnier, who had married Chalit's granddaughter. Inspired by the revolutionary movements in their homeland, Chalit and Snégaroff began as the leaders of a workers' collective and then asserted their rights of ownership in

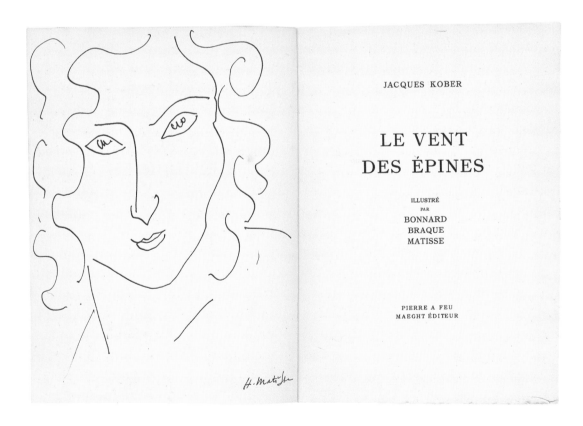

Fig. 1. Frontispiece and title page, *Le vent des épines,* Frances and Michael Baylson Collection

the firm, although some of its original ideals remained in its name, a French adaptation of Кооперативная Типографія Союз. They printed radical tracts for their compatriots and attracted the patronage of Baroness Oettingen and Serge Férat, who hired them to print the avant-garde journal *Les soirées de Paris.* This journal established their reputation in the art world of Paris and brought them to the attention of dealers and critics such as Christian Zervos, whose *Cahiers d'art* were printed at their establishment between 1926 and 1933. Iliazd relied on their letterpress facilities for his artists' books, broadsides, posters, and other graphic inventions, including his master-piece *Poésie de mots inconnus* (No. 39). Maeght was a regular customer beginning with Pierre à Feu no. 1, *Provence noir* (1945). They printed more than a hundred issues of his house magazine *Derrière le miroir* until

he transferred the production of the quarterly to his son Adrien Maeght in 1959. Louis Barnier continued to do business with Maeght after he took over the management of the Imprimerie Union. In an attempt to modernize, he adopted photocomposition methods and installed offset printing presses, which were used for original graphics and fine art reproductions. He retired in 1989, and the firm closed down in 1995. One of the last books printed under his supervision was Duthuit's massive catalogue raisonné of books illustrated by Matisse.[2]

PAGE SIZE: 28.5 × 21 cm.
PAGINATION: [4] 22 [6] pp.; the first two and the last two leaves blank.
ILLUSTRATIONS: 2 full-page reproductions of drawings by Georges Braque and Henri Matisse; 1 half-page reproduction of a drawing by Pierre Bonnard.
TYPOGRAPHY: Printed by the Imprimerie Union, the text set in 16-point Deberny et Peignot Montaigne.
PAPER: Handmade laid Auvergne à la main, supplied by the Moulin Richard de Bas, Ambert.
BINDING: Printed wrappers.
EDITION: Printed 19 March 1947. Edition of 400 copies: 270 copies numbered 1 to 270; 30 copies hors commerce numbered H.C. 1 to H.C. 30; 100 *"exemplaires de presse"* on vélin Artois without illustrations numbered S.P. 1 to S.P. 100. Priced at 1,200 francs or 1,500 francs.
COPIES EXAMINED: PML 195633 (no. 71); MoMA PQ 2671.O3 V4 1947 (no. 159).
REFERENCE: Duthuit 1988, no. 51.
EXHIBITION: Saint-Paul de Vence 1972, pp. 36–37.

36.

Jules Romains (1885–1972), *Pierres levées: poèmes. Frontispice original de Henri Matisse.* **Paris: Flammarion, 1948.**

With this lithograph frontispiece Matisse did a favor for a friend he had known and respected for thirty years. He saw Romains almost on a daily basis during parts of 1918 and 1919, when they were both living in Nice. He had come there in search of better light, a more temperate climate, and a respite from the distractions of the Paris art world. Romains taught philosophy at schools in Nice for two years while writing on the side. He often visited the artist's studio and acquired some paintings that he displayed in his Paris apartment during the 1930s; one was a portrait of his first wife. As if to cement their friendship, he wrote an appreciation of Matisse's work, which he viewed as an encouraging sign of a classicizing tendency in contemporary art, a prime example of the equilibrium and self-possession one might find in an ode of Horace or a prelude by Bach. Romains's reminiscences are some-what confused on the chronology of their acquaintance, but it would seem that he made a return trip to Nice sometime in the early 1930s, when he watched the master at work on the mural for Albert Barnes.[1]

During the Second World War, Matisse lost contact with many of his friends and family, including Romains, who left France to live in exile in the United States and Mexico. The writer could count on a warm reception abroad, where he was already famous for his drama, poetry, and fiction, especially the comedy *Knock* and the epochal series of novels, *Les hommes de bonne volonté.* He finished the series and saw six volumes through the press in association with an expatriate publishing house in New York. A similar establishment

in Mexico published *Pierres levées* (1945), a collection of poems about the war with vivid images of desolate landscapes and bitter reflections on the transience of life, the plight of refugees, and the decay of civilized values. The title could be loosely translated as *Standing Stones,* an allusion to the monumental vestiges of prehistoric cultures, mute testimony of the distant past not unlike the ruins of modern warfare. Romains visualized a wasteland of bombed-out buildings, equally enigmatic as to their original purpose and significance as menhirs in Brittany and statues of Easter Island. Shattered hopes, human savagery, panic, flight, and fatigue are the dominant themes in these verses.

It doesn't matter, vagrant:
The wall may hold or crash.
Your joy tastes of ash.
They've cured you of being decent.

Romains returned to France after the war with superb political and literary credentials. Prompted by General de Gaulle, he put himself up for election to the Académie française, even though he had previously disparaged that venerable institution. He was duly admitted and given the seat vacated by a member who had been condemned for collaboration with the enemy. He clearly enjoyed the publicity and attention he received as one of his country's most distinguished men of letters, the guest of honor at public functions, a celebrity constantly in demand for interviews and articles on current events. Henri Flammarion, the managing director of his publishing firm, escorted him to Paris and organized a reception to welcome back this profitable and prestigious author. Romains's sixtieth birthday occasioned a collection of congratulatory essays published by the Flammarion firm in 1945. Despite this

special treatment, in 1948 he reverted to his former publisher, Gallimard, for an edition of selected poems, a successful venture so popular with the public that it went through at least five printings. He defected from Flammarion just this once. His regular publishers continued to have exclusive rights to his writings, but, not to be outdone, produced their own tribute to the poet by reprinting *Pierres levées* in a lavish limited edition.[2]

It is not clear how or when Matisse became involved in this project. By one account the author and the publisher jointly asked him to contribute the frontispiece lithograph, a last-minute request compelling the artist to start work after the text portion of the book had been completed. It should be noted, however, that the *achevé d'imprimer* is dated 1 April 1948 and that Matisse had already prepared a drawing, which Romains praised in a letter dated March 30th. "I should thank you so much for your noble and expressive drawing," he wrote graciously. "I am glad that our names appear together in this book. For me this is a new confirmation of an old friendship." Matisse was able to oblige his friend on short notice because this single lithograph was conceived purely as decoration. There was no attempt to illustrate these verses, which addressed subjects altogether too dire for his taste and temper. He sought serenity in his portrait studies and succeeded with this notably demure example, not unlike the many other portrait prints he was making in this period. He sketched a similar face in the *nominatif* copy designated for Henri Flammarion with a cordial inscription dated August 1948.[3]

Correspondence accompanying Flammarion's copy could controvert that account with evidence indicating that the artist had received the commission years in advance. When this copy came up for sale at Christie's in 2003, the catalogue noted

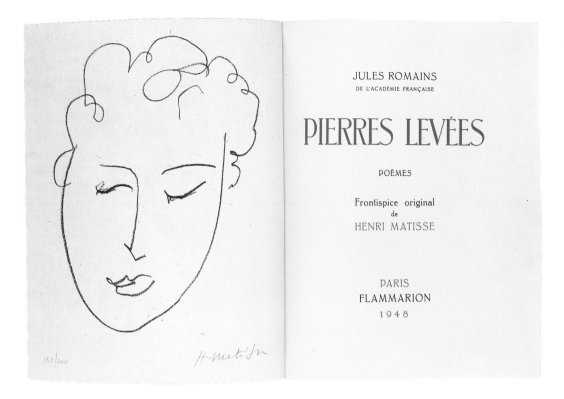

Fig. 1. Frontispiece and title page, *Pierres levées,* The Morgan Library & Museum

the presence of seven letters from Matisse to Flammarion dated between 5 May 1943 and 31 April 1948. In the last letter, Matisse told the publisher that he could pick up his copy and he should call sometime to arrange a visit (which would have been in August, when Matisse inscribed the drawing). Christie's catalogue entry states explicitly that these letters discuss the illustration of the book in sufficient detail to show that Matisse had been working on it for quite some time. This statement cannot be verified because repeated attempts to ascertain the present where-abouts of the letters have been unsuccessful. The drawing was removed from the book sometime after the sale, and I can only suppose that the correspondence suffered a similar fate in a scheme to display a work of art in solitary splendor.

In any case it seems doubtful that the first letter referred to *Pierres levées,* which Romains had just begun in 1943 and did not publish until 1945. Matisse was much more likely to have been writing about a book of his drawings, which he hoped Flammarion would publish with prefatory remarks by his friend André Rouveyre. Beginning in January 1943, Rouveyre struggled with this assignment and may have never finished it. "I have begun to sketch out some ideas for this one-page text about you," he reported in March but confessed that he was having problems. "The simple fact of writing a single page does not seem in itself such a complicated thing, but in my case, all this ends up in a time-consuming reverie again and again." Flammarion and Matisse still had hopes for this project in June, when they revisited their original proposals and agreed to formalize them in an exchange of letters. The edition of the Matisse-Rouveyre correspondence contains a letter of 5 May by Matisse, who informed Flammarion that he had prepared ten or twelve drawings and had asked Rouveyre for a page and a half of text. That letter must be the same as the first one in this group, but some of the later ones may contain valuable information about *Pierres levées.* This attempt to summarize its publishing history must be considered tentative until they come to light.[4]

Flammarion hired the master printer Pierre Bouchet to design *Pierres levées* and execute the presswork. Bouchet made his reputation as a pressman in the employ of the Art Deco illustrator François-Louis Schmied, whose intricate color wood engravings required infinitely meticulous make-ready and registration. As early as 1919, he was working with Schmied on a French edition of Kipling's *Jungle Book* with color illustrations by Paul Jouve. He also helped to engrave the blocks for some of the Schmied imprints, in which he is credited as *pressier* and *graveur* between

1922 and 1927. He then went into business for himself at a workshop near Paris, where he printed fine books for publishers specializing in bibliophile limited editions. The quality of impression in *Pierres levées*, the rigorous uniformity of inking, and the exquisitely rendered color headings attest to his technical prowess and precision workmanship. It is harder to commend his design decisions, which suggest that his typographical sensibilities were still rooted in the Art Deco era. He set the work in Excelsior, an obscure and eccentric typeface that had already fallen out of favor. Nonetheless, he used an even larger font of Excelsior in another book printed the same year, a folio edition of Mallarmé's *L'après-midi d'un faune* illustrated with etchings by Pierre-Yves Trémois. Flammarion gave him at least one more commission, the wood-engraved initials in a book illustrated by Picasso, Maurice Toesca's *Six contes fantasques* (1953). The last book I know to have been printed by him is Arthur de Gobineau's *Mademoiselle Irnois,* published by the Compagnie Typographique in 1963.[5]

Bibliophile societies like the Compagnie Typographique are responsible for some of the major French achievements in the book arts between the wars. Founded in 1932, this organization took the usual approach in producing books for its members, who subscribed in advance and participated to some degree in choosing texts, commissioning illustrations, and planning production. But its publication program differed from the others in one fundamental respect, which, in theory, would place Bouchet above Matisse. Votaries of "pure typography," these contrarian collectors relished the subtleties of letterpress printing to the exclusion of all else and agreed as a matter of policy that they would never admit illustrations in their books.[6]

PAGE SIZE: Carré quarto; 28 × 22 cm.
PAGINATION: 2 p. l., 104 [5] pp.; the second preliminary leaf blank.
ILLUSTRATIONS: Chine-collé frontispiece lithograph printed by Mourlot Frères, Paris, signed by Matisse in pencil. 12 numbered artist's proofs issued separately (Prints, Bonham's, San Francisco and Los Angeles, 11 May 2009, lot 115).
TYPOGRAPHY: Printed by Pierre Bouchet. Text in 16-point Excelsior, display printed in red.
PAPER: The letterpress portion printed on a mold-made vélin de Lana supplied by Papeteries de Lana, Docelles.
BINDING: Printed wrappers, in cardboard slipcase.
EDITION: Printed 1 April 1948 and issued before 20 August 1948. Inscribed to Lydia Delectorskaya in August 1948. 340 copies, of which 300 numbered 1 to 300, 25 numbered I to XXV, and 15 *exemplaires nominatifs* designated for the participants in the publication. Priced at 3,000 francs.
COPY EXAMINED: PML 195701 (no. 152).
REFERENCE: Duthuit 1988, no. 23.
EXHIBITIONS: Geneva 1959, no. 41; Saint Petersburg 1980, nos. 32 and 101; Fribourg 1982, no. 25; Nice 1986, no. 75.

Tristan Tzara (1896–1963), *Midis gagnés,*
poèmes, huit dessins de Henri Matisse.
Nouvelle édition. Paris: Les Éditions
Denoël, 1948.

The future of the Denoël firm was still in
doubt during 1948. Jeanne Loviton was still
defending her claims to the ownership of
the business in litigation with Denoël's
widow (see No. 17) and did not obtain a
conclusive judgment until December 1950.
Although Denoël was exonerated for his
wartime publishing ventures, that case only
concerned his personal culpability and did
not pertain to the operations of his firm. A
complaint against his company had been
filed just a month before he was murdered,
and the proceedings were revived in
conjunction with other actions against

prominent publishing houses during the
postwar period. The prosecution put the
Société des Éditions Denoël on trial for
collaboration with the enemy and other
offenses, including its anti-Semitic
publications and its financial ties to a
German investor. On 30 April 1948, it was
acquitted on all charges, a turn of events
commonly attributed to Loviton's legal
expertise and social connections.[1]

This new edition of *Midis gagnés* came
off the press that same day, perhaps not too
much of a coincidence given Tzara's
reputation and Denoël's predicament. Tzara
distinguished himself before and during the
war by his antifascist political activities and
his role in the Resistance. By reprinting this
book, his publishers could remind the
public that their house had cordial relations
with Jewish authors such as Tzara and
Triolet, both active members of the

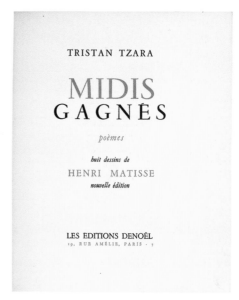

Fig. 1. Title page, *Midis gagnés* (1948), Frances and
Michael Baylson Collection

Fig. 2. Illustration and facing text, *Midis gagnés* (1948),
Frances and Michael Baylson Collection

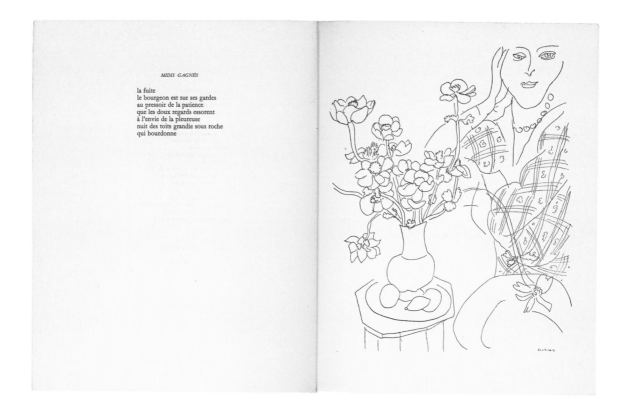

Underground. Yes, they had dealt with discreditable authors in the past. Céline, however, had attained a kind of literary respectability despite his reprehensible opinions, and their other objectionable writers were now out of print. They also reprinted in 1948 antiwar memoirs by Blaise Cendrars and the Italian journalist Curzio Malaparte. They could discern similar antiwar sentiments in *Midis gagnés* and could hope that this publication would help with the rehabilitation of their firm.

Once again Matisse agreed to contribute illustrations for *Midis gagnés*. He selected two more drawings to accompany additional text in this edition, and he designed a frontispiece for the specials, although this time he opted for a lithograph instead of a drypoint. This edition was improved in other ways as well: instead of hiring a trade printer for the letterpress, the publishers commissioned Georges Girard to do the composition and presswork in a small shop specializing in deluxe limited editions. Girard also printed the Ronsard *Florilège des amours* (No. 38) for Matisse in the same year, and he continued to be active in the 1960s and 1970s. In the Anglo-American book world, he is probably best known for his work on the text of the Abstract Expressionist–Pop Art portfolio of lithographs *One Cent Life* (1964).

PAGE SIZE: 24 × 19 cm.
PAGINATION: 166 [6] pp.; pages 1–4 and 169–72 blank.
ILLUSTRATIONS: 8 reproductions of drawings; 15 copies containing a lithograph frontispiece, printed by Fernand Mourlot and signed by the artist.
TYPOGRAPHY: Printed by Georges Girard, Paris. Text in 12-point Garamond, title page printed in red and black.
PAPER: Lithograph on Chine; the letterpress portion on Alfa-Mousse supplied by Papeteries Navarre.
BINDING: Printed wrappers. Front cover printed in red and black.
EDITION: Printed 30 April 1948. Edition of 1,000 copies, including 50 copies hors commerce numbered AI to AL and 950 copies numbered A1 to A950, of which the first 15 contain the frontispiece lithograph. Priced at 1,250 francs, copies with the frontispiece lithograph at 4,500 francs.
COPIES EXAMINED: PML 195610 (no. A546); Beinecke Library 1988 705 (no. A62).
REFERENCES: Barr 1951, p. 560; Berggruen 1951, no. 30; Harwood 1974, no. 29; Tzara 1975, vol. 3, p. 578; Duthuit 1988, no. 24; Monod 1992, no. 10804.
EXHIBITIONS: Geneva 1959, no. 15; Fribourg 1982, no. 20; Nice 1986, no. 74.

38.

Pierre de Ronsard (1524–1585), *Florilège des amours de Ronsard par Henri Matisse.* **Paris: Albert Skira, 1948.**

The increasing fame of his illustrated Mallarmé caught the imagination of Matisse, who began to think of producing another book in the same style. He marveled at the high prices it commanded in the collectors' market, where it was selling for as much as 60,000 francs (nearly three times its original value adjusted for inflation). Others were also impressed by its success and believed it could be a model for a similar publication. In 1939 the publisher Philippe Gonin proposed to him an illustrated edition of Ronsard's *Amours* to be printed in the same size as the Mallarmé with a dozen etchings in an edition of fifty copies. Gonin offered him half of the edition as his payment, promised to pay all expenses, and named Aristide Maillol as someone who could vouch for the probity and reliability of the Gonin firm. Matisse respected Maillol's opinion and admired his books, several of which were published by that firm, but he preferred to work with publishers he knew and trusted. He rejected those proposals and took the Ronsard idea to Albert Skira, who had proved his mettle with the Mallarmé and hoped to follow up on its success with an equally splendid *livre d'artiste*. Like *Lettres portugaises* (No. 27), the *Florilège des amours* began with one publisher and ended up with another more agreeable to Matisse and more capable of dealing with an ambitious project. In this case, however, it was not a simple transfer of title but rather a dramatic resolution of a dispute between the publisher and artist while they were deciding the fate of a different publication venture.[1]

At first Matisse expected to publish with Skira a volume of his reminiscences. He agreed to a series of interviews with the art critic Pierre Courthion, who was to edit them for publication with the working title *Bavardages avec Henri Matisse.* That title has been translated as *Chatting with Henri Matisse,* but he used the word *bavardages* more in a self-deprecating sense to suggest a series of garrulous digressions. He insisted on that nuance of meaning because he realized that he had allowed himself to speak with less restraint than usual while he was in a dazed and giddy state of mind. Miraculously he had survived a serious operation and had been taking a new lease on life as well as a new perspective on his past during his convalescence. As soon as he started talking, out poured a torrent of memories and anecdotes. Farther along in his recovery, he reviewed the transcripts and tried to put them in order, but he began to regret the confidences he made to Courthion and finally decided to suppress them. He told Skira to cancel the project, secure in the knowledge that the contract forbade publication without his consent. Just in case, he consulted with a lawyer and solicited the assistance of a surgeon who could testify on his mental condition at the time of the interviews. Under no circumstances should these unguarded remarks ever see the light of day. He ordered Skira to relinquish any record he might have of them and compelled Courthion to pledge that he would never use them in his writings.[2]

Skira was devastated by this turn of events. From April until August 1941, he had worked feverishly on the preparation of this book. He had already backed down after trying to cut the text and change the title. He catered to all of Matisse's design ideas, including specifications of the type, the layout of the cover, and the disposition of the illustrations. Here too he abided by the contract, which gave the artist the right to participate in the preparation of the

Fig. 1. Title page, *Florilège des amours de Ronsard,* Frances and Michael Baylson Collection

maquette. In July the artist sent him a red chalk self-portrait for the cover, ten drawings for chapter headings, and a linocut to serve as a frontispiece for the specials. They expected to issue a trade edition of 5,000 copies priced at 100 francs with 110 specials priced at 500 francs. The illustrations were supposed to be reproductions of drawings. Predictably the specials were more interesting to Matisse, who wanted to embellish them with original lithographs instead of reproductions and then illustrate the ordinary copies with reproductions of the lithographs. That change of plans arrived just a few days before his "disastrous decision." Surely there must be some misunderstanding, protested an obviously shaken Skira, who explained that it was too late to turn back now. He had invested heavily in the edition, he had succeeded in selling almost all of it in advance, and he had been negotiating for another edition in America. He counted on

it to inaugurate a newly founded publishing business in Geneva, where he had formed a partnership with another devotee of fine books, Pierre Cailler. Just when he was about to start this firm, he would have to admit that he had fallen out with one of the artists who had made his reputation. It was at this point that Matisse suggested a face-saving compromise. Instead of *Bavardages,* he would undertake to illustrate the *Amours* of Ronsard on the same terms as those offered by Gonin, with his payment comprising half of the edition, although he would provide lithographs rather than etchings, and the lithographs would be printed in Switzerland. By accommodating Skira, he maintained good relations with a publisher who could make a book as magnificent as the Mallarmé and might help out in other ways. Aragon advised him that Skira was more reliable than Fabiani, whose political sympathies were suspect and whose business prospects grew dimmer the closer the Allies came to liberating Paris. Skira took over the distribution of *Dessins: Thèmes et variations* (No. 20) after Fabiani failed in the task of marketing that edition.[3]

After patching up his differences with Skira, Matisse was eager to get started with Ronsard ("for I am fired up, and I have a yen to make a beautiful book"). Rouveyre had seen him in this state before and urged him not to be carried away by his enthusiasm, which would work to the detriment of his painting. "Don't fool yourself about this," Rouveyre advised, "you know what is at stake after having done your Mallarmé." They both knew about his tendency to become obsessive about a project, but Matisse could not help himself once he began to think about typographical design. Ideas about type and layout came to him while he was still trying to terminate *Bavardages.* The Ronsard edition would be

a luxury edition "in the style of Mallarmé," although it would be larger, 38 centimeters high and in the Jésus quarto format rather than a raisin quarto. As always, he wanted to have a clear picture in his mind of a typical text page, which would be the conceptual framework for his illustrations. Skira submitted to him sample pages set in Elzévir, Cochin, Plantin, and Garamond italic, even going so far as to print proof copies of the entire text in 24-point Garamond italic. He consulted at least two modern critical editions: the *Poésies choisies de Ronsard,* edited by Pierre de Nolhac (1924), and the two volumes of *Amours* in the seven-volume Classiques Garnier complete works of Ronsard (1923–24). On the basis of the Classiques Garnier edition, he constructed a maquette with pasted-up stanzas on a smaller page, 27 × 21 centimeters, and sketches of illustration ideas in pen and pencil. Maybe he would pick twenty-five to thirty texts, maybe as many as fifty sonnets suitable for a style of illustration not "anecdotal" in nature but arranged in suites to portray the three muses of Ronsard: Cassandre, Marie, and Hélène. He had even chosen the models for the threesome. Descendant of a sultan, "Princess" Nézy-Hamidé Chawkat would play the part of Cassandre; his studio assistant Lydia Delectorskaya would be Marie; and the art student Janie Michels would take on the role of Hélène, although some of the roles could be interchangeable, and he was worried that his "princess bird," or rather his "bird princess," would fly away before he could finish his drawings. He would not neglect the erotic content of this verse but would revel in the sensations of youth and beauty, pleasures he could still enjoy, if only indirectly at that time of life. "At my age! What will they think of me in my condition?" Increasingly intrigued by these illustration possibilities, he declared

that he was now better disposed to take on Ronsard than when he was a young man of twenty-five.[4]

By April 1942 he was far enough along to negotiate a contract for the book, now titled *Florilège des amours de Ronsard,* on the recommendation of Rouveyre. It was to be printed on handmade Rives in an edition of 250 copies, including 50 specials with an extra suite of prints on the same paper. The Kundig firm of Geneva would print the text in a 20-point foundry Elzévir set by hand. The illustrations would consist of 30 lithographs plus a number of headpieces and tailpieces to be designed as needed. For payment the artist would receive half of the edition, 100 of the ordinary copies and 25 of the specials, with the provision that he would not try to sell them below the prices set by the publisher. As usual, Matisse asserted his right to retain the preparatory artwork. Skira wanted to print the entire book in Switzerland, the letterpress by Kundig and the lithographs by Wolfensberger, proprietor of a Zurich printmaking studio founded in 1902 (and still active in family hands). Matisse did not like the proofs he received from Wolfensberger, who botched the job of transferring his drawings to the stone, but he looked forward to directing the work on site in Zurich. An expense-paid trip to Switzerland would be a pleasant change of pace after spending so much time confined to quarters by health problems and wartime travel constraints.[5]

Unfortunately his health did not improve. During the spring and summer of 1942, he suffered a series of agonizing gallbladder attacks that delayed his departure—first scheduled for the end of June, then the beginning of August, then the spring of 1943. While the doctors debated the pros and cons of surgery, he tried to distract himself by drawing

additional illustrations—designs for the frontispiece, studies of ornaments, and portraits of a fourth model, Michaella Avogadro. He pinned some of the designs to the wall facing his bed, others to proof sheets, which enabled him to judge how they bore the weight of the page. The spring of 1943 came and went without any progress in his plans for a sojourn in Switzerland. By December he was feeling better, but travel had become even more difficult. Skira suggested that they wait until they could supervise the presswork of the letterpress as well as the lithographs. They let eight months go by without exchanging a word about Ronsard. Matisse was working on the *Poèmes de Charles d'Orléans* (No. 41) as well as other publication projects, and Skira was busy with his new monthly periodical, *Labyrinthe.* Neither was in a hurry to get back to this project, although they kept in touch now and then, and Matisse reported that he had finally finished with the illustrations.[6]

By that time, August 1945, Kundig had printed the text portion of the book, everything except the title and back matter. Apparently Skira had become less adamant about obtaining the artist's approval of the presswork and felt that he could proceed confidently by following the layout indicated in the maquette. After viewing the proofs, they decided against the Garamond italic and instructed Kundig to reset the entire text in Caslon roman, a letter less "tormented" in appearance and more sympathetic to the broad line of the lithographs. Now that the war was over, Matisse was no longer quite so keen on a trip to Switzerland and proposed to print the lithographs in Paris. Skira asked if he could send up to Paris the sheets Kundig had printed and then take them back so he could assemble and publish the books in Geneva. If worst came to worst, he would

Fig. 2. Study for an illustration, *Florilège des amours de Ronsard,* The Pierre and Tana Matisse Foundation, New York

bear the expense of printing the text again in Paris ("for I am determined to finish our book"). Either way he did not succeed in getting any action on Ronsard, which remained in suspense until they had a meeting in June 1946, their first opportunity to review the complete set of illustrations. During all those delays the number of illustrations had grown from thirty to more than a hundred. Skira said that he was stupefied, although he knew that Matisse had been adding lithographs here and there. He realized that printing in Switzerland was out of the question and that the Kundig sheets would have to be discarded. They would have to start again and design an entirely different *Florilège* on a larger scale.[7]

Matisse reorganized the layout of the book on the basis of a new maquette, a

graph-paper notebook containing thumb-nail sketches of the illustrations and diagrams designating blocks of text. This new maquette served as a guide for the placement of lithographs he had already completed. His design thinking had advanced to the stage that he could assign page numbers to poems without making further adjustments. Compositors in a Paris shop reset the text for a third time in the Kundig font of Caslon, which had been sent up from Switzerland, and the printing of a new set of sheets was completed in May 1947. Worn and battered, Kundig's Caslon did not perform well in press, and the printers had to compensate for its defects by making an extra heavy impression. Altogether it took eight months for the presswork and the additional steps

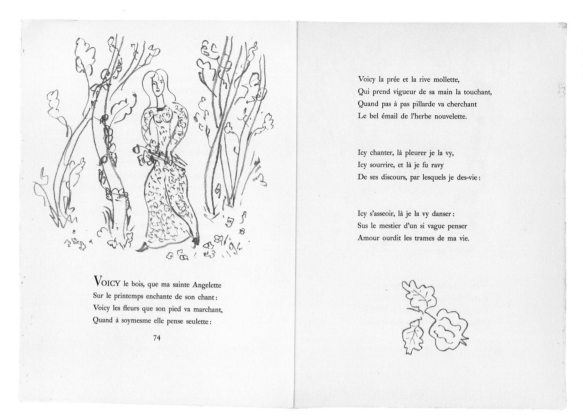

VOICY le bois, que ma sainte Angelette
Sur le printemps enchante de son chant :
Voicy les fleurs que son pied va marchant,
Quand à soymesme elle pense seulette :

74

Voicy la prée et la rive mollette,
Qui prend vigueur de sa main la touchant,
Quand pas à pas pillarde va cherchant
Le bel émail de l'herbe nouvelette.

Icy chanter, là pleurer je la vy,
Icy sourrire, et là je fu ravy
De ses discours, par lesquels je des-vie :

Icy s'asseoir, là je la vy danser :
Sus le mestier d'un si vague penser
Amour ourdit les trames de ma vie.

required to make the surface of the sheets smooth enough for the lithographs, which were supposed to have been printed in September 1947. When the sheets were taken out of storage, it was discovered that their edges had yellowed during the summer and the stains could not be removed. Those sheets would also have to be discarded.[8]

Once again Skira demonstrated his determination. He had to find a substitute for the decrepit font of Caslon, which had been used so hard that it was now beyond repair. A version of Caslon supplied by the Radiguer foundry in Paris was deemed unsatisfactory. He inquired at other European foundries for a typeface similar in weight and color without success until he contacted the Haas foundry in Switzerland.

Triumphantly he reported that this establishment retained in its historic holdings some of the original punches of William Caslon and that it cast for him a special font of 20-point Caslon, the genuine article in pristine condition. He made this a selling point of the book and mentioned it in the colophon—but it was almost certainly not true. The few remaining original punches are still in England. Some sets of matrices in the smaller sizes may have been acquired by Haas, and they may have been rediscovered in the early 1940s. The foundry revived its Caslon types and offered them for sale, although some were more authentic than others because the larger sizes had to be recut. Several sources repeat Skira's story about his quest for Caslon as evidence of his unstinting efforts to attain typographical

perfection—not that they were ever in doubt. His willingness to go back to press repeatedly should be enough to show the strength of his commitment.[9]

Georges Girard printed the fourth and final iteration of *Florilège des amours de Ronsard.* Other printers could have done the job—Skira mentioned the Imprimerie Nationale and Fequet et Baudier as possibilities—but Girard had won other prestigious commissions at this time (Nos. 24 and 37) and must have been in favor with the bibliophile community. Matisse was in Paris while the book was in press and stopped by the shop at least once to supervise production. A Skira catalogue contains photographs of him inspecting the quality of the impression, checking the register of a sheet, and holding a piece of

Fig. 4. Ina Bandy, photograph of Matisse in the shop of Georges Girard, The Morgan Library & Museum

the precious Caslon type. "Henri Matisse is also a typographer," reads the caption. "He is pleased to hold in his hand a piece of type in the font he has chosen." Likewise, there is a publicity shot of him correcting a stone in the shop of Mourlot. Taking advantage of another round of delays, he had changed his mind about the color of the lithographs and decided that Mourlot should print them in sanguine. The Arches mold-made wove paper is slightly tinted to complement that color. Trial proofs of the lithographs

were exhibited at the Philadelphia Museum of Art retrospective exhibition in April 1948. Girard's compositors finished at the end of July, his pressmen at the end of November, and completed copies became available around the end of the year. The *Florilège* was featured in a Paris exhibition running between 7 and 30 December 1948. Matisse was relieved to see it finally in print and considered it to be a success at the very least because the entire edition had sold out to the subscribers.[10]

Skira considered it a major milestone in his career. Twenty years before, he founded his first publishing business in Lausanne. He now had offices in Geneva and Paris producing a fully diversified line of trade editions and luxury *livres d'artistes*, including this most recent example of fine bookmaking. He celebrated his anniversary and this achievement by issuing a catalogue of his publications, *Vingt ans d'activité*, containing the photographs of Matisse at work on the Ronsard. Matisse designed the

cover of the catalogue and contributed a frontispiece portrait of Skira with a dedicatory inscription congratulating him on his successful *"activité d'éditeur."* Facing the frontispiece is a tribute to him by Éluard, and then the first item of business is a detailed account of the Ronsard edition, beginning with the original idea and recounting the many mishaps and changes in direction along the way. This "Story of a Book" skirts around awkward episodes such as the *Bavardages* affair and misrepresents the origins of the Caslon types, but it reveals some of the more attractive traits of the publisher—his fortitude, stamina, and generosity. This kind of moral fiber was necessary when dealing with Matisse in the construction of a book built upon a typographical foundation no less important than its illustrations.[11]

PAGE SIZE: Jésus quarto in half sheets; 38 × 28.2 cm.

PAGINATION: [2] 185 [9] pp.; the first 3 leaves and the last 2 leaves blank.

ILLUSTRATIONS: 126 lithographs printed by Mourlot Frères, Paris.

TYPOGRAPHY: Printed by Georges Girard, Paris. Text in 20-point Caslon cast by the Haas'sche Schriftgiesserei, Münchenstein, Switzerland.

PAPER: A tinted mold-made wove vélin d'Arches.

BINDING: White wrappers with the author's name printed in Caslon caps on the front cover, lithographs in sanguine on the front and back cover, chemise composed of white boards and a purple velvet back with the author's name in blind, white slipcase decorated with a leaf pattern.

EDITION: Printed 29 November 1948. Edition of 320 copies signed by the artist and publisher: 20 copies numbered 1 to 20, including 2 suites of original lithographs on Japon impérial initialed by the artist, the 12 lithographs in the first suite designated as *pierres refusées,* the 8 lithographs in the second suite presented as variant illustrations for the poem *"Marie, qui voudroit vostre nom retourner";* 30 copies numbered 21 to 50, including a suite of 8 original lithographs on Japon impérial initialed by the artist and presented as variant illustrations for the poem *"Marie, qui voudroit vostre nom retourner";* 250 copies numbered 51 to 300; 20 copies hors commerce numbered H.C. I to H.C. XX. Priced at 3,000 CHF (nos. 1–20); 2,400 CHF (nos. 21–50); 1,800 CHF (nos. 51–300).

COPIES EXAMINED: PML 195611 (no. 263); HRC f PQ 1676 A6 1948 (no. 14); Beinecke Library Folio Whitney 22 (no. 17); Ursus Rare Books (no. 24); BnF (H.C., not numbered); Indiana University Art Museum 98.499 (no. H.C. XI).

REFERENCES: Skira 1948, pp. 10–17; Barr 1951, pp. 271–72 and 560; Strachan 1969, p. 338; Chapon 1973, pp. 373–75; Guillaud 1987, pp. 480–515; Duthuit 1988, no. 25; Monod-Fontaine et al. 1989, p. 401; Monod 1992, no. 9909; Delectorskaya 1996, p. 260; Skira 1996.

EXHIBITIONS: Geneva 1959, no. 33; Boston 1961, no. 201; Paris 1970, nos. 212 and 213; New York 1978, pp. 142–43 and 218; Saint Petersburg 1980, no. 10; Fribourg 1982, no. 10; Nice 1986, nos. 26–27; Paris and Humlebaek 2005, pp. 80–91.

39.

Poésie de mots inconnus. **Paris: Le Degré 41, 1949.**

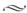

At eighty years of age, Matisse participated in one of the most radical artists' books to appear in France after the Second World War. *Poésie de mots inconnus* was an illustrated collection of avant-garde sound poetry, described by its publisher as a chrestomathy: an anthology of works by classic authors used not only for disseminating literature but for teaching language. The language, in this case, was phonetic and abstract: from Khlebnikov's and Kruchenykh's experiments with *zaum*—a transrational language employed by the Russian Futurists—to the Dadaist experiments of Kurt Schwitters, Raoul Hausmann, and poets prone to unorthodox vociferations, such as Antonin Artaud. Each leaf of text was adorned with graphic work by a leading artist—Matisse, Picasso, Braque, Giacometti, and Miró, to name a few—with variations in page design applied uniquely to each pairing of poet and painter by the book's editor, designer, and publisher, Iliazd (1894–1975).[1]

Iliazd was a Georgian poet and artists' book publisher. His sense of design and peculiar typographic logic rightly warrant him the epithet of *auteur* in the postwar *livre d'artiste*. Born Ilia Zdanevitch, he was an active participant in the performances and print culture of Russian Futurism before immigrating to Paris in 1921. There, he joined the confluence of avant-garde factions at the explosive transitional moment between Dada and Surrealism, adopting the appellation Iliazd—a contraction of his first and last names, which seemed to materialize from the experimental typography of his own poster designs. Iliazd wrote plays, poems, ballets, and novels and made contributions to the

study of Byzantine church architecture and philology. His Paris-based imprint, Le Degré 41, initially published books of his own, but between 1940 and 1974, he produced more than twenty typographically inventive artists' books, working most often with Picasso. One of the aspirations of his polymath career was to work with Matisse. *Poésie de mots inconnus* was first and foremost a polemic and extraordinary *livre d'artiste*, but it was also a chance for Iliazd to audition for Matisse in hopes of satisfying what he called his *ancienne idée* to collaborate with the master on an illustrated book.[2]

Iliazd began wooing Matisse in early 1947, several months before *Poésie* took shape. He appeared at the door of the artist's Paris apartment with an early copy of *Pismo,* illustrated by Picasso, offered as credentials. Iliazd's *ancienne idée* to make a book with Matisse likely points further back in time, reflecting, perhaps, the reverberations of Matisse's momentous trip to Russia in 1911. Although Iliazd was then still a few months away from leaving his native Tiflis, the circle of radical artists he would shortly join was part of the select group assembled at a reception for the French artist. The establishment painter reportedly inspired awe in Iliazd's proto-Futurist friends Michel Larionov and David Burliuk (two of the young "Russian Matisses," as the press called them) with his public praise of Russian icons: "Here is the primary source of all artistic endeavour. The modern artist should derive his inspiration from these primitives"—an idea perfectly in sync with the goals of the burgeoning Futurists, who saw icons as the visual equivalent of primitive, popular language that comprised their *zaum* compositions.[3]

In late 1947, Iliazd and Matisse met again in the south of France. There, the publisher tried to persuade Matisse to contribute a work of art to *Poésie de mots*

inconnus as well as some phonetic poetry—something Jean Arp, Camille Bryen, Hausmann, Wols, and Picasso would do. Although Matisse declined the invitation to provide a poem, he consented to Iliazd's request for an original print. Hoping to instigate a major project, Iliazd also managed to get him to agree to design sets for his new *zaum* ballet, which presumably accounts for the dance Iliazd performed in front of the supine Matisse, which made him laugh. The set designs failed to materialize (Iliazd blamed a press report that falsely linked a Vichy collaborationist to the project), and Matisse returned Iliazd's draft of the ballet before the end of the year. In early 1949, however, an engraved linoleum block for *Poésie de mots inconnus* arrived in the mail as promised.[4]

The immediate context for *Poésie de mots inconnus* was the postwar cage match of the *querelle de lettrisme* in which Iliazd, representing the old guard of Futurism and Dadaism, faced off against Isidore Isou, the outspoken young leader of the rebellious Lettrist movement. Lettrism emerged on the Paris scene in 1946 as a welcome diversion amid the cultural malaise following the Occupation. The movement's poetics called for the eradication of the structures and meaning of language; in its place, Isou proposed a language based solely on letters and phonemes. His writings and diagrams mapping the teleology of Lettrism seemed to erase most of the Russian Futurists and Dadaists from the prewar canon. The *querelle* ignited in 1947, when Isou's claims of having originated abstract poetry sparked a resentful reaction from Iliazd. The two held conferences and counterconferences, often crashing each other's events to hurl catcalls from the audience (or sending others to do so). The press delighted in this clash between young and old, made more colorful by Isou's

Fig. 1. Raoul Hausmann woodcut with text by Kurt Schwitters, *Poésie de mots inconnus,* The Morgan Library & Museum

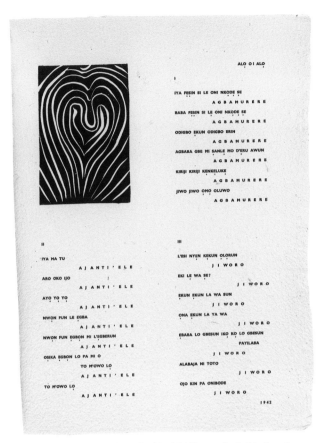

Fig. 2. Matisse linocut with text by Ibironké Akinsemoyin, *Poésie de mots inconnus,* The Morgan Library & Museum

arrogance and his refusal to utter Iliazd's name, referring to him only as the plagiarist of Futurism. The Lettrists promised an anthology of their literary precursors along the lines of André Breton's *Anthologie de l'humour noir.* To the chagrin of Iliazd, their genealogy was reported to leapfrog from Baudelaire, Rimbaud, and Mallarmé to Joyce, Michaux, and Queneau, with a token hat tip to Tristan Tzara. At his 1947 conference, *Après nous le lettrisme,* Iliazd announced his own pre-Lettrist anthology as a preemptive and alternative history to Isou's—one that would validate the

activities of Iliazd's radical past, now seemingly diluted by the hiatus of war and largely unknown to the Lettrist upstarts not yet born when Futurism and Dada were peaking. In a rehearsal of one of the Dada soirées of old, *Après nous le lettrisme* ended in a brawl. The Lettrist contingent, which had been shouting insults from the back of the room, rushed the stage, and the conference dissolved into chaos with Iliazd's co-organizer, Camille Bryen, catching a blow to the head.[5]

Iliazd set to work gathering and soliciting examples of phonetic poetry from

1910 to 1948 along with original prints to accompany them. He asked Paul Éluard to write an introduction to prove that whatever the Lettrists were claiming as innovation had been invented by the book's contributors decades earlier. Éluard, who had notoriously reneged on a promise to write the introduction to Iliazd's 1923 typographic masterpiece, *Lidantiu faram,* disappointed the Georgian once again, agreeing only to sign his name to anything Iliazd wrote. The halfhearted offer was not pursued, leaving Iliazd's polemic devoid of any critical or historical apparatus. Two

Fig. 3. Rejected design, *Poésie de mots inconnus,* courtesy of Frances and Michael Baylson

years elapsed between the announcement of the *Après nous le lettrisme anthologie* and its eventual incarnation under the title *Poésie de mots inconnus.* This is no surprise, given its complexity and lack of uniform page design. The multiple illustration processes required the assistance of four printers: Mourlot Frères for the lithographs, Paul Haasen for Chagall's etching, and Roger Lacourière for the engravings. Matisse's linocut, the woodcuts, and the letterpress text were printed at the Imprimerie Union, where Iliazd worked exclusively from his arrival in Paris until his death.[6]

The Imprimerie Union was founded in 1910 as the Kooperativnaïa typografia soïouz by the Russian émigrés Volf Chalit and Dimitri Snégaroff, who renamed the establishment Imprimerie Union in 1913. From the start, their stock of Cyrillic type made the press a magnet for the growing community of Russian exiles in Paris. One of Union's habitués, the Russian painter Serge Férat, helped to enhance the press's artistic cachet by bringing a magazine he coedited with Apollinaire to the shop for its second series. For the next eighty years, Union's name would be ubiquitous in artists' books,

exhibition catalogues, periodicals, and monographs published by leading figures of French artistic publishing. As their most loyal client, Iliazd became close friends with Union's directors—first Snégaroff and, later, Louis Barnier, who cut his teeth as an apprentice shortly after the production of *Poésie de mots inconnus.* Iliazd's early training in Russia as a printer earned him the respect of Union's journeymen, known for mocking publishers who purported to understand what they were demanding. They kept a press and typecase in reserve for Iliazd at all times along with his personalized tools, brushes, and composing sticks, engraved with the name *ILIAZD* in Gill Sans.[7]

Iliazd composed each leaf of *Poésie de mots inconnus* by transcribing by hand each author's copytext in capital letters onto a penciled-in grid on sheets of Île de France. Some artists sketched out their illustrations directly on the handwritten mock-up. When a proof of the print was pulled, Iliazd would paste it in one of the four quadrants that had been stenciled or printed on the sheet to act as imposition guides (though they were invariably transgressed by his typography). The text was then printed on proof paper, and Iliazd cut out each word or line individually, pasting them in their desired space over the grid with variations in spacing and compositional patterns. For the first time in his career, Iliazd requested uniform-sized upper-case Gill Sans (in this instance, alone, Gill Sans Bold) to unify the book's radical variations in page design into a harmonious and distinctive mise-en-page. The phonetic poems by Kurt Schwitters, Audiberti, and Iliazd's inimitable colophon made use of overprinting, sometimes in two colors, resulting in a text that seemed to vibrate or tremble, reflecting both the sounds of the words and, sometimes, the artists' designs.[8]

Iliazd's esteem for Matisse would seem to have informed the choice to feature his

illustration with the first poem in the collection—a text written in Yoruban by Ibironké Akinsemoyin (1919–1945), Iliazd's wife. Ronké, as she was known, had died tragically in 1945 from a respiratory illness she had contracted while interned at Vittel during the early part of the war. The grief and sense of responsibility he felt at her death and as a single father to their two-year-old son haunts the book as much as the poignancy of Iliazd's other deceased *compagnons* who are commemorated with his wife on the dedicatory title page. Matisse's design for the book's only female poet evokes a range of images, some of them suggestive: an open mouth, a flower unfolding, multitudes of nested hearts or arabesques, and that rarest of Matisse creations—something abstract. The block used for the design was probably larger than its finished state since only one of the arcing lines ends naturally on the block—an exception to almost every linocut he created. According to Duthuit, Matisse proposed two designs for *Poésie de mots inconnus*. The rejected design—a flaming image masking a female figure—was created on a block measuring 20.6 × 15 centimeters, similar in size to the linocuts Matisse was designing for *Pasiphaé,* and, indeed, Duthuit dated the rejected block to 1943. That a larger, five-year-old design would have been radically trimmed to conform to Iliazd's layout of quadrants is inconsistent both with Iliazd's practice and Matisse's own method of illustrating books. Questions also persist as to whether Iliazd was expecting a linocut or some other kind of print. In Iliazd's manuscript draft of the list of contributors, Matisse's name is notated with a *B* for *bois* (woodcut), later amended with a question mark. Early drafts and proofs of the colophon, which dutifully credit every printer and respective medium,

also fail to mention the linocut. When it finally makes its first appearance on a later maquette of the colophon, the linocut is attributed to Pierre Matisse(!). Although Matisse had not executed woodcuts in decades, the *B* for *bois* may have been wishful thinking on Iliazd's part, since he admitted to Matisse that he had no experience wrestling a linoleum block into submission. In the end, Iliazd was pleased with the results, despite the unforgiving Île de France paper, but the special artist's proofs on vellum were another matter, resulting in unsightly lines at the edges of the block. Iliazd experimented with printing the linocut in red before settling on the blue and sent artist's proofs to Matisse in both colors.[9]

All of the book's illustrations were printed in April and May of 1949 (Matisse's print on 16 May), the lone stragglers being Léger's colorful full-page design and Picasso's lithographed *lettres inconnus,* which, like the text, were ready with little time to spare before the *bonnes feuilles* were put on display at the Galerie Graphique Thésée on 30 June 1949—almost five weeks before the official publication date of 2 August. Assembling all the copies took more time. The unbound leaves were folded twice and gathered into five volumes, nested in layers of paper and vellum wrappers, and finally enclosed in a stiff parchment portfolio. The folded leaves and multiple layers of enclosures were vital to Iliazd's conception of the work, achieving his desired theatrical effects in the reader's repetitive gestures of opening and unfolding. Some copies for collectors and institutions, however, were deliberately left unfolded. Iliazd compiled these copies with inconsistent arrangements of endleaves and wrappers, creating custom-made containers and cases composed of parchment or paper, no two seemingly alike. The nominative copies

for the forty-one participants were sent out in the fall and early 1950, some dated as late as January 1951. Matisse was again accorded special treatment by Iliazd's decision to prepare nominative copies for him and for his assistant, Lydia Delectorskaya. In addition, Iliazd had promised him four regular copies—a substantial portion of the total edition of 158 and more than double what he sent to some of the other artists.[10]

A press conference scheduled for the eve of the gallery exhibition seemed to garner little attention. By this time, the Lettrists' project was expanding into experimental cinema and Isou would soon help form the more radical Situationist movement. Although a reporter from *Life* magazine in 1949 informed potential tourists to the Left Bank that they were likely to see a demonstration or counterdemonstration in the street by Iliazd and Isou, the coverage in the French press of their rivalry had cooled. Whatever Iliazd had intended his deluxe artists' book-cum-polemic to be, it was seen by few beyond the circle of contributors, transforming its legacy into a nostalgic homage to the *compagnons* of Iliazd's youth—on the avant-garde battlefields of Russia of the teens and the Montparnasse cafés, balls, and soirées of the 1920s.[11]

Despite the disappointment of Matisse's decision not to design sets for Iliazd's *zaum* ballet, the publisher did not give up his *ancienne idée.* Later in 1949, Iliazd sent Matisse a maquette of a sonnet sequence, still in the early stages of development, and expressed hope that the artist might illustrate it with seven engravings. Matisse's attentions would have been focused on the final stages of *Charles d'Orléans,* and he chose to reserve his energy for the few remaining books of his career.[12]

SHEELAGH BEVAN

PAGE SIZE: 30.7 × 25.5 cm unfolded; the quarto copies measure 17.5 × 14 cm.

PAGINATION: [1] 26 [2] sheets; the first sheet and the last sheet blank (unfolded copy).

ILLUSTRATIONS: 27 prints (etchings, drypoints, aquatints, engravings, lithographs, woodcuts, 1 linocut), some in color, by Jean Arp, Georges Braque, Camille Bryen, Marc Chagall, Oscar Dominguez, Serge Férat, Alberto Giacometti, Albert Gleizes, Raoul Hausmann, Henri Laurens, Fernand Léger, Alberto Magnelli, André Masson, Henri Matisse, Jean Metzinger, Joan Miró, Pablo Picasso, Léopold Survage, Sophie Taeuber-Arp, Edgard Tytgat, Jacques Villon, and Wols. Intaglios printed by Roger Lacourière and Paul Haasen, lithographs by Mourlot Frères, relief cuts by the Imprimerie Union.

TYPOGRAPHY: Printed by the Imprimerie Union after designs by Iliazd. Text in 8-point upper case Gill Sans Bold.

PAPER: Laid handmade Île de France.

BINDING: Loose sheets, usually folded in quarto, gathered into 5 chemises printed with authors' and artists' names and enclosed in double chemise inside small parchment wrapper with a zinc-cut vignette after a drawing by Georges Ribemont-Dessaignes and the legend *ne coupez pas mes pages* stamped on front. Last two folded sheets sometimes stitched together, demonstrating *avis muet au relieur*. There are variations in the sequence and composition of outer leaves, wrappers, and enclosures, especially in unfolded copies. Most copies housed in additional parchment wrapper or portfolio, with the title printed or embossed in blind. Unfolded copies may be enclosed in a large parchment envelope and cardboard portfolio, with the title

embossed in blind. May include additional blue-gray sheets (probably handmade by Richard de Bas, Auvergne) as lining for parchment wrappers or laid in as endleaves.

EDITION: Printed 2 August 1949. Edition of 158 copies: 115 copies numbered 1 to 115; 41 copies hors commerce for *compagnons* numbered I to XLI; 2 deposit copies designated *A* and *B*. In addition 13 proofs on Chine and vellum numbered 13-1 to 13-13.

COPIES EXAMINED: PML 195699 (no. 6); NYPL Spencer Collection (no. XXVIII); Beinecke Library Ernst +76 (no. 4); MoMA Louis E. Stern Collection (no. 44).

REFERENCES: Chapon 1974, pp. 208–9; Duthuit 1988, no. 26; Monod 1992, no. 9197.

EXHIBITIONS: Boston 1961, no. 305; Paris 1978b, p. 113; Montreal 1984, pp. 125–26; Nice 1986, no. 76; New York 1987, no. 30; Paris 1988, no. 7; New York 1994, p. 98; Toledo 2003, p. 206.

40.

René Leriche (1879–1955), *La chirurgie: Discipline de la connaissance*. Nice: La Diane Française, 1949.

The frontispiece portrait in this volume was an act of gratitude and a tribute to a distinguished member of the medical profession. Professor Leriche was one of the doctors who operated on Matisse in January 1941, a procedure dangerous enough that the patient prepared for it by making a will and sending cautionary letters to his friends. The surgery was a success, and even though he suffered from other health problems in later years, Matisse credited that team of doctors with saving his life and giving him additional years of fruitful labor. He formed a friendship with Leriche, a public intellectual renowned for his research papers and philosophical essays. Leriche in turn cultivated his acquaintance with the artist, who agreed to make a portrait of his daughter in 1943. He was an avid student of art, literature, and philosophy, a breadth of interests evident in his writings on medicine and the humanities. Curious and perceptive, he impressed Matisse with a penetrating question about the apparent facility of his drawings. "I answered that they were like the revelations resulting from an analysis but made without at first apparently knowing what subject I had to deal with: a kind of meditation." In reply Leriche noted that he made diagnoses with the same combination of rigorous thinking and bold intuition, an inexplicable leap of imagination invested with absolute certainty. Matisse liked the idea of this interdisciplinary exchange and quoted it in the conclusion of his essay in *Portraits* (No. 47).[1]

What little I know about the Diane Française publishing house is derived from the online advertisements for a successor firm, the Galerie Qvadrige. Pierre Cottalorda founded La Diane Française around 1949, possibly in association with David

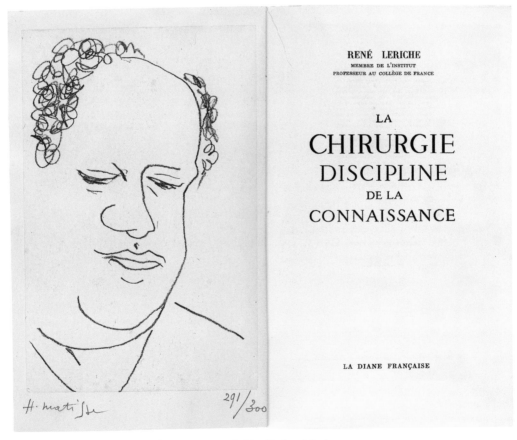

Fig. 1. Frontispiece and title page, *La chirurgie,* Frances and Michael Baylson Collection

Selig and Maurice Brenner. One of the first of his publications, *La chirurgie* is identified in the colophon as the first volume in the monograph series Collection d'histoire des idées. The series also includes André Masson's *Le plaisir de peindre* (1950) and Jean Rostand's *Instruire sur l'homme* (1953). Cottalorda issued other books on medicine as well as occasional titles on art, literature, and tourism. In 1992 the imprint passed into the hands of Jean-Paul Aureglia, proprietor of the Galerie Qvadrige in Nice. His Web site advertises several ambitious publications containing original prints and cites a history of the firm, *Dix ans et plus* (2002), which I have not seen.

PAGE SIZE: Carré octavo; 23 × 14 cm.
PAGINATION: 509 [11] pp.; the first 2 leaves and the last leaf blank.
ILLUSTRATION: Frontispiece lithograph printed by Mourlot Frères, Paris, not included in the pagination.
TYPOGRAPHY: Printed by the Imprimerie Meyerbeer, Nice. Text in 10-point Linotype Ronaldson Old Style.
PAPER: Frontispiece on Chine appliqué. Although described as a vélin à la forme, the text paper is a mold-made wove Rives. The trade edition is on an unwatermarked machine-made wove.
BINDING: Beige wrappers printed in black and red, beige cardboard slipcase.

EDITION: Printed 15 November 1949. Edition includes 300 specials numbered 1 to 300 (of which 50 are hors commerce numbered 1 to 50) printed on Rives and illustrated with the frontispiece numbered and signed by Matisse. In addition 750 numbered copies illustrated with photographs, a laid-in color plate, and portraits by Matisse, André Masson, and Charles Berthold-Mahn. The specials priced at 6,000 francs, the illustrated copies at 1,350 francs, the trade edition at 900 francs.
COPIES EXAMINED: PML 195612 (no. 291); BnF 8-R-53329 [1] (trade edition).
REFERENCE: Duthuit 1988, no. 27.
EXHIBITIONS: Fribourg 1982, no. 26; Nice 1986, no. 77.

41.

Charles d'Orléans (1394–1465), *Poèmes de Charles d'Orléans, manuscrits et illustrés par Henri Matisse.* **Paris: Tériade Éditeur, 1950.**

The poetry of Charles d'Orléans took on a new meaning for Matisse during the Second World War. He learned about it in survey texts of French literature and scouted out a scholarly edition to study it in depth. He sampled other poets of the medieval period, worthy predecessors of his beloved Ronsard, but this one had a special charm in the character and context of his work. Son of Louis, duke of Orléans, father of Louis XII, Charles d'Orléans wrote *chansons, ballades,* and *rondeaux* on traditional themes cultivated by aristocratic authors of the time. Within these conventions flow a melancholy undercurrent that appealed to Matisse, who would have perceived parallels with his situation and the state of his country. Charles d'Orléans fought for France in the Hundred Years' War and was one of the French noblemen captured in the Battle of Agincourt. Because of his high rank and political importance, his captors were reluctant to release him, and he spent twenty-five years in England as a hostage and prisoner of war. For him poetry was a consolation, a pastime, and a means of dealing with defeat while retaining his Gallic gaiety and cultivating a courtly wit. He wrote about reversals of fortune, affairs of the heart, and the travails of old age, a topic that would have also endeared him to Matisse.[1]

"I am obsessed by this poetry," he told Rouveyre, "so much so that I can't read anything else." He paid tribute to it and sought to delineate its charms by transcribing choice passages in an elegant pen-and-ink cursive script and framing them in decorative borders drawn with color crayons. Dating to 1942, these calligraphic broadsides are among his earliest exercises in penmanship and prefigure the ornamental initials he designed for books of the 1940s as well as the handwritten text of *Jazz* (No. 34). At first he wrote them out purely for his enjoyment, but he also sent them to Rouveyre, who encouraged him to think of publishing them in a suite comprising fifteen or twenty of the best examples. Rouveyre urged him to dispense with letterpress printing altogether and strive for an intermarriage of drawing and writing purely of his own creation. Matisse came around to the idea and compiled lists of possible texts in February 1943. In February and March he could envision the book in sufficient detail that he could draft ornamental title pages with the imprint of his publisher Martin Fabiani. Following the advice of his friend, he kept the pictorial content to a minimum, although he could not resist the opportunity to draw a patrician profile for the frontispiece. He experimented with the wording of the title to find the best expression of his intentions, the publication of an artistic homage to the poet in the form of manuscript facsimiles rather than a conventionally illustrated typographic book.[2]

The publication remained in suspense for several years until he could solve the problem of reproducing his manuscripts and their multicolor decorated frames. Fabiani declined to publish them because they were not marketable as original prints and could not fetch a price high enough to offset the production costs. From previous experience, Fabiani knew that his client would insist on using materials and methods too expensive for him to turn a profit on this venture. Even if he knew how to make it pay, he ceased to be a viable business partner after he fell from grace at the end of the war. Mourlot volunteered to take it over, but he too bowed out because of the financial difficulties posed by making and selling such a book. Matisse turned his attention to other, more urgent projects, allowing himself the pleasure of working on this one when he was in the mood. In April 1947, he reopened his file on Charles d'Orléans and found the wherewithal to construct a maquette. This was to keep him occupied while waiting for the slipcases of *Repli* and supervising the production of *Jazz.* At this time he had become increasingly close to Tériade, publisher of *Verve* and *Jazz,* a loyal friend and a courageous colleague who more than once demonstrated a willingness to test the boundaries of book illustration. He negotiated a contract with Tériade, who signed it two days after the launch of *Jazz.* They agreed that the publisher would print at his own expense an edition of 1,200 copies plus 20 copies for the collaborators. As usual the printer would be Mourlot, the paper would be Arches, and the design would be entirely in the hands of the artist, who would have the right to approve the proofs before the book went to press. After it was printed, the lithographic stones would be canceled, and three sets of proofs would be pulled to document the fact, one each to be retained by the artist, the publisher, and the Bibliothèque Doucet. For payment Matisse would take 300 copies (a fourth of the print run) as well as 2 hors commerce. The maquette and all the preparatory studies would remain his personal property.[3]

Tériade set the size of the print run to profit from the economies of scale. Mourlot could print the photolithographic reproductions of the calligraphic broadsides at a unit cost much lower than the pochoirs of *Jazz* or the combination of letterpress and lithography in *Lettres portugaises.* At 15,000 francs, the official retail price of *Charles d'Orléans*

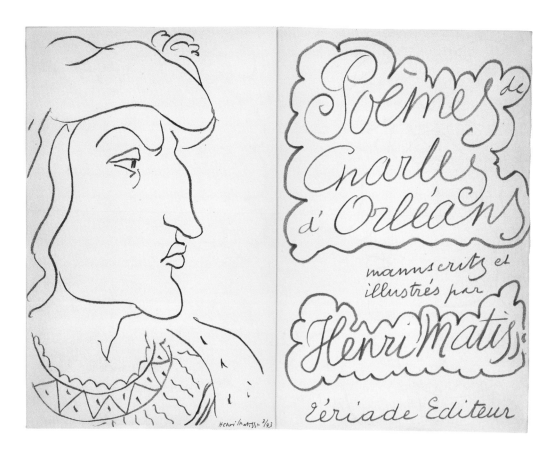

Fig. 1. Frontispiece and title page, *Poèmes de Charles d'Orléans,* Frances and Michael Baylson Collection

Fig. 2. Preliminary design for the title page, *Poèmes de Charles d'Orléans,* The Pierre and Tana Matisse Foundation, New York

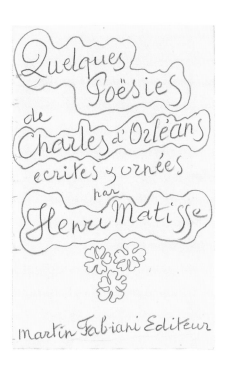

was about forty times the price of an ordinary novel, but it was less than a sixth the price of *Jazz* adjusted for inflation. Tériade calculated it on a scale balancing the fame of the artist with the perceived value of photolithographic reproductions, deemed less desirable by collectors, who preferred original prints and smaller editions. To satisfy them, Matisse supplemented the collotype reproductions in *Dessins: Thèmes et variations* with a linocut frontispiece and embellished other books with signed frontispiece portraits. Here his artistic contributions are less obvious, although he signed all the copies and made it clear in the colophon that he had supervised the printing of the text, which he had written and "illuminated." Indeed he inspected the proofs as stipulated

by the contract and even revised them to correct a slip of the pen and redo the script of an entire page. Whatever it lacked in prestige, photolithography gained in convenience when the artist wanted to make last-minute improvements. He received the final proofs and finished signing the colophon by May 1950.[4]

He expected the book to be available for sale shortly after the 20th of October, when he wrote about it to his son Pierre. From what he could tell, it would be "fairly successful despite the crisis of the book trade," but in any case he was not expecting any great financial reward from his share of the edition. He gave away copies freely, including two for his grandsons in America. "Don't let the children have them before

Christmas day." It was not a money-making proposition but rather a homage to the author and an expression of appreciation for work he believed to be a vital part of the French literary heritage. He wanted Charles d'Orléans to be known as a national poet in whose verse ran royal blood, a proud and noble lineage worth remembering while the country was suffering the disasters of war. After the war, the book could still be read as a patriotic document steeped in history. Most of the two-page openings display a field of fleurs-de-lis facing the text in a decorative frame, a heraldic composition denoting the birthright and achievements of the author.[5]

~

PAGE SIZE: 41 × 26.5 cm.

PAGINATION: [4] 100 [8] pp.; the first 2 leaves and the last 2 leaves blank.

ILLUSTRATIONS: Photolithographic illustrations printed in color by Mourlot Frères, Paris.

TYPOGRAPHY: Letterpress colophon probably printed by Draeger Frères.

PAPER: Mold-made wove vélin d'Arches specially made for this edition.

BINDING: White wrappers with the author's name in calligraphic lettering in black on front cover, fleur-de-lis designs in green on front cover and black on back cover, gray cardboard slipcase with printed spine label.

EDITION: Printed 25 February 1950. Edition of 1,230 copies signed by the artist: 1,200 copies numbered 1 to 1,200; 30 copies hors commerce numbered I to XXX. Priced at 15,000 francs. Completed copies were on the market in October or November 1950.

COPIES EXAMINED: PML 195613 (no. 505); HRC f PQ 1553 C5 1950 (no. 68); Baltimore Museum of Art (no. 439).

REFERENCES: Barr 1951, pp. 272–73 and 560; Strachan 1969, pp. 110 and 320; Duthuit 1988, no. 28; Monod 1992, no. 8773.

EXHIBITIONS: Geneva 1959, no. 36; Boston 1961, no. 202; Paris 1970, nos. 214 and 215; New York 1978, p. 218; Saint Petersburg 1980, no. 11; Fribourg 1982, no. 11; Nice 1986, no. 32; Paris 1988, no. 10; Florence and Le Cateau-Cambrésis 1996, pp. 196–203; New York 1997, pp. 53–54.

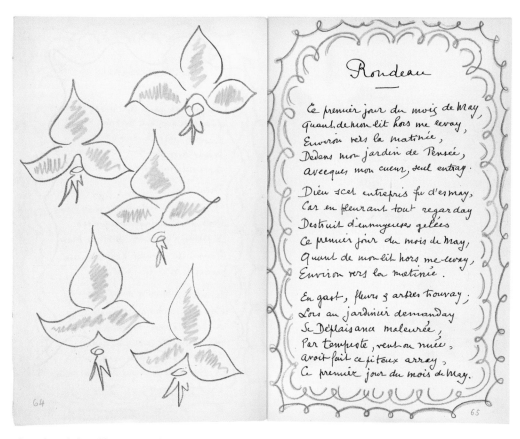

Fig. 3. Fleurs-de-lis and facing text, *Poèmes de Charles d'Orléans,* Frances and Michael Baylson Collection

42.

Estampes, introduction de Robert Rey. **Paris, Nice: L'Image Littéraire; New York: Rafael Finelli-Feugère, 1950.**

~

This volume contains twelve prints by various artists, each accompanied by an essay by a different author. In this respect it resembles collaborative publications, such as *Alternance* (No. 24) and *Tableaux de Paris* (No. 10), assembled with the intention to highlight the diversity and value of original graphics. But here the prints are reproductions, albeit sanctioned by the artists and approved by the art historian Robert Rey, who helped to choose them and see them through the press. The rationale for this publication is not easily discernible. The publishers were not prominent members of the trade, although L'Image Littéraire did produce some limited-edition illustrated books after the war. Those books were quite modest in comparison to this ambitious folio, which must have required a sizable outlay to cover the manufacturing costs and payments to the contributors. Who hired Rey to oversee the production of this book? Why should he recruit such a distinguished cast of characters to endorse a dozen reproductions? I believe that this book was conceived as a promotional effort on behalf of the printer, Robert Coulouma, who wanted to advertise his ability to print facsimiles of fine art as well as luxury editions of literary texts.

Coulouma had been one of the most prolific printers of demiluxe illustrated books during the 1920s. Based in Argenteuil, his firm produced around two thousand titles in twenty years, starting just after the First World War and closing down around 1937, probably because of the Depression. For a while his artistic director was Henri Barthélemy, who oversaw the typographical design of their publications while he tended the front office and maintained the manufacturing facilities. In November 1944 Coulouma resumed the printing trade in partnership with Cristobal de Acevedo, formerly an Ecuadorian diplomat stationed in France. Acevedo took charge of the finances, which included an ample supply of start-up capital. They were able to rehire many of Coulouma's original employees. They moved into lavish quarters at a prestigious address in the Faubourg Saint-Honoré and announced their arrival on the scene by publishing an elegant specimen of their work, Pierre Mac Orlan's *Essai sur Coulouma* (1945). Mac Orlan's remarks and an appended reply by Coulouma are my main source of historical information about this firm. It seems to have been active until the mid-1950s, still specializing in higher quality products. In his reply to Mac Orlan, Coulouma expressed a desire to reach a target audience somewhere between demiluxe Argenteuil and cost-is-no-object Daragnès.[1]

Color wood engravings were a specialty of the Coulouma firm. They were a popular illustration medium during the 1920s, when artists like Schmied and Daragnès used them in bibliophile editions decorated in the Art Deco style. Amenable to all types of letterpress printing inks, they could express the salient features of that style with metallic tints, solid colors, and crisply variegated geometrical designs. They also served as a reproductive medium, a method of printing facsimiles of color artwork without having to resort to the unsightly halftone screen employed in the commercial four-color process. Instead of breaking down the image, they built it up. Each color was rendered in a separate impression, and sometimes dozens of impressions would be necessary to express all the subtleties of hue and texture in the original. Costly and labor-intensive, this

Fig. 1. Title page, *Estampes,* The Harry Ransom Center, University of Texas at Austin

technique was feasible only for limited-edition prints priced at a premium in a collector's market. Théo Schmied, son of the Art Deco artist, offered to interpret a painting or a cutout by Matisse in this manner and noted that he had already obtained permission to make wood-engraved reproductions after artwork by Albert Marquet and Henry de Waroquier. He proposed an edition of fifty copies, each signed by Matisse. If Matisse had been in better health at that time, June 1954, he might have agreed to this printmaking venture, which was similar in principle to the publication of *Estampes.* He had praised Théo Schmied's facsimile wood engravings in *Les fleurs du mal* and preferred these traditional craft techniques to the mass-production methods of the printing trade.[2]

Estampes demonstrates the capabilities of the color wood-engraving reproduction process as practiced by the Coulouma firm. Each of the twelve prints is signed by the

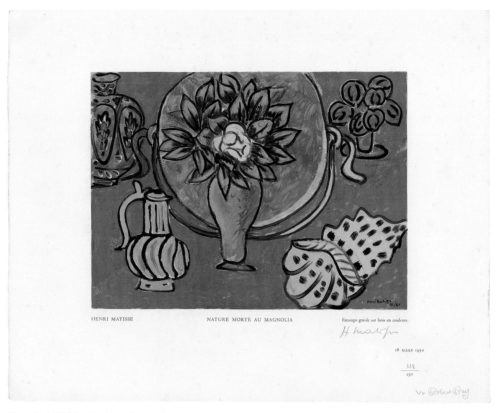

HENRI MATISSE NATURE MORTE AU MAGNOLIA Estampe gravée sur bois en couleurs

18 MARS 1950

Fig. 2. *Red Still Life with Magnolia,* wood-engraved reproduction in *Estampes,* The Harry Ransom Center, University of Texas at Austin

artist to certify the quality of the reproduction. Every copy contains a *decomposition* of one of the prints—a series of color proofs showing how the image had been constructed out of its constituent parts, each depicted by a separate block. The Waroquier print required more than thirty blocks, the Braque more than forty, and the Desnoyer more than fifty. Gérard Angiolini is credited with this virtuoso feat of color analysis. He succeeded in replicating many of the distinctive traits of oil paintings—the brushstrokes, feathery white highlights, and even some of the impasto effects. Under his supervision, the pressmen mixed inks to match his specifications and worked off each additional color in perfect register. He

supplied color illustrations for the firm for as long as it was in business, serving either as a salaried employee or a specialist on retainer. In addition he sometimes took on the job of typographical designer, perhaps acting as a successor to Barthélemy.

Estampes also advertised Coulouma's typographical facilities. The texts printed here have little to do with the color artistry of Angiolini, although some refer to the artwork in sufficient detail as to show that the authors had seen it in advance. The literary critic and historian Georges Albert-Roulhac helped to commission the texts, one of several editorial tasks he performed for Coulouma at that time. Some of the authors he recruited are better

known than others, but many of the usual participants in bibliophile miscellanies are present in this roster: Jean Cassou, André Chamson, Jean Cocteau, Daniel-Rops, René Huyghe, Jacques de Lacretelle, Pierre Mac Orlan, André Maurois, Jean Paulhan, Jérôme and Jean Tharaud, Jean-Louis Vaudoyer, and Louise de Vilmorin. Each of them signed their work as if they were validating the letterpress credentials of Coulouma just as the artists praised the quality of the reproductions. Cocteau wrote the essay on Matisse, an opportunity for a gracious recantation of unkind remarks he had made about an exhibition in 1919. No longer did he think of the master as a "pussycat" but as a "genius who triumphs

over all difficulties" and a free spirit who deploys his graphic powers like a cowboy performing rope tricks on horseback.

Matisse chose artwork that had already posed a problem in color printing. His reservations about the four-color process were one of the reasons he was ready to cancel the color issue of *Verve* (see No. 34). Eventually he allowed it to proceed, although the publisher conceded the defects of photomechanical illustration by juxta-posing reproductions of Matisse's paintings with schematic drawings indicating the correct color values that should have been achieved in the reproductions. One of the paintings was *Red Still Life with Magnolia,* completed in 1941, purchased in 1945 by the Musée national d'art moderne, and now housed in the Centre Pompidou. Aimé Maeght made it the centerpiece of his inaugural exhibition in Paris. It was the cover image for the catalogue of the Philadelphia Museum of Art retrospective exhibition in 1948. The halftone version in *Verve* is printed on coated paper, which is already a mark against it, but it is also slightly out of register, the dot pattern is too conspicuous, and the background is more of a splotchy orange than a ruby red, which is the theme of the painting. One could easily imagine why Matisse would want to note the true color values in the schematic drawing and why he might want to try again by allowing Angiolini to reproduce the same picture in *Estampes.* A side-by-side comparison of the two prints reveals pluses and minuses in both reproduction processes, but Angiolini clearly wins out in

this contest of man vs. machine. His rendition of the red background is closer to the spirit of the painting, and he succeeded in depicting some of its most difficult and distinctive features: the opalescent vase, the mottled foliage of the flower, and the complementary colors of the other objects in the composition.[3]

If any fault can be found in Angiolini's work, it could be in certain details he accentuated to make the print look painterly. But that was the concept of the book—the grandiose typographical design, the array of essays, the celebrity endorse-ments, all this was intended to show that the products of the press could reach the level of fine art. To drive the point home, Coulouma packaged the loose sheets of some copies in a box case with an ornately carved gilt wooden frame affixed to the front cover. The frame displays one of the prints as if it was a painting, as if it had the value and prestige of the original.

Angiolini's illusionistic effects are more subtle than those of Coulouma, who should have been content with the artists' signatures to vouch for the accuracy of the wood engravings. Like Angiolini, he compromised his efforts with an excess of zeal, one reason this book has not fared well in the market-place. Some dealers have opted to eliminate the letterpress and break up the set of prints to sell them separately at a higher profit, a scheme attesting to the renown of the artists and the quality of the reproductions. The parts may be worth more than the whole because prints are easier to sell than books. As far as I can tell, no one has tried to sell the essays separately, although they too have authenticating signatures.

≈

PAGE SIZE: 46.6 × 36.6 cm.

PAGINATION: [12] xii [2] 72 [14] pp.; the first 3 leaves and the last 3 leaves blank.

ILLUSTRATIONS: 12 plates not included in the pagination containing color wood engravings by Gérard Angiolini after artwork by Georges Braque, Maurice Brianchon, Marc Chagall, François Desnoyer, Kees van Dongen, Raoul Dufy, Marie Laurencin, Henri Matisse, Pablo Picasso, Maurice Utrillo, Maurice de Vlaminck, and Henry de Waroquier. Most copies contain a set of color proofs for one of the plates.

TYPOGRAPHY: Printed by Robert Cou-louma, Paris. Text in 24-point Monotype Centaur.

PAPER: Heavyweight mold-made wove supplied by Van Gelder Zonen, Apeldoorn, the color proofs on a lighter mold-made wove by Papeteries de Lana, Docelles.

BINDING: Cream wrappers with the title printed in red on the front cover; BnF copy in brown cloth box with a color reproduc-tion in a carved wooden frame on front cover, title on spine lettered in gilt; HRC copy in steel gray leather chemise with title on front cover lettered in gilt and a slipcase covered with marbled paper and matching leather edges.

EDITION: Printed 20 April 1950. Edition of 250 copies: 100 copies for distribution in France and French territories, numbered I to C; 150 copies for distribution in other countries numbered 1 to 150. In addition some copies were printed for the partici-pants in the publication and are designated *exemplaire d'artiste.* Priced at 248,000 francs.

COPIES EXAMINED: BnF Res Atlas-V-62 (*exemplaire d'artiste*); HRC -f- NE 1149.3 E882 LAK (no. 55).

REFERENCE: Duthuit 1988, no. 54.

43.

Colette (1873–1954), *La vagabonde, lithographie originale de Matisse.* **Paris: Imprimerie Nationale, André Sauret, Éditeur, 1951 (Grand prix des meilleurs romans du demi-siècle, vol. 13).**

Among the books not completed by Matisse is a collection of lithographs, *Danseuses acrobates,* which was to be published by Fernand Mourlot. They signed a contract in 1948 for an edition of 240 copies plus 20 hors commerce, the artist to receive a quarter of the edition and 3 hors commerce copies for his payment. As usual he would take charge of the typographic design and retain ownership of the maquette, and the publisher would cover the costs of production. The lithographs had been completed some time previously, and all they needed was a suitable text, which the collector Max Pellequer suggested that they commission from Colette. Matisse liked the idea and ordered proofs of the lithographs so that he could show them to her and describe the project.[1]

He looked forward to a meeting with this grand dame of French literature and had to break a date with Rouveyre to make the most of this opportunity. "She is expecting me Friday, the second of July," he explained, "precisely at the moment when you were going to visit me. What a stroke of fate!! . . . What to do? You who know these things so well, perhaps you could give me some advice if I revealed her name—no, no, no, I won't say it! And if she knew that I made so many speling mistakes, and such mistakes!" He called on her at her Paris residence, which she rarely left in her state of health, and sat by her bedside to show the proofs. She enjoyed this encounter and remarked on his inner strength and self-assurance, which seemed to have filled the room to which she was confined. For a while this writing assignment was beyond her powers. She finally finished it in May 1950, but by then Matisse had moved on to other projects. Apparently he had been thinking of printing the letterpress in several colors, a concept similar to Bernouard's in *Les jockeys camouflés.* Perhaps it was just as well that he abandoned *Danseuses acrobates,* but it did result in other publications. Relying on photographs and memories of this visit, Matisse drew a charcoal portrait of Colette and produced two lithographs, one published in *Portraits* (No. 47), the other in this book.[2]

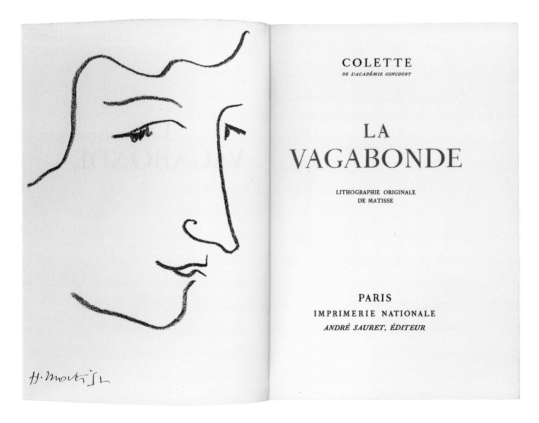

Fig. 1. Frontispiece and title page, *La vagabonde,* Frances and Michael Baylson Collection

The frontispiece in *La vagabonde* was part of a marketing ploy devised by the publisher André Sauret and the management of the Imprimerie Nationale. On the occasion of reaching the midcentury, they sponsored a prize to honor the dozen most distinguished works of French fiction published during the last fifty years. They formed a jury composed of journalists and writers including the director of *Le Figaro,* who helped to publicize the competition, and the author Francis Carco, who had the original idea and was a close friend of Colette. On his prompting, perhaps, they asked her to be the honorary president of the jury, and she accepted on condition that her work be removed from consideration. Proust, Gide, Sartre, and Jules Romains were among the twelve award-winning novelists. The selection was duly announced in *Le Figaro,* and the books were placed on exhibition, the opening of which she attended in the company of Carco, Sauret, and the director of the Imprimerie Nationale. Meanwhile the jurors overruled her and chose *La vagabonde* to be a supplementary volume, a gallant gesture and an adroit means of adding a woman to the list. *La vagabonde* was a good choice because it was her first major independent work of fiction and had been a strong candidate for the Prix Goncourt, France's most prestigious literary prize. Autobiographical in parts, it described her early career as a music-hall performer in such vivid detail that one could easily imagine why Matisse wanted her to write about *Danseuses acrobates.*[3]

Each of the volumes in this series contained a frontispiece portrait of the author. The imprint of the Imprimerie Nationale conferred an additional distinction on these books as if they had been sanctioned by government officials. The colophon cites the department heads who oversaw the manufacturing operations and notes that the text had been set by hand in the Romains du roi, the French national typeface designed under the auspices of Louis XIV. The size of the edition was large, in the democratic spirit, but the typographic appurtenances displayed the political prerogatives and cultural authority of the people behind this project. The jurors' decisions gained credence from the stately appearance of these volumes. Their selections were so successful that Sauret followed up with other "grand prize" collections in partnership with the Imprimerie Nationale. Based in Monaco, he was not part of the publishing establishment, but he dealt regularly with French artists and printers such as Fernand Mourlot, who probably recruited him to be the publisher of *Portraits.* After he died in 1969, his son-in-law Raymond Lévy took over the Éditions André Sauret imprint and continued to publish *livres d'artistes* and artists' monographs into the 1990s.[4]

PAGE SIZE: 22.5 × 16.8 cm.

PAGINATION: 280 [8] pp.; the first 2 leaves and the last 2 leaves blank.

ILLUSTRATION: Lithograph frontispiece printed by Mourlot Frères, Paris.

TYPOGRAPHY: Printed by the Imprimerie Nationale, Paris. Text in a newly cast 13-point font of the Romains du roi.

PAPER: Mold-made wove Arches, the specials on laid mold-made grand vergé d'Arches with the frontispiece on Chine.

BINDING: White wrappers printed in black and red with the device of the Imprimerie Nationale on the back cover.

EDITION: Printed 6 September 1951. Edition of 3,400 copies: 300 specials numbered I to CCC; 3,000 copies numbered 1 to 3,000; 100 copies hors commerce designated H.C.

COPIES EXAMINED: PML 195614 (no. 1482); BnF 8-Y2-88193 [13] (H.C.); HRC PQ 2605 O28 V333 (no. XXXIX).

REFERENCE: Duthuit 1988, no. 29.

EXHIBITIONS: Fribourg 1982, no. 27; Nice 1986, no. 81.

44.

Alfred H. Barr, Jr. (1902–1981), *Matisse: His Art and His Public.* **New York: The Museum of Modern Art, 1951.**

Alfred Barr admitted that this book had become much larger than he intended. The first director of the Museum of Modern Art, Barr lost that job in 1943 after a falling-out with the trustees, but he stayed on as a scholar in residence and the Director of Museum Collections. He initially expected to compile an exhibition catalogue, merely an update of the catalogue for the museum's 1931 retrospective exhibition. The more he studied Matisse's work, however, the more he became convinced that it deserved a comprehensive record with detailed commentary and a full complement of illustrations. He tried to identify all the major paintings completed up to the date of publication, while also describing how they were conceived, produced, sold, exhibited, and received by collectors, critics, journalists, and the public at large. He made a valiant effort to account for the illustrated books and enlisted his MoMA colleague William S. Lieberman to list them in a bibliographical appendix (frequently cited in this catalogue). A staunch and conscientious scholar, he solicited information from Matisse and members of the artist's family by sending them questionnaires about pictures famous and obscure, including some even they could not remember. This fact-finding mission exasperated the artist, but he gradually came to understand the magnitude of the achievement and agreed to contribute a cover design for the comparatively modest 1951 exhibition catalogue as well as a dust jacket and a frontispiece for the monograph.[1]

The dust jacket and frontispiece did not turn out the way he wanted because of misunderstandings and a tight production schedule. The frontispiece lithograph was supposed to face the title page in the special copies, standard practice for the artist. He was quite particular on that point but did not reckon with the technical difficulties of rearranging the front matter in a mass-produced trade edition. *Matisse: His Art and His Public* already had a frontispiece, a color reproduction of *Woman with the Hat,* which would have had to be discarded or moved elsewhere in the volume. Instead the lithograph was tipped in after the title between two leaves, a blank leaf and the

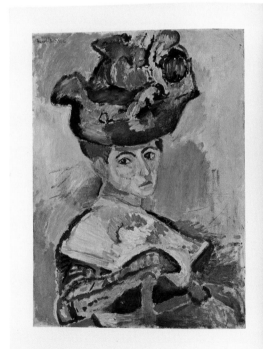

Fig. 1. Frontispiece and title page, *Matisse: His Art and His Public,* Frances and Michael Baylson Collection

MATISSE
HIS ART AND HIS PUBLIC

BY ALFRED H. BARR, JR.

THE MUSEUM OF MODERN ART　NEW YORK

limitation statement signed by the author. Matisse believed that his assignment was to produce the cover for the book in the form of wrappers or pictorial boards. To that end, he produced a cutout design—a photograph of him in his studio shows the template laid out on a table—and inquired whether it could be printed by Mourlot under his supervision to ensure the quality of the colors. Here too he would have to be disappointed, for the specials were to be bound in cloth, and commercial considerations required a dust jacket with flaps displaying the price, the blurb, the name of the distributor, and an advertisement for another book by Barr. He wanted his cutout design to be an integral part of the book, not an ornamental accessory or a transitory piece of advertising ephemera. Nonetheless he reconciled himself to the idea of a dust jacket and pointed out a portion of the composition that could be used as a compartment for the spine title. Although compromises had to be made, *Matisse: His Art and His Public* was a handsome volume amply rewarding the efforts of the author and publisher. Some copies of the trade edition contain a laid-in note stating that this was the "largest and most expensive publication ever issued by the Museum."[2]

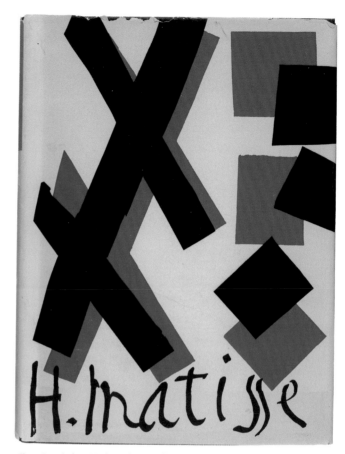

Fig. 2. Dust jacket, *Matisse: His Art and His Public,* Frances and Michael Baylson Collection

PAGE SIZE: 25.5 × 19 cm.
PAGINATION: [16] 591 pp.; pages [11–12] blank.
ILLUSTRATIONS: Lithograph printed by Mourlot Frères, Paris. Colorplates printed by John P. Smith Co., Rochester, New York.
TYPOGRAPHY: Printed by the Plantin Press, New York. Text in 9-point Monotype Baskerville.
PAPER: Machine-made wove.
BINDING: Full blue cloth, gilt-stamped, dust jacket after a paper cutout design by Matisse, black cardboard slipcase. The trade

edition was bound by J. F. Tapley Co., New York, in quarter red cloth and gilt-stamped black boards.
EDITION: 495 specials with a limitation statement signed by the author and dated December 1951. Printed in November 1951, the trade edition was priced at $12.50 but was distributed gratis to members of the Museum of Modern Art. Arno Press reprinted this edition in 1966. A paperback edition with additional plates appeared in 1974.

COPIES EXAMINED: PML 195615 (no. 413); PML 416 M433 B2 (trade edition); MoMA Archives AHB11.V.1.b (no. 1); MoMA Archives AHB11.V.1.a (no. 76).
REFERENCES: Barr 1986, p. 280; Duthuit 1988, no. 30.
EXHIBITIONS: Washington, Detroit, and St. Louis 1977, no. 122; New York 1978, p. 224; Saint Petersburg 1980, no. 70; Nice 1986, no. 108.

45.

André Rouveyre (1879–1962), *Apollinaire.*
Paris: Raisons d'Être, 1952.

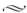

Apollinaire passed through the hands of five different publishers while Matisse and Rouveyre tried out different concepts for this book. At first it was to be a collection of articles that Rouveyre had previously published in literary journals between 1920 and 1943. It would contain a memoir of the poet, an appreciation of his work, an account of his military service in the First World War, and a long essay about the women in his life. For the memoir Rouveyre could draw on his personal acquaintance with the poet and their extensive correspondence, which included some of the concrete poetry in *Calligrammes* as well as lighthearted verse written at the front:

Why don't you write me any more
My dear André Rouveyre
What in me do you abhor
Guillaume Apollinaire

Gaston Gallimard reprinted these articles in a trade edition (1945) and agreed to issue them as a book illustrated by Matisse, although he also allowed the author to publish them elsewhere provided that the print run did not exceed 300 copies. At this point they were thinking of only two illustrations, portraits of the author and the poet. Gallimard procrastinated, however, and Rouveyre exercised his right to undertake a limited edition with another publisher, Robert J. Godet (1921–1960).[1]

Godet came highly recommended by a friend who had published two of the articles and had been the intermediary with Gallimard: "He is rich. He is not stupid. I forgot: he is the judo champion of France." During a desultory career in the book trade,

he produced just over twenty titles, all in limited editions, three with etchings by Picasso. He wrote a history of judo and two volumes about his travels through exotic lands in the famously cheap and sturdy Citroën 2CV. He was a disciple of Gurdjieff and a patron of the painter Yves Klein, who developed the method of using a nude model as a "living brush" in his apartment. An amateur pilot, he died at the controls of a twin-engine plane that crashed while taking off from an airstrip in India. Matisse had a low opinion of this wealthy dilettante, who had grand ambitions but failed to focus on the business at hand. In August 1944 Godet promised to publish *Apollinaire* by the end of the year. He included it in a list of forthcoming titles and announced that it would contain twelve lithographs, which would have been six portraits of Apollinaire and the six portraits of Rouveyre later published in *Repli*. But in early 1946, seeing no signs of progress, Matisse lost patience and recommended that they drop Godet, repossess the artwork, and take counsel on how to salvage the project. They could no longer sell their work as a first edition because the trade edition had come out while Godet was wasting their time. Rouveyre deferred to his wishes as always and decided to jettison the idea of reprinting his articles. Instead he would write new material beginning with an essay about Matisse's portraits of Apollinaire.[2]

Next in line was Mathias Tahon, publisher of *Repli, Richard Winslow,* and the Léautaud *Choix de pages.* Rouveyre nominated him for the job in 1946 and suggested that the new essay, "Apollinaire et Matisse," could be illustrated with two suites of prints; the six portraits of Apollinaire, which were completed by this time, and six self-portraits of the artist. Tahon conferred with Matisse, who was encouraged by his proposals but did not want to

make any commitments until the text was completed. Negotiations stalled for eighteen months while they were engaged in other projects. Rather than writing additional text, Rouveyre suggested that they use his essay as a twelve-page preface for a portfolio containing the portraits of Apollinaire. He made a maquette to show what he had in mind and suggested what kind of payment they might demand from the publisher—the artist receiving half of the edition, the author asking for only 10,000 francs. Matisse continued to be noncommittal, another year went by, Tahon drifted off, but Rouveyre did not forget about the essay and the lithographs. On the last day of 1949, Matisse's birthday, he sent New Year's greetings and presented a new candidate for publisher—Louis Broder.[3]

Among other qualifications, Broder had been working closely with Albert Skira as the French agent for *Labyrinthe.* Skira would vouch for him, as would the printer Georges Girard and the lithographer Fernand Mourlot, the three principals in the production of the Ronsard. He was the proprietor of Galerie Graphique Thésée and the small but "highly esteemed, very serious" publishing house Éditions Thésée. Between 1949 and 1971, he issued books by André Breton, Antonin Artaud, Paul Éluard, and René Char—an impressive lineup of authors associated with equally prominent artists, such as Max Ernst, Jean Arp, Georges Braque, and Joan Miró. Rouveyre reported that Broder had seen the lithographic stones with the portraits of Apollinaire and was so captivated by them that he wanted to get started as soon as possible. He proposed to send specimen pages and a maquette right away. In February 1950 he discussed a contract with Rouveyre, who told him that Matisse would want half of the edition and that the edition would amount to between 250 and 280 copies. He offered to pay

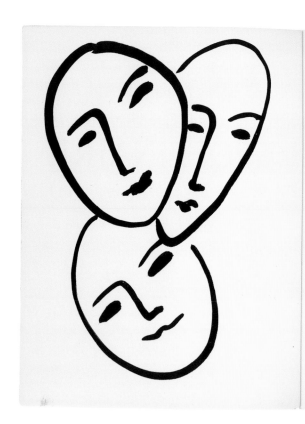

ANDRÉ ROUVEYRE

APOLLINAIRE

HENRI MATISSE

« RAISONS D'ÊTRE »
PARIS

Fig. 1. Frontispiece and title
page, *Apollinaire,* Frances and
Michael Baylson Collection

Fig. 2. Frontispiece, *Lettres à
Lou,* Frances and Michael
Baylson Collection

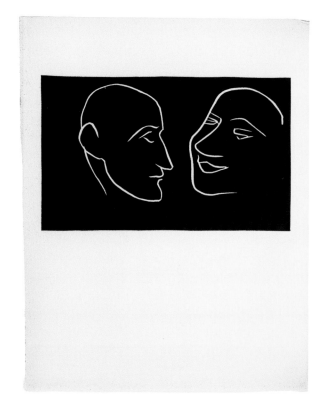

Rouveyre 10 percent of the top price he set on the copies he would receive as his portion of the edition. "That would still make a nice bundle for me," remarked Rouveyre, who was delighted at the progress they were making.[4]

All this was a good sign, but Broder had opinions on how to organize the book. First he asked the author to provide enough additional copy so that each of the lithographs could be placed inside four pages of text. Rouveyre gladly complied and sought to reach a total of twenty-four pages in type. Then Broder wanted him to insert the better known poems of Apollinaire, a last-minute idea not so kindly received by the author, who complained that it would ruin his attempts to arrive at a word count in proportion to the number of illustrations. He suspected a hidden agenda behind this change in plans. Meanwhile Broder was supervising the typesetting operations at the Coulouma printing plant with the goal of submitting to Matisse a pasteup maquette complete with title page and decorative initials by 22 September. He seemed to be overcoming one obstacle after another in his zeal to meet that deadline. Coulouma's employees refused his request to work at night, citing the labor regulations of their union. They tried Monotype composition, but some sorts were lacking. They set the text by hand and pulled galley proofs as a first step toward assembling the maquette. While the book was taking shape, however, a perceptibly nervous Broder suddenly decided that he would have nothing more to do with it. He quit, he said, because he could no longer endure the constant interference of the author, but he may also have been worried about the profitability of the venture. He objected to the half-and-half arrangement by which he was supposed to pay the artist, whose share of the edition he wanted to reduce to eighty copies. Something snapped, and rather than

haggling any more, he wrote off his investment and offered to return the artwork. This latest debacle delayed *Apollinaire* for another year while the participants in the project regrouped and enlisted another publisher, the director of Éditions Raisons d'Être.[5]

Not much is known about this small and short-lived firm. Specializing mainly in poetry and political commentary, it started soon after the war and closed down soon after the publication of *Apollinaire*. Its managing director appears to have been Marie-Thérèse Adda-Géraud, who was also associated with (and perhaps married to) André Adda-Géraud. In May 1951 Adda-Géraud signed a contract with Fernand Mourlot for a book with the working title *Stature d'Apollinaire*, which was to contain seven Matisse lithographs printed by Mourlot. Rouveyre acted as if Mourlot was now in charge of the project, although he met Madame Adda-Géraud on at least two occasions. Somewhat chastened after the go-round with Broder, he asked for no compensation for his text beyond some complimentary copies and the right to reprint it in a trade edition, perhaps a companion volume to his *Apollinaire* of 1945. The text turned out to be fairly substantial, comprising three chapters, not just the essay about the portraits but also an account of the poet's love affair with Louise de Coligny and a commentary on the poems written during the war. Rouveyre first laid eyes on the completed book in late May 1952 and signed the large paper copies in July. By that time it had been sent out for review, and Matisse could congratulate the author on an appreciative notice in a literary journal as well as the word-of-mouth approbation of the leading poets in their milieu.[6]

The graphic ingredients of *Apollinaire* changed after it came into hands of Louis Broder. Matisse designed linocut initials for

the chapter openings, which he expected to be printed in the same poppy red he prescribed for the initials of *Pasiphaé*. Unfortunately the red text on the title page did not match the color of the initials, even though the pressmen swore that they used ink from the same container. Matisse was also concerned that the fine strokes in the letters might deteriorate while the fragile linocuts were in press. He instructed the printers to pull a few proofs, from which they could make zinc cuts, a sturdy substitute for the original blocks. The initials therefore are not originals despite the small size of the edition.[7]

At first he intended to decorate the chapter openings with two linocuts, each with a red initial and a black headpiece. "Solemn, like a portal," the headpiece he proposed for the beginning of the book consisted of an ornamental fruit-and-flower motif in the eighteenth-century typographical tradition. The other two headpieces were to be intimate and familiar, each displaying portraits of Apollinaire and Rouveyre facing one another and grinning like schoolboys on a lark. In fact those portraits are based on a short cinematic flip book they made together in a primitive photo booth on a Paris boulevard in 1914. The two of them mugging before the camera can be seen in several Web sites devoted to Apollinaire. Rouveyre gave Matisse the constituent photographs of the *petit ciné* for his reference in making the double portraits. He felt that he had succeeded in expressing the different physical and moral character of the two individuals, a pleasant contrast, but then decided against the black headpieces, which probably looked too busy on the page. Instead he relied on the frontispiece to address the theme of friendship. One of the preliminary studies is titled *A l'amitié*. More than ten studies have survived as litho-

graphs and aquatints displaying portraits of Apollinaire, Rouveyre, and Matisse, who included himself in the group because he too had been a friend of Apollinaire. The portraits are in the form of masks, the aquatints more abstract than the lithographs, in which the artist caricatured himself with his beard and glasses. Rouveyre praised one of the lithographs but much preferred the intense expression in an aquatint, an opinion that might have influenced the decision to use that version for the frontispiece. The colophon implies that the frontispiece is a lithograph, in which case the design would have been adapted for that printing process. If the frontispiece is an aquatint (as stipulated by Duthuit and other authorities), it would not have been printed by Mourlot but by Edmond Desjobert, who printed the proofs so greatly admired by Rouveyre.[8]

Rouveyre used one of the linocut headpieces in another publishing imbroglio. He had obtained permission to quote the love letters to Louise de Coligny, but he also hoped to publish a complete edition of the correspondence. An edition appeared in 1947 under the imprint of the Geneva publisher Pierre Cailler, but he considered it to be incomplete and "traitorous" to the intentions of the poet. Cailler then invited him to write the preface for a facsimile edition, a scrupulous attempt to reproduce each of the 220 letters with the utmost precision and fidelity. For the first time, the concrete poems could be read exactly as they were written. Rouveyre was proud of this accomplishment and wished it to be known that he was acting as a literary executor, if not in the legal sense then in virtue of his loyalty and friendship. Facing the title page of *Lettres à Lou* is one of the double-portrait headpieces originally made for *Apollinaire* (see Fig. 2). How it got there is not entirely clear because there is no mention of Matisse in this book, which must have appeared after the artist died in 1954. In any case, Cailler had more to worry about than crediting the artist; Apollinaire's widow learned about his edition just when it was about to be completed and compelled him to destroy it. For the record he held back a few copies and gave them to the people involved in that project. The Morgan's copy contains a publisher's note stating that it was not for sale and a handwritten addendum certifying that it was one of the few surviving remnants of the doomed facsimile edition.[9]

PAGE SIZE: Raisin quarto; 32.8 × 25.2 cm.
PAGINATION: 86 [10] pp.; the first 2 leaves and the last 2 leaves blank.
ILLUSTRATIONS: Lithograph frontispiece, 6 full-page lithographs and 1 lithograph tailpiece printed by Mourlot Frères, Paris.
TYPOGRAPHY: Printed by Coulouma S.A., Paris, the design based on a maquette by Matisse. Text in 18-point Caslon.
PAPER: Mold-made wove Arches.
BINDING: White wrappers decorated with a petal pattern composed of yellow cutouts and a black crayon outline, author's name in black crayon on the front cover, blue chemise with white cutouts forming the author's name on the front cover, botanical design on the back cover, yellow spine, blue cardboard slipcase.
EDITION: Printed 24 April 1952. Edition of 350 copies: 30 copies on grand vélin d'Arches signed by the author and artist, accompanied with a suite of lithographs, numbered 1 to 30; 300 copies on vélin d'Arches numbered 31 to 330; 20 copies hors commerce numbered I to XX as well as some nominative copies on grand vélin. Priced at 18,000 francs, copies on grand vélin d'Arches at 30,000 francs.
COPIES EXAMINED: PML 195616 (no. XI); BnF Res G-Z-314 (no. 190).
REFERENCES: Duthuit 1988, no. 31; Monod 1992, no. 10004; Klein 2001, pp. 142–43.
EXHIBITIONS: Washington, Detroit, and St. Louis 1977, nos. 188 and 189; Saint Petersburg 1980, no. 12; Fribourg 1982, no. 13; Nice 1986, no. 35; Paris 1995, no. 355; Paris and Humlebaek 2005, pp. 142–53.

46.
Échos. **Paris: Fernand Mourlot, 1952.**

∼

The generosity of spirit attributed to Matisse is nowhere more material than in *Échos,* the last and least known of the major illustrated books published during his lifetime. The book was conceived by female patients at a Vence sanitarium as a poetic miscellany to honor the clinic's medical director, Jean Palliès. His devotion to the young women suffering from pulmonary ailments had resulted in a relapse of his own tuberculosis. Several times during spring 1952 the artist visited this clinic, called La Maison Blanche, to discuss his designs for the nearby Vence Chapel. Matisse described these encounters to André Rouveyre as something akin to a spiritual experience. He was deeply affected by the patients' sincere questions and curiosity about his artistic process. Their youthful beauty and profound gratitude to their doctor touched Matisse, who took pity on them for the predicament that had forced them to leave Paris universities for this magic mountain in Provence. When they invited him to contribute a frontispiece to their book, Matisse was moved to do more. He assumed full responsibility for its design and production, planning ornamental initials, tailpieces, and original lithographs to interpose the eleven poems by Jacques Prévert (1900–1977), André Verdet (1913–2004), Nâzim Hikmet (1902–1963), and others. Within a few months, the book was published at Matisse's expense by Fernand Mourlot in an edition of fifteen copies designated for Palliès and the collaborators, who had all donated their work for the cause.[1]

Matisse's own precarious state of health in May of that year was in a rare upswing, affording him the energy necessary to begin work on *Échos.* By the time he took control of the project, the young women had already collected poems from two local writers whom Matisse knew: Verdet, who had just conducted a soon-to-be-published interview with the artist, and Prévert, the ex-Surrealist, lyricist, and screenwriter who was at that time the country's bestselling poet. Matisse took it upon himself to petition André Rouveyre to contribute to *Échos.* Rouveyre obliged his close friend within two days, sending what the author described as a graceful, delicate poem, perhaps more accurately described as facile. He aligns the sanitarium La Maison Blanche with Matisse's own *maison blanche,* the Vence Chapel, regrettably concluding the awkward lines with a couplet that rhymed the Madonna smiling (*sourit*) with the painter *Henri.* At a time when Matisse and Rouveyre were corresponding almost daily, the feeble offering was met with silence. Rouveyre nudged Matisse the following day, asking if he had received the poem and remarking on his particular pleasure at the last two lines. More silence ensued. Rouveyre's next letter beseeched Matisse to let him know if he was disappointed by the poem. He quoted his last two lines again, savoring the clever gesture that placed his friend's name in such close proximity to the Virgin Mary: *"Tu comprends: Jésus, Marie, Joseph, Henri . . ."* The poem's attention to Matisse in a dedicatory work for someone else must have seemed inappropriate to the painter, who was planning to leave his own name off the title page. The matter between the intimate friends was dropped and Rouveyre's poem was never published.[2]

Échos divides unevenly into two parts: the works by Prévert and Verdet comprise the first section, entitled *Préfaces;* the second and longer section, *La présence et les jours,* includes seven anonymous poems and concludes with a 1931 poem by the Turkish poet Nâzim Hikmet, appropriately titled *Adieu.* This unorthodox structure (and the use of the word *Préfaces*) has sometimes led to the misattribution of all eight poems in *La présence et les jours* to Hikmet. The unattributed poems, some of which make reference to illness and La Maison Blanche, were likely written by the sanitarium's staff or the women themselves, who wished to maintain the sense of a collective homage by remaining anonymous.[3]

Matisse's artistic contributions to *Échos* were fairly straightforward. The personal nature of the women's project was reflected in the hand-lettered lithographed title, which appears on an otherwise blank page in red and black. Matisse experimented with linocut tailpieces of the women's faces before settling on floral red and blue lithographic ornaments, preserving the linoleum for simple cursive initials to be printed in red. To further enhance its imagery, he produced five portraits in addition to the frontispiece, seeking to capture the women's smiles and what he described to Rouveyre as their fresh, pretty faces, reminiscent of the beautiful rain-soaked spring. Two ostensible portraits of his clients also appear on the wrappers, which employed his cutout technique to depict female silhouettes in yellow against green, echoed in reversed colors on the back.[4]

With the maquette completed, the book came together very quickly. The nominal publisher of *Échos* was Fernand Mourlot, who also printed the lithographs and cutout cover. The project's origins and the people involved struck a chord with Mourlot, who fondly recounted the story of *Échos* in both his memoirs. Even without the participation of Mourlot's good friend, Prévert, the printer's generosity in handling the publication in exchange for a copy comes as no surprise. In 1952, Rouveyre described the attitude toward Matisse at Mourlot Frères as bordering on religious devotion. The atelier's ascendance in the 1940s was inextricably tied to its numerous collaborations with Matisse. In turn, the Imprimerie Union, which printed the

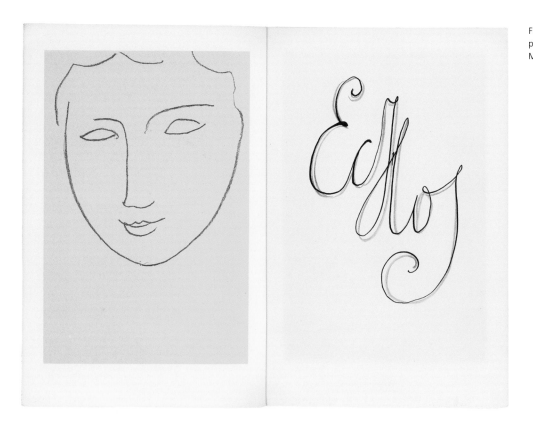

Fig. 1. Frontispiece and title page, *Échos,* Frances and Michael Baylson Collection

letterpress, had reasons to behave generously toward Mourlot. During the Occupation, Mourlot's fictitious acquisition of this firm protected its directors, Dimitri Snégaroff and Volf Chalit, both of whom were of Russian-Jewish origin. The ruse, which enabled Union to survive the war, did not fool an official inspector and might have landed Mourlot in a concentration camp had he not been saved by a sympathetic bureaucrat.[5]

By the end of August, a mere four months after its conception, *Échos* was completed in Paris. To the dismay of Mourlot, the imbalance of varnish and oil used for the red linocut initials at Union caused offset oxidation on facing pages. Matisse, however, must have been pleased with the realization of one of his last maquettes. His initial intention to produce

a scant ten copies for the doctor and contributors was revised to fifteen, ensuring that *Échos* was treated like his other illustrated books, with deposit copies designated for the Bibliothèque nationale, the Bibliothèque Doucet, and Matisse's faithful assistant, Lydia Delectorskaya. Transformed from a modest collection of honorific poems to an equal balance of image and text reflective of the artist's vision, *Échos* was a fitting coda to more than two decades of extraordinary artists' books—an artful and coherent Matisse production, despite the fact that his name appears only in the colophon.[6]

Doctor Palliès recovered from his relapse, remaining in the area to devote himself to pulmonary diseases, especially those of women and adolescents. The remission of Matisse's own recurring

asthmatic crises and various ailments persisted until November. His doctors assured him that the regression was momentary, but Matisse knew that age was against him.[7]

SHEELAGH BEVAN

PAGE SIZE: 31 × 20.5 cm.
PAGINATION: 49 [11] pp.; the first 2 leaves and the last 3 leaves blank.
ILLUSTRATIONS: 6 full-page lithographs (5 in black, frontispiece in sepia), 9 lithographic ornaments in blue and red and title page with lettering in red and black, printed by Mourlot Frères, Paris. 11 linocut initials printed in red by the Imprimerie Union, Paris.
TYPOGRAPHY: Printed by the Imprimerie Union, Paris, the design based on a

D'UN CONTE BLEU

C LAIRIÈRE où des jeunes filles
Seules combattent
L'incendie des forêts
Le feu les assiège
La terre s'entr'ouvre
Une source jaillit
Où boivent à tire d'ailes
De libres gazelles
Le feu devient rideau de mousse.

ANDRÉ VERDET

Fig. 2. Text page, *Échos,*
Frances and Michael Baylson
Collection

Fig. 3. Lithograph, *Échos,*
Frances and Michael Baylson
Collection

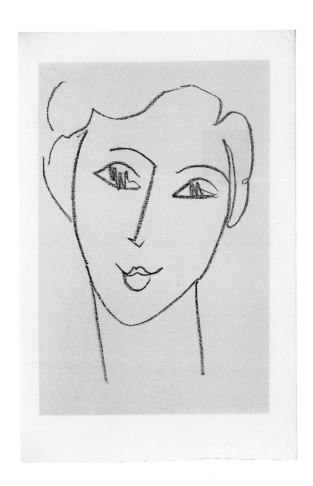

maquette by Matisse. Text in 20-point
Deberny et Peignot Firmin Didot.
PAPER: Mold-made wove vélin d'Arches.
BINDING: Wrappers with yellow and green
cutout designs on front and back cover, title
and date 24 June 1952 in blue crayon
lettering reproduced on front cover.
EDITION: Printed 28 August 1952. Edition of
15 nominative copies hors commerce.
COPIES EXAMINED: PML 195617 (not
numbered, designated for Fernand Mour-
lot); BnF Res G-YE-300 (no. XI, desig-
nated for BnF).
REFERENCE: Duthuit 1988, no. 32.
EXHIBITIONS: Geneva 1959, no. 43; Bern
1960, no. 22; Moscow and Saint Petersburg
1969, no. 86; Washington, Detroit, and St.
Louis 1977, no. 190; Saint Petersburg 1980,
no. 13; Nice 1986, no. 37.

47.

Henri Matisse (1869–1954), *Portraits.*
Monte-Carlo: André Sauret, Éditions du
Livre, 1954.

&

Although Matisse died before the publication of *Portraits*, it deserves consideration here because he assembled the contents, wrote the text, specified the layout, and designed the cover. One could say that it was entirely his own creation. He did not see it through the press, but he dictated the typographical details with an assurance acquired from extensive experience in making books. He knew that his wishes would be respected, having established a routine with associates who understood his stylistic preferences and working methods. He prepared a maquette for Mourlot, who acted as production manager and liaison with the printers. As usual he obtained sample settings for his approval of the page proportions and the typeface. He collected photographs to be used for the portrait reproductions and asked his son Pierre to help with picture research in America. At every stage of the planning process, he exercised complete control of this project, which was more of an artistic credo than a commercial proposition.[1]

This volume sums up a lifetime devoted to the art of portraiture. It contains a prefatory essay and ninety-three plates displaying his best efforts during his entire career, the earliest dating to 1895, the latest to 1952. Every form of graphic expression is represented—drawings, prints, and paintings. Studies for book illustrations remind the reader of his work on Mallarmé, Baudelaire, Charles d'Orléans, Apollinaire, and Colette. A separate section of color reproductions forms a revealing sequence of paintings, arranged in chronological order to show changes in style, developments in

Fig. 1. Title page, *Portraits,*
Frances and Michael Baylson
Collection

Fig. 2. Front cover, *Portraits,*
Frances and Michael Baylson
Collection

technique, and preferences in subject matter, mainly friends and members of his family. In book form these paintings were easy to compare, but to see the originals, one would have to visit private collections and public museums as far away as Moscow, Tokyo, and Copenhagen, not to mention the notoriously inaccessible Barnes Foundation in Merion, Pennsylvania. Located in Honolulu, *Annelies, White Tulips, and Anemones* was one of his favorite paintings, and it pained him that the public knew it only by a "horrible reproduction." Now he could show it properly, having persuaded Pierre to secure a good-quality photograph for the use of Mourlot. The picture credits frequently mention American museums. One more can be added to the list through the good offices of Eugene Thaw, who recently donated to the Morgan one of the charcoal drawings reproduced in this book.[2]

The preface recapitulates thoughts on portraiture already expressed in interviews and conversation. Once again he described his procedures for studying a subject during several sittings, a mental exercise requiring discipline and restraint while also giving free rein to the imagination (see No. 40). Here

too he adduced the pastels of Quentin de La Tour as a benchmark for achieving a likeness—if that was the goal of the artist (see No. 26). He experimented with writing short "anecdotal" accounts of the portraits and sent them to Mourlot but then asked for them back after deciding that an overview would be better than a commentary. These were his last words on this topic, and he wanted them to communicate its importance to him and its relevance to his work. It was constantly on his mind while he was planning the production of his books, where portraits predominate either as a solitary frontispiece in minor commissions or the conceptual basis of major achievements, such as the *Lettres portugaises, Repli,* and *Les fleurs du mal.* He depended on them to express his understanding of the text and his admiration of the author. This catalogue begins with a frontispiece portrait of a lifelong friend and ends with this conspectus of a main ingredient in nearly thirty of his illustrated books.[3]

PAGE SIZE: 31.5 × 24.5 cm.
PAGINATION: [4] 151 [3] pp.; the first 2 leaves blank.

ILLUSTRATIONS: Frontispiece lithograph printed by Mourlot Frères, Paris; 60 collotype reproductions printed by Louis Duval, Paris; 33 color lithographs printed by Mourlot Frères, Paris.

TYPOGRAPHY: Printed by the Imprimerie Union, Paris. Text in 18-point Monotype Bodoni.

PAPER: Machine-made wove supplied by the Papeterie de Renage, Isère.

BINDING: White wrappers, reproduction of a brush and ink drawing with cutout ornaments on front cover, cutout design on the back cover, gray cardboard chemise with blue embossed text on spine, gray cardboard slipcase.

EDITION: Printed 20 December 1954. Edition of 2,850 copies numbered 1 to 2,850. Priced at 9,000 francs.

COPIES EXAMINED: PML 195618 (no. 2610); HRC q ND 553 M37 A44 LAK (no. 1509).

REFERENCE: Duthuit 1988, no. 33.

EXHIBITIONS: Washington, Detroit, and St. Louis 1977, no. 217; Saint Petersburg 1980, no. 83; Fribourg 1982, no. 28; Nice 1986, no. 52.

NOTES

1. Louis Thomas, *André Rouveyre*

1. Paris 1995; Matisse 2001, pp. 11–23.

2. Matisse 2001, p. 28; Duthuit 1988, no. 40. Page proofs for this book with Rouveyre's annotations are in the Librairie Dorbon-Aîné Records at the Harry Ransom Center, University of Texas at Austin. Revisions in the wording of the title page indicate that he obtained the frontispiece portrait after the first set of proofs had been produced.

3. Klein 2001, pp. 138–39.

2. *Cézanne*

1. Dauberville 1995, vol. 1, pp. 9, 26–29, and 70–78; Mirbeau 1990, pp. 224–25; Mirbeau 1993, vol. 2, pp. 533–80.

2. Benjamin 1989, pp. 184–93; Basel 1989, p. 289. Gaillard announced that he had acquired the bindery and printing plant of the Société Française d'Édition d'Art in an advertisement dated 30 January 1905 (*Bibliographie de la France*, 4 February 1905, p. 235).

3. Basel 1989, pp. 289–91; Spurling 2001, pp. 180–82, 210, and 329; Rewald 1996, vol. 1, p. 238.

4. Rewald 1996, no. 647; Spurling 2007, pp. 38 and 252. The charcoal drawing is at the Metropolitan Museum of Art (1999.408).

3. Pierre Reverdy, *Les jockeys camouflés*, Bernouard edition

1. Duthuit 1988, no. 41; Hubert 2011, nos. 3, 44, and 69.

2. Barr 1951, pp. 155 and 180.

3. Rothwell 1989.

4. Bernouard 1946; Dassonville 1988.

5. Reverdy 2010, vol. 1, pp. 488 and 530–31; Duthuit 1988, no. 41.

4. Pierre Reverdy, *Les jockeys camouflés*, Birault edition

1. Scholars persist in seeing significance in the placement of pictures and interpret it as an attempt to build another level of meaning through the juxtaposition of image and text, but their arguments (Hattendorf 1991; Linarès 2007) are unconvincing in light of the documentary evidence. No amount of close reading can controvert the fact that Reverdy gave Matisse a free hand in the choice of drawings and that some of them had already been published. If Reverdy had discussed them with Matisse, surely he would have known better than to describe them as "unpublished" on the title page of this and the Bernouard edition. If he disliked Bernouard's disposition of the pictures, he would have mentioned that too in his list of complaints. It is more likely that he sought to distribute them evenly in the book and did not intend them to influence the interpretation of his poetry except as an expression of camaraderie, an amicable sign of the common goals and the kindred spirit of poets and painters.

2. Hubert 2011, p. 26; Reverdy 2010, vol. 1, p. 1354 (see pp. 487 and 503 for more comments about the punctuation of modern poetry).

3. Rothwell 1989, pp. 35–40; Hubert 2011, nos. 168 and 172.

5. Marcel Sembat, *Henri Matisse*

1. Sembat's essay is reprinted with a commentary in Matisse 2004, pp. 177–95.

2. Matisse 2004, pp. 21–22; Spurling 2007, pp. 226 and 255.

3. Klein 2001, pp. 202–3, where the preparatory drawings are dated in the summer of 1920. Matisse must have made them in 1919 before the publication of the Sembat monograph.

6. Henri Matisse, *Cinquante dessins*

1. Dauberville 1995, vol. 1, pp. 41 and 102–8.

2. Duthuit 1988, p. 8. A list of Vildrac's publications can be found in Bouquet and Menanteau 1959, pp. 218–20. The headpiece drawing is on the verso of a proof of plate 12 in *Cinquante dessins* (PML 195715).

3. Spurling 2007, p. 242.

4. Matisse 2002, p. 158; PM to Earle Rowe, Rhode Island School of Design, 16 September 1932, PMGA; "50 Dessins par Henri Matisse," PMGA box 190, folder 29; PM to Gordon B. Washburn, Albright Art Gallery, 2 March 1933, PMGA. The Pierre Matisse Gallery *Exhibition of Fifty Drawings* was reviewed in *Parnassus* 4, December 1932, pp. 9–10 and *Art Digest* 7, 1 December 1932, p. 13, where it was reported that the drawings "have never before been shown to the public, even in France."

5. "Cinquante Dessins: Books—Sold," PMGA box 90, folder 8; New York 1978, pp. 136–37.

7. *L'almanach de Cocagne*

1. Fouché 1984, pp. 207–8.

2. Fouché 1984, pp. 47–49 and 199–206.

3. Fouché 1984, pp. 44, 50, 137–40, and 214–29.

8. Henri Matisse, *Dessins*

1. PM to HM, 27 December 1924, PMGA; HM to PM, 5 April 1925, PMGA.

2. Rakint and Walter to HM, 8 September 1925, AM; Rakint to HM, 10 March 1926, AM.

3. Raczymow 1988, pp. 146–49 and 158–72; *Formes: An International Art Review*, no. 21, January 1932, p. 209.

4. Desbiolles 2008.

5. Duthuit 1988, pp. 10–11; Daniel Jacomet to PM, 20 September 1958, PMGA.

6. Nude woman, collotype with pen work (BMA 1950.12.465). Matisse forgot how the print had been produced and mistakenly described it as a photogravure in his note for Etta Cone.

9. Henri Matisse, *Dix danseuses*

1. Waldemar-George, *Willi Baumeister* (Paris: Galerie d'Art Contemporain, 1927); "Jacques Levi Alvares," *Journal de musicologie* 33, 1951, pp. 154–55.

2. Fouché 1987, vol. 1, p. 21, and vol. 2, pp. 213–18; Fouché 1998, p. 172.

3. Smith College 1985, no. 87.

10. *Tableaux de Paris*

1. See Daragnès 2001, which contains a biography of Daragnès and a list of his illustrated books, both by Peter Frank.
2. Daragnès 2001; Fouché 1987, vol. 1, p. 242.
3. Barr 1951, p. 69; Spurling 2007, p. 145; Duthuit 1988, pp. 12–13. Preliminary studies for *Le pont Saint-Michel* are reproduced in Duthuit 1983, nos. 107 and 108. Matisse must have finished the print around September 1926, when he received a 2,000-franc honorarium from the publishers (Émile-Paul Frères to HM, 14 September 1926, AM). *Alternance* includes an etching by Daragnès along with contributions by nine other artists and authors involved in *Tableaux de Paris*.

11. Jacques Guenne, *Portraits d'artistes*

1. *L'art vivant* 3, 1 December 1927, pp. 973–74; Duthuit 1983, no. 445.
2. Jacques Guenne, "Entretien avec Henri Matisse," *L'art vivant* 1, 15 September 1925, pp. 1–6. Dominique Fourcade reprinted the interview portion of the article in Matisse 1972. Jack Flam translated the interview in Matisse 1995 but incorporated the revisions and corrections that had been made in the book version of the text.
3. Pia 1998, cols. 12, 847–48, and 1401–2.

12. Jean Cocteau, Mac Ramo, and Waldemar-George, *Maria Lani*

1. *Journal des débats politiques et littéraires*, 7 July 1929, p. 5; Lecombre 1994, no. 216; Duthuit 1988, p. 342.
2. Lackman 2014; *Variétés: Revue mensuelle illustrée de l'esprit contemporain*, 15 August 1929, p. 299; *Le populaire*, 3 October 1930, p. 2; Lecombre 1994, no. 216; Raczymow 1988, p. 174; Arnaud 2003, p. 735; "Speaking of Pictures . . . These Are the Faces of Parisian Model Maria Lani," *Life*, 3 December 1945, pp. 14–16; *Books Abroad* 29, no. 2, 1955, p. 160. A copy of the prospectus for *Maria Lani* is in the Louis Bromfield Collection at Ohio State University. The prospectus states that it was published under Ramo's artistic direction "in collaboration with Mr. Maurice Sachs," although Ramo's preface implies that Sachs took over the project after he had the original idea. Sachs's initials appear in a publisher's device on the first page of the prospectus, but the device was not used in *Maria Lani*.

3. "Art Activities in New York," *Parnassus* 1, no. 7, November 1929, pp. 3–5.
4. "Speaking of Pictures . . . These Are the Faces of Parisian Model Maria Lani," *Life*, 3 December 1945, p. 14. Signed "Mir.," the book review is in *Variétés: Revue mensuelle illustrée de l'esprit contemporain*, 15 August 1929, p. 299.

13. Stéphane Mallarmé, *Poésies*

1. Matisse 1995, p. 166.
2. Matisse 1995, pp. 215–16. Formerly owned by Bonnard, a copy of *Parallèlement* in the Graphic Arts Collection, Princeton University Library, contains wrappers and titles with and without the *République française* device.
3. Van Dijk 1992, pp. 98–99.
4. Bordas 1997, p. 205; Chapon 1973, p. 367; Skira 1948, p. 73; Duthuit 1988, no. 97; Matisse 1995, p. 96.
5. My only sources for this episode are the not entirely reliable memoirs of Pierre Bordas and a sanitized history on the Skira company Web site.
6. Bordas 1997, p. 205; Fouché 1998, pp. 826 and 844; http://www.skira.net (accessed 23 November 2013).
7. PM to HM, 2 October 1946, PMGA; HM to Skira, 9 August 1949, AM; Skira to HM, 18 August 1949, AM; Skira to HM, 20 October 1949, AM; Skira 1948, p. 78; Spurling 2007, pp. 450 and 458–59.
8. Contract between Skira and HM, 28 April 1930, AM.
9. Aragon 1972, vol. 1, p. 108; Matisse 2001, p. 89; Matisse 1995, p. 115.
10. Barr 1951, p. 89; Duthuit 1988, p. 17; Vulaines-sur-Seine 2002, pp. 37 and 42–43; Labrusse 1999, pp. 145–79.
11. Matisse 1972, pp. 214–15; Vulaines-sur-Seine 2002, pp. 12 and 32; Austin 1987, pp. 132–37; Arnar 2011, pp. 59–70.
12. Mallarmé's *Poésies* went through more than twenty editions by 1920 and more than fifty by 1937, although it is hard to tell what the publishers meant by a new edition. Some of the editions of the 1920s were line-by-line reprints with minor stylistic differences. These reprints are based on the 1913 recension of the *Poésies*, and one of them was used to make the maquette in the Matisse Foundation, but it is not quite correct to say that Matisse consulted the 1913 edition (Vulaines-sur-Seine, p. 34). That edition must have been reset at least once before printing the version used in the maquette.

13. Matisse 2001, p. 80; Skira 1948, p. 68. Tériade might have also had a say in the choice of the typeface. In addition to being art director of *Minotaure*, he was associated with Skira in some of the *livre d'artiste* publishing ventures, although it is not clear what his responsibilities were in that part of the business.
14. There are several reasons to beware of facsimiles, and this is one of them. In 1976 a Geneva direct-mail publishing firm obtained permission to produce a reduced facsimile of the Matisse *Poésies*, printed on good paper and housed in a slipcase also containing a separate suite of the prints. It certainly looked the part, but one plate is out of place, three plates face in the wrong direction, and a section title was omitted.
15. Pichon 1924, pp. 2 and 36–37; Van Dijk 1992, pp. 111–12; Bidwell 1999; René Billoux, *Encyclopédie chronologique des arts graphiques* (Paris: René Billoux, 1943), p. 130. The exact date of Pichon's retirement is not clear. In 1936 he printed for *Philobiblon* an appreciation of his work, which he also distributed as an offprint, perhaps not just a keepsake for friends but also a promotional piece for potential customers (Focillon 1936).
16. Vulaines-sur-Seine 2002, p. 33; Yeide 1999.
17. Matisse 2001, p. 283. A draft and a revised version of the letter to Lacourière are quoted in Labrusse 1999, p. 166, and Vulaines-sur-Seine 2002, p. 37.
18. Contract between Skira and HM, 28 April 1930, AM; invoice from Skira to MD, 25 October 1932, AM; Breeskin 1935. The invoice stipulates twenty-eight *planches refusées* and twenty-nine canceled plates, but Duthuit lists thirty *planches refusées* in the Cone Collection and calls for thirty-four canceled plates. Each of the five special copies contains a preparatory drawing, which also helps to document the creative process. As of this writing, two of the five specials are on the market. Bound in with copy no. 3 (Ursus Rare Books, New York) are three of the *planches refusées*, perhaps a gift to the first owner on the part of the publisher or the artist. Copy no. 2 (Jean-Baptiste de Proyart, Paris) belonged to Marie Harriman, who also had a duplicate proof on chine of one of the etchings. It was not uncommon for specials to be supplemented with proofs, drawings, and manuscript material not called for in the limitation statement. For other examples of this practice, see Nos. 21 and 36.

19. Vulaines-sur-Seine 2002, pp. 38–39; Duthuit 1988, p. 18; HM to PM, 10 April 1942, PMGA. A prospectus for the Mallarmé (PML 195648) contains an announcement of the Paris exhibition.
20. Matisse 1995, p. 96.
21. Breeskin 1935; Barr 1951, p. 246; Matisse 1972, p. 214; Vulaines-sur-Seine 2002, pp. 13 and 32.

14. James Joyce, *Ulysses*

1. Barr 1951, p. 222; Ellmann 1982, pp. 666–67.
2. Macy to Joyce, 8 February 1934, Macy Archive; Macy to Paul Léon, 26 June 1934, Macy Archive; Macy to Joyce, 20 August 1934, Macy Archive; Goodwin 1999, pp. 88–89 and 92–93; McCleery 2008, p. 40; Macy 1935b.
3. Picasso to Macy, 14 March 1933, Macy Archive; Limited Editions Club 1959, p. 245. Matisse heard a slightly different story, in which Macy had a falling out with Picasso, who then left the plates in the printmaking shop of Roger Lacourière with instructions not to release them until payment had been made in cash (HM to PM, 2 March 1935, PMGA). Carol Grossman and Jerry Kelly very kindly advised me about the operations of the Limited Editions Club. I am especially grateful for their helpful suggestions as well as for an HRC research fellowship, which made it possible for me to study *Ulysses* and *Lysistrata* materials in the Macy Archive.
4. Duthuit 1988, p. 37; Macy to Lévy, 25 July 1933, Macy Archive; Macy to PM, 2 February 1934, PMGA; HM to PM, 17 February 1934, PMGA.
5. Macy to PM, 2 February 1934, PMGA; PM to HM, 10 February 1934, PMGA; Russell 1999, p. 107; Badaracco 1995, p. 167; Barr 1951, p. 249.
6. Matisse contract with the Limited Editions Club, 1 May 1934, Macy Archive; Lévy to Macy, 18 April 1934, Macy Archive.
7. Duthuit 1988, p. 37; Macy 1935a, p. 2; Limited Editions Club 1959, p. 247; Dorothy Bussy to Stuart Gilbert, 8 March 1934, Stuart Gilbert Papers, HRC.
8. HM to PM, 17 February 1934, PMGA; HM to PM, 10 August 1934, PMGA; Duthuit 1988, p. 37.
9. Duthuit 1988, pp. 37–38.
10. Joyce 1966, vol. 3, pp. 314 and 317–18; Macy to Lévy, 30 July 1934, Macy Archive.
11. HM to PM, 10 August 1934, PMGA; HM to PM, 7 November 1934, PMGA; Léon to Macy, 16 August 1934, Macy Archive; Knapp 2000, p. 1056;

Duthuit 1988, p. 38. To be precise, Joyce ordered four extra copies at various times and agreed to pay the retail price for them. On the other hand, he once described Matisse's illustrations as "ugly and shapeless" in comparison to his daughter's calligraphy, which he pronounced to be "beautiful and shapely." The context of his comment suggests that he was not criticizing Matisse as much as venting his frustration about his daughter's health problems and her unrewarding artistic career. This exasperated outburst probably does not represent his true feelings about the book, which he liked well enough to buy at the price of $10 a copy.
12. Matisse 1972, pp. 215 and 217. Matisse made a more precise distinction between decoration and illustration in a letter to Raymond Escholier, where he used the same metaphors of a parallel approach and a dialogue between the first and second violins. Here, however, he assigned a more assertive role to the illustrator, who would play as part of "a concerted whole" (Escholier 1960, p. 129).
13. HM to PM, 28 March 1934, PMGA; PM to HM, 29 March 1934, PMGA; HM to PM, 11 April 1934, PMGA; Matisse 1972, p. 216.
14. Macy to Lévy, 6 December 1934, Macy Archive; Matisse 1972, p. 216; Macy 1935a, p. 3.
15. Macy to PM, 21 June 1934, PMGA; Macy to PM, 19 September 1934, PMGA; HM to PM, 11 September 1934, PMGA; HM to PM, 24 September 1934, PMGA; HM to PM, 21 October 1934, PMGA; Lévy to Macy, 21 August 1934, Macy Archive; Macy to Lévy, 26 September 1934, Macy Archive.
16. Macy to Gilbert, 23 July 1935, Macy Archive; Daniel to Macy, 8 August 1935, Macy Archive; Gilbert to Macy, 30 September 1935, Macy Archive; Goodwin 1999, pp. 97–102; Macy 1935a, p. 3.
17. Lévy to Macy, 25 October 1934, Macy Archive; Ralph Duenewald to G. M. Stimson, 18 July 1935, Macy Archive; Goodwin 1999, p. 95; PM to HM, 7 November 1934, PMGA; HM to PM, 8 January 1934 [i.e., 1935], PMGA.
18. Benstock 1980, p. 467 and fig. 2; Paris, Copenhagen, and New York 2012, pp. 11–12 and 148–52; HM to PM, 21 October 1934, PMGA. On the other hand, another critic argues that the preliminary studies detract from the "expressive, sensual quality" of the etchings (Knapp 2000, p. 1064).
19. Duthuit 1988, pp. 37–38; Lévy to Macy, 3 August 1934, Macy Archive; HM to PM, 10

August 1934, PMGA; HM to PM, n.d. [September 1934], PMGA. Matisse passed over *Ulysses* in silence when recounting his illustration career in his essay "How I Made My Books." By omitting it, however, he could make a stronger case for his artistic versatility. He could say that he had started with the Mallarmé etchings, an exercise in black on white, and then resorted to the opposite effect with the white on black linocuts in *Pasiphaé*, "my second book." He was more willing to acknowledge it while discussing his illustration theories with Raymond Escholier and included it in a list of his books he compiled for Escholier (Escholier 1960, p. 128).
20. Macy to Lévy, 26 September 1934, Macy Archive; PM to HM, 5 October 1934, PMGA; Macy to PM, 19 September 1934, PMGA; Macy 1935a, p. 3; Duthuit 1988, p. 38. Proprietor of the Photogravure & Color Company, Charles Furth printed the Picasso etchings for *Lysistrata* as well as other illustrations for the Limited Editions Club.
21. Copy of a cable to Helen Kastor Joyce, 13 August 1934, Macy Archive; estimate of Yale University Press, 24 January 1935, Macy Archive; estimate of E. L. Hildreth & Co., 1 March 1935, Macy Archive.
22. Lévy to Macy, 21 August 1934, Macy Archive; Lévy to Macy, 25 October 1934, Macy Archive.

15. Ventura García Calderón, *Explication de Montherlant*

1. Duthuit 1988, p. 53; Place 1974, nos. 45, 96a, and 115b.
2. Duthuit 1983, nos. 538–40; Janine C. Huppert, "Montherlant vu par Matisse," *Beaux-Arts,* 27 August 1937, pp. 1–2. Huppert's article is illustrated with three charcoal portraits and two line drawings, a three-quarter view and a profile. The profile drawing was used again on the cover of *Sur les femmes.* Portions of the article appear in Matisse 1972, p. 179; Duthuit 1988, p. 344; and Klein 2001, p. 139. See Delectorskaya 1996, p. 130, for an account of the lithograph portraits, which are supposed to have been done at a later date, when a publisher solicited an original print to be the frontispiece of one of Montherlant's books.
3. Domenget 2003, p. 250.
4. The occasion of Flouquet's portrait is not recorded.
5. Brussels 1975.

16. *Paris 1937*

1. Paris 1987, pp. 364 and 468; Barker 2003. Matisse was the only prominent artist not to receive a commission from the exposition officials, but his work received ample recognition in an ancillary exhibition at the Petit Palais, where sixty-one of his paintings were on display (Barr 1951, p. 571).
2. Boinet 1937, vol. 40, pp. 129–30. Roger Lacourière borrowed from Matisse some of the Mallarmé proof etchings for the exposition, although he probably intended to show them in the prints section rather than the *livres d'art* display organized by Daragnès (HM to PM, 10 April 1942, PMGA).
3. Boinet 1937, vol. 40, pp. 113–18.
4. Duthuit 1988, p. 44.
5. Duthuit 1983, nos. 248–50; Daragnès 2001, pp. 52–53.
6. Daragnès 2001, p. 90.

17. Tristan Tzara, *Midis gagnés*

1. As if prompted by the author, one of Tzara's friends reviewed *Midis gagnés* in terms that acknowledged the transitional nature of this text: "Now that the scandal has passed and the spirit of rebellion is stirring in another domain, we can simply surrender to this lyricism and forget about the method by which it was made, just as we surrender to the voice of another poet" (Tzara 1975, vol. 3, p. 581).
2. Fouché 1987, vol. 1, pp. 15 and 215–16, vol. 2, p. 168; Thyssens 2013. Denoël sold more than 100,000 copies of Céline's *Journey to the End of the Night* between 1932 and 1947. Céline also urged him to publish an illustrated edition and asked if he might sound out one of the "popes" of high art, such as Segonzac or Matisse, although as yet nobody of that stature had expressed interest in the book. An edition illustrated by Gen Paul appeared in 1942 and sold more than 30,000 copies by 1947 (Céline 1991, pp. 24 and 55).
3. Fouché 1987, vol. 2, pp. 202–5 and 235; Staman 2002, pp. 205–6 and 295–96; Jour 2006, pp. 291–303; Thyssens 2013.
4. Nevers 2012; Duthuit 1988, pp. 46–47.
5. Tzara 1975, vol. 3, pp. 578–87.

18. Henry de Montherlant, *Sur les femmes*

1. Duthuit 1988, p. 54.
2. Laurent and Mousli 2003, pp. 7–10, 96–97, 212, 288, and 295–307; Jolly 1960, vol. 2, pp. 518–19; Aragon 1972, vol. 1, p. 179.

19. Louis Aragon, *Brocéliande*

1. Aragon 1997, pp. 188, 260, 308, and 312; Aragon 1972, vol. 1, pp. 38–41.
2. Aragon 1972, vol. 1, pp. 103–4; Duthuit 1988, no. 69.
3. Seghers 1978, vol. 1, p. 204; Béguin 1976, p. 213.
4. Fouché 1987, vol. 2, p. 59; Fouché 1998, pp. 55, 794, 804, and 832; Grotzer 1967, pp. 37–44; Frey-Béguin 1993, p. 58.
5. Kundig 1932; Lawrence 1971.
6. Aragon 1972, vol. 1, pp. 171 and 179.

20. Henri Matisse, *Dessins: Thèmes et variations*

1. Matisse 2001, p. 100; Fabiani 1976, pp. 117–21; HM to PM, 11 March 1942, PMGA.
2. Fabiani 1976, pp. 18, 73–74, 118, 137–40, and 157; Nicholas 1994, pp. 92–93, 170, 415, and 425–26; Matisse 2001, p. 67; Spurling 2007, p. 422; Spotts 2008, pp. 176–78; HM to PM, 11 March 1942, PMGA.
3. Fabiani 1976, p. 62; Strachan 1969, pp. 86–87.
4. HM to PM, 11 March 1942 and 3 April 1942, PMGA. Matisse wrote several accounts of this drawing revolution because he believed that his letters might get lost in the mail during the war, but he also wanted to confide in people who would understand his intentions and excitement. "It is like a rebirth," he told his daughter Marguerite Duthuit, "one of those things for me that makes life worth living" (Duthuit 1988, p. 48).
5. HM to PM, 10 April 1942 and 12 February 1945, PMGA; Aragon 1972, vol. 1, p. 58; Delectorskaya 1996, pp. 201–4 and pp. 280–81, which contain two photographs of the drawings completely covering a wall in his hotel rooms at Nice.
6. Aragon 1972, vol. 1, pp. 51–144; Duthuit 1988, p. 49.
7. HM to PM, 10 April 1942, PMGA; HM to Fabiani, 25 June 1942, AM; Duthuit 1988, p. 48; Delectorskaya 1996, pp. 207 and 281; Matisse 2001, p. 100. Fabiani proposed the same mode of payment to Picasso a few months later when they signed a contract for an edition of *Don Quixote* (which never appeared, viz. Fabiani 1976, pp. 134–35).
8. Aragon 1972, vol. 1, p. 170; Duthuit 1988, pp. 48–49; Delectorskaya 1996, p. 293; Chamonard 2001, pp. 16–18.
9. Delectorskaya 1996, pp. 205–6; Aragon 1972, vol. 1, p. 169, vol. 2, pp. 48–54; Klein 2001, p. 266; HM to PM, 3 April 1942, PMGA. Matisse also had a vexed relationship with Breton (Matisse 1995, pp. 12–13).

21. Henry de Montherlant, *Pasiphaé*

1. Place 1974, nos. 18, 35a, 39a–k, and 67a–c.
2. Tériade to HM, 14 December 1938, AM; Delectorskaya 1996, pp. 476–93; Fabiani 1976, p. 119; MD to Montherlant, 29 June 1966, PMGA; Montherlant to MD, 18 July 1966, PMGA.
3. Matisse 1995, p. 168; Aragon 1972, vol. 1, pp. 184–85; Delectorskaya 1996, pp. 481 and 543; Baltimore 2009, pp. 24–26 and 65; Matisse 2001, p. 54. Sometime before 22 January 1944 Matisse told Gaston Diehl that he had been working on *Pasiphaé* "exclusively" for more than six months (Diehl 1944a, p. 6).
4. Duthuit 1988, pp. 54–55.
5. Duthuit 1988, p. 54; Matisse 1995, p. 167; *Importants livres anciens, livres d'artistes, et manuscrits*, Christie's, Paris, 11 May 2012, lot 186.
6. Duthuit 1988, p. 54; Matisse 2001, p. 276; *Le livre et ses amis* 1 no. 2, 1945, p. 8. Proofs in red and black with annotations about tints and inking are in the PTMF archive. The *Pasiphaé* maquette at Doucet (8377) shows alternative versions of the red initials.
7. Paris 1981, nos. 165 and 166; Le Cateau-Cambrésis 1987, nos. 3–6; Nice 1986, nos. 6 and 7; *Importants livres anciens, livres d'artistes, et manuscrits*, Christie's, Paris, 11 May 2012, lot 186.
8. Duthuit 1988, p. 55; Matisse 2001, p. 280; Delectorskaya 1996, p. 493.
9. HM to PM, telegram, 21 April 1945, PMGA; PM to HM, 5 June 1945, PMGA; PM to HM, telegram, 14 June 1945, PMGA; Duthuit 1988, p. 55.
10. Delectorskaya 1996, p. 539.
11. MD to Montherlant, 29 June 1966, PMGA; Montherlant to MD, 18 July 1966, PMGA; MD, draft of a letter to Montherlant, ca. 27 December 1966, PMGA.
12. *Gravures originales sur le thème de Chant de Minos (Les Crétois) pour le texte de H. de Montherlant; Gravures originales sur le thème de Pasiphaé pour le texte de H. de Montherlant* (Paris: Heirs of the artist, 1981); MD to PM, 16 July 1976, PMGA; MD to PM, 16 February 1978, PMGA; Duthuit 1988, nos. 38 and 38 bis.

22. Elsa Triolet, *Le mythe de la baronne Mélanie*

1. Aragon 1972, vol. 2, pp. 301–2; Nice 1986, nos. 61–63.
2. *Lettres et manuscrits autographes*, Paris Drouot, 9

July 1996, lot 68.

3. Duthuit 1988, no. 106; Nice 1986, no. 64. The 1996 edition (PML 195972) is still in print and can be ordered online from the publisher.

23. Henri Matisse, *Visages*

1. Duthuit 1988, p. 71; Duthuit 1983, no. 561; Mourlot 1974, p. 53; Matisse 1995, p. 163.

2. Duthuit 1988, p. 71; Reverdy 2010, vol. 1, pp. 555–57 and 1360–62. Others in Reverdy's coterie were not so enthusiastic about the exhibition—Cocteau came away from it convinced that the "sun-drenched Fauve had been turned into a Bonnard pussycat."

3. Matisse 2001, pp. 296 and 319; Hubert 2011, nos. 205, 247, and 260. Misled by Matisse's statements, Duthuit believed that Reverdy's poetry had been prompted by the lithographs and sought to find in it imagery inspired by the theme of *visages*.

4. Matisse 1995, p. 168.

5. Duthuit 1988, p. 72. Large quantities of trial initials for *Visages* and *Les fleurs du mal* have been preserved in the PTMF archive.

6. Brinks 2005, pp. 58–59 and 190; Mourlot 1974, pp. 53–54. Jay Fisher very kindly provided information about the properties of lithographic transfer paper. The lithographs were probably more pleasing to Reverdy than the linocuts, given the preferences he expressed in a tribute to Matisse: the paintings he liked best might feature "a simple line on a color background," a spare and sober beauty he also saw in book illustrations comprising "a line of color on a white page" (Reverdy 2010, vol. 2, p. 1341).

7. Fouché 1987, vol. 1, pp. 246–48; Fouché 1998, p. 751; Girodias 1990, vol. 1, pp. 361–67 and vol. 2, pp. 150–73.

24. *Alternance*

1. Auxerre 2004.

25. Tristan Tzara, *Le signe de vie*

1. Duthuit 1983, nos. 583, 584, 585, and 587.

2. Tzara 1975, vol. 3, pp. 606–14.

3. Bordas 1997; Fouché 1998, pp. 746–47.

4. Bordas 1997, pp. 165–71. The 1950 edition of *Le dur désir de durer* was published in America with the imprint of the Grey Falcon Press, which was also the American distributor of *Le signe de vie*. Its ink stamp appears on the front flyleaf of the two Morgan copies as well as a signed fine-paper copy in the Museum of Fine Arts, Boston, which was purchased directly from the distributor for the price of $13 in 1947.

5. Bordas 1997, pp. 150, 167, and 181; Gervais 1996, pp. 51–54. Christian Crublé very kindly provided biographical information about Zichieri (who died in 1964 at the age of 79).

26. Paul Léautaud, *Choix de pages*

1. Paris 1995, pp. 32–33 and 129–33; Matisse 2001, pp. 15–20.

2. Matisse 2001, pp. 64, 114–15, 152, and 321; Léautaud 1954, vol. 18, p. 119.

3. Léautaud 1954, vol. 16, pp. 11–12, 175–76, 302–3, and 364, vol. 17, p. 14, vol. 18, p. 119.

4. Léautaud 1954, vol. 16, pp. 23 and 307, vol. 17, pp. 34, 46, 74, 278, and 327–28; Fouché 1987, vol. 2, p. 57. The pamphlet is *Marly-le-roi et ses environs* (1945), listed as out of print in the advertisements on the wrappers of *Choix de pages*.

5. Léautaud 1954, vol. 16, p. 362, vol. 17, pp. 9, 36, and 40.

6. Matisse 2001, pp. 320–22 and 418; Léautaud 1954, vol. 16, pp. 362–64. It is not clear how many times Léautaud posed for Matisse, but three sittings are mentioned in the journal (18, 19, and 22 August 1946).

7. Léautaud 1954, vol. 17, pp. 7–10, vol. 18, pp. 65 and 154.

8. Kemp 1946, p. 3; Léautaud 1954, vol. 17, pp. 10, 20, 25, and 34.

9. Matisse 2001, pp. 419, 422, and 604; Léautaud 1954, vol. 17, pp. 73–74 and 312–13, vol. 18, pp. 96, 155, and 194–95.

10. Duthuit 1983, nos. 593–603; Léautaud 1954, vol. 17, p. 52; Paris 2001, pp. 84 and 98; PM to HM, ca. January 1947, PMGA; HM to PM, 4 February 1947, PMGA; Matisse 2001, p. 488.

11. Léautaud 1954, vol. 17, p. 8, vol. 18, p. 65; Klein 2001, pp. 139–41; Duthuit 1988, no. 48; Matisse 1995, pp. 172, 179–81, and 219–23.

27. Gabriel Joseph de Lavergne, vicomte de Guilleragues, *Lettres [de] Marianna Alcaforado*

1. Duthuit 1988, p. 91. Duthuit's account of this transaction is the only evidence I have for the publishing ventures of Guéguen, better known as a poet, literary critic, and author of essays on contemporary art (Théry 2010). He wrote an article on Matisse for *Cahiers d'art* in 1931. I can only conjecture that he held some kind of management position in Éditions Ariel, an imprint I find only in a few publications between 1939 and 1949.

2. Matisse 2001, p. 303. The authorship controversy could be said to have started in 1926 and to have reached a peak in 1962, with ripostes and counter-attacks continuing as late as 2009 (Leiner 1962; Guilleragues 2009). A piracy of the first edition named Guilleragues as the translator, and that theory continued to gain credence after the first attribution was made to Alcoforado in 1810 (Guilleragues 1972, pp. 64–75). Matisse and his associates did not decide how to spell her name until they corrected the proofs in the maquette, in which they chose a less common version, "Alcaforado." Her name could also be rendered as Maria Ana Alcaforada.

3. Anthonioz 1988, pp. 11–19; Florence and Le Cateau-Cambrésis 1996, pp. 19–45.

4. Anthonioz 1988, pp. 21–22; New York 1997, pp. 40–43.

5. Anthonioz 1988, pp. 25–27.

6. Florence and Le Cateau-Cambrésis 1996, pp. 62–63; Anthonioz 1988, pp. 35–36; Tériade to HM, 25 June 1954, AM.

7. Anthonioz 1988, pp. 197–99.

8. Tériade to HM, 1 January 1943, AM; HM to Tériade, 27 March 1943, AM; HM to Tériade, 27 May 1943, AM; HM to Tériade, 29 December 1943, AM; Tériade to HM, 23 January 1944, AM; *Matisse: Seize peintures, 1939–1943* (Paris: Éditions du Chêne, 1943); Matisse 2001, p. 336.

9. HM to Tériade, 20 August 1950, AM; Florence and Le Cateau-Cambrésis 1996, pp. 72–74, 132, and 218–19; New York 1997, pp. 63–64.

10. Matisse 2001, p. 403; New York 1997, p. 141.

11. HM to Tériade, 25 November 1945, AM; Tériade to HM, 28 December 1945, AM.

12. Florence and Le Cateau-Cambrésis 1996, p. 71; Tériade to HM, 13 December 1945, AM.

13. New York 1997, pp. 116–33.

14. Aragon 1972, vol. 1, p. 285.

15. Guilleragues 1972, p. 77; Duthuit 1983, nos. 588–92; H. Alquier, representing Claude Duthuit, subpoena to the Imprimerie Mourlot, 8 July 1982, PMGA; Tériade to HM, 27 December 1945, AM; Tériade to HM, 19 April 1946, AM; Duthuit 1988, p. 92.

16. Matisse 2001, pp. 420–22.

17. Nice 1986, no. 14 bis; HM to PM, 9 January 1947, PMGA; Barr 1951, p. 273.

28. Henri Matisse, *Vingt-trois lithographies de Henri Matisse*

1. Hesse 1929, vol. 2, pp. 85–91; Silverman 2008, pp. 61–88; Duthuit 1988, p. 130.
2. Bussillett, Faist and Vautheret to HM, 25 November 1938, HRC; Faist to Daragnès, 30 January 1939, HRC.
3. Spurling 2001, pp. 84 and 117–18; Spurling 2007, pp. 421–23; HM to Daragnès, 29 December 1938, HRC; HM to Daragnès, 13 May 1939, HRC.
4. HM to Daragnès, 27 November 1944, HRC.
5. Le Cateau-Cambrésis 1992, pp. 42–54.
6. *"Pieces de B. dont je travaille l'illustration,"* PTMF.
7. HM to Daragnès, 25 February 1939, AM; Janine Daragnès to Moulard, 16 May 1957, HRC; Duthuit 1983, no. 715.
8. Matisse 1971, p. 32.
9. Aragon 1972, vol. 2, p. 11; Mourlot 1974, p. 64; Mourlot 1979, p. 110; Le Cateau-Cambrésis 1992, p. 56.
10. Duthuit 1988, p. 131; Aragon 1972, vol. 2, p. 14.
11. Le Cateau-Cambrésis 1992, p. 58.
12. Matisse 2001, pp. 314–22 and 657; Daragnès to HM, May 1945, AM; HM to Daragnès, 15 May 1945, HRC; Vautheret to Daragnès, 23 December 1945, HRC.
13. Daragnès to HM, 4 April 1946, AM; Daragnès to HM, 31 May 1947, AM; HM to Daragnès, 4 June 1947, HRC. In June 1949 Vautheret was somewhat taken aback to hear from Matisse and sent a pleading letter in return, more a halfhearted gesture than a serious proposition (Duthuit 1988, no. II).

29. *Les miroirs profonds*

1. Gall 1992, pp. 13–62; London 2008, pp. 14–35; Duthuit 1988, no. 105.
2. Kober 1993, pp. 170–84; London 2008, p. 39.
3. Aragon 1972, vol. 2, pp. 1–26; Ferrara 2010, no. 5. The two versions of the shark and seagull drawing are illustrated in Duthuit 1988, nos. 17 and 77.
4. Matisse 2001, pp. 318 and 352.
5. Gall 1992, p. 85.

30. Franz Villier, *Vie et mort de Richard Winslow*

1. Arnaud 2003, pp. 486–91, 497, 525, and 594.
2. *Les nouvelles littéraires,* 27 March 1947, p. 3. Arnaud mistakenly believed that Cocteau wrote a preface for this book and that it was Thomassin's only publication.
3. Duthuit 1983, nos. 604–17.

31. Charles Baudelaire, *Les fleurs du mal*

1. Le Cateau-Cambrésis 1992, pp. 65–68.
2. Fouché 1987, vol. 2, p. 61; Fouché 1998, p. 758; Bouju 2010, pp. 207–10.
3. Le Cateau-Cambrésis 1992, p. 58; Duthuit 1983, no. 744; Jacques Guignard, "Joseph Dumoulin," *Bibliothèque de L'École des chartes* 113, 1955, pp. 359–60. PTMF has sample pages of *"La chevelure"* and *"Tu mettrais l'univers"* in a collection of preliminary designs for *Les fleurs du mal.*
4. Le Cateau-Cambrésis 1992, p. 82; Aragon 1972, vol. 2, p. 26; Matisse 2001, p. 426; HM to PM, 24 November 1946, PMGA.
5. Le Cateau-Cambrésis 1992, pp. 68 and 77–78. Pen-drawn studies for the initials are in PTMF.
6. Le Cateau-Cambrésis 1992, pp. 86–90; Matisse 2001, pp. 426 and 453.
7. Barr 1951, p. 273; Baltimore 2009, p. 26; Aragon 1972, vol. 2, p. 26. These are the hammer prices, not counting the 17.5 percent premium of the auction house (*Les nouvelles littéraires,* 27 May 1948, p. 7).

32. André Rouveyre, *Repli*

1. Matisse 2001, pp. 50–51 and 103.
2. Matisse 2001, pp. 93, 96, and 108; Léautaud 1954, vol. 17, p. 119.
3. Matisse 2001, pp. 347–58.
4. Matisse 2001, pp. 351, 462, 474, and 658.
5. Matisse 2001, pp. 394–96.
6. Matisse 2001, pp. 404–5.
7. André Rouveyre to Mathias Tahon, ca. 26 April 1946, PTMF. Lydia Delectorskaya made the tracing, which is now in the PTMF collection of preliminary studies for *Repli.*
8. André Rouveyre to Mathias Tahon, ca. 26 April 1946, PTMF; HM to Mathias Tahon, 17 April 1947, PTMF; Matisse 2001, p. 413. The Bélier edition of Maurice Maindron's *M. de Clérambon* (1945) contains pochoirs by Nervet.
9. Matisse 2001, pp. 414–21; Léautaud 1954, vol. 17, p. 103.
10. Matisse 2001, pp. 426–28, 446, and 461–62.
11. Matisse 2001, pp. 456 and 470.
12. Matisse 2001, pp. 450–58.
13. Matisse 2001, pp. 458, 505, and 529–30.

33. René Char, *Le poème pulvérisé*

1. Greilsamer 2004, pp. 137–220; Char 1983, pp. lxxii–lxxv and 1131–34; Saint-Paul de Vence 1971, no. 82 ff.; Matisse 2001, pp. 331–37.

2. The explanatory note is a revised and abridged version of a text Char submitted for Matisse's approval (Char to HM, 12 July 1946, AM).
3. Char to HM, 22 January 1946, AM; Duthuit 1983, nos. 294–99 and 750–61; Duthuit 1988, no. 58. Char's biographical memoir of Bernard is reprinted in Char 1983, pp. 646–47.
4. Duthuit 1988, no. I; Char to HM, 5 October 1947, AM; Char to HM, 8 September 1948, AM; Janine Quiquandon to MD, 11 August 1969, PMGA; Daniel Jacomet et Cie. to MD, 30 September 1969, PMGA.
5. Char 1983, pp. lxxvi and 1265; Char to HM, ca. April 1947, AM (this letter is undated, but the letterhead indicates that it was written in 1947, when Char was staying at the Hôtel Montalembert in Paris [Greilsamer 2004, p. 232]).
6. Bokanowsky 1945; "Brève histoire de Fontaine," *Fontaine* 41, April 1945. Most sources date the *Fontaine* publication of *"Liberté"* to June 1942, but Fouchet claimed it came out in May.
7. Char to HM, 16 May 1946, AM; Char to HM, 26 May 1946, AM; Goddet 1991, pp. 143–46.
8. Duthuit 1988, p. 156.
9. Fouché 1998, p. 614.

34. Henri Matisse, *Jazz*

1. A list of exhibitions is in Lavarini 2000, pp. 251–55.
2. Matisse 1995, p. 294.
3. Washington, Detroit, and St. Louis 1977, nos. 1 and 10; Tériade to HM, 20 August 1940, AM; Tériade to HM, 10 June 1941, AM; HM to Tériade, 29 March 1942, AM; Tériade to HM, 2 April 1942, AM.
4. Delectorskaya 1996, p. 514; Matisse 1957, pp. 45–46; Tériade to HM, 5 October 1943 (?), AM; Schneider 1984, p. 709.
5. Tériade to HM, 29 November 1943, AM; Tériade to HM, 25 December 1943, AM; Tériade to HM, undated but probably April 1944, AM; Matisse 1983, p. x.
6. HM to Tériade, 29 December 1943, AM; HM to Lamotte and Tériade, 7 March 1944, MoMA; Tériade to HM, undated but probably April 1944, AM.
7. Tériade to HM, 22 March 1944, AM.
8. Lavarini 2000, pp. 46–48.
9. Matisse to Tériade, 13 April 1946, AM; Tériade to HM, 19 April 1946, AM; HM to Lamotte and

Tériade, 7 March 1944, MoMA; Matisse 1995, pp. 171–74 and 293.

10. Matisse 1995, p. 293; Lavarini 2000, pp. 12–13; Matisse 1957, p. 46; HM to Tériade, 22 April 1946, AM; Tériade to HM, 10 April 1944, AM.

11. HM to Lamotte and Tériade, 7 March 1944, MoMA; Diehl 1944b.

12. Matisse 2001, p. 427; shipping slip of Draeger Frères, 11 December 1947, AM.

13. Berès to PM, 31 January 1948, telegram, PMGA; PM to Goldschmidt, 14 February 1948, PMGA; PM to HM, 18 February 1948, PMGA; PM to HM, 24 March 1948, PMGA; Tériade to HM, 22 December 1947, telegram, AM; Lavarini 2000, pp. 241–42. Berès advertised the exhibitions in *Les nouvelles littéraires,* 18 December 1947, p. 6.

14. Matisse 2001, pp. 476–78.

15. HM to PM, 18 January 1948, PMGA.

16. Matisse 2001, pp. 486–87. For the conservation problems posed by the cutouts, see the Technical Appendix of Antoinette King in Washington, Detroit, and St. Louis 1977, pp. 272–77, and compare no. 16 in that volume with a deteriorated version of the *Clown* cutout reproduced in Matisse 2009b, vol. 1, p. 148.

35. Jacques Kober, *Le vent des épines*

1. Gall 1992, pp. 39, 59, 86, and 101. "From Bonnard to Surrealism" is one of two works in progress noted beneath the limitation statement of *Le vent des épines.* This project appears to have been abandoned.

2. Perriol 2013.

36. Jules Romains, *Pierres levées*

1. Romains 1970, pp. 90–94; Duthuit 1988, p. 186; Paris 1978a, no. 211; Faure et al. 1920, pp. 19–20.

2. Rony 1993, pp. 384–87 and 554–56.

3. Duthuit 1988, p. 186; Duthuit 1983, nos. 789–91; "Collection de Monsieur et Madame Henri Flammarion," Christie's, Paris, 21 October 2003, lot 27.

4. Matisse 2001, pp. 224, 269–71, and 653–54.

5. Ritchie 1976, p. 32.

6. Bidwell 1999.

37. Tristan Tzara, *Midis gagnés*

1. Fouché 1987, vol. 2, pp. 235–36; Fouché 1998, pp. 755–56; Staman 2002, pp. 295–96; Thyssens 2013.

38. Pierre de Ronsard, *Florilège des amours*

1. HM to PM, 11 March 1942, PMGA; HM to PM, 3 April 1942, PMGA; Philippe Gonin to HM, 24 March 1939, AM.

2. Skira to HM, 11 April 1941, AM; Matisse 2013, pp. 1–21; Matisse 2001, p. 651.

3. Skira to HM, 24 June 1941, AM; HM to Skira, 22 July 1941, AM; HM to Skira, 10 August 1941, AM; Skira to HM, 15 October 1941, AM; HM to PM, 11 March 1942, PMGA; Aragon to HM, 5 August 1942, AM; HM to Skira, 3 July 1944, AM.

4. HM to Skira, 1 November 1941, AM; Matisse 2001, pp. 72, 80, and 83; Skira to HM, 27 November 1941, AM; Skira to HM, 6 December 1941, AM; Skira 1948, p. 10. The paste-up maquette is in the BnF Réserve (Paris 1981, no. 162). Proof sheets in Monotype Garamond italic are in the PTMF collection.

5. Matisse 2001, pp. 81–85; Skira to HM, 18 April 1942, AM; Skira 1996, p. 97; HM to PM, 10 April 1942, PMGA.

6. Matisse 2001, p. 138; Delectorskaya 1996, pp. 353, 356, 360–61, 423, and 478; Skira to HM, 27 December 1943, AM; Skira to HM, 23 March 1945, AM.

7. Skira to HM, 22 August 1945, AM; Skira 1996, p. 97.

8. Paris 1981, no. 163; Skira 1948, pp. 13–14; Skira to HM, 10 December 1947, AM.

9. Skira 1996, p. 100; Jaspert 2001, p. 38; Dodson 1993, p. 5; Howes 2000, p. 2.

10. Skira to HM, 10 December 1947, AM; Skira to HM, 31 July 1948, AM; Skira 1948, pp. 12–13; Philadelphia 1948, no. 271; *Les nouvelles littéraires,* 2 December 1948, p. 4; Matisse 2001, p. 507.

11. Skira 1948; Skira 1996.

39. *Poésie de mots inconnus*

1. Iliazd 1990, p. 53. Other poetic movements represented include French Paroxysme, Chilean Creacionismo, and Russian Surrealism, with texts by Ibironké Akinsemoyin, Pierre Albert-Birot, Jean Arp, Jacques Audiberti, Hugo Ball, Nicolas Beauduin, Camille Bryen, Paul Dermée, Vicente Huidobro, Iliazd, Eugene Jolas, Pablo Picasso, Boris Poplavsky, Michel Seuphor, Igor Terentiev, Tristan Tzara, and Wols.

2. Paris 1978b, pp. 13–16; New York 1987, pp. 21–24; Iliazd to HM, 20 May 1949, cited in Duthuit 1988, p. 221. Iliazd's imprint Le Degré 41 dates back to

Russia as the name of an artists' collective Iliazd cofounded in 1916 with A. Kruchenykh (1886–1968) and Igor Terentiev (1892–1937). The group also used the name for its magazine, imprint, conferences, events, and a "university." After 1921, Iliazd obtained the name for his own activities in France. Johanna Drucker's extensive writings on Iliazd over several decades are an invaluable context for this (and any) examination of *Poésie de mots inconnus.* See, for instance, "Iliazd and the Art of the Book" (Toledo 2003, pp. 73–87). I am equally indebted to the works of Régis Gayraud and Françoise Le-Gris Bergmann.

3. Duthuit 1988, p. 220; Iliazd 1990, p. 54; Rusakov 1975, pp. 288–90. The book Iliazd purportedly offered as his credentials was possibly another book illustrated by Picasso, *Afat* (1940). Matisse left Paris before April that year (Spurling 2007, p. 446) and *Pismo* (1948) would have existed only in its preliminary form.

4. Duthuit 1988, pp. 220–21; Iliazd 1990, pp. 53–55; Montreal 1984, pp. 42 and 119–20. Like *Poésie,* Iliazd's *zaum* ballet, *La chasse sous-marine,* was a reaction to the Lettrists—a ballet *de mots inconnus,* reminiscent of Iliazd's collaborations with Lisica Codreano in the 1920s. Pierre Minet's article in *Combat* (8 November 1947) mistakenly reported that the dancer Serge Lifar would costar. Lifar had been blacklisted since the war because of his participation in the Vichy-sponsored delegations of artists sent to Germany. Tristan Tzara and other mutual friends of Iliazd and Matisse reacted angrily, and Iliazd atrributed Matisse's change of heart to the controversy.

5. Toledo 2003, pp. 80–82; Iliazd 1990, pp. 52–53. Isidore Isou, *Introduction à une nouvelle poésie et une nouvelle musique* (Paris: Gallimard, 1947), p. 55; Isidore Isou, *Les véritables créateurs et les falsificateurs de Dada, du surréalisme et du lettrisme, 1965–1973* (Paris: Lettrisme, 1973), pp. 63–70; *Camille Bryen à revers* (Paris: Somogy, 1997), p. 57. Isou's colleague, Brice Parain, announced the pre-Lettrist anthology (never published) in an article attributed to Sidoine, "La Danse du Scalp à la mode lettriste," *Arts, beaux-arts, littérature, spectacle* 77, 30 August 1946, p. 3. For Lettrism, see Greil Marcus's *Lipstick Traces* (Cambridge: Harvard University Press, 2009).

6. Iliazd 1990, p. 56.

7. Perriol 2010, pp. 14–17 and 34; Paris 1978b, p. 24;

Bibliothèque Lucie et Louis Barnier, Imprimerie Union (Paris: Artcurial, 2005), pp. 13 and 107, lot 183.
8. The Beinecke Library, Yale University, holds a collection of preliminary drafts and maquettes for the project: Iliazd papers relating to *Poésie de mots inconnus,* 1947–1964 (GEN MSS 1007). Françoise Le-Gris Bergmann has emphasized the theatrical and architectural aspects of Iliazd's books as well as the trembling vocal qualities suggested by his technique of overprinting (Montreal 1984, pp. 25–77; New York 1987, pp. 21–46).
9. Iliazd 1990, pp. 50–51; Duthuit 1983, no. 749; Beinecke GEN MSS 1007; Duthuit 1988, p. 221.
10. Duthuit 1988, p. 221.
11. John Stanton, "The New Expatriates," *Life* 27, no. 8, 22 August 1949, p. 76.
12. Gayraud 2000, pp. 82–86. Iliazd continued to work on the sonnet project for more than a decade, finally bringing it to light in 1961 as *Sentences sans paroles* with engravings by Giacometti and Braque.

40. René Leriche, *La chirurgie*

1. Spurling 2007, pp. 398–99; Matisse 2001, p. 207; Matisse 1995, p. 223.

41. Charles d'Orléans, *Poèmes*

1. Matisse preferred to read Charles d'Orléans in the old-spelling, critical edition of Pierre Champion, 2 vols. (Paris: Honoré Champion, 1923–27).
2. Matisse 2001, pp. 155, 164, 205–8, and 223–26; Diehl 1943. Studies for the title page are in the PTMF archive and in the Rouveyre holdings of the Royal Library, Copenhagen. A list of texts is reproduced in facsimile in Delectorskaya 1996, pp. 462–63.
3. Matisse 2001, pp. 147–48 and 432; Tériade to HM, 22 December 1947, AM.
4. Tériade to HM, 3 May 1950, telegram, AM. A camera-ready pasteup with a substituted page of text (p. 45) is in the collection of Frances and Michael Baylson along with an annotated proof (p. 20) and artwork in an earlier state before a spelling correction and an adjustment to a pen flourish (p. 47).
5. HM to PM, 20 October 1950, PMGA.

42. *Estampes*

1. Mac Orlan 1945.
2. Théo Schmied to HM, 17 June 1954, AM.

3. A picture of Maeght's exhibit installation is in London 2008, p. 34.

43. Colette, *La vagabonde*

1. Duthuit 1983, nos. 526–37 and 628; HM to Mourlot, 27 March 1947, AM; Mourlot to HM, 2 August 1948, AM.
2. Matisse 2001, pp. 495–96; Duthuit 1988, pp. 244–45; Mourlot 1974, pp. 66 and 69; Monod-Fontaine et al. 1989, no. 112; Henri Matisse, *Portraits* (Monte-Carlo: André Sauret, Éditions du Livre, 1954), pp. 76 and 77.
3. Colette 1984, vol. 1, p. 1593, and vol. 4, pp. l and lii.
4. Defert 1983.

44. Alfred H. Barr, Jr., *Matisse*

1. Barr 1986, pp. 28–29; Monroe Wheeler to Alfred H. Barr, Jr., 19 March 1950, AHB 11.I.B.1a.iii, MoMA Archives, NY; Alfred H. Barr, Jr., to HM, 24 December 1951, AHB 11.I.A.10, MoMA Archives, NY; Washington, Detroit, and St. Louis 1977, no. 123. Research queries and questionnaires are in PMGA box 192.15 and the MoMA Archives, NY.
2. HM to Monroe Wheeler, 1 September 1951, AHB 11.I.A.10, MoMA Archives, NY; HM to Monroe Wheeler, 18 September 1951, AHB 11.I.A.10, MoMA Archives, NY. The photograph of Matisse is reproduced in Washington, Detroit, and St. Louis 1977, fig. 55. A group of studies related to the frontispiece are reproduced in Duthuit 1983, nos. 660–63.

45. André Rouveyre, *Apollinaire*

1. Matisse 2001, pp. 52, 281, and 322.
2. Matisse 2001, pp. 281 and 359–60; Imbert 2000.
3. Matisse 2001, pp. 394–96, 413, and 505.
4. Matisse 2001, pp. 529–30 and 536.
5. Matisse 2001, pp. 535 and 590–92.
6. Matisse 2001, pp. 606, 621, and 625–27.
7. Matisse 2001, p. 585.
8. Matisse 2001, pp. 545–49 and 589–90; Duthuit 1983, nos. 625–26, 763–65, and 824–29; Duthuit 1988, p. 255; Pelachaud 2010, pp. 272–73.
9. Matisse 2001, pp. 474, 484, and 524; Duthuit 1988, no. 34; Apollinaire 2007, pp. 214–15.

46. *Échos*

1. Matisse 2001, pp. 619–20. Matisse often sent examples of his own works to René Leriche, one

of the Lyons doctors who had saved his life ten years before (Spurling 2007, p. 464).
2. Matisse 2001, pp. 619–21; André Verdet, *Préstiges de Matisse, précédé de Visite à Matisse, Entretiens avec Matisse* (Paris: Émile-Paul Frères, 1952).
3. It is tempting to speculate that Matisse may have been responsible for the inclusion of Hikmet, who had been a *cause célèbre* for Aragon and Tristan Tzara as part of an international campaign to free the poet from a Turkish prison. Despite the colophon's claims that *Échos* contained only unpublished material, Hikmet's valedictory *Adieu* had in fact appeared in the first collection of his poems to be published in French (*Poèmes de Nazim Hikmet.* Paris: Éditeurs Français Réunis, 1951).
4. Matisse 2001, p. 619; Washington, Detroit, and St. Louis 1977, no. 190. Trials for the linocut initials and vignettes are in the PTMF archive. The front wrapper of *Échos* bears Matisse's hand-lettered date of 24 June 1952, matching the date printed on the dedicatory page. Flam has suggested the possibility of an earlier date, noting its similarity to the silhouette cutouts of 1949.
5. Mourlot 1974, pp. 33–34 and 65–66; Mourlot 1979, pp. 80–82 and 111–12; Matisse 2001, p. 622; Perriol 2013.
6. Mourlot 1979, p. 112.
7. HM to PM, 12 November 1952, PMGA; Spurling 2007, p. 464; HM to PM, 2 November 1952, PMGA. Palliès remained at the clinic in its various incarnations from 1950 until 1977 (E-mail correspondence from Didier Périssé, directeur, Clinique Médicale et Pédagogique "Les Cadrans Solaires," Vence, 5 May 2014).

47. Henri Matisse, *Portraits*

1. Duthuit 1988, pp. 262–64; HM to Mourlot, 8 May 1953, AM; HM to PM, 30 March 1954, PMGA.
2. HM to PM, 9 April 1952, PMGA. *Cocoly Agelasto,* charcoal on wove paper, ca. 1915, Thaw Collection, 2010.127.
3. Duthuit 1988, p. 263; Klein 2001, p. 257. This essay becomes the final chapter of Jack Flam's definitive anthology of Matisse's writings on art (Matisse 1995, pp. 219–23).

HOW I MADE MY BOOKS (1946)

"How I Made My Books" is a specialized essay contributed to an anthology of statements by artist-illustrators. It is a literal account of Matisse's method of working, descriptive rather than theoretical, with the notable exception of the parallel drawn between making a painting and making a book. This procedure from the broad conception to detail, and then through a process of distillation and reduction to essentials, seems to run throughout Matisse's writings. JACK FLAM

HOW I MADE MY BOOKS

To start with my first book—the poems of Mallarmé.

Etchings, done in an even, very thin line, without hatching, so that the printed page is left almost as white as it was before printing.

The drawing fills the entire page so that the page stays light, because the drawing is not massed towards the center, as usual, but spreads over the whole page.

The recto pages carrying the full-page illustrations were placed opposite facing verso pages that carry the text in 20-point Garamond italic. The problem was then to balance the two pages—one white, with the etching, the other comparatively black, with the type.

I obtained my result by modifying my arabesque in such a way that the spectator should be interested as much by the white page as by his expectation of reading the text.

I compare my two pages to two objects taken up by a juggler. Suppose that his white ball and black ball are like my two pages, the light one and the dark one, so different, yet face to face. In spite of the differences between the two objects, the art of the juggler makes a harmonious whole in the eyes of the spectator.

——

My second book: *Pasiphäé* by Montherlant.

Linoleum engravings. A simple white line upon an absolutely black background. A simple line, without hatching.

Here the problem is the same as that of the "Mallarmé," except the two elements are reversed. How can I balance the black illustrating page against the comparatively white page of type? By composing with the arabesque of my drawing, but also by bringing the engraved page and the facing text page together so that they form a unit. Thus the engraved part and the printed part will strike the eye of the beholder at the same moment. A wide margin running all the way around both pages masses them together.

At this stage of the composition I had a definite feeling of the rather bleak character of this black and white book. A book, however, is generally like that. But in this case the large, almost entirely black page seemed a bit funereal. Then I thought of red initial letters. That pursuit caused me a lot of work; for after starting out with capitals that were pictorial, whimsical, the invention of a painter, I had to settle for a more severe and classical conception, more in accord with the elements already settled—the typography and engraving.

So then: Black, White, Red.—Not so bad . . .

Now for the cover. A blue came to my mind, a primary blue, a canvas blue, but with a white line engraved on it. As this cover has to remain in the slipcase or in a binding, I had to retain its "paper" character. I lightened the blue, without making it less blue, but through a woven effect—which came from the linoleum. Unknown to me, an attempt was made whereby the paper, saturated with blue ink, looked like leather. I rejected it immediately because it had lost the "paper" character I wanted it to have.

This book, because of the numerous difficulties in its design, took me ten months of effort, working all day and often at night.

——

My other books, notably *Visages,* the *Poésies de Ronsard,* the *Lettres portugaises,* those in the process of publication, which are waiting their turn at press, though they differ in appearance, were all done according to the same principles, which are:

1st. Rapport with the literary character of the work;

2nd. Composition conditioned by the elements employed as well as by their decorative values: black, white, color, kind of engraving, typography. These elements are determined by the demands of harmony for the book as a whole and arise during the actual progress of the work. They are never decided upon before the work is undertaken, but develop coincidentally as inspiration and the direction of my pursuits indicate.

I do not distinguish between the construction of a book and that of a painting and I always proceed from the simple to the complex, yet I am always ready to reconceive in simplicity. Composing at first with two elements, I add a third

insofar as it is needed to unite the first two by enriching the harmony—I almost wrote "musical."

I reveal my way of working without claiming that there are no others, but mine developed naturally, progressively.

———

I want to say a few words about lino engraving.

Linoleum shouldn't be chosen just as a cheap substitute for wood, as it gives the print a particular character, very different from that of wood, and for which it should be sought.

I have often thought that this simple medium is comparable to the violin with its bow: a surface, a gouge—four taut strings and a swatch of hair.

The gouge, like the violin bow, is in direct rapport with the feelings of the engraver. And it is so true that the slightest distraction in the drawing of a line causes a slight involuntary pressure of the fingers on the gouge and has an adverse effect on the line. Likewise, a change in the pressure of the fingers that hold the bow of a violin is sufficient to change the character of the sound from soft to loud.

Lino engraving is a true medium predestined to be used by the painter-illustrator.

I have forgotten a valuable precept: put your work back on the block twenty times over and then, if necessary, begin over again until you are satisfied.

SOURCES AND ABBREVIATIONS

AM
Archives Henri Matisse, Issy-les-Moulineaux.

Anthonioz 1988
Michel Anthonioz, *Verve: The Ultimate Review of Art and Literature (1937–1960)*, New York: Harry N. Abrams, 1988.

Apollinaire 2007
Guillaume Apollinaire, *Je pense à toi mon Lou: Poèmes et lettres d'Apollinaire à Lou*, edited by Laurence Campa, Paris: Textuel, 2007.

Aragon 1972
Louis Aragon, *Henri Matisse: A Novel*, translated by Jean Stewart, 2 vols., New York: Harcourt Brace Jovanovich, 1972.

Aragon 1997
Louis Aragon, *Album Aragon*, edited by Jean Ristat, Paris: Gallimard, 1997.

Arnar 2011
Anna Sigríður Arnar, *The Book as Instrument: Stéphane Mallarmé, the Artist's Book, and the Transformation of Print Culture*, Chicago and London: The University of Chicago Press, 2011.

Arnaud 2003
Claude Arnaud, *Jean Cocteau*, Paris: Gallimard, 2003.

Austin 1987
Lloyd Austin, *Poetic Principles and Practice: Occasional Papers on Baudelaire, Mallarmé and Valéry*, Cambridge: Cambridge University Press, 1987.

Badaracco 1995
Claire Hoertz Badaracco, *Trading Words: Poetry, Typography, and Illustrated Books in the Modern Literary Economy*, Baltimore and London: The Johns Hopkins University Press, 1995.

Barker 2003
Michael Barker, "International Exhibitions at Paris Culminating with the Exposition Internationale des Arts et Techniques dans la vie moderne—Paris 1937," *The Journal of the Decorative Arts Society, 1850–the Present* 27, 2003, pp. 6–21.

Barr 1951
Alfred H. Barr, Jr., *Matisse: His Art and His Public*, New York: The Museum of Modern Art, 1951.

Barr 1986
Alfred H. Barr, Jr., *Defining Modern Art: Selected Writings*, edited by Irving Sandler and Amy Newman, New York: Harry N. Abrams, 1986.

Béguin 1976
Albert Béguin, *Lettres, 1920–1957, [correspondance de] Albert Béguin, Marcel Raymond*, edited by Gilbert Guisan, Lausanne and Paris: La Bibliothèque des Arts, 1976.

Benjamin 1989
Roger Benjamin, "Recovering Authors: The Modern Copy, Copy Exhibitions and Matisse," *Art History* 12, 1989, pp. 176–201.

Benstock 1980
Shari Benstock, "The Double Image of Modernism: Matisse's Etchings for *Ulysses*," *Contemporary Literature* 21, no. 3, summer 1980, pp. 450–79.

Berggruen 1951
Bibliographie des oeuvres de Tristan Tzara, 1916–1950, Paris: Berggruen et Cie., 1951.

Bernouard 1946
François Bernouard, "François Bernouard ou les confidences d'un typographe," interview by Léon Vérane, *Le livre et ses amis* 2, no. 4, 1946, pp. 37–47.

Biblio
Biblio: Bibliographie des ouvrages en langue française parus dans le monde entier, 37 vols., 1934–70.

Bidwell 1999
John Bidwell, "The Compagnie Typographique," *Matrix* 19, 1999, pp. 130–37.

BnF
Bibliothèque nationale de France, Paris.

Boinet 1937
Amédée Boinet, "Le livre et les arts graphiques à l'Exposition internationale de Paris," *La Bibliofilia* 39, 1937, pp. 404–30; and 40, 1938, pp. 113–31.

Bokanowsky 1945
Hélène Bokanowsky, "French Literature in Algiers," *Books Abroad* 19, 1945, pp. 125–30.

Bordas 1997
Pierre Bordas, *L'édition est une aventure*, Paris: Éditions de Fallois, 1997.

Bouju 2010
Marie-Cécile Bouju, *Lire en communiste: Les maisons d'édition du Parti communiste français, 1920–1968*, Rennes: Presses Universitaires de Rennes, 2010.

Bouquet and Menanteau 1959
Georges Bouquet and Pierre Menanteau, *Charles Vildrac*, Poètes d'aujourd'hui 69, Paris: Éditions Pierre Seghers, 1959.

Breeskin 1935
Adelyn D. Breeskin, "Swans by Matisse," *The American Magazine of Art* 28, 1935, pp. 622–29.

Brinks 2005
John Dieter Brinks, ed., *The Book as a Work of Art: The Cranach Press of Count Harry Kessler*, Laubach and Berlin: Triton Verlag; Williamstown, Mass.: Williams College, 2005.

Brown 2013
Kathryn Brown, "Enacting Beauty: Baudelaire, Matisse, and *Les fleurs du mal*," *The Art Book Tradition*

in Twentieth-Century Europe, edited by Kathryn Brown, pp. 31–44, Farnham: Ashgate, 2013.

Capelleveen et al. 2009
Paul van Capelleveen, Sophie Ham, and Jordy Joubij, *Voices and Visions: The Koopman Collection and the Art of the French Book,* compiled by Clemens de Wolf and Paul van Capelleveen, The Hague: Koninklijke Bibliotheek; Zwolle: Waanders Publishers, 2009.

Carteret 1946
Léopold Carteret, *Le trésor du bibliophile: Livres illustrés modernes, 1875 à 1945, et souvenirs d'un demi-siècle de bibliophilie de 1887 à 1945,* 5 vols., Paris: L. Carteret, 1946–48.

Céline 1991
Céline & les Éditions Denoël, 1932–1948, edited by Pierre-Edmond Robert, Paris: IMEC Éditions, 1991.

Chamonard 2001
Marie Chamonard, "Réflexion sur le dépôt légal des livres d'artistes à partir d'une étude sur un imprimeur typographe, François da Ros," thesis, L'École nationale supérieure des sciences de l'information et des bibliothèques, 2001, online version at http://www.enssib.fr/bibliotheque-numerique/document-983.

Chapon 1973
François Chapon, "Sur quelques livres d'Albert Skira," *Bulletin du bibliophile,* 1973, pp. 366–76.

Chapon 1974
François Chapon, "Bibliographie descriptive des livres édités par Iliazd de 1940 à 1974," *Bulletin du bibliophile,* 1974, pp. 207–16.

Char 1983
René Char, *Oeuvres complètes,* Paris: Gallimard, 1983.

Colette 1984
Colette, *Oeuvres,* edited by Claude Pichois et al., 4 vols., Paris: Gallimard, 1984–2001.

Cranston 1973
Mechthild Cranston, "*Arrière-histoire du Poème pulvérisé:* René Char's *Winterreise,*" *The French Review* 46, 1973, pp. 141–58.

Daragnès 2001
Jean-Gabriel Daragnès, Villeneuve-sur-Yonne: Les Amis du Vieux Villeneuve; Paris: Éditions du Linteau, 2001.

Dassonville 1988
Gustave Arthur Dassonville, *Catalogue des impressions de feu Monsieur François Bernouard,* Bagnolet: La Typographie, 1988.

Dauberville 1995
Guy-Patrice Dauberville and Michel Dauberville, *Matisse: Henri Matisse chez Bernheim-Jeune,* 2 vols., Paris: Éditions Bernheim-Jeune, 1995.

Defert 1983
Thierry Defert, "Éditions André Sauret—A Modern Patron of the Book Beautiful," *Graphis* 39, no. 228, 1983, pp. 46–55.

Delectorskaya 1996
Lydia Delectorskaya, *Henri Matisse: Contre vents et marées, peinture et livres illustrés de 1939 à 1943,* Paris: Éditions Irus et Vincent Hansma, 1996.

Desbiolles 2008
Yves Chevrefils Desbiolles, "Le critique d'art Waldemar-George: Les paradoxes d'un non-conformiste," *Archives juives* 41, no. 2, 2008, pp. 101–17.

Diehl 1943
Gaston Diehl, "Avec Matisse le classique," *Comoedia,* no. 102, 12 June 1943, pp. 1 and 6.

Diehl 1944a
Gaston Diehl, "Matisse, illustrateur et maître d'oeuvre," *Comoedia,* nos. 132 and 133, 22 January 1944, pp. 1 and 6.

Diehl 1944b
Gaston Diehl, "La leçon de Matisse," *Comoedia,* nos. 146 and 147, 29 April 1944, pp. 1 and 4.

Dodson 1993
Alan Dodson, "A Type for All Seasons," *Matrix* 13, 1993, pp. 1–10.

Domenget 2003
Jean-François Domenget, *Montherlant critique,* Histoire des idées et critique littéraire 411, Geneva: Librairie Droz, 2003.

Doucet
Bibliothèque littéraire Jacques Doucet, Paris.

Duthuit 1983
Marguerite Duthuit-Matisse and Claude Duthuit, *Henri Matisse: Catalogue raisonné de l'oeuvre gravé,* compiled with the assistance of Françoise Garnaud, 2 vols., Paris: s.n., 1983.

Duthuit 1988
Claude Duthuit, *Henri Matisse: Catalogue raisonné des ouvrages illustrés,* compiled with the assistance of Françoise Garnaud, Paris: s.n., 1988.

Ellmann 1982
Richard Ellmann, *James Joyce,* new and revised edition, New York, Oxford, Toronto: Oxford University Press, 1982.

Escholier 1960
Raymond Escholier, *Matisse from the Life,* translated by Geraldine and H. M. Colvile, London: Faber and Faber, 1960.

Fabiani 1976
Martin Fabiani, *Quand j'étais marchand de tableaux,* Paris: Julliard, 1976.

Faure et al. 1920
Elie Faure, Jules Romains, Charles Vildrac, and Léon Werth, *Henri-Matisse,* Paris: Éditions des Cahiers d'Aujourd'hui, chez Georges Crès et Cie., 1920.

Focillon 1936
Henri Focillon, *Léon Pichon: Imprimeur parisien,* Paris: Léon Pichon, 1936.

Fouché 1984
Pascal Fouché, *La Sirène,* Paris: Bibliothèque de Littérature Française Contemporaine, 1984.

Fouché 1987
Pascal Fouché, *L'édition française sous l'Occupation, 1940–1944,* 2 vols., Paris: Bibliothèque de Littérature Française Contemporaine, 1987.

Fouché 1998
Pascal Fouché, ed., *L'édition française depuis 1945,* Paris: Éditions du Cercle de la Librairie, 1998.

Frey-Béguin 1993
Françoise Frey-Béguin, ed., *Les Cahiers du Rhône: "Refuge de la pensée libre,"* Boudry: Éditions de la Baconnière, 1993.

Gall 1992
Annie and Michel Gall, *Maeght le magnifique: Une biographie,* Étrépilly: Christian de Bartillat, 1992.

Gayraud 2000
Régis Gayraud, "Iliazd et le sonnet," *Pérennité des formes poétiques codifiées,* pp. 81–92, edited by Laurent Cassagnau and Jacques Lajarrige, Clermont-Ferrand: Presses Universitaires Blaise Pascal, 2000.

Gervais 1996
Reynold Gervais and Béatrice Beyney-Gervais, *André-Charles Gervais: Biographie d'un honnête homme du XXᵉ siècle,* Suresnes: Cultures & Devenirs, 1996.

Girodias 1990
Maurice Girodias, *Une journée sur la terre,* 2 vols., Paris: Éditions de la Différence, 1990.

Goddet 1991
Jacques Goddet, *L'équipée belle,* Paris: Robert Laffont/Stock, 1991.

Goodwin 1999
Willard Goodwin, "'A Very Pretty Picture M. Matisse but You Must Not Call It Joyce': The Making of the Limited Editions Club *Ulysses.* With Lewis Daniel's Unpublished *Ulysses* Illustrations," *Joyce Studies Annual* 10, 1999, pp. 85–103.

Greilsamer 2004
Laurent Greilsamer, *L'éclair au front: La vie de René Char,* Paris: Fayard, 2004.

Grotzer 1967
Pierre Grotzer, *Les écrits d'Albert Béguin: Essai de bibliographie,* Neuchâtel: Éditions de la Baconnière, 1967.

Guillaud 1987
Jacqueline and Maurice Guillaud, *Matisse: Le rythme et la ligne,* Paris and New York: Guillaud Editions, 1987.

Guilleragues 1972
Gabriel Joseph de Lavergne, vicomte de Guilleragues, *Chansons et bons mots, Valentins, Lettres portugaises,* edited by Frédéric Deloffre and Jacques Rougeot, Geneva: Librairie Droz, 1972.

Guilleragues 2009
——, *Lettres d'amour de la religieuse portugaise,* edited by Philippe Sollers, Bordeaux: Elytis, 2009.

Harwood 1974
Lee Harwood, *Tristan Tzara: A Bibliography,* London: Aloes Books, 1974.

Hattendorf 1991
Richard L. Hattendorf, "'Piracy' Proves the Difference: Pierre Reverdy's *Les jockeys camouflés et Période hors-texte,*" *Dalhousie French Studies* 20, 1991, pp. 39–59.

Hesse 1929
Raymond Hesse, *Histoire des sociétés de bibliophiles en France de 1820 à 1930,* 2 vols., Paris: L. Giraud-Badin, 1929–1931.

HM
Henri Matisse.

Howes 2000
Justin Howes, "Caslon's Punches and Matrices," *Matrix* 20, 2000, pp. 1–7.

HRC
Harry Ransom Center, The University of Texas at Austin.

Hubert 2011
Étienne-Alain Hubert, *Bibliographie des écrits de Pierre Reverdy,* Paris: Comité Pierre Reverdy/Éditions des Cendres, 2011.

Iliazd 1990
Iliazd, "En approchant Éluard," edited by Régis Gayraud, *Les carnets de l'Iliazd club,* no. 1, 1990, pp. 35–76.

Imbert 2000
Maurice Imbert, "Robert J. Godet, éditeur de Bataille, Michaux et Desnos," *Histoires littéraires* 1, no. 3, 2000, pp. 71–82.

Jaspert 2001
W. Pincus Jaspert, W. Turner Berry, A. F. Johnson, *Encyclopaedia of Type Faces,* 4th edition, London: Cassell, 2001.

Jolly 1960
Jean Jolly, *Dictionnaire des parlementaires français: Notices biographiques sur les ministres, sénateurs et députés français de 1889 à 1940,* 8 vols., Paris: Presses Universitaires de France, 1960–77.

Jour 2006
Jean Jour, *Robert Denoël, un destin,* Coulommiers: Éditions Dualpha, 2006.

Joyce 1966
James Joyce, *Letters of James Joyce,* 3 vols., vols. 2 and 3 edited by Richard Ellmann, New York: The Viking Press, 1966.

Kemp 1946
Robert Kemp, "Le neveu de Diderot," *Les nouvelles littéraires,* 31 October 1946, p. 3.

Klein 2001
John Klein, *Matisse Portraits,* New Haven and London: Yale University Press, 2001.

Knapp 2000
James A. Knapp, "Joyce and Matisse Bound: Modernist Aesthetics in the Limited Editions Club *Ulysses,*" *ELH* 67, no. 4, winter 2000, pp. 1055–81.

Kober 1993
Jacques Kober, *Un pigment d'horizon: Anthologie,* Charlieu: La Bartavelle, 1993.

Kundig 1932
Imprimerie Kundig, 1832–1932, Geneva: Imprimerie Kundig, 1932.

Labrusse 1999
Rémi Labrusse, *Matisse: La condition de l'image,* Paris: Gallimard, 1999.

Lackman 2014
Jon Lackman, "Maria Lani's Mystery," *Art in America,* June/July 2014, pp. 49–52.

Laroche 1999
Jean-Paul Laroche, *Les livres illustrés par Raoul Dufy du fonds Michel Chomarat de la Bibliothèque municipale de Lyon,* Lyons: Éditions Michel Chomarat, 1999.

Laurent and Mousli 2003
François Laurent and Béatrice Mousli, *Les Éditions du Sagittaire, 1919–1979,* Paris: Éditions de L'IMEC, 2003.

Lavarini 2000
Beatrice Lavarini, *Henri Matisse: Jazz (1943–1947), ein Malerbuch als Selbstbekenntnis,* Beiträge zur Kunstwissenschaft 79, Munich: Scaneg, 2000.

Lawrence 1971
George H. M. Lawrence, "André Kundig—Editor and Publisher of Kundig's Minuscules," *Miniature Book News* 23, March 1971, pp. 2–4.

Léautaud 1954
Paul Léautaud, *Journal littéraire,* 19 vols., Paris: Mercure de France, 1954–66.

Lecombre 1994
Sylvain Lecombre, *Ossip Zadkine: L'oeuvre sculpté,* Paris: Paris-Musées, 1994.

Leiner 1962
Wolfgang Leiner, "Les 'Lettres portugaises' démystifiées," *Zeitschrift für französische Sprache und Literatur* 72, 1962, pp. 129–35.

Limited Editions Club 1959
Limited Editions Club, *Quarto-Millenary: The First 250 Publications and the First 25 Years, 1929–1954, of the Limited Editions Club,* New York: The Limited Editions Club, 1959.

Linarès 2007
Serge Linarès, "Images de la poésie: Les recueils illustrés de Pierre Reverdy," *Revue d'histoire littéraire de la France* 107, 2007, pp. 181–200.

Mac Orlan 1945
Pierre Mac Orlan, *Essai sur Coulouma,* Paris: Robert Coulouma, 1945.

Macy 1935a
George Macy, "Mr. Homer and Mr. Joyce," *The Monthly Letter of the Limited Editions Club* 77, October 1935, pp. 1–3.

Macy 1935b
George Macy, "Mr. Joyce's Signature," *The Monthly Letter of the Limited Editions Club* 77, October 1935, p. 4.

Macy Archive
George Macy Companies, Limited Editions Club Archive, HRC.

Mahé 1931
Raymond Mahé, *Bibliographie des livres de luxe de 1900 à 1928 inclus,* 3 vols., Paris: René Kieffer, 1931–39.

Matisse 1957
Henri Matisse, *Jazz,* text translated into German by Ursula Klein, afterword by Tériade, Munich: R. Piper & Co., 1957.

Matisse 1971
"Correspondance Henri Matisse–Charles Camoin," edited by Danièle Giraudy, *Revue de l'art* 12, 1971, pp. 7–34.

Matisse 1972
Henri Matisse, *Écrits et propos sur l'art,* edited by Dominique Fourcade, new edition, revised and corrected, Paris: Hermann, 1972.

Matisse 1983
Henri Matisse, *Jazz,* introduction by Riva Castleman, text of *Jazz* translated by Sophie Hawkes, New York: George Braziller, 1983.

Matisse 1993
Henri Matisse, M.-A. Couturier, L.-B. Rayssiguier, *La chapelle de Vence: Journal d'une création,* edited by Marcel Billot, foreword by Dominique de Menil. Paris: Cerf, 1993.

Matisse 1995
Henri Matisse, *Matisse on Art,* edited by Jack Flam, revised edition, Berkeley, Los Angeles, and London: University of California Press, 1995.

Matisse 2001
Matisse–Rouveyre correspondance, edited by Hanne Finsen, Paris: Flammarion, 2001.

Matisse 2004
Matisse–Sembat correspondance: Une amitié artistique et politique, 1904–1922, edited by Christian Phéline and Marc Baréty, Lausanne: La Bibliothèque des Arts, 2004.

Matisse 2009a
Henri Matisse, *Jazz,* postscript by Katrin Wiethege, text of *Jazz* translated by Christopher Wynne, Munich: Prestel, 2009.

Matisse 2009b
Henri Matisse, *Cut-Outs, Drawing with Scissors,* edited by Gilles and Xavier-Gilles Néret, texts by Xavier-Gilles Néret, 2 vols., Cologne: Taschen, 2009.

Matisse 2013
Chatting with Henri Matisse: The Lost 1941 Interview, Henri Matisse with Pierre Courthion, edited by Serge Guilbaut, translated by Chris Miller, Los Angeles: Getty Research Institute, 2013.

McCleery 2008
Alistair McCleery, William S. Brockman, and Ian Gunn, "Fresh Evidence and Further Complications: Correcting the Text of the Random House 1934 Edition of *Ulysses,*" *Joyce Studies Annual,* 2008, pp. 37–77.

MD
Marguerite Duthuit.

Mirbeau 1990
Octave Mirbeau, *Correspondance avec Claude Monet,* edited by Pierre Michel and Jean-François Nivet, Tusson, Charente: Du Lérot, 1990.

Mirbeau 1993
Octave Mirbeau, *Combats esthétiques,* edited by Pierre Michel and Jean-François Nivet, 2 vols., Paris: Séguier, 1993.

MoMA
The Museum of Modern Art, New York.

Monod 1992
Luc Monod, *Manuel de l'amateur de livres illustrés modernes, 1875–1975,* 2 vols., Neuchâtel: Ides et Calendes, 1992.

Monod-Fontaine et al. 1989
Isabelle Monod-Fontaine, Anne Baldassari, and Claude Laugier, *Matisse: Oeuvres de Henri Matisse,* Collections du Musée national d'art moderne, Paris: Centre Georges Pompidou, 1989.

Mourlot 1974
Fernand Mourlot, *Souvenirs & portraits d'artistes,* Paris: A. C. Mazo, 1974.

Mourlot 1979
Fernand Mourlot, *Gravés dans ma mémoire,* Paris: Robert Laffont, 1979.

Nevers 2012
"Fiche patrimoine: L'Imprimerie Chassaing," *Nevers: Ça me botte!,* May 2012, pp. 39–40, online version at http://www.nevers.fr/assets/files/ncmb/ncmb180.pdf.

Nicholas 1994
Lynn H. Nicholas, *The Rape of Europa: The Fate of Europe's Treasures in the Third Reich and the Second World War,* New York: Alfred A. Knopf, 1994.

NYPL
New York Public Library.

O'Brian 1999
John O'Brian, *Ruthless Hedonism: The American Reception of Matisse,* Chicago and London: The University of Chicago Press, 1999.

Pelachaud 2010
Gaëlle Pelachaud, *Livres animés: Du papier au numérique,* Paris: L'Harmattan, 2010.

Perriol 2010
Antoine Perriol, "Iliazd & L'Imprimerie Union (1921–1975)," *Les carnets de L'Iliazd Club,* no. 7, 2010, pp. 11–52.

Perriol 2013
Antoine Perriol, "L'Imprimerie Union," http://imprimerie-union.org, Web site launched in 2013 on the basis of the author's two-volume thesis at the Université de Paris-Sorbonne, UFR Art et archéologie, 2005–6.

Pia 1998
Pascal Pia, *Les livres de l'Enfer: Bibliographie critique des ouvrages érotiques dans leurs différentes éditions du XVIᵉ siècle à nos jours,* Paris: Fayard, 1998.

Pichon 1924
Léon Pichon, *The New Book-Illustration in France,* London: The Studio, 1924.

Place 1974
Georges Place, *Montherlant,* Paris: Éditions de la Chronique des Lettres Françaises, 1974.

PM
Pierre Matisse.

PMGA
Pierre Matisse Gallery Archives, 1903–90, The Morgan Library & Museum.

PML
The Morgan Library & Museum.

PTMF
The Pierre and Tana Matisse Foundation, New York.

Raczymow 1988
Henri Raczymow, *Maurice Sachs, ou, Les travaux forcés de la frivolité,* Paris: Gallimard, 1988.

Reverdy 2010
Pierre Reverdy, *Oeuvres complètes,* 2 vols., edited by Étienne-Alain Hubert, Paris: Flammarion, 2010.

Rewald 1996
John Rewald, in collaboration with Walter Feilchenfeldt and Jayne Warman, *The Paintings of Paul Cézanne: A Catalogue Raisonné,* 2 vols., New York: Harry N. Abrams, 1996.

Ritchie 1976
Ward Ritchie, *François-Louis Schmied, Artist, Engraver, Printer: Some Memories and a Bibliography,* Tucson: Graduate Library School, University Library, University of Arizona, 1976.

Romains 1970
Jules Romains, *Amitiés et rencontres,* Paris: Flammarion, 1970.

Rony 1993
Olivier Rony, *Jules Romains, ou, L'appel au monde,* Paris: Robert Laffont, 1993.

Rothwell 1989
Andrew Rothwell, "Reverdy's *Les jockeys camouflés:* From Aesthetic Polemic to Art Poétique," *Nottingham French Studies* 28, 1989, pp. 26–44.

Rusakov 1975
Yu. A. Rusakov, "Matisse in Russia in the Autumn of 1911," translated by J. E. Bowlt, *Burlington Magazine,* no. 866, May 1975, pp. 284–91.

Russell 1999
John Russell, *Matisse Father & Son,* New York: Harry N. Abrams, 1999.

Schneider 1984
Pierre Schneider, *Matisse,* translated by Michael Taylor and Bridget Strevens Romer, New York: Rizzoli, 1984.

Seghers 1978
Pierre Seghers, *La Résistance et ses poètes,* 2 vols., Verviers: Marabout, 1978.

Silverman 2008
Willa Z. Silverman, *The New Bibliopolis: French Book Collectors and the Culture of Print, 1880–1914,* Toronto, Buffalo, London: University of Toronto Press, 2008.

Skira 1946
Albert Skira, *Anthologie du livre illustré par les peintres et sculpteurs de l'École de Paris,* Geneva: Éditions Albert Skira, 1946.

Skira 1948
Albert Skira, *Vingt ans d'activité,* Geneva: Éditions Albert Skira, 1948.

Skira 1996
Albert Skira, "The Story of a Book: Illustrations by Henri Matisse for *Florilège des amours de Ronsard,*" translated and introduced by Peter Allen, *Matrix* 16, 1996, pp. 95–101.

Slocum and Cahoon 1953
John J. Slocum and Herbert Cahoon, *A Bibliography of James Joyce (1882–1941),* New Haven: Yale University Press, 1953.

Smith College 1985
Smith College Museum of Art, *The Selma Erving Collection: Nineteenth and Twentieth Century Prints,* essays by Charles Chetham and Elizabeth Mongan, catalogue by Colles Baxter et al., edited by Nancy Sojka and Christine Swenson, Northampton, Mass.: Smith College Museum of Art, 1985.

Spotts 2008
Frederic Spotts, *The Shameful Peace: How French Artists and Intellectuals Survived the Nazi Occupation*, New Haven and London: Yale University Press, 2008.

Spurling 2001
Hilary Spurling, *The Unknown Matisse, A Life of Henri Matisse: The Early Years, 1869–1908*, Berkeley and Los Angeles: University of California Press, 2001.

Spurling 2007
Hilary Spurling, *Matisse the Master, A Life of Henri Matisse: The Conquest of Colour, 1909–1954*, New York: Alfred A. Knopf, 2007.

Staman 2002
A. Louise Staman, *With the Stroke of a Pen: A Story of Ambition, Greed, Infidelity, and the Murder of the French Publisher Robert Denoël*, New York: St. Martin's Press, 2002.

Strachan 1969
W. J. Strachan, *The Artist and the Book in France: The 20th Century Livre d'artiste*, New York: George Wittenborn, 1969.

Szymusiak 2002
Dominique Szymusiak et al., *Matisse Museum, Le Cateau-Cambrésis: Henri Matisse, Auguste Herbin, Geometrical Abstraction, Tériade, Art Editor*, Le Cateau-Cambrésis: Musée Matisse, 2002.

Théry 2010
Jean-François Théry, *Pierre Guéguen: Le korrigan du Vésinet, suivi d'une anthologie*, Rennes: La Part Commune, 2010.

Thyssens 2013
Henri Thyssens, *Robert Denoël, éditeur*, http://www.thyssens.com/index.php, 2005–13.

Tzara 1975
Tristan Tzara, *Oeuvres complètes*, edited by Henri Béhar, 6 vols., Paris: Flammarion, 1975–91.

Van Dijk 1992
C. van Dijk, *Alexandre A. M. Stols, 1900–1973, Uitgever, Typograaf*, Zutphen: Walburg Pers, 1992.

Yeide 1999
Nancy H. Yeide, "The Marie Harriman Gallery (1930–1942)," *Archives of American Art Journal* 39, nos. 1/2, 1999, pp. 3–11.

EXHIBITIONS

Auxerre 2004
Musée-Abbaye Saint-Germain, Auxerre, *Jacques Maret, l'insolite*, essays by Max Jacob, Arlette Albert-Birot, and Micheline Durand, 2004.

Baltimore 1971
Baltimore Museum of Art and other venues, *Matisse as a Draughtsman*, catalogue by Victor I. Carlson, 1971.

Baltimore 2009
Baltimore Museum of Art and other venues, *Matisse as Printmaker: Works from the Pierre and Tana Matisse Foundation*, essays by William S. Lieberman and Jay McKean Fisher, catalogue by Jay McKean Fisher, 2009.

Basel 1989
Kunstmuseum Basel, *Paul Cézanne: Die Badenden*, catalogue by Mary Louise Krumrine, 1989.

Bern 1960
Klipstein & Kornfeld, Bern, *Henri Matisse: Das illustrierte Werk, Zeichnungen und Druckgraphik*, 1960.

Boston 1961
Museum of Fine Arts, Boston, *The Artist & the Book, 1860–1960, in Western Europe and the United States*, catalogue by Eleanor M. Garvey, 1961.

Brussels 1975
Galerie Jacques Damase, Brussels, *Pierre Louis Flouquet*, essays by Phil Mertens, L.-L. Sosset, and Pierre Bourgeois, 1975.

Ferrara 2010
Palazzo dei Diamanti, Ferrara, *Da Braque a Kandinsky a Chagall: Aimé Maeght e i suoi artisti*, texts by Tomás Llorens, Chiara Vorrasi, and Boye Llorens, 2010.

Florence and Le Cateau-Cambrésis 1996
Museo Mediceo, Florence, and Musée Matisse, Le Cateau-Cambrésis, *Matisse et Tériade*, essays by Henri Matisse, Jack Flam, Tériade, Jean Leymarie, Dominique Szymusiak, and Xavier Girard, 1996.

Fribourg 1982
Musée d'Art et d'Histoire, Fribourg, *Henri Matisse, 1869–1954: Gravures et lithographies*, catalogue by Margrit Hahnloser-Ingold, Yvonne Lehnherr, Christine E. Stauffer, and Roger Marcel Mayou, 1982.

Geneva 1959
Galerie Gérald Cramer, Geneva, *Le livre illustré par Henri Matisse: Dessins, documents*, 1959.

Geneva 1981
Galerie Patrick Cramer, Geneva, *Pasiphaé*, 1981.

Le Cateau-Cambrésis 1987
Musée Matisse, Le Cateau-Cambrésis, *Henri Matisse, Pasiphaé, texte d'Henry de Montherlant*, prefatory texts by Jean Guichard-Meili and Dominique Szymusiak, 1987.

Le Cateau-Cambrésis 1992
Musée Matisse, Le Cateau-Cambrésis, *Matisse et Baudelaire*, exhibition organized by Dominique Szymusiak, 1992.

London 2004
Sims Reed Gallery, London, *Henri Matisse: Jazz*, 2004.

London 2008
Royal Academy of Arts, London, *Behind the Mirror: Aimé Maeght and His Artists, Bonnard, Matisse, Miró, Calder, Giacometti, Braque*, catalogue by Lucy Bennett, David Breuer, Sophie Oliver, Peter Sawbridge, Sheila Smith, and Nick Tite, 2008.

Mexico City 1983
Museo Rufino Tamayo, Mexico City, *Matisse: Obra gráfica, Jazz y Pasiphaé*, essays by William S. Lieberman, Jack D. Flam, and Ana Zagury, 1983.

Montreal 1984
Galerie d'art, Université du Québec, Montreal, *Iliazd, maître d'oeuvre du livre moderne*, catalogue by Françoise Le Gris-Bergmann, 1984.

Moscow and Saint Petersburg 1969
A. S. Pushkin Museum, Moscow, and the State Hermitage Museum, Saint Petersburg, *Matiss*, 1969.

New York 1978
The Museum of Modern Art, New York, *Matisse in the Collection of the Museum of Modern Art*, catalogue

by John Elderfield with additional texts by William S. Lieberman and Riva Castleman, 1978.

New York 1987
The Museum of Modern Art, New York, *Iliazd and the Illustrated Book,* catalogue by Audrey Isselbacher, essay by Françoise Le Gris-Bergmann, 1987.

New York 1994
The Museum of Modern Art, New York, *A Century of Artists Books,* catalogue by Riva Castleman, 1994.

New York 1997
Yoshii Gallery, New York, *Matisse and Tériade: Collaborative Works by the Artist and Art Publisher from Verve (1937–1960)* [and] Lettres portugaises, *1946,* essay by Casimiro Di Crescenzo, 1997.

New York 2002
The Morgan Library & Museum, New York, *Pierre Matisse and His Artists,* catalogue by William M. Griswold and Jennifer Tonkovich, 2002.

New York 2011
The Grolier Club, New York, *The Best of Both Worlds: Finely Printed Livres d'Artistes, 1910–2010,* catalogue by Jerry Kelly, Riva Castleman, and Anne H. Hoy, 2011.

Nice 1986
Musée Matisse, Nice, *Henri Matisse: L'art du livre,* catalogue by Xavier Girard et al., 1986.

Nuremberg 2007
Germanisches Nationalmuseum, Nuremberg, *Matisse: Jazz,* catalogue by Anja Grebe, 2007.

Paris 1970
Bibliothèque nationale de France, Paris, *Matisse: L'oeuvre gravé,* catalogue by Françoise Woimant and Jean Guichard-Meili, 1970.

Paris 1973
Centre national d'art contemporain, Paris, *Hommage à Tériade,* text by Michel Anthonioz, 1973.

Paris 1978a
Bibliothèque nationale de France, Paris, *Jules Romains,* catalogue by Annie Angremy et al., 1978.

Paris 1978b
Musée national d'art moderne, Paris, *Iliazd,* catalogue by Annick Lionel-Marie and Germain Viatte, assisted by Laure de Buzon-Vallet, 1978.

Paris 1981
Bibliothèque nationale de France, Paris, *Henri Matisse: Donation Jean Matisse,* catalogue by Françoise Woimant and Marie-Cécile Miessner, 1981.

Paris 1987
Musée d'art moderne de la Ville de Paris, *Paris 1937: Cinquantenaire de l'Exposition internationale des arts et des techniques dans la vie moderne,* catalogue produced under the direction of Bertrand Lemoine, assisted by Philippe Rivoirard, 1987.

Paris 1988
Bibliothèque nationale de France, Paris, *50 livres illustrés depuis 1947,* catalogue by Antoine Coron, 1988.

Paris 1995
Bibliothèque Historique de la Ville de Paris, Paris, *André Rouveyre, 1879–1962, entre Apollinaire et Matisse,* catalogue by Catherine Coquio and Jean-Paul Avice, 1995.

Paris 2001
Centre Pompidou, Paris, *Dubuffet,* catalogue by Daniel Abadie, 2001.

Paris 2007
Bibliothèque nationale de France, Paris, *René Char,* catalogue texts by Dominique Fourcade, Jean-Claude Mathieu, and François Vezin, exhibition organized by Antoine Coron, 2007.

Paris, Copenhagen, and New York 2012
Musée national d'art moderne, Paris, Statens Museum for Kunst, Copenhagen, The Metropolitan Museum of Art, New York, *Matisse: In Search of True Painting,* catalogue edited by Dorthe Aagesenn and Rebecca A. Rabinow, 2012.

Paris and Humlebaek 2005
Musée du Luxembourg, Paris, and Louisiana Museum of Modern Art, Humlebaek, Denmark, *Matisse: A Second Life,* catalogue by Catherine Coquio, Anne Coron, Hanne Finsen, Claudine Grammont, and Isabelle Monod-Fontaine, 2005.

Philadelphia 1948
Philadelphia Museum of Art, *Henri Matisse: Retrospective Exhibition of Paintings, Drawings, and Sculpture,* catalogue by Henry Clifford, 1948.

Saint-Paul de Vence 1970
Fondation Maeght, Saint-Paul de Vence, *À la rencontre de Pierre Reverdy et ses amis,* catalogue with a preface by Jacques Dupin, 1970.

Saint-Paul de Vence 1971
Fondation Maeght, Saint-Paul de Vence, *Exposition René Char,* catalogue by Nicole S. Mangin with the assistance of Ariane Faguet, 1971.

Saint-Paul de Vence 1972
Fondation Maeght, Saint-Paul de Vence, *Maeght Éditeur,* catalogue with a preface by Jean-Louis Prat, 1972.

Saint Petersburg 1980
State Hermitage Museum, Saint Petersburg, *Henri Matisse: L'art du livre,* catalogue by Y. Roussakov, 1980.

Sens 2007
Musées de Sens, *Jean-Gabriel Daragnès, 1886–1950: Un artiste du livre à Montmartre,* catalogue by Sylvie Ballester-Radet and Virginie Garret, 2007.

Toledo 2003
Toledo Museum of Art, Toledo, Ohio, *Splendid Pages: The Molly and Walter Bareiss Collection of Modern Illustrated Books,* catalogue by Julie Mellby, contributions by Walter Bareiss et al., 2003.

Vulaines-sur-Seine 2002
Musée départemental Stéphane Mallarmé, Vulaines-sur-Seine, *Matisse et Mallarmé,* essays by Marie-Anne Sarda, Susanne Kudielka, Branden W. Joseph, and Vincent Lecourt, catalogue by Vincent Lecourt, 2002.

Washington, Detroit, and St. Louis 1977
National Gallery of Art, Washington, The Detroit Institute of Arts, The St. Louis Art Museum, *Henri Matisse: Paper Cut-Outs,* catalogue by Jack Cowart and Dominique Fourcade with contributions by John Hallmark Neff, Jack D. Flam, and John Haletsky, 1977.

INDEX

ACKNOWLEDGMENTS

Many friends and colleagues helped with the preparation of this catalogue. In addition to those acknowledged in the Director's Foreword, I am greatly indebted to the following for their advice and assistance: Jo Ellen Ackerman, Katherine D. Alcauskas, John D. Alexander, Patrick Alexander, Kevin Auer, Brian Beer, Jean-Luc Berthommier, Claire E. Bidwell, Céline Chicha-Castex, Antoine Coron, Caroline Duroselle-Melish, Benoît Forgeot, Shana H. Fung, Peter Gammie, Elizabeth L. Garver, Carol P. Grossman, V. Heidi Hass, Andrea L. Immel, Eric J. Johnson, Jerry Kelly, Declan Kiely, John Lancaster, Benjamin Levy, John McQuillen, Julie Mellby, Maria Molestina, Christine Nelson, Jennifer Norton, Richard W. Oram, Paula Pineda, Gloria C. Phares, Sima Prutkovsky, David R. Whitesell, and Sophie Worley. I am very grateful for the opportunity to speak about my work in progress at the Grolier Club, the Indiana University Art Museum, the Material Texts Seminar at the University of Pennsylvania, and the *Making Sense: Handwriting & Print* symposium at Texas A & M University. A short-term fellowship at the Harry Ransom Center, University of Texas at Austin, made it possible for me to examine Matisse publications and correspondence in that collection. An earlier version of the entry on *Ulysses* (No. 14) appeared in the journal *Matrix*, vol. 32 (2014).

PHOTO CREDITS

Every effort has been made to trace copyright owners and photographers. The Morgan apologizes for any unintentional omissions and would be pleased in such cases to add an acknowledgment in future editions.

PHOTOGRAPHIC COPYRIGHT:
All works by Henri Matisse © 2015 Succession Henri Matisse / Artists Rights Society (ARS), New York. The Baltimore Museum of Art: The Cone Collection, formed by Dr. Claribel Cone and Miss Etta Cone of Baltimore, Maryland, pp. vi, 23 (BMA 1950.12.910.7), pp. 18, 36 (BMA 1950.12.694.1), p. 24 (BMA 1950.12.694.17), p. 27 (BMA 1950.12.67), p. 29 (BMA 1950.256), p. 30 (BMA 1950.258), p. 34, Fig. 9, p. 35, Fig. 11 (BMA 1950.12.691.1), p. 35, Fig. 10, p. 38 (BMA 1950.12.691.2 and BMA 1950.12.691.3), p. 39, Fig. 16 (BMA 1950.12.696), p. 39, Figs. 17–18 (BMA 1950.12.697), p. 39, Fig. 19 (BMA 1950.12.694.4), p. 73 (BMA 1950.12.465); courtesy of Frances and Michael Baylson, p. v, top right, pp. 16, 178, 181, 200; Bibliothèque littéraire Jacques Doucet, Paris, p. 124; Bibliothèque nationale de France, p. 123, Fig. 4; Butler Library, Columbia University in the City of New York, p. 141, Fig. 2; © Henri Cartier-Bresson / Magnum Photos, pp. 146, 224; Claribel Cone and Etta Cone Papers, Archives and Manuscripts Collection, The Baltimore Museum of Art, p. 31 (CP.30.1, CP.30.6, CP.30.9, CP.30.14, CP.30. 21, CP.30.22); Marquand Library of Art and Archaeology, Princeton University, p. 104; The Pierre and Tana Matisse Foundation, p. v, second from bottom right, pp. 21, 50, 91, 99, 121, 123, Fig. 3, p. 147, Fig. 5, pp. 164–65, Figs. 2–3, p. 168, Fig. 3, pp. 170, 179, 182, 194, p. 206, Fig. 2; The Morgan Library & Museum, back cover, p. 196 (MA 5020, The Pierre Matisse Gallery Archives © Ina Bandy / Association Ina Bandy), front cover, p. x (PML 195598), pp. i–ii, 164, Fig. 1, p. 252 (PML 195607), p. v, top left, pp. 151, 153 (PML 195604), p. v, middle left, pp. 5, 120, 125 (PML 195598), p. v, bottom left, p. 216, Fig. 1 (PML 195616), p. v, second from top right (PML 195603), p. v, right bottom, pp. 116, 118 (PML 195597), p. 8 (PML 195613), pp. 14, 195 (PML 195611), pp. 42, 97, Fig. 2 (MA 5020, The Pierre Matisse Gallery Archives), p. 52 (PML 195635), p. 55, Fig. 1, p. 55, Fig. 2 (397.1 C658 M53), p. 56 (PML 195588), p. 58 (PML 195627), p. 61 (PML 195626), p. 63, Fig. 1 (PML 195714 and PML 195628), p. 63, Fig. 2 (PML 195628), p. 65 (PML 195589), p. 67 (PML 195715), p. 69 (PML 195986), pp. 77, 79 (PML 195591), p. 81 (PML 195634), pp. 83–84 (PML 195629), p. 87, Fig. 1, pp. 89, 92, 103 (PML 195592), p. 87, Fig. 2, p. 97, Fig. 1, p. 100 (PML 195653), p. 97, Fig. 1 (PML 195593), p. 105 (PML 195706 © 2015 Jean-Gabriel Daragnès / Artists Rights Society (ARS), New York / ADAGP, Paris), p. 107, Fig. 2 (PML 195706 © 2015 Henri Verge-Sarrat / Artists Rights Society (ARS), New York / ADAGP, Paris), p. 107, Fig. 3 (PML 195706), pp. 109–10 (PML 195594), pp. 112–13 (PML 195630), p. 115 (PML 195967), pp. 127–28 (PML 195978), pp. 129–31 (PML 195599), pp. 133–34 (PML 195600), p. 136 (PML 195601), p. 139 (PML 195602), pp. 143, 147, Fig. 6, p. 149 (PML 195603), p. 145, Fig. 2 (PML 195647), p. 145, Fig. 3 (PML 196075), pp. 158–59 (PML 195605), p. 161 (PML 195606), p. 168, Figs. 1–2, p. 169 (PML 77241), p. 175 (PML 195609), p. 185 (PML 195633), p. 188 (PML 195701), p. 190 (PML 195610), pp. 192, 195 (PML 195611), p. 199, Fig. 1 (PML 195699 © 2015 Raoul Hausmann / Artists Rights Society (ARS), New York / ADAGP, Paris), p. 199, Fig. 2 (PML 195699), p. 203 (PML 195612), pp. 206–7 (PML 195613), p. 211 (PML 195614), pp. 213–14 (PML 195615), p. 216, Fig. 2 (PML 195619), pp. 220–21 (PML 195617), p. 222 (PML 195618); The Museum of Modern Art, New York, NY, U.S.A., digital image © The Museum of Modern Art / Licensed by SCALA / Art Resource, NY © 2015 Jean Dubuffet / Artists Rights Society (ARS), New York / ADAGP, Paris, p. 141, Fig. 3; Harry Ransom Center, The University of Texas at Austin, pp. 154–55, 208–9; Smith College Museum of Art, Northampton, Massachusetts, gift of Selma Erving, class of 1927, p. 75.

PHOTOGRAPHY:
© Ina Bandy / Association Ina Bandy, back cover, p. 196; © Henri Cartier-Bresson / Magnum Photos, pp. 146, 224; Alvin Langdon Coburn, p. 55, Fig. 2; Graham S. Haber, front cover, pp. i–ii, v, x, 4–5, 8, 14, 16, 21, 50, 52, 55, Fig. 1, pp. 56, 58, 61, 63, 65, 67, 69, 77, 79, 81, 83–84, 87, 89, 91–92, 97, Fig. 1, pp. 99–100, 103, 105, 107, 109–10, 112–13, 115–16, 118, 120–21, 123, Fig. 3, pp. 125, 127–31, 133–34, 136, 139, 143, 145, 147, 149, 151, 153, 158–59, 161, 164–65, 168–70, 175, 178–79, 181–82, 185, 188, 190, 192, 194–95, 199–200, 203, 206–7, 211, 213–14, 216, 220–22, 252; Mitro Hood, pp. vi, 18, 23–24, 27, 29–31, 34–36, 38–39, 73; Petegorsky / Gipe Photography, p. 75.

TEXT COPYRIGHT:
© Editions Flammarion, pp. 58, 61, 131, Fig. 3; © 2015 Kurt Schwitters / Artists Rights Society (ARS), New York / VG Bild-Kunst, Bonn, p. 199, Fig. 1; *Matisse on Art* edited by Jack Flam. Copyright © 1995 by Jack Flam. English translation copyright © 1995 by Jack Flam. Underlying text and illustrations by Matisse. Copyright © 1995, 1973 by Succession Henri Matisse (University of California Press). Reprinted by permission of Georges Borchardt, Inc., for Jack Flam, pp. 233–34.

THE PENN STATE SERIES
IN THE HISTORY OF THE BOOK

James L. W. West III, General Editor

EDITORIAL BOARD
Robert R. Edwards (Pennsylvania State University)
Paul Eggert (University of New South Wales at ADFA)
Simon Eliot (University of London)
William L. Joyce (Pennsylvania State University)
Beth Luey (Massachusetts Historical Society)
Jonathan Rose (Drew University)
Willa Z. Silverman (Pennsylvania State University)

PREVIOUSLY PUBLISHED TITLES IN THE PENN STATE SERIES IN THE HISTORY OF THE BOOK

Peter Burke, *The Fortunes of the "Courtier": The European Reception of Castiglione's "Cortegiano"* (1996)

Roger Burlingame, *Of Making Many Books: A Hundred Years of Reading, Writing, and Publishing* (1996)

James M. Hutchisson, *The Rise of Sinclair Lewis, 1920–1930* (1996)

Julie Bates Dock, ed., *Charlotte Perkins Gilman's "The Yellow Wall-paper" and the History of Its Publication and Reception: A Critical Edition and Documentary Casebook* (1998)

John Williams, ed., *Imaging the Early Medieval Bible* (1998)

Ezra Greenspan, *George Palmer Putnam: Representative American Publisher* (2000)

James G. Nelson, *Publisher to the Decadents: Leonard Smithers in the Careers of Beardsley, Wilde, Dowson* (2000)

Pamela E. Selwyn, *Everyday Life in the German Book Trade: Friedrich Nicolai as Bookseller and Publisher in the Age of Enlightenment* (2000)

David R. Johnson, *Conrad Richter: A Writer's Life* (2001)

David Finkelstein, *The House of Blackwood: Author-Publisher Relations in the Victorian Era* (2002)

Rodger L. Tarr, ed., *As Ever Yours: The Letters of Max Perkins and Elizabeth Lemmon* (2003)

Randy Robertson, *Censorship and Conflict in Seventeenth-Century England: The Subtle Art of Division* (2009)

Catherine M. Parisian, ed., *The First White House Library: A History and Annotated Catalogue* (2010)

Jane McLeod, *Licensing Loyalty: Printers, Patrons, and the State in Early Modern France* (2011)

Charles Walton, ed., *Into Print: Limits and Legacies of the Enlightenment, Essays in Honor of Robert Darnton* (2011)

James L. W. West III, *Making the Archives Talk: New and Selected Essays in Bibliography, Editing, and Book History* (2012)

John Hruschka, *How Books Came to America: The Rise of the American Book Trade* (2012)

A. Franklin Parks, *William Parks: The Colonial Printer in the Transatlantic World of the Eighteenth Century* (2012)

Roger E. Stoddard, comp., and David R. Whitesell, ed., *A Bibliographic Description of Books and Pamphlets of American Verse Printed from 1610 Through 1820* (2012)

Nancy Cervetti, *S. Weir Mitchell: Philadelphia's Literary Physician* (2012)

Karen Nipps, *Lydia Bailey: A Checklist of Her Imprints* (2013)

Paul Eggert, *Biography of a Book: Henry Lawson's "While the Billy Boils"* (2013)

Allan Westphall, *Books and Religious Devotion: The Redemptive Reading of an Irishman in Nineteenth-Century New England* (2014)

Scott Donaldson, *The Impossible Craft: Literary Biography* (2015)

PUBLISHED BY THE PENNSYLVANIA STATE UNIVERSITY PRESS
AND THE MORGAN LIBRARY & MUSEUM

The Morgan Library & Museum

Karen Banks, *Publications Manager*
Patricia Emerson, *Senior Editor*
Eliza Heitzman, *Editorial Assistant*

PROJECT STAFF

Marilyn Palmeri, *Manager, Imaging and Rights*
Eva Soos, *Assistant Manager, Imaging and Rights*
Kaitlyn Krieg, *Administrative Assistant, Imaging and Rights*
Graham S. Haber, *Photographer*

The Pennsylvania State University Press

Jennifer Norton, *Design and Production Manager*
Laura Reed-Morrisson, *Managing Editor*
Patty Mitchell, *Production Coordinator*
Hannah Hebert, *Editorial Assistant*

Designed by Bessas & Ackerman
Typeset in Adobe Caslon Pro
Printed on Garda Silk and bound by Friesens

The publishers wish to thank Thomas Bollier,
Linda Purnell, Hannah Rhadigan, Peter Rohowsky,
Min Tian, and John L. Tofanelli.